WILD CARDS FOR YOUR SOUL

Artwork by

Aunt T Pathfinder

Copyright © 2016 & 2018 Aunt T Pathfinder

All rights reserved.

ISBN: 9781980544500

DEDICATION

FOR FAMILY AND FRIENDS OF THE HEART, OF THE MIND, OF THE SOUL
AND BLOOD,
FOR THE WORLD AND ALL LIFE UPON, IN, OR ABOVE IT, AND
FOR THOSE WHO ARE HERE NOW, WERE HERE, OR WILL EVER BE IN OUR
REALM OF EXISTENCE...
I OFFER THE WILD CARDS TO AID IN HEALING, HOPING TO FIND A WAY WE
CAN ENJOY EACH OTHER'S COMPANY AND CELEBRATE THE DIFFERENCES
BETWEEN US AS WELL AS THAT WHICH IS THE SAME.
UNCONDITIONAL LOVE TO ALL.

CONTENTS

	Acknowledgments	i
WILD CARDS	A - B	2
WILD CARDS	C	30
WILD CARDS	D – E - F	90
WILD CARDS	G – H - I – J – K - L	146
WILD CARDS	M - N	202
WILD CARDS	(no O) P - Q	248
WILD CARDS	R - S	292
WILD CARDS	T	338
WILD CARDS	U – V – W (no X –Y – Z)	384
	ABOUT THE ARTIST	406

ACKNOWLEDGMENTS

Wild Cards evolved from collaborations between True Creator/God, the Spirit of Trees clinging to the multi-purpose printing paper (mainly), and me... Aunt T Pathfinder (seeking to understand, heal, and clean myself). Using #2 0.7mm mechanical pencils (mainly), my drawing style evolved from a mediocre level (trying to capture what was in my mind's eye), through sliding my fingertip across the paper until it stuck (mark it and slide again, etc), into drawing only what is on the paper (even stains). I call this Unconceived Drawing and it is fun since I have no idea what the paper (God and Tree) is showing me until it builds up over time. Can you tell the difference in them?

I can sometimes search through a stack of paper (forward and back) before finding the one ready for me to draw upon it. When drawing, if I get too focused on one place and feel my ego trying to show me what it might be, I turn away from the drawing or go to a different place on the paper. In this way I have helped in the creation of over 190 drawings, some taking just a few hours and some decades and some that are not for me to finish. I mean, some are for others to finish. Perhaps you reading this?

Turn the drawings in a circle (clockwise for inward, or opposite) and discover new things in them. Have fun... play with the Wild Cards or grow with them... or use them for target practice if you wish. Rofl... Sorry, I couldn't resist.
Hugs always, Aunt

WILD CARDS A - B

A: Addiction Blocker; Alliance Seeker; Anti-Virus Shield and Base Guards found with Viral Vase; Armor of Justice; Attachment Vacuum Gun; Aware Scissors; Awareness Conduit; Awareness Key.

B: Bacterial Trap; Bird of Parchment; Bird of True Destiny; Birth Star; Block of Dust.

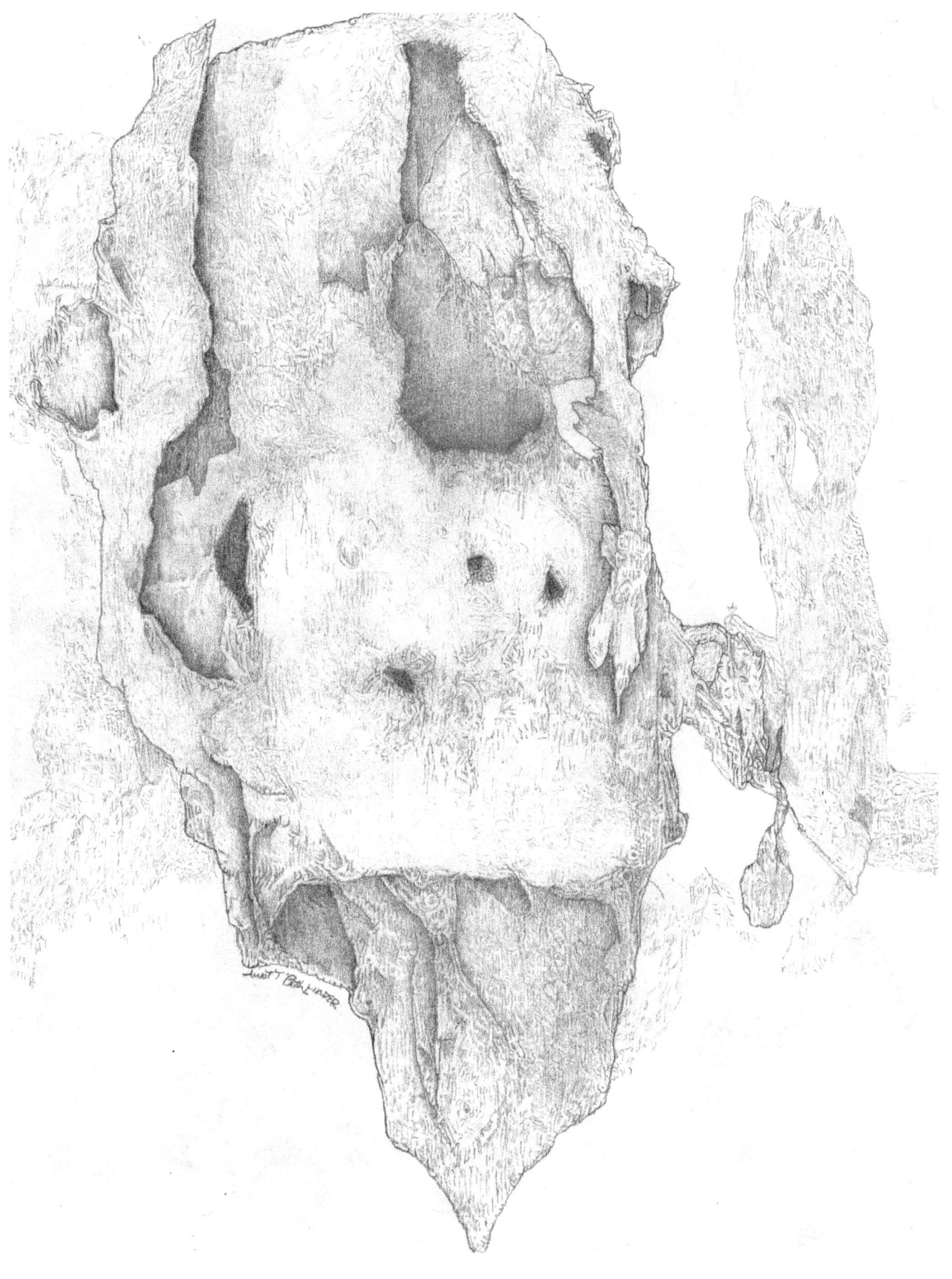

ADDICTION BLOCKER

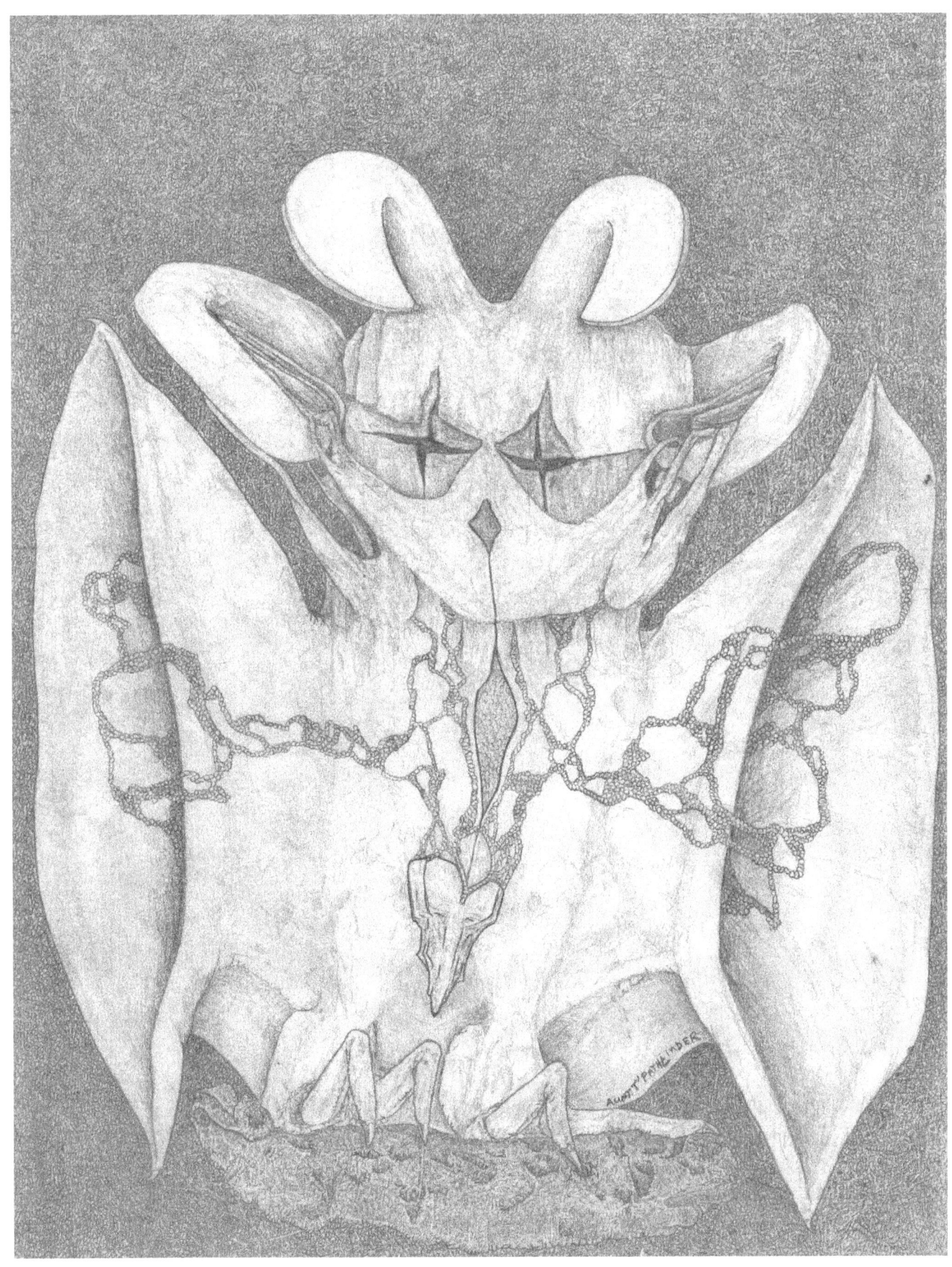

ALLIANCE SEEKER AKA SHIPHOLDER

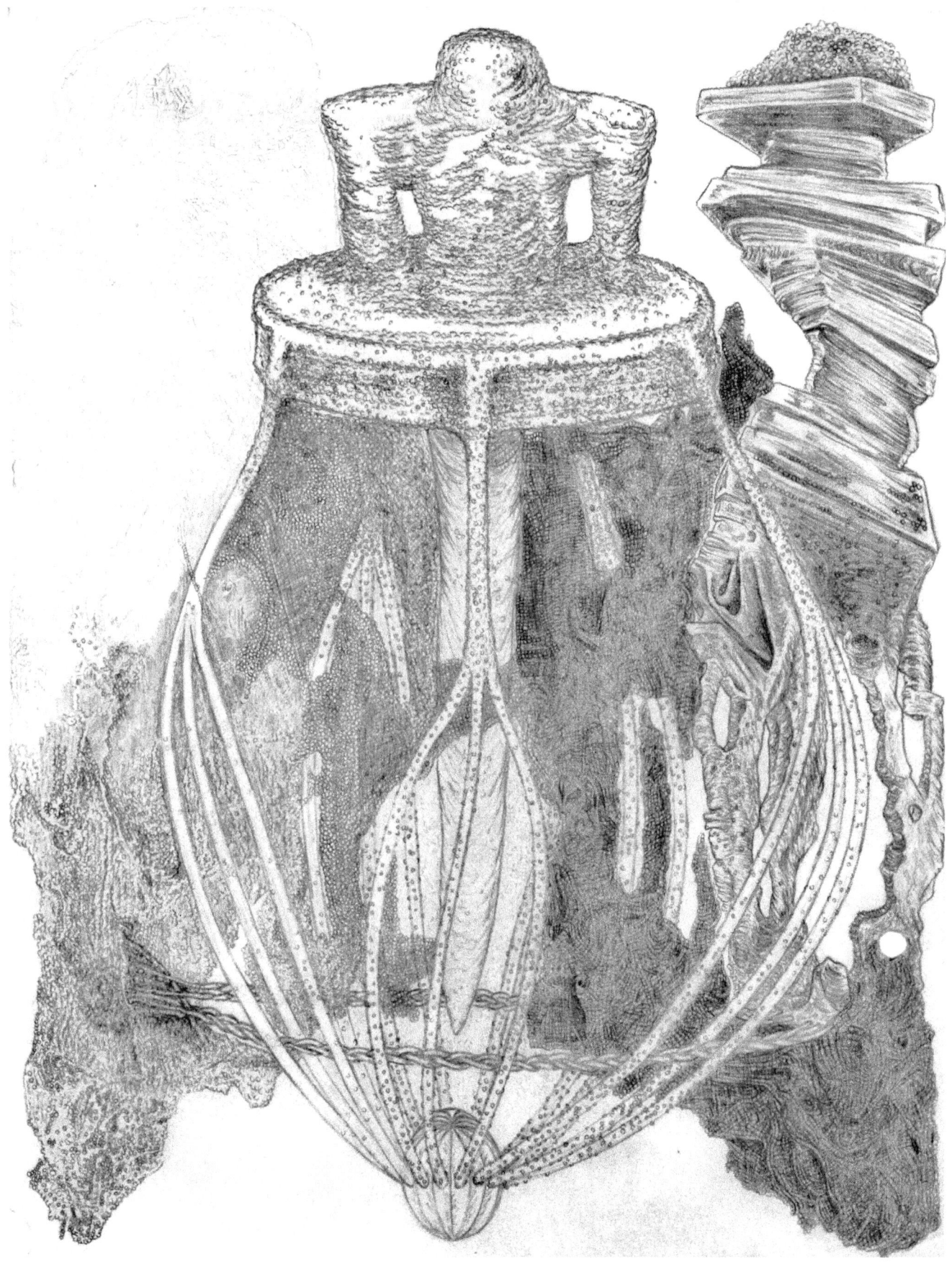

ANTI-VIRUS SHIELD & BASE GUARDS FOUND WITH VIRAL VASE

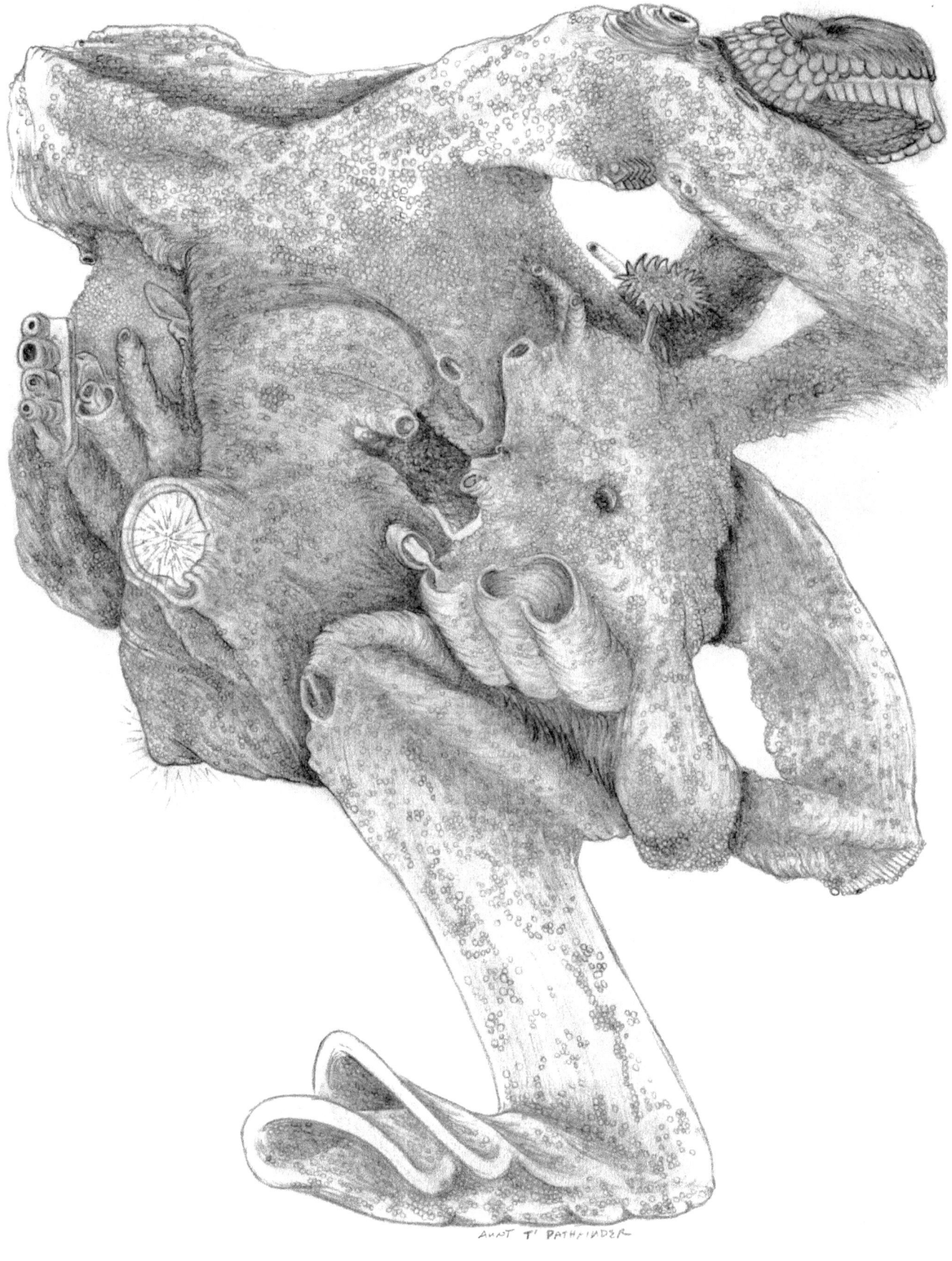

ARMOR OF JUSTICE

WILD CARDS FOR YOUR SOUL

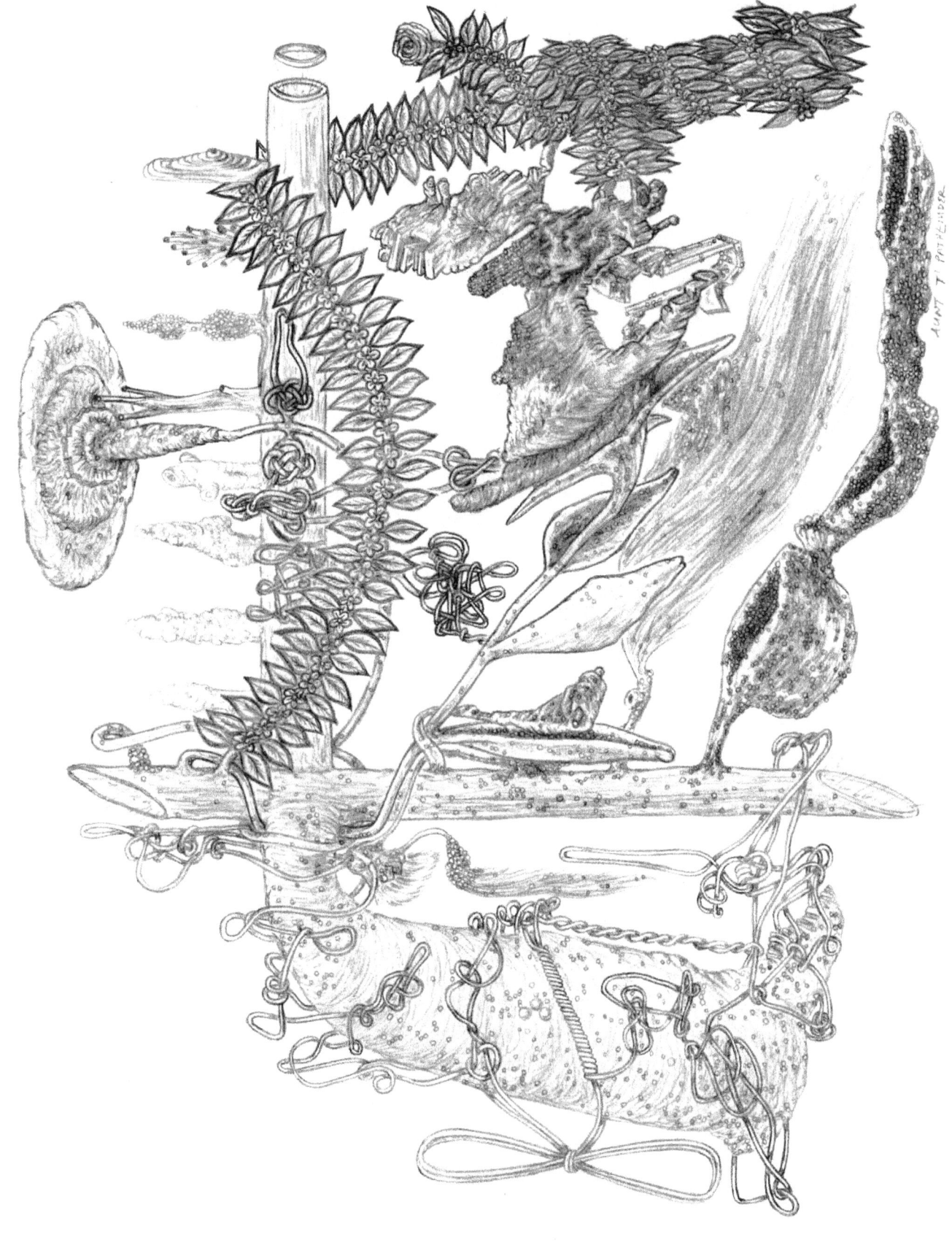

ATTACHMENT VACUUM GUN

← BOTTOM

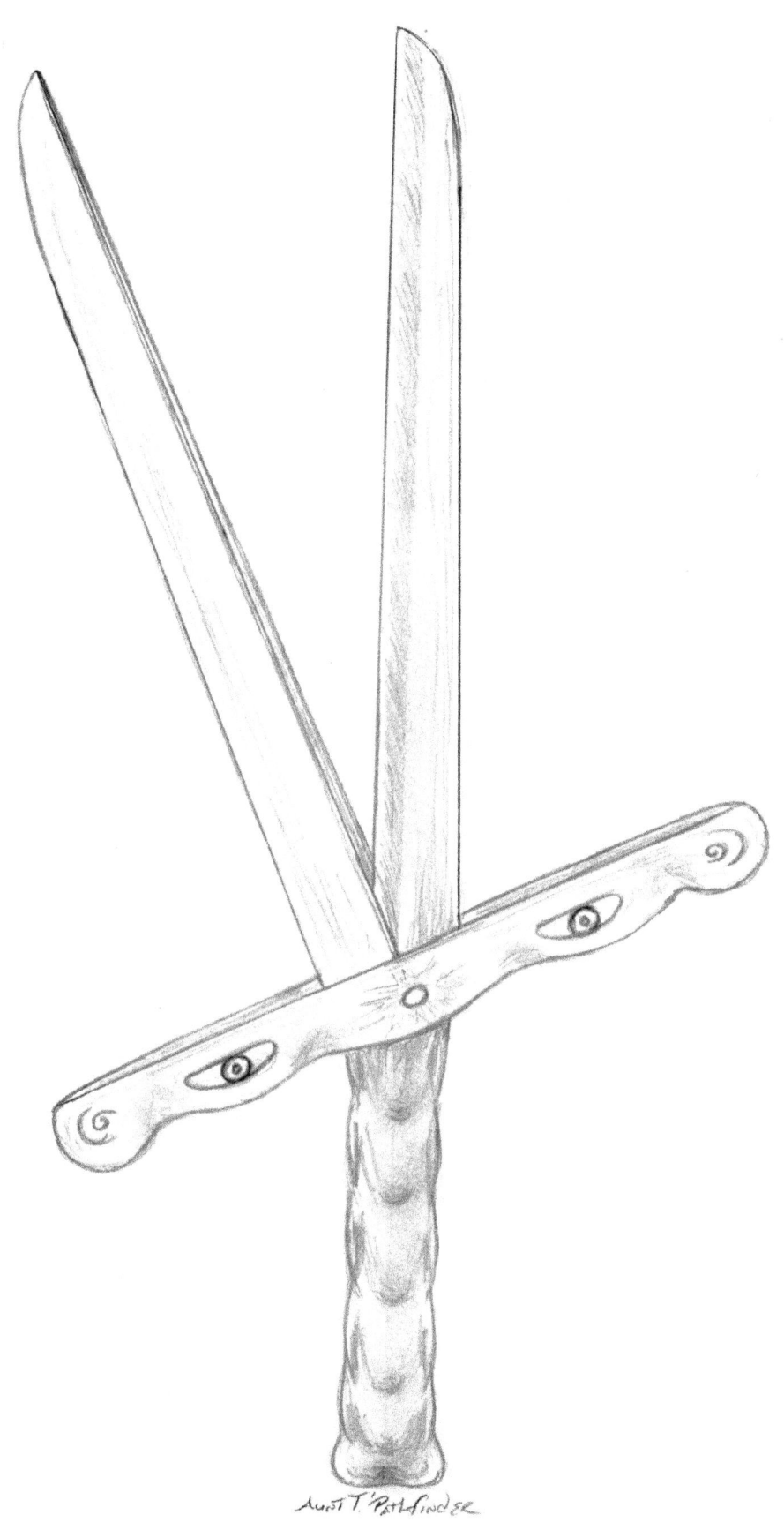

AWARE SCISSORS

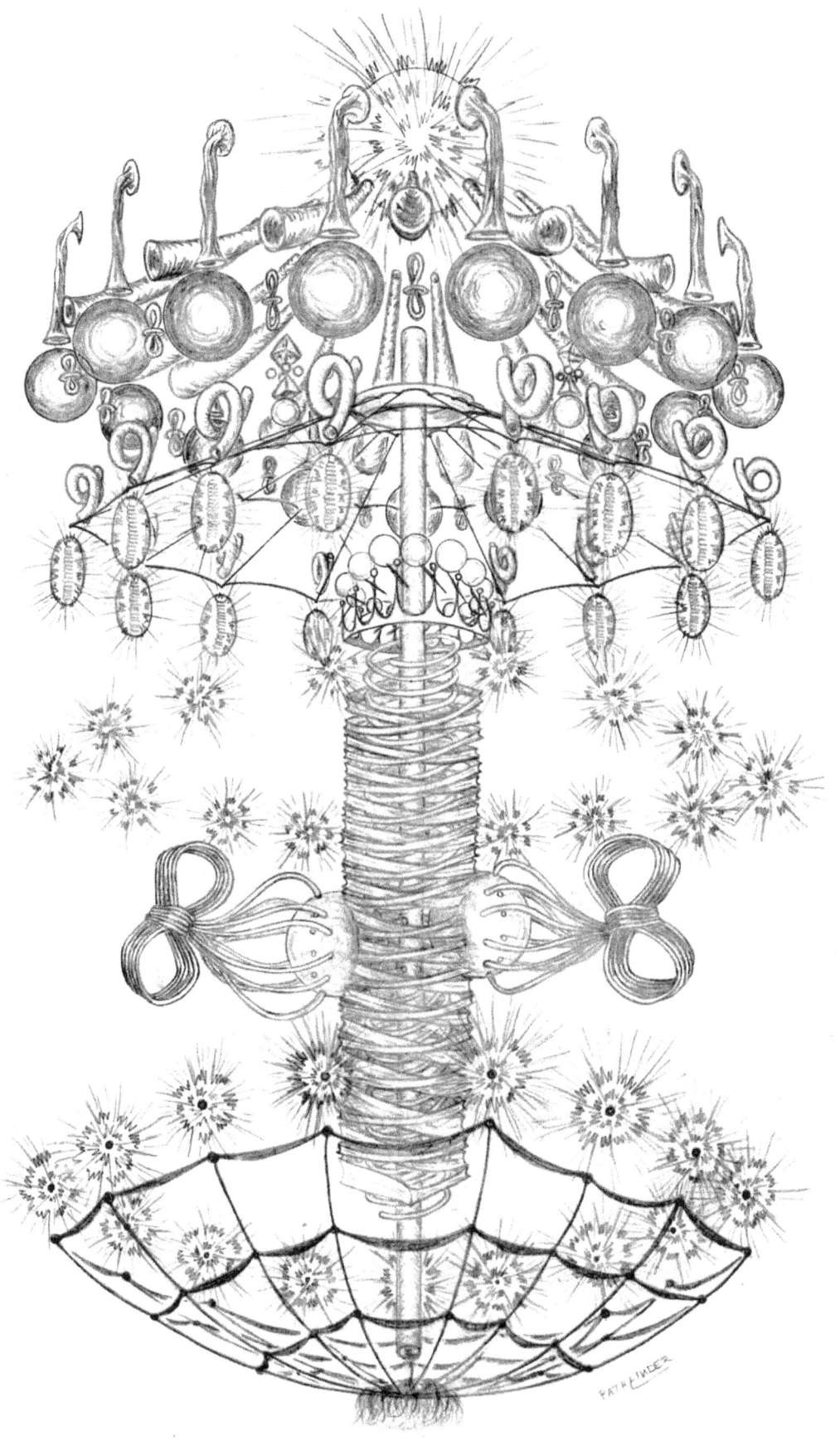

AWARENESS CONDUIT

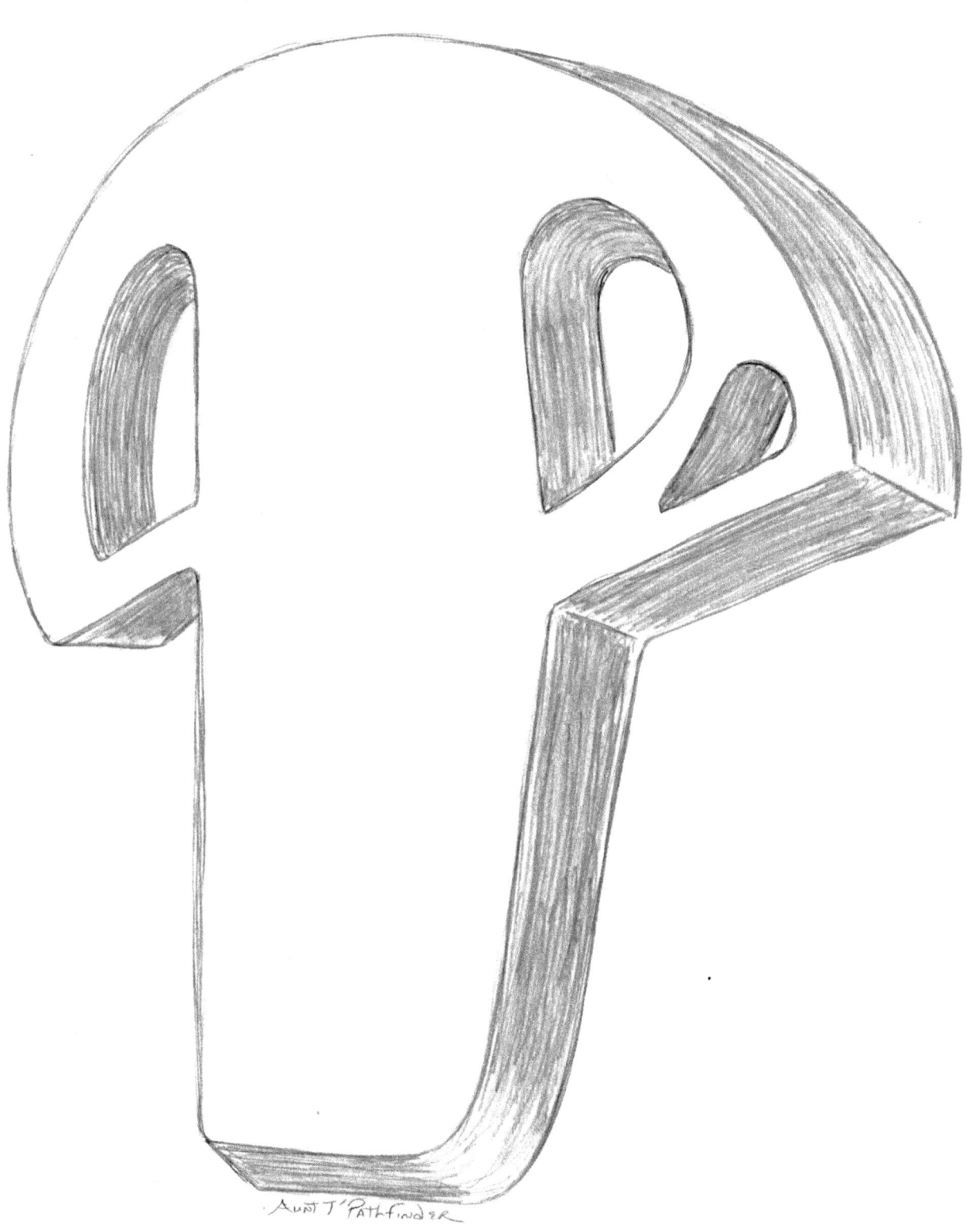

AWARENESS KEY

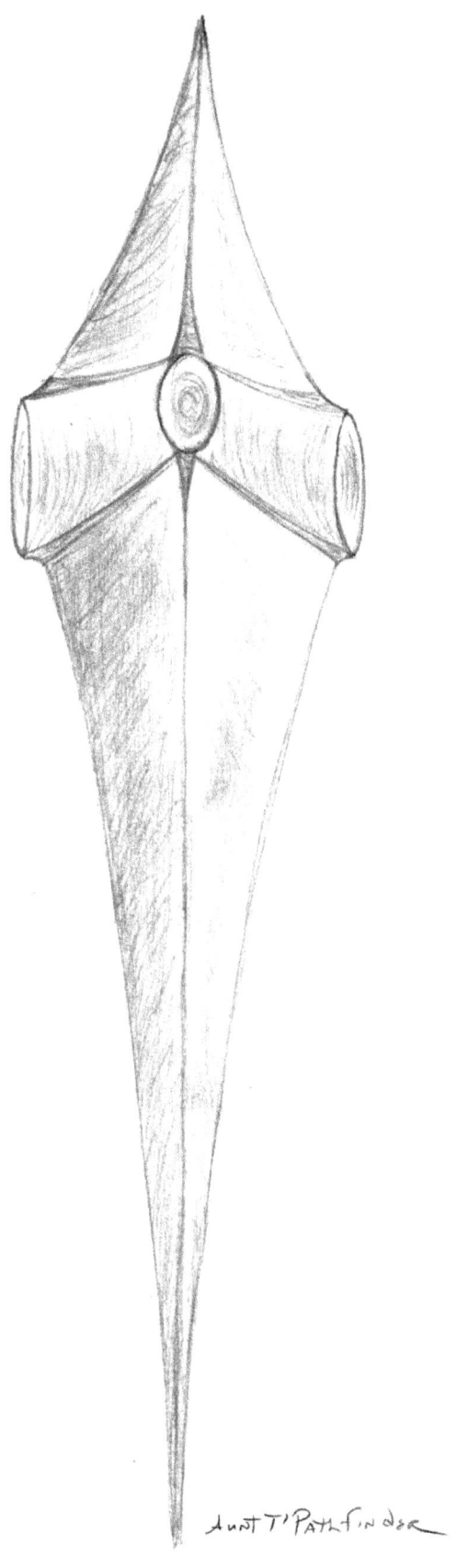

BACTERIAL TRAP

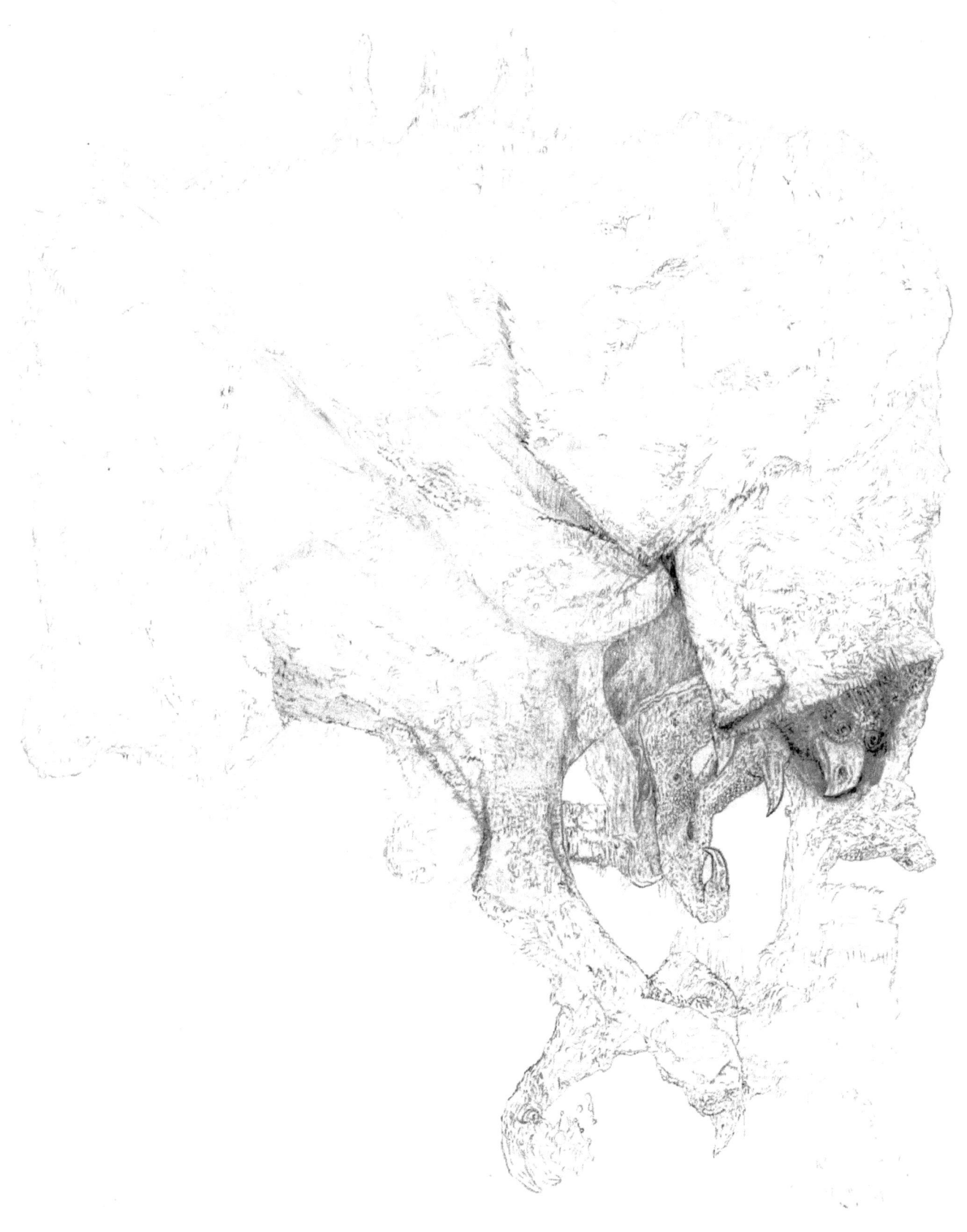

BIRD OF PARCHMENT

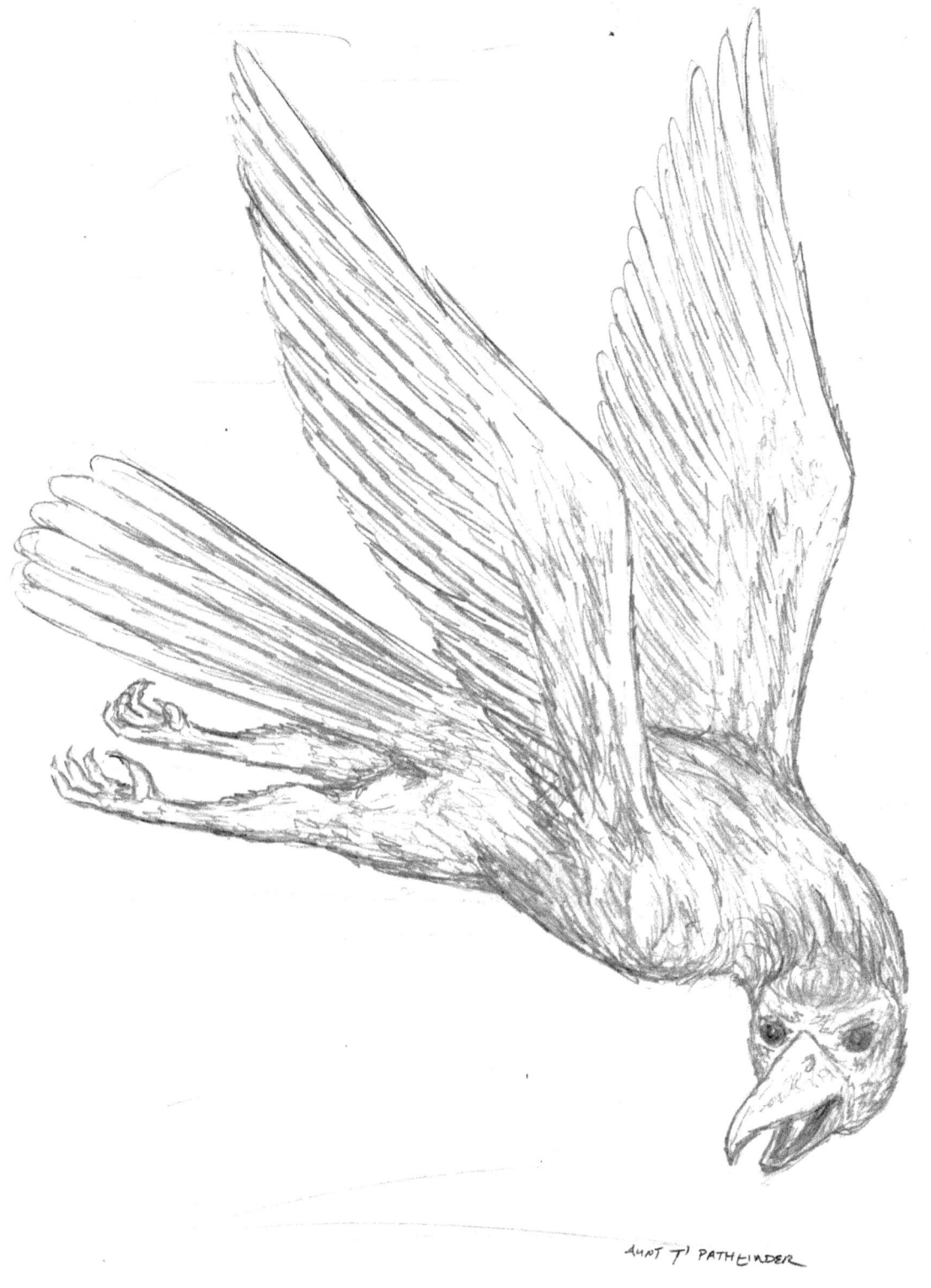

BIRD OF TRUE DESTINY

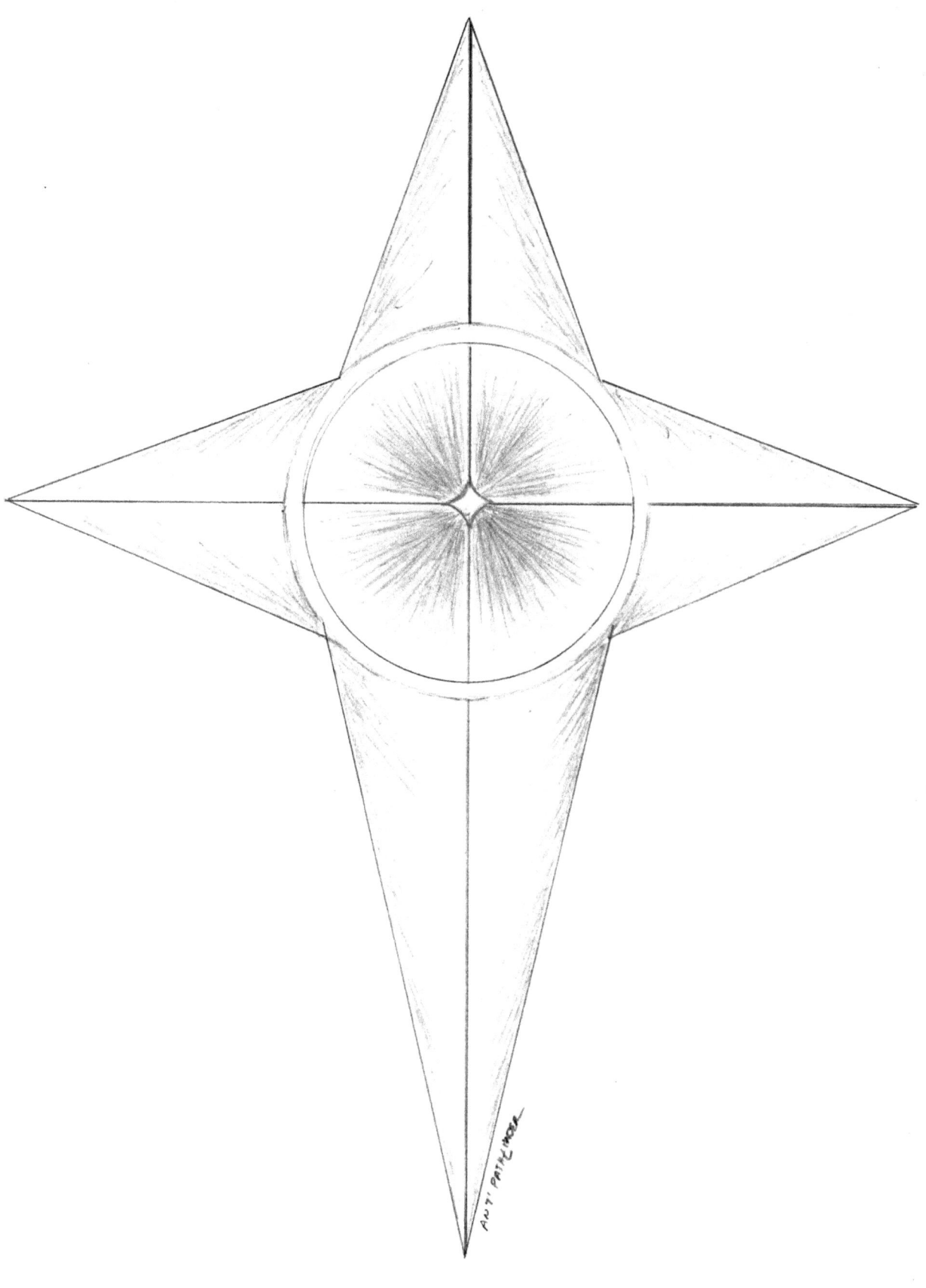

BIRTH STAR

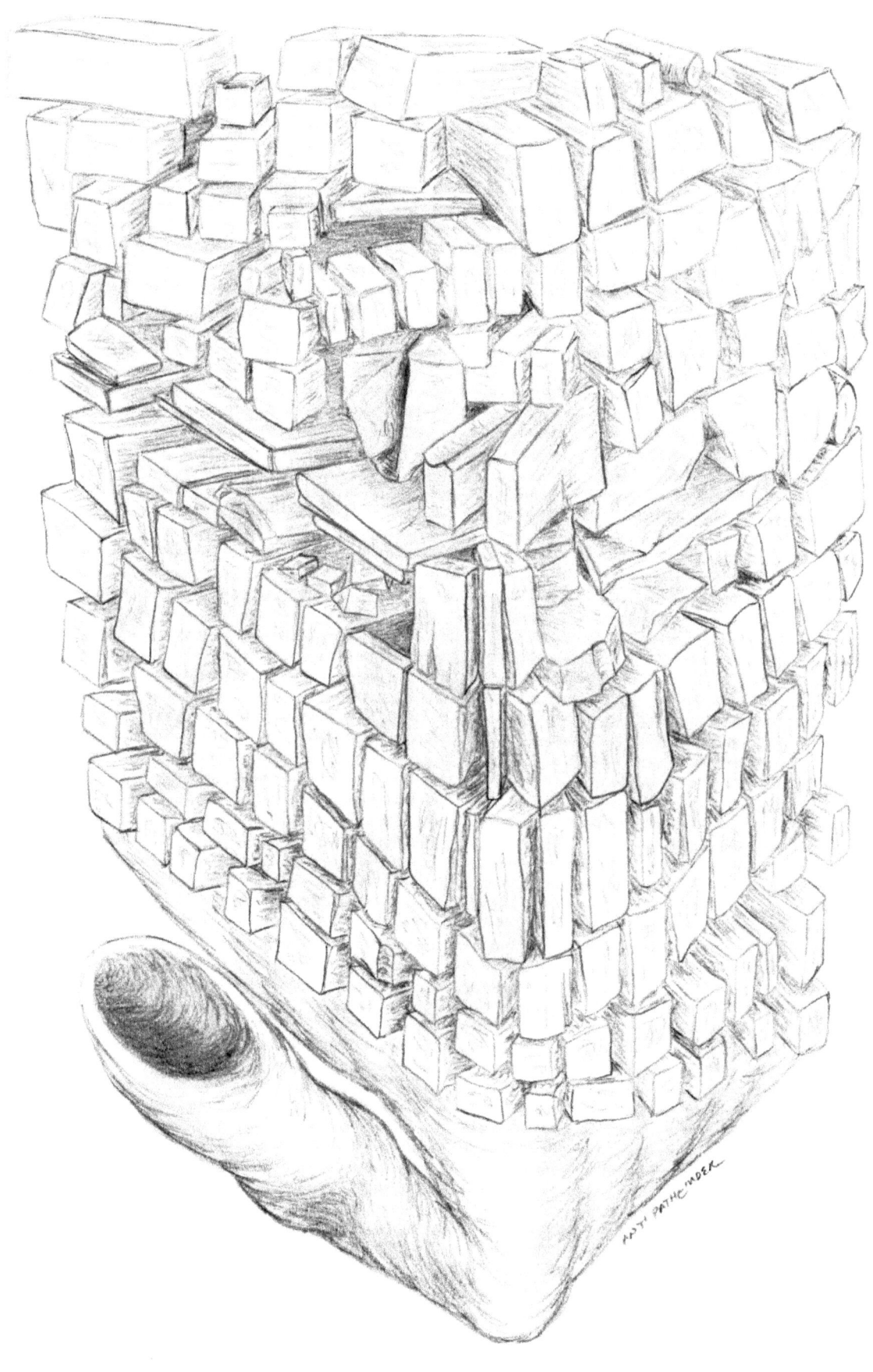

BLOCK OF DUST

WILD CARDS C

C: Captains Channel; Center Guardian; Chalice of Flesh aka Living Womb; Cetakah & Megaversal Eggs found in Megaversal Realm; Chain of Command; Child's Steward; Children's Conduit; Choice Pin; Ch'raiyn Tri aka Reality Womb; Cleansing Mind Hook; 'Coccus Probe; Command Bone; Command Conduit; Command Disc aka Mind Womb; Command Focus; Command Hook; Command Horn & Truth Orbs; Command Pump; Command Pump; Command Screw; Compassion Born Silo aka Grandma's Snow Globe; Control Room aka Power Womb at top of Ivory Tower; Core Cracker; Creation Dagger found with Creation Machine; Creation Machine found with Creation Dagger; Creations Cross aka Paradox Womb; Creation's Music Box; Crown of Time & Throne of Shape; Crown of Truth; Crystal Wind & Chaos Cloud.

WILD CARDS FOR YOUR SOUL

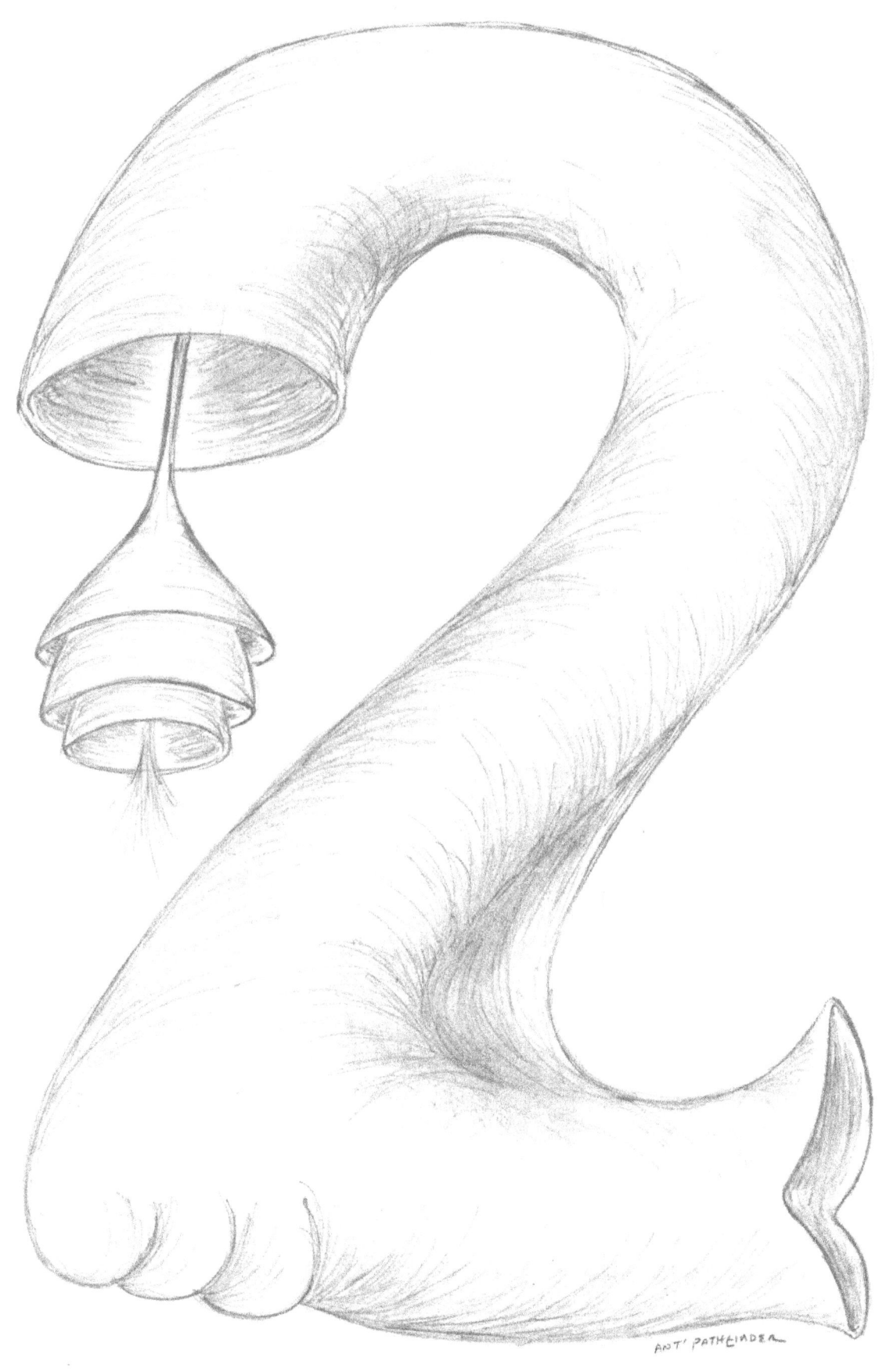

CAPTAINS CHANNEL

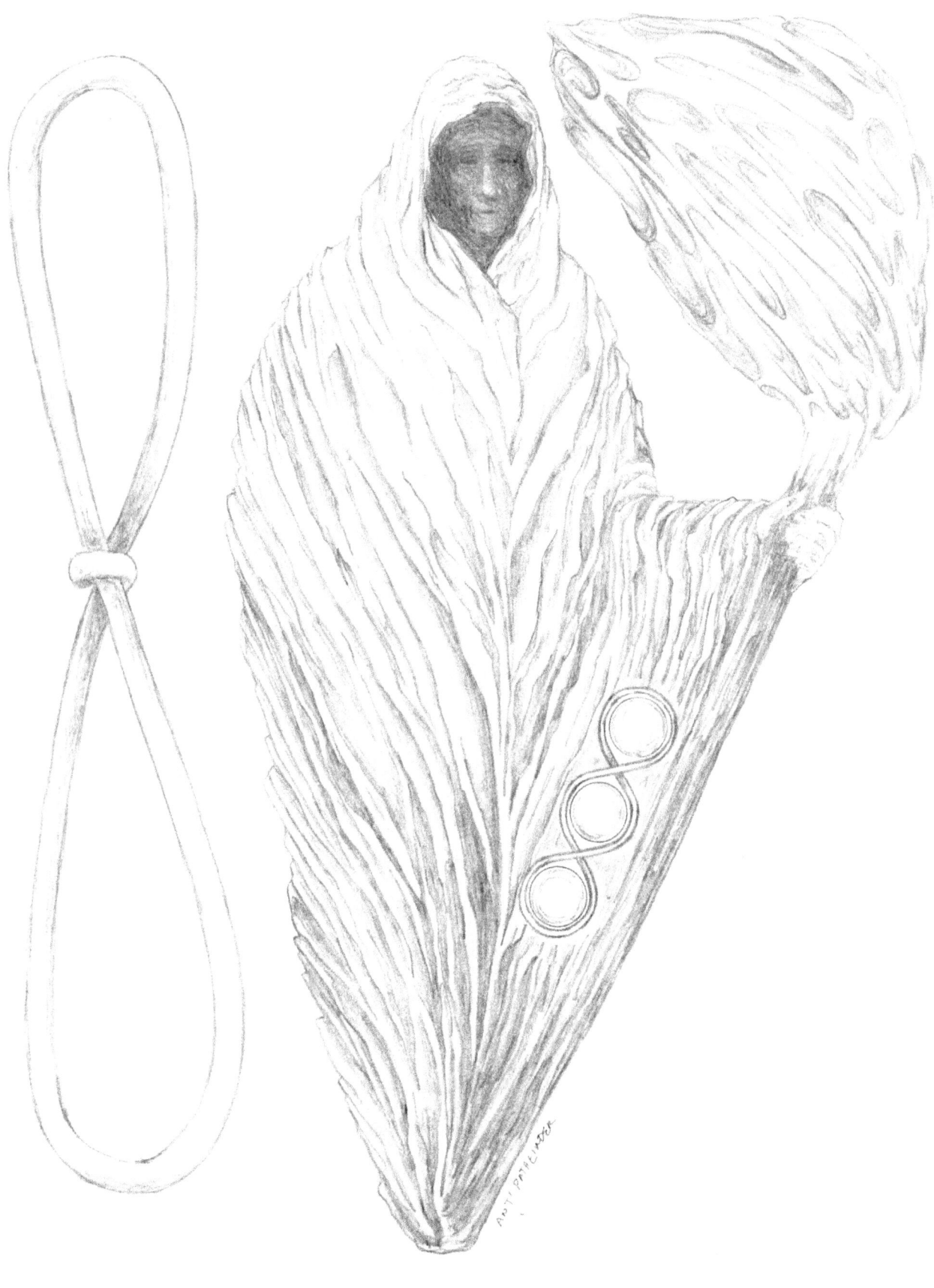

CENTER GUARDIAN

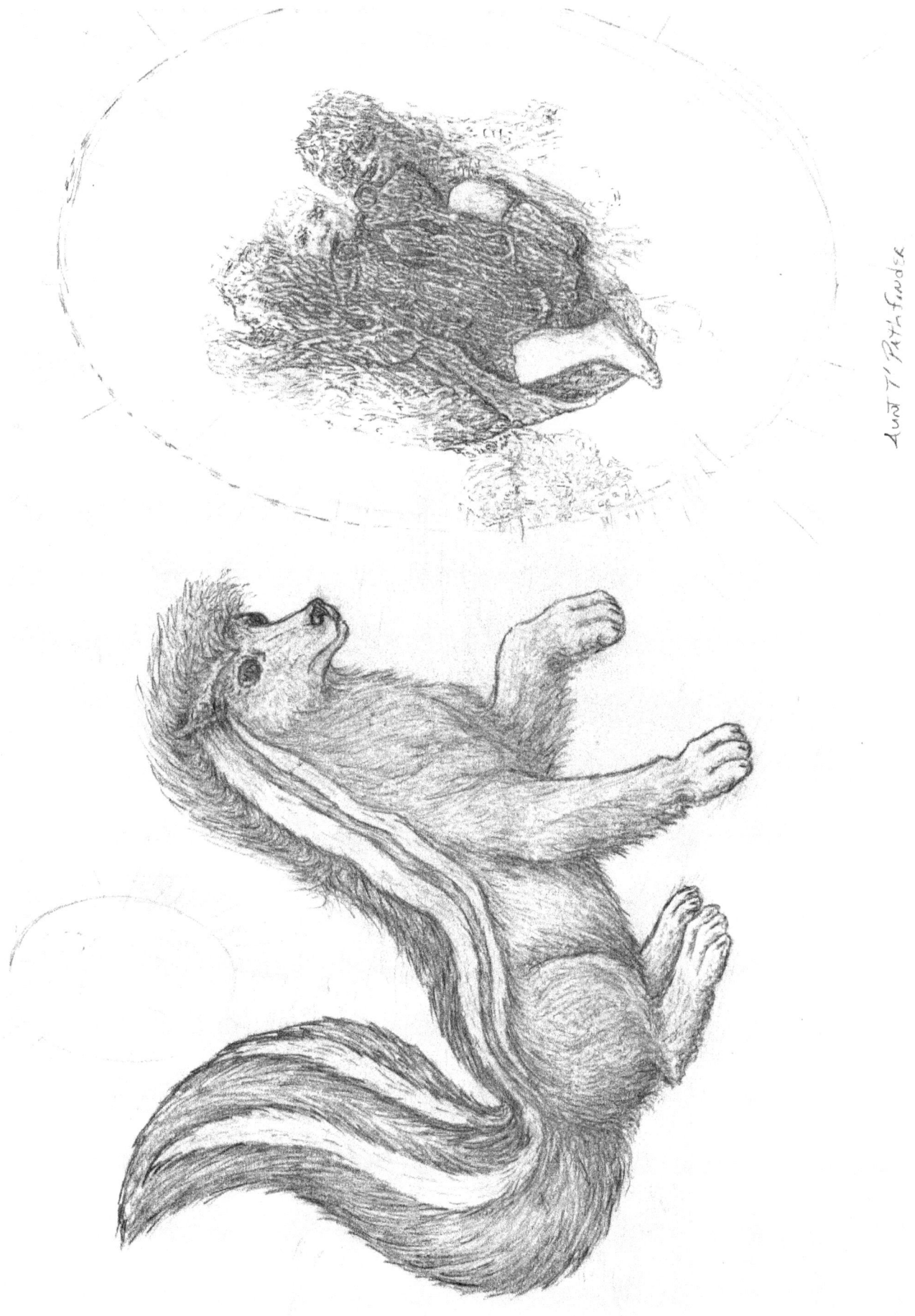

CETAKAH & MEGAVERSAL EGGS
FOUND IN MEGAVERSAL REALM
← BOTTOM

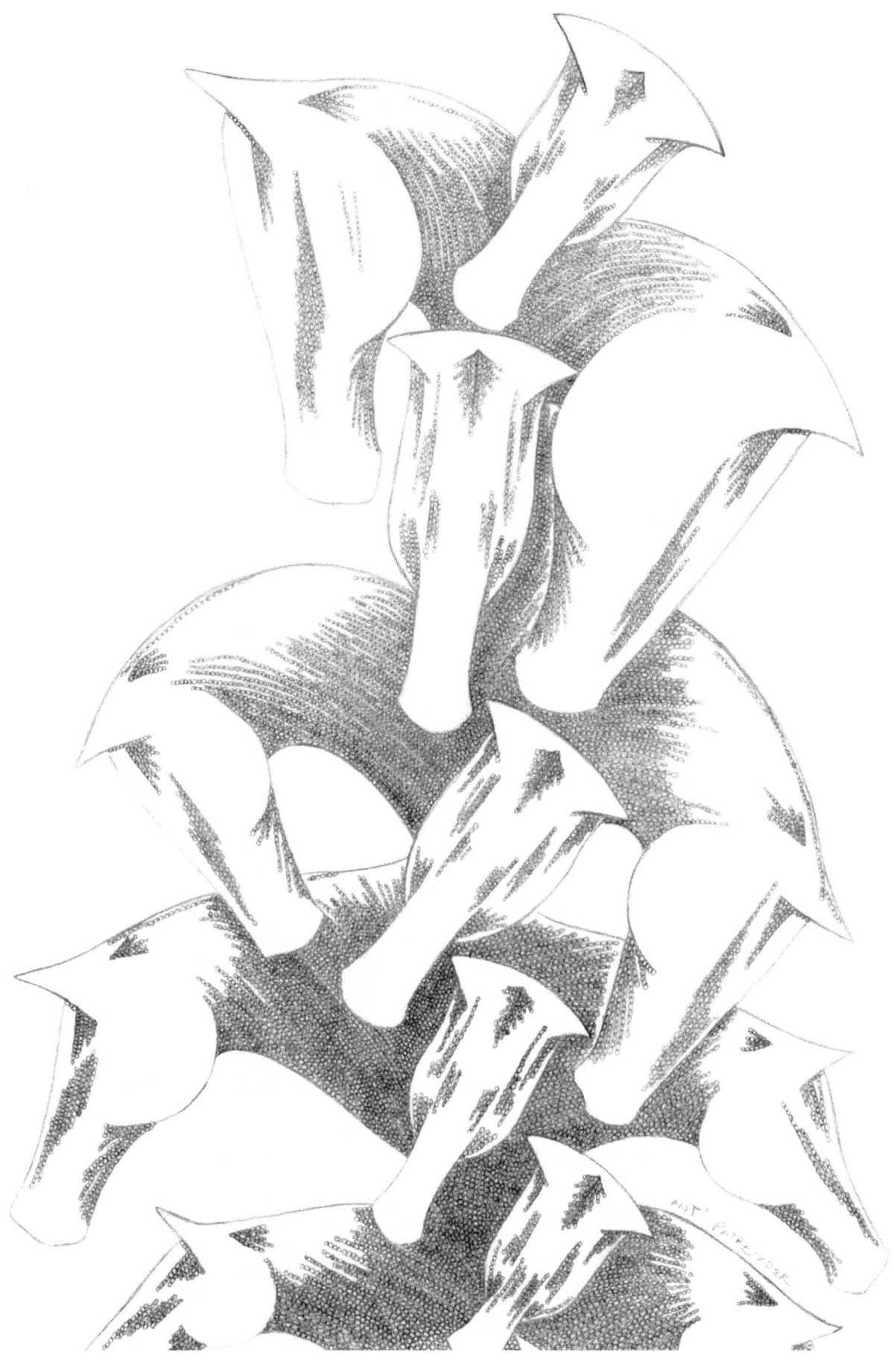

CHAIN OF COMMAND

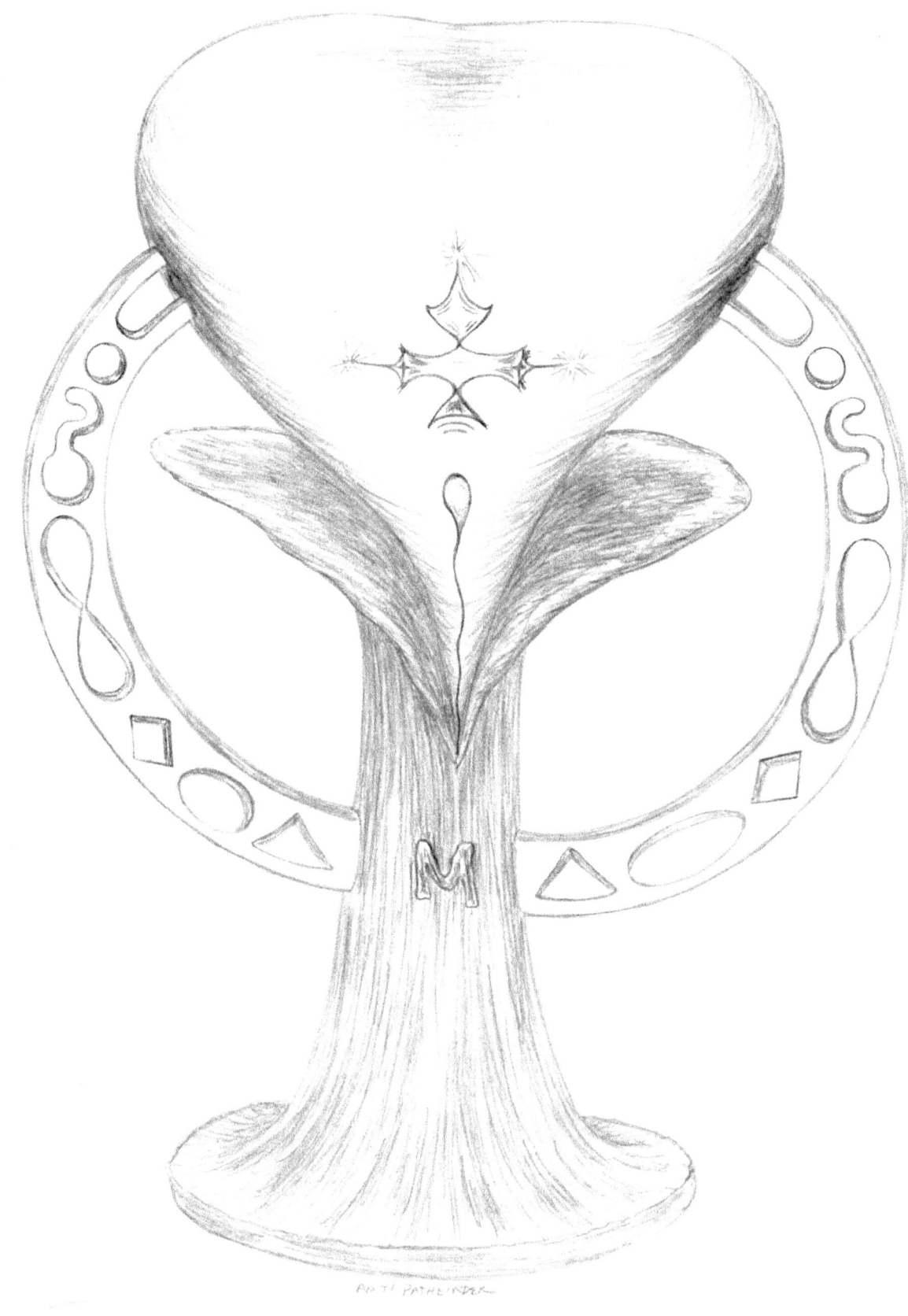

CHALICE OF FLESH AKA LIVING WOMB

WILD CARDS FOR YOUR SOUL

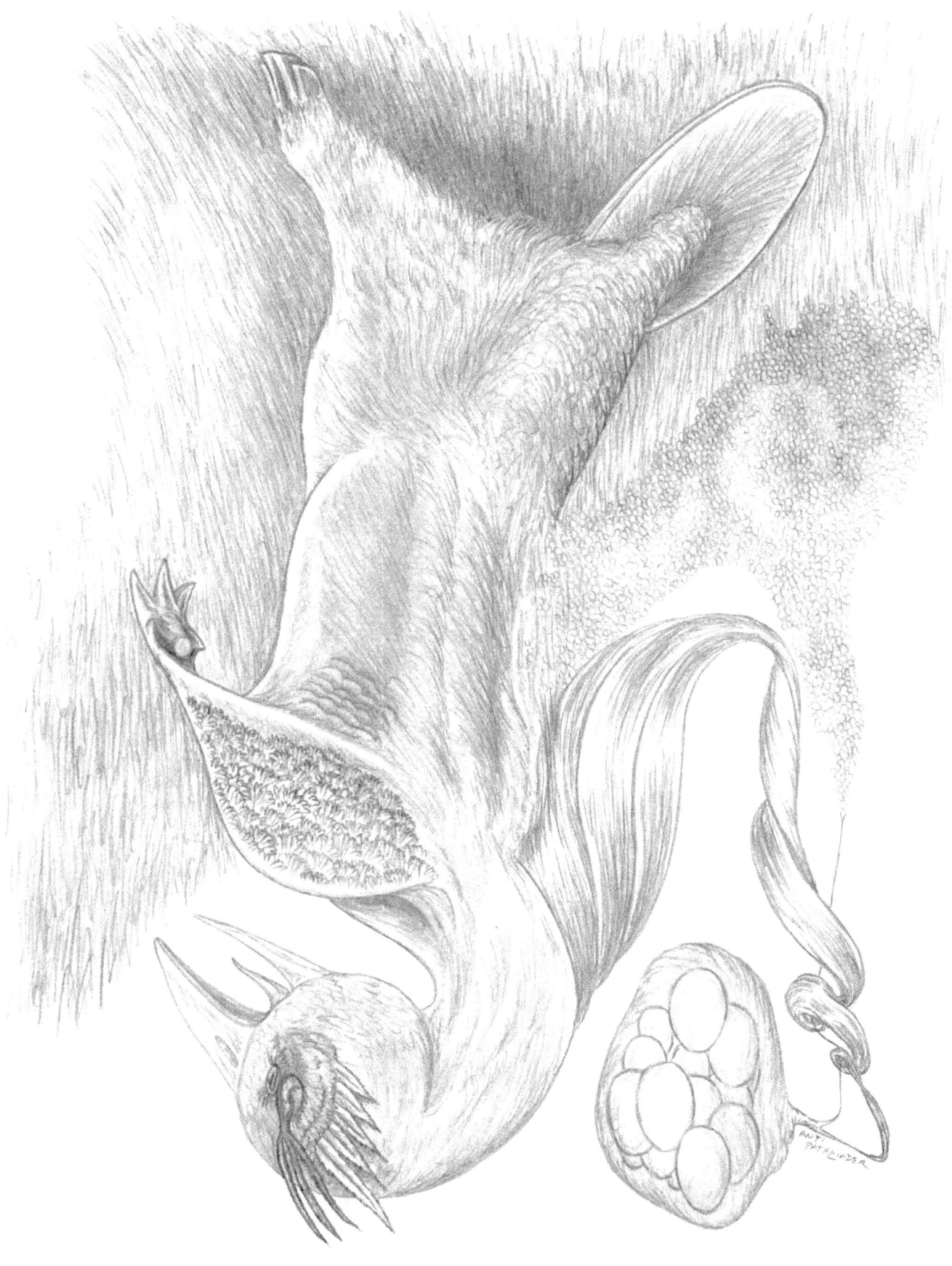

CHILD'S STEWARD

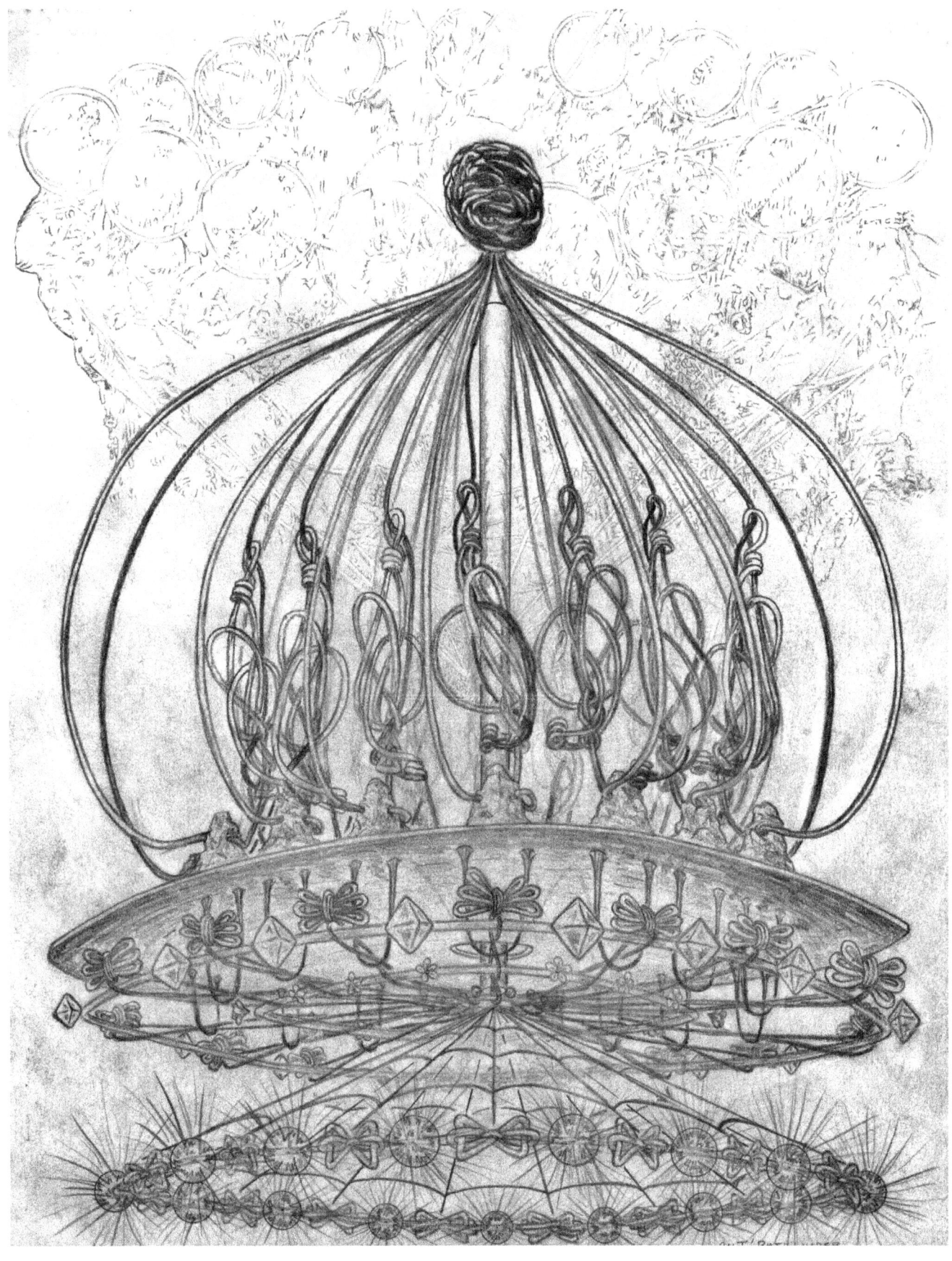

CHILDREN'S CONDUIT

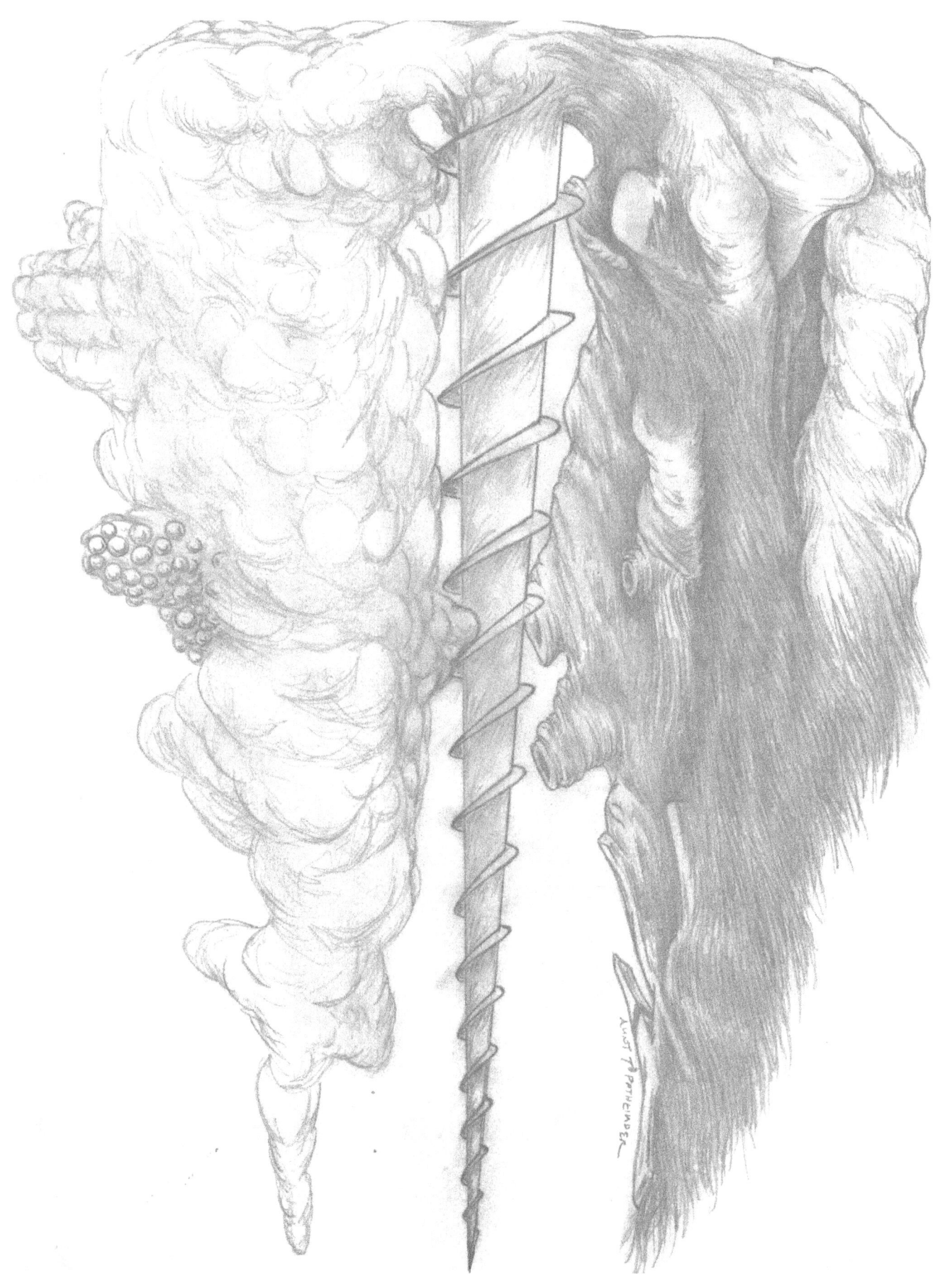

CHOICE PIN

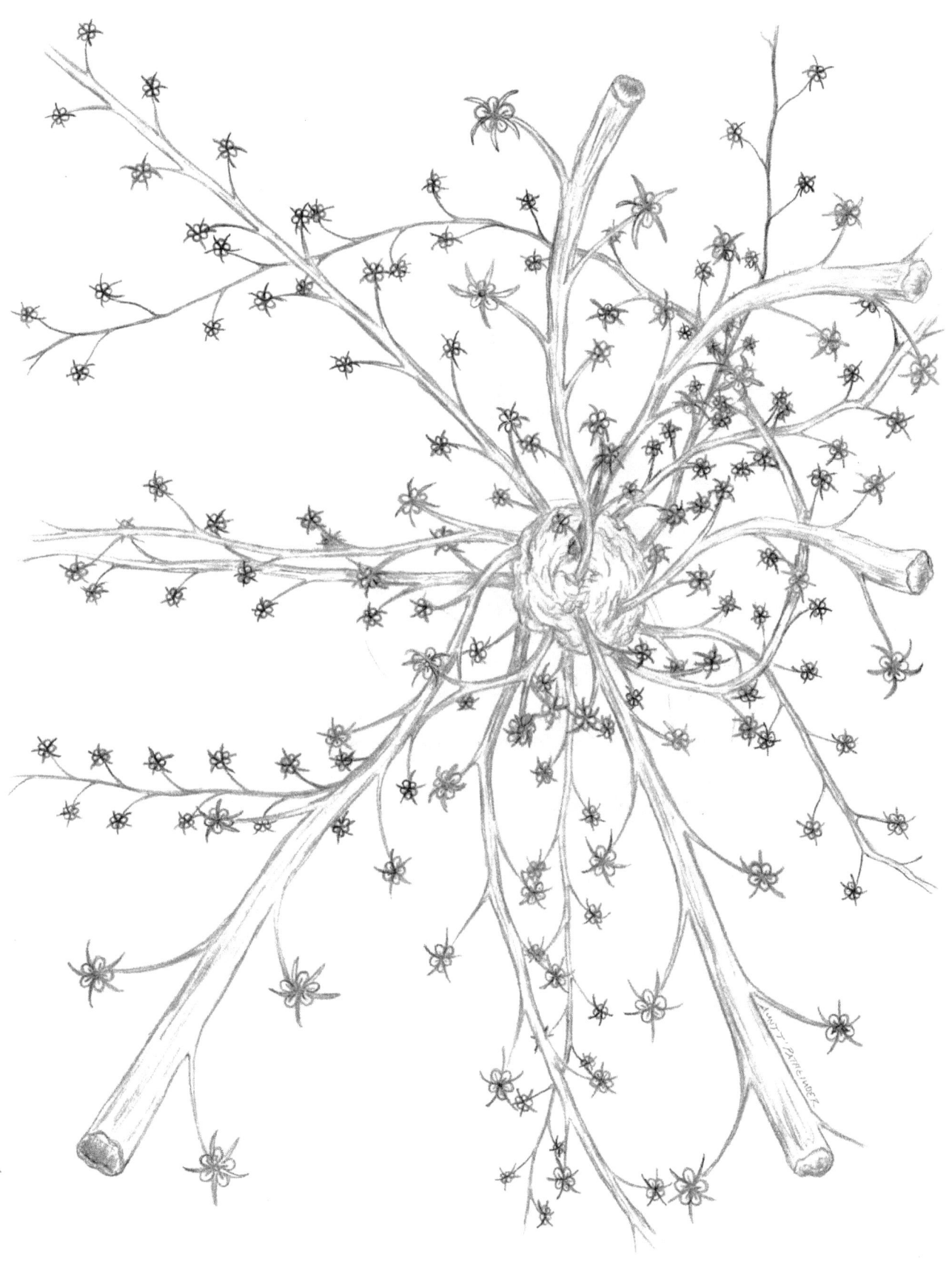

CH'RAIYN TRI AKA REALITY'S WOMB

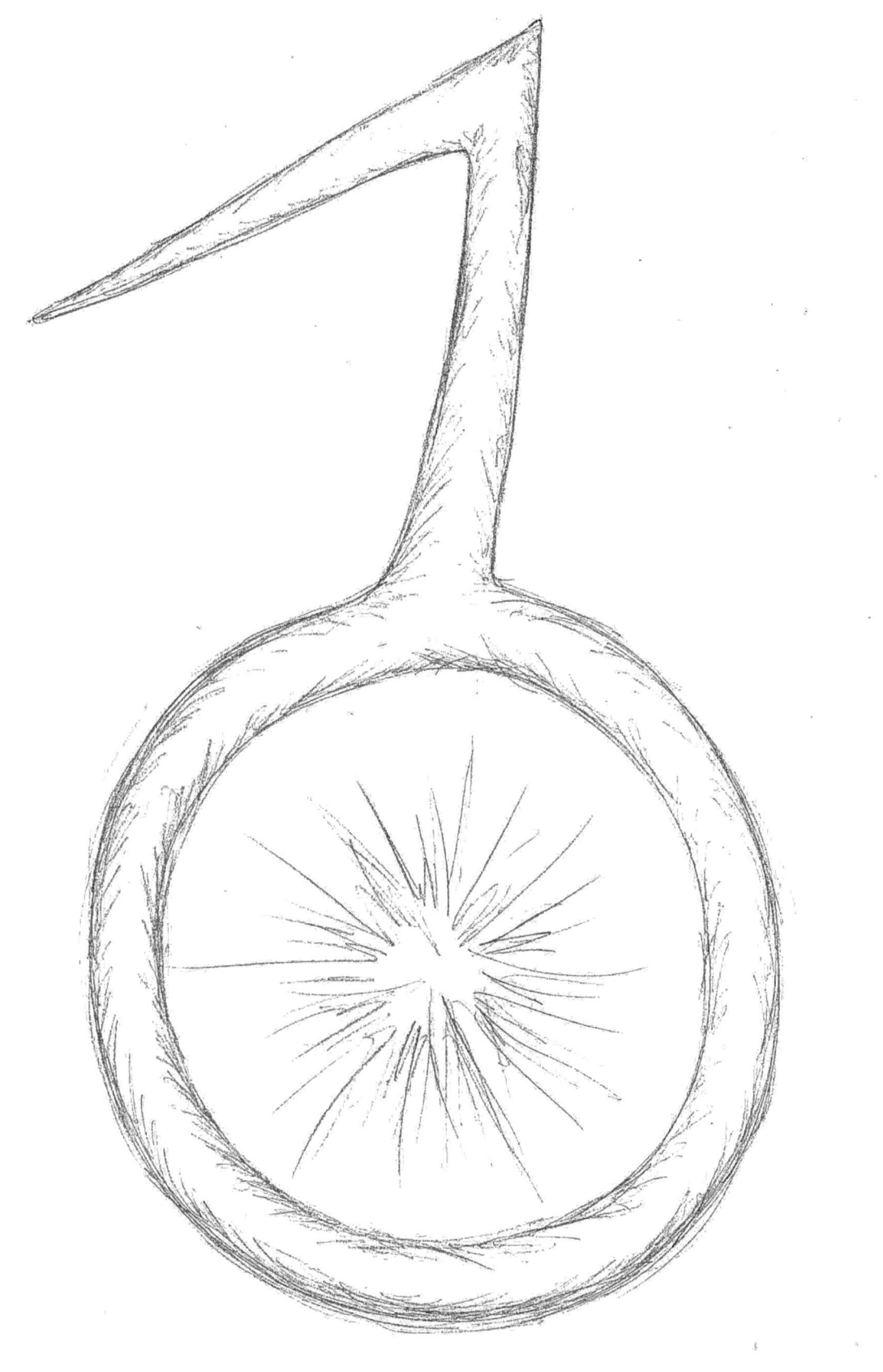

CLEANSING MIND HOOK

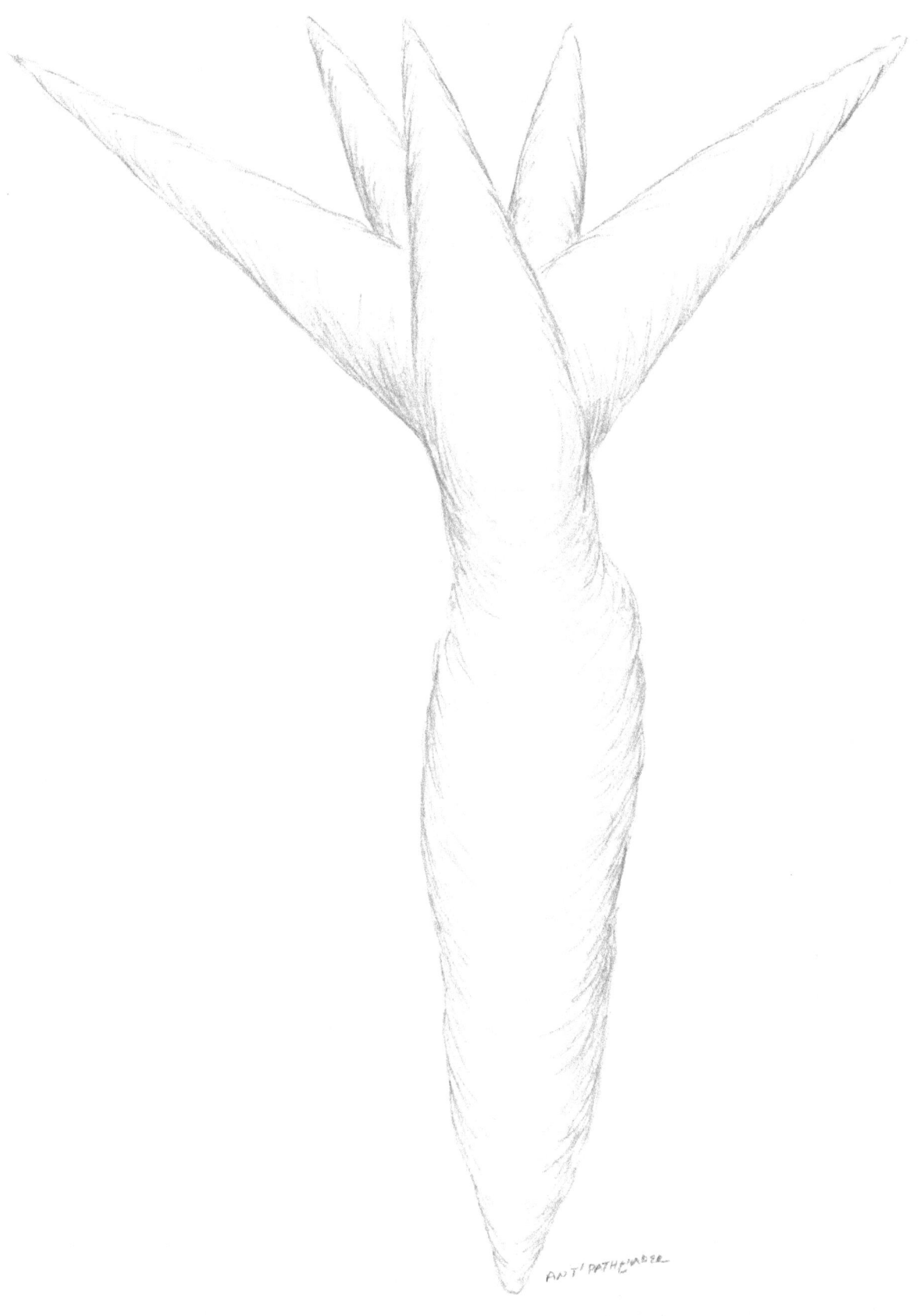
Antipathfinder

'COCCUS PROBE

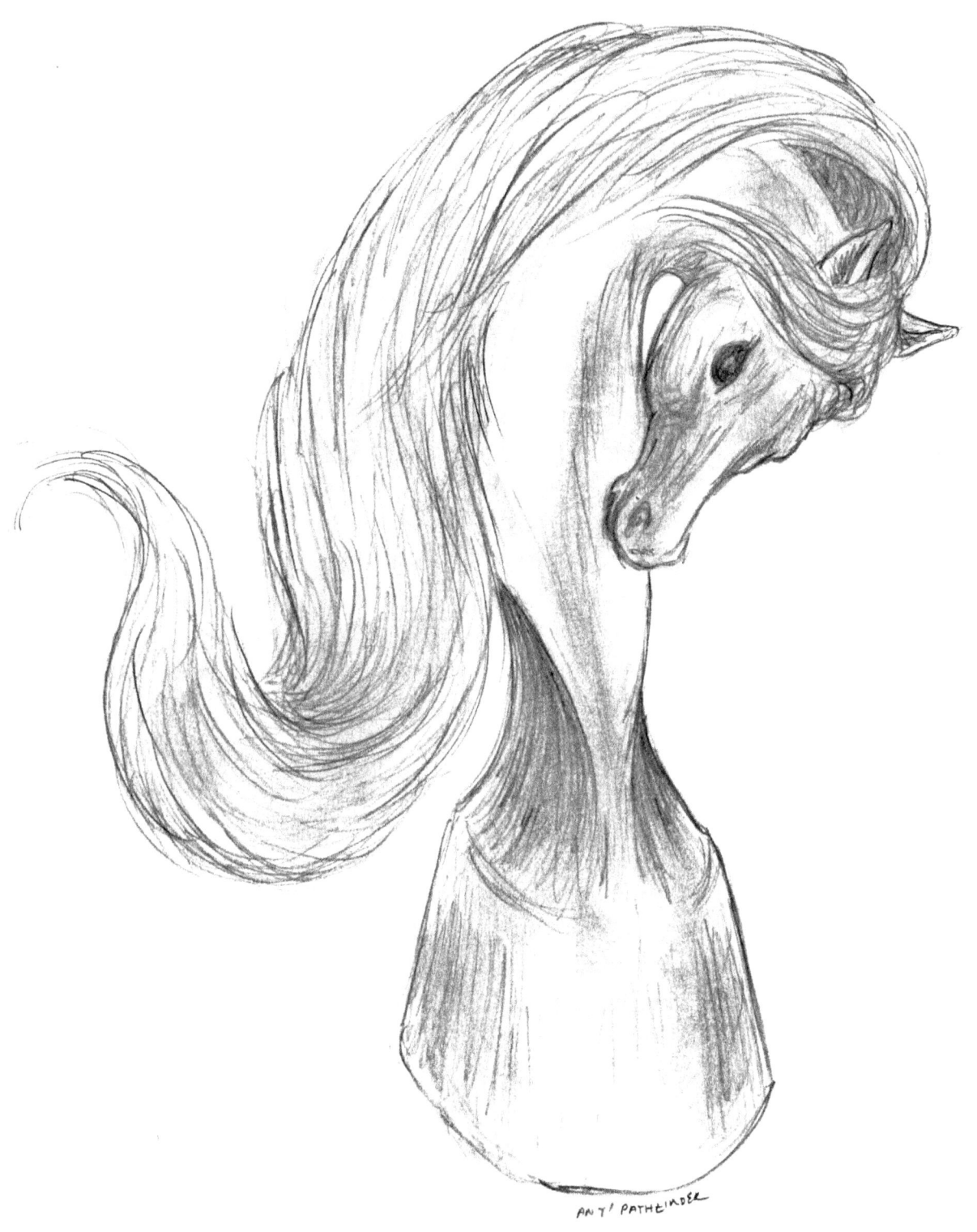

COMMAND BONE

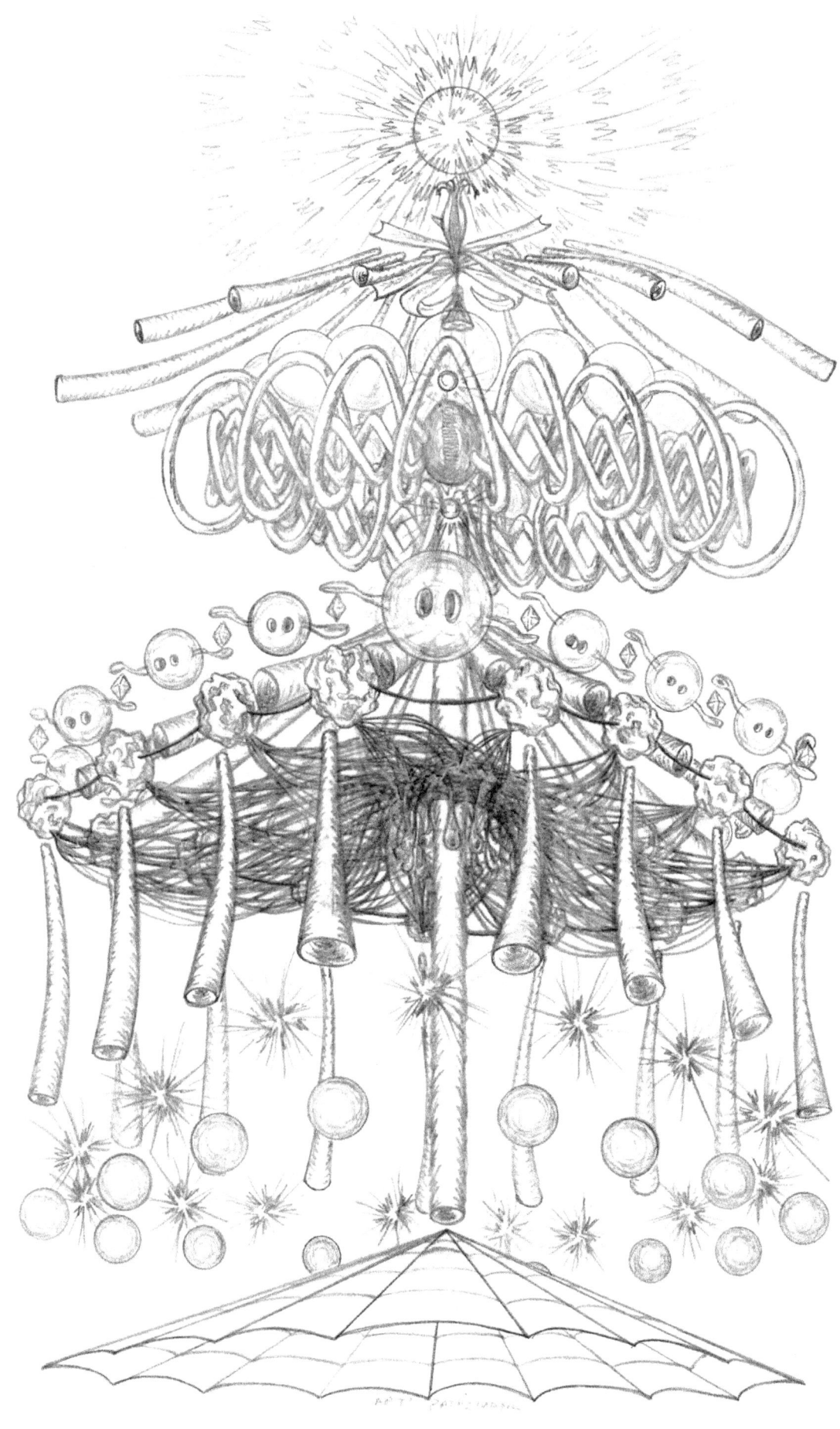

COMMAND CONDUIT

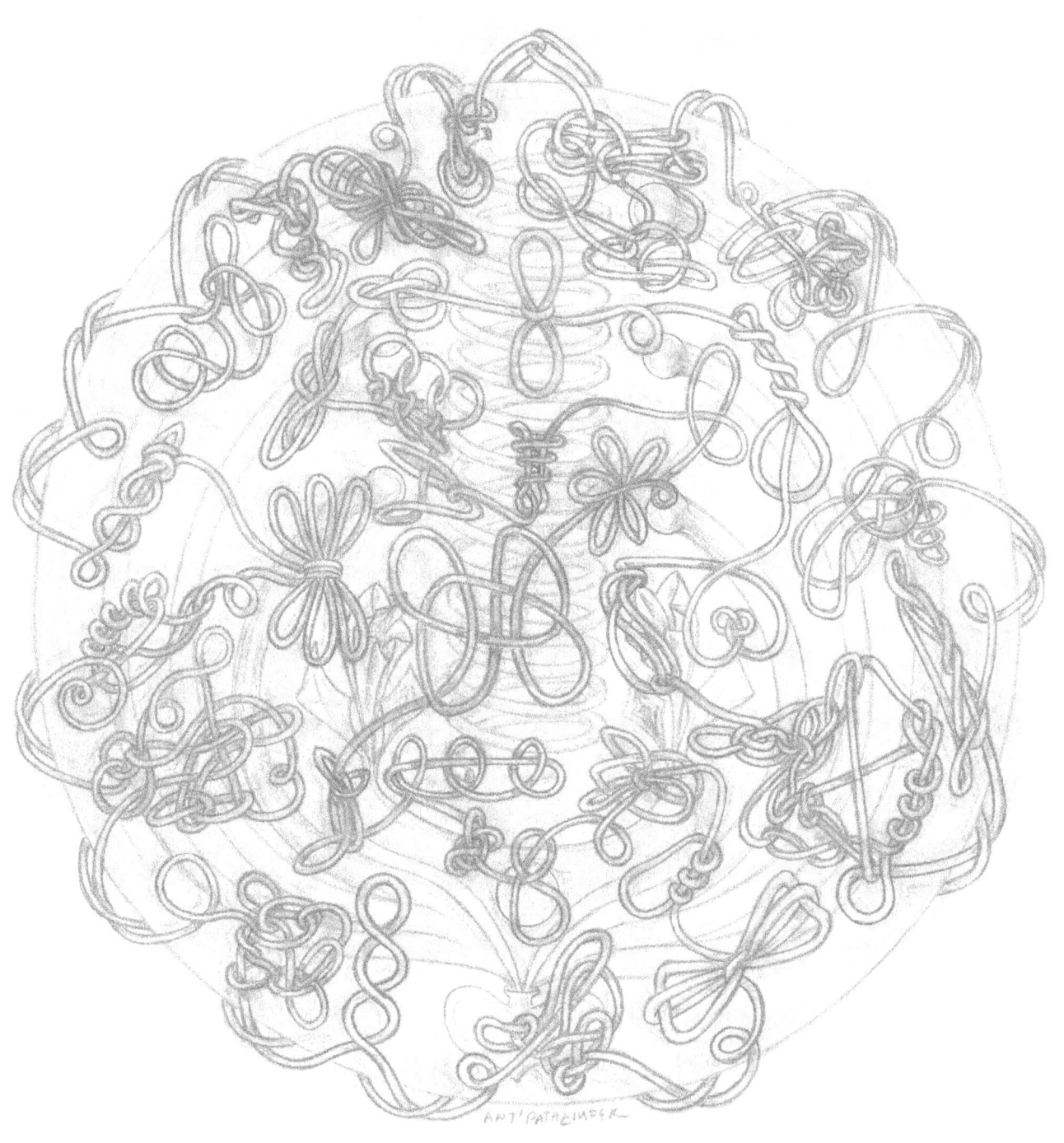

COMMAND DISC AKA MIND WOMB

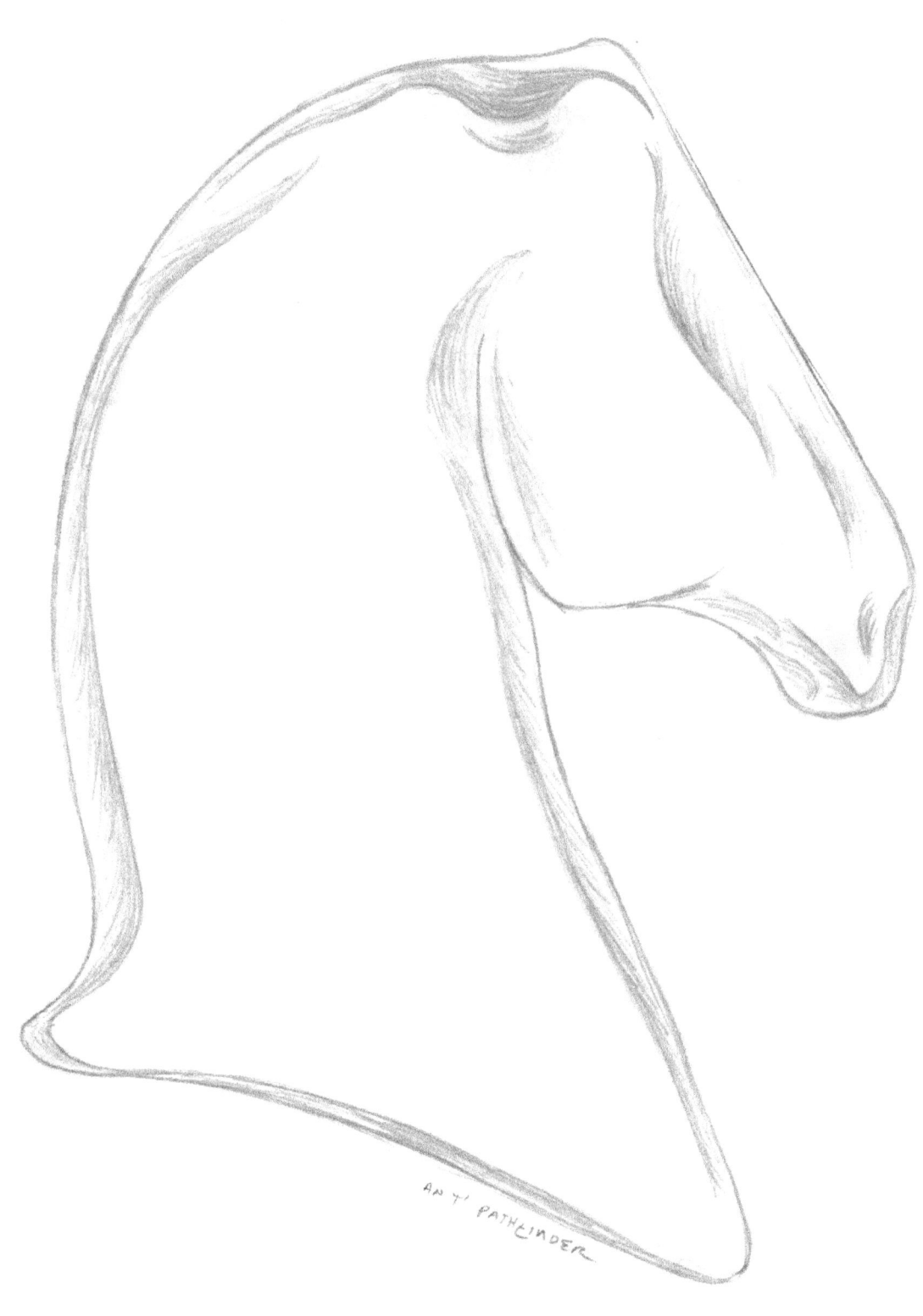

COMMAND FOCUS

WILD CARDS FOR YOUR SOUL

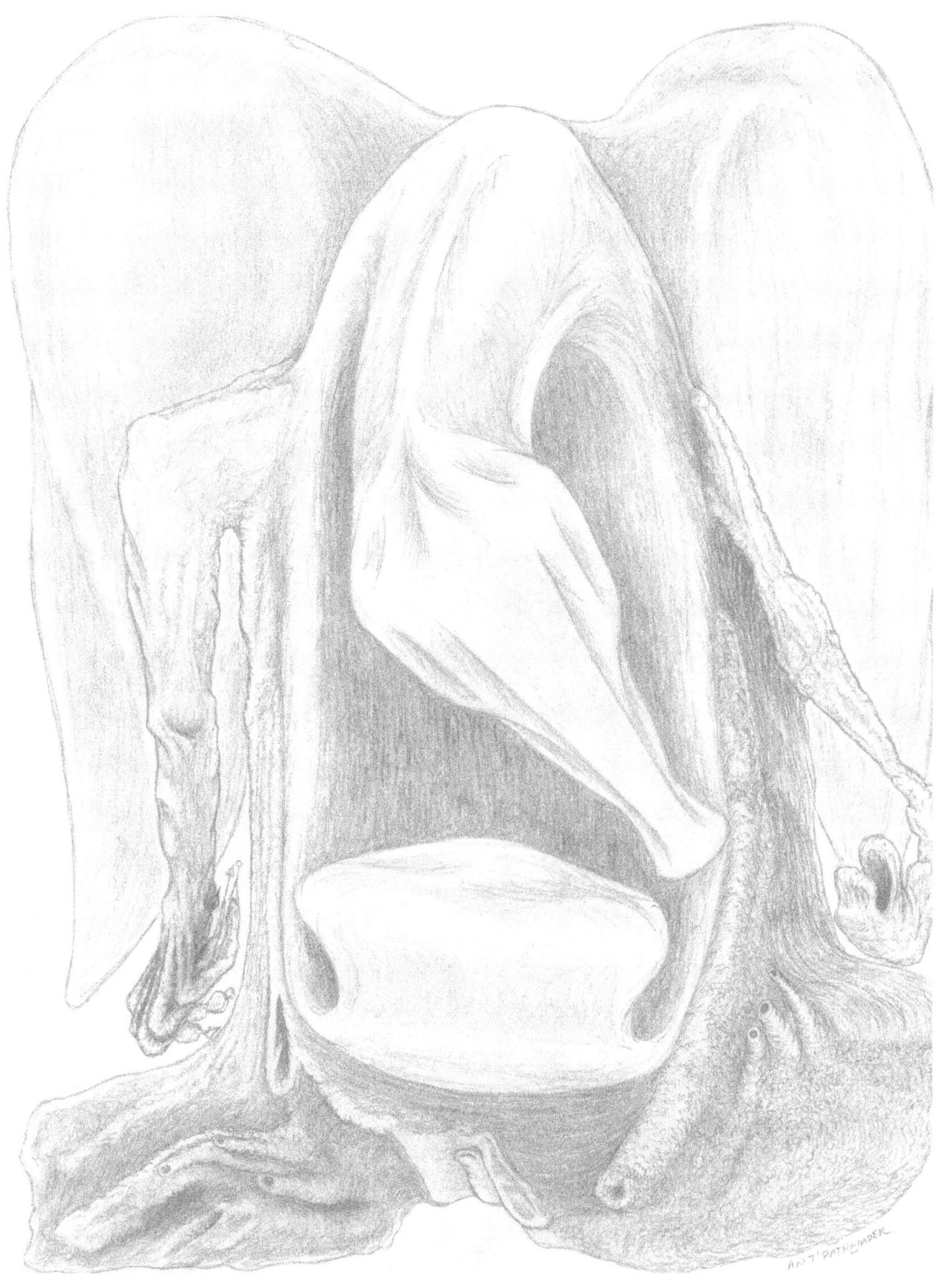

COMMAND HOOK

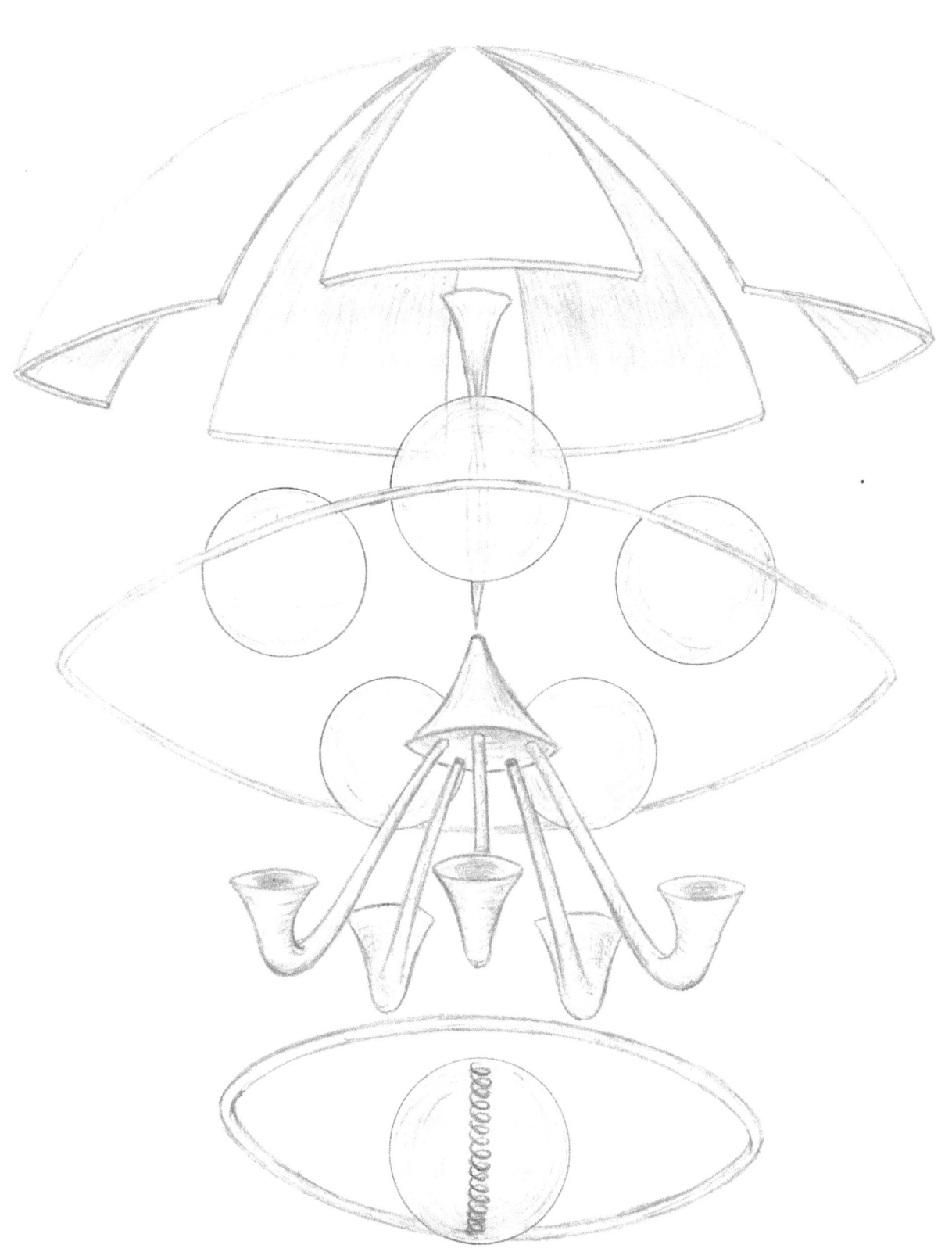

COMMAND HORN & TRUTH ORBS

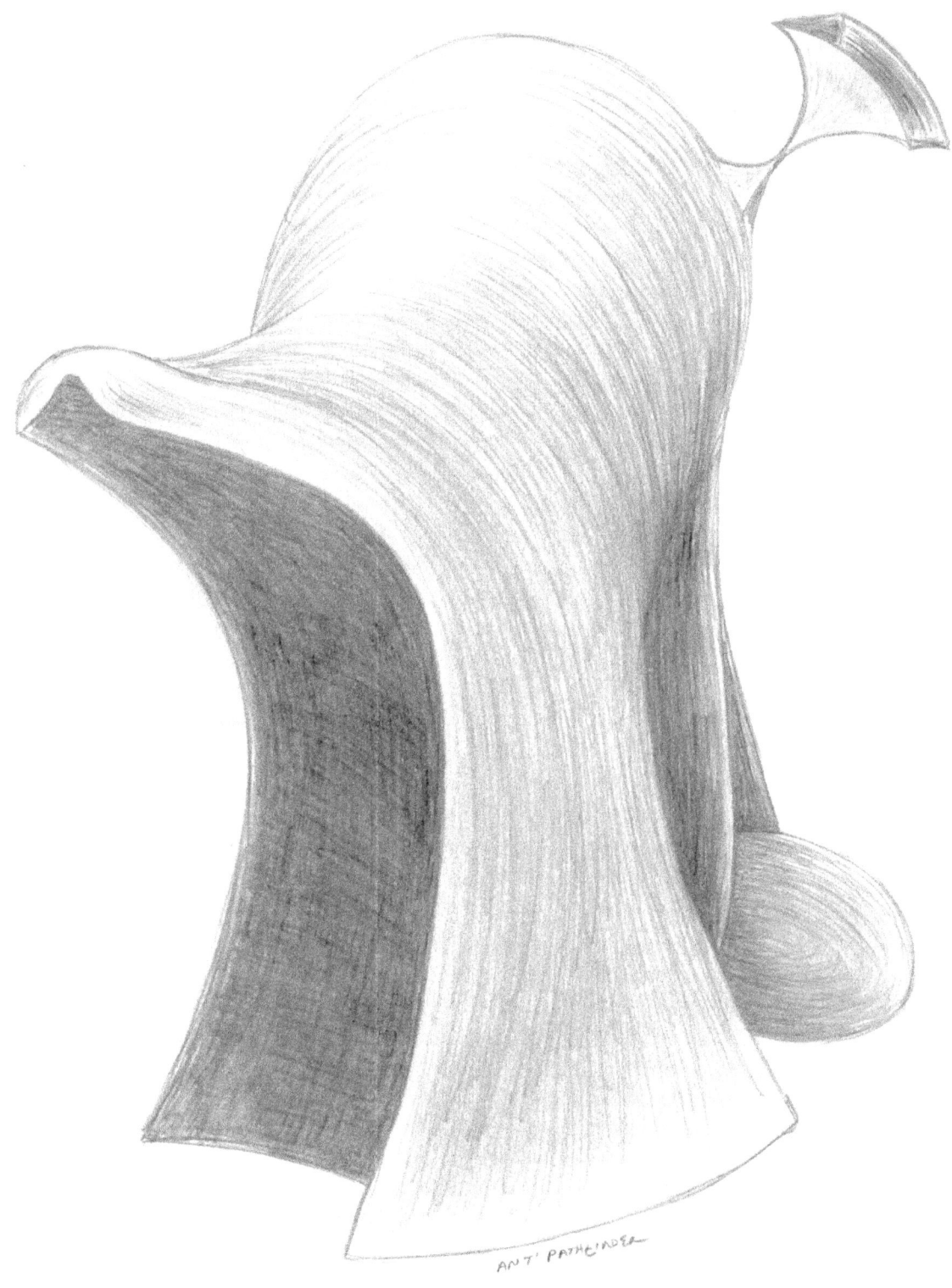

COMMAND PUMP

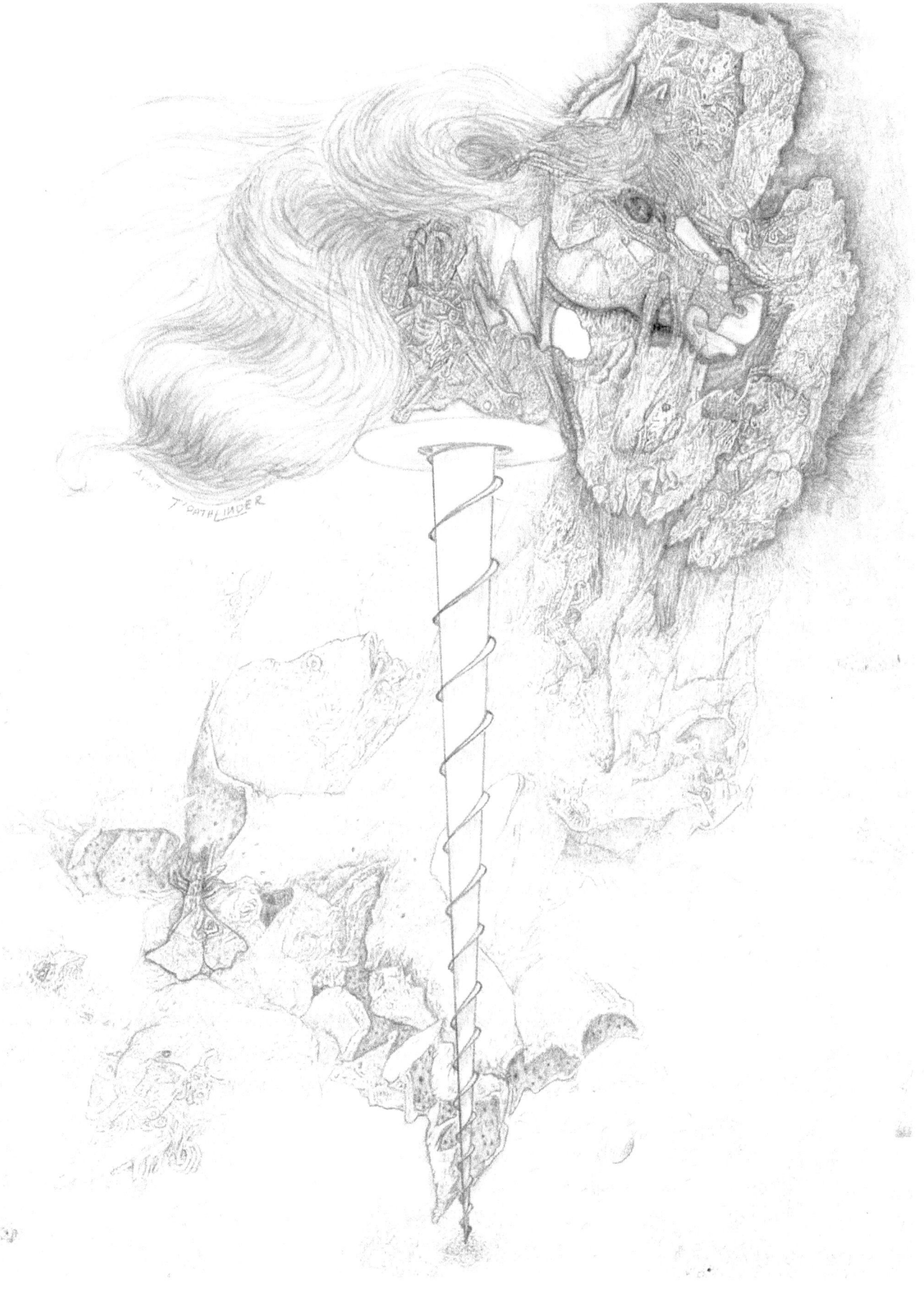

COMMAND SCREW

COMPASSION BORN SILO AKA GRANDMA'S SNOW GLOBE

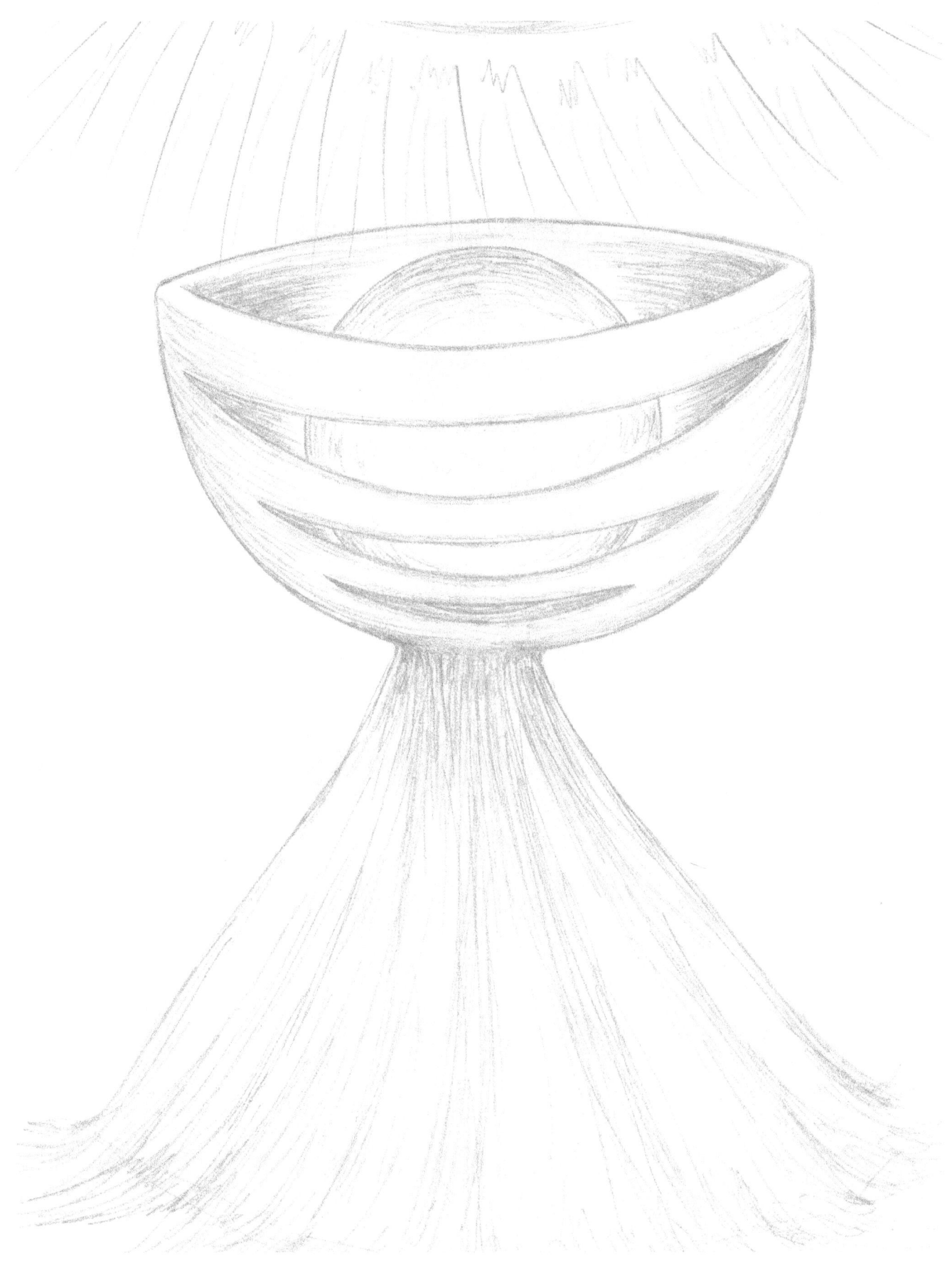

CONTROL ROOM AKA POWER WOMB
FOUND AT TOP OF IVORY TOWER

WILD CARDS FOR YOUR SOUL

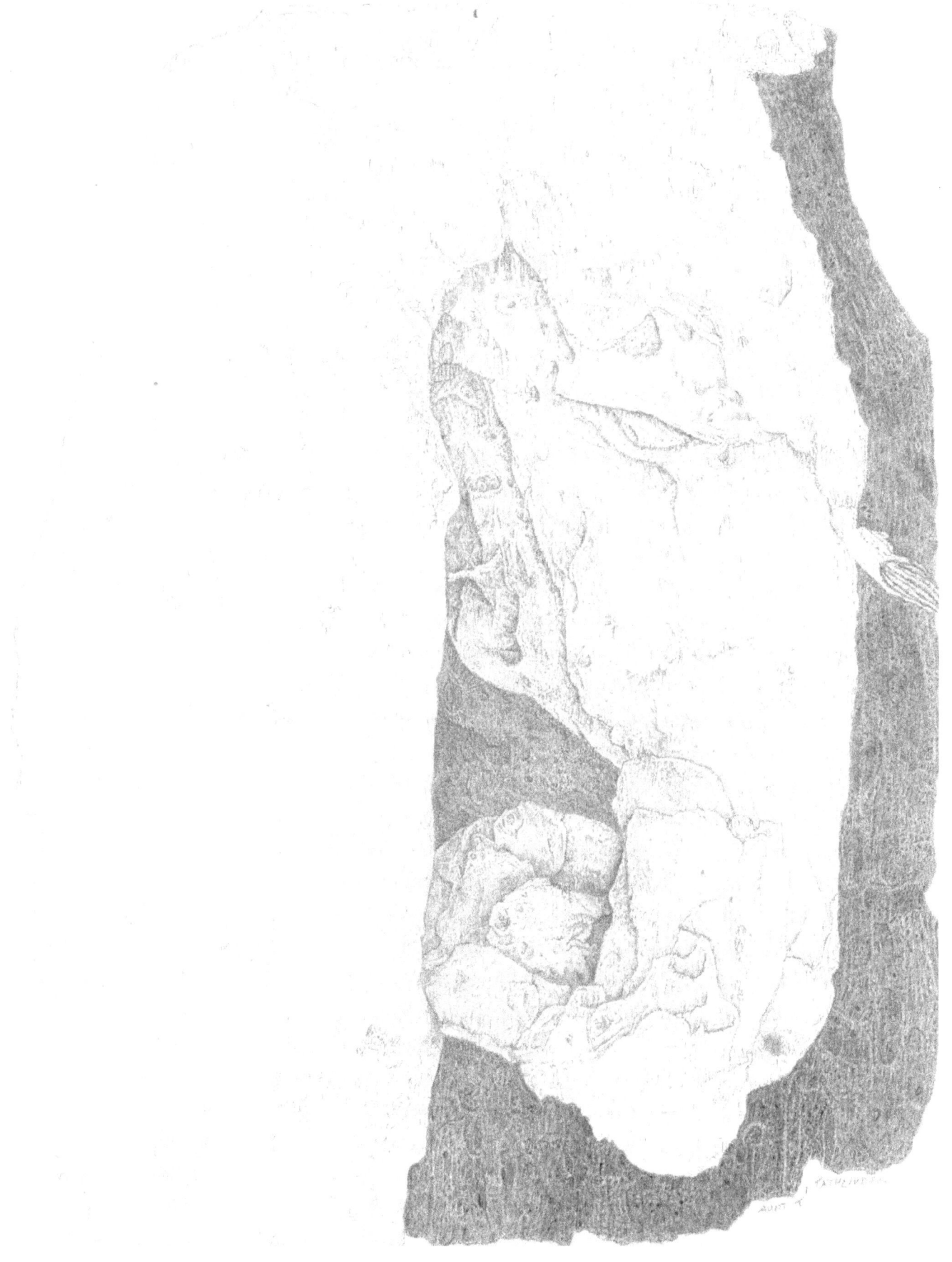

CORE CRACKER

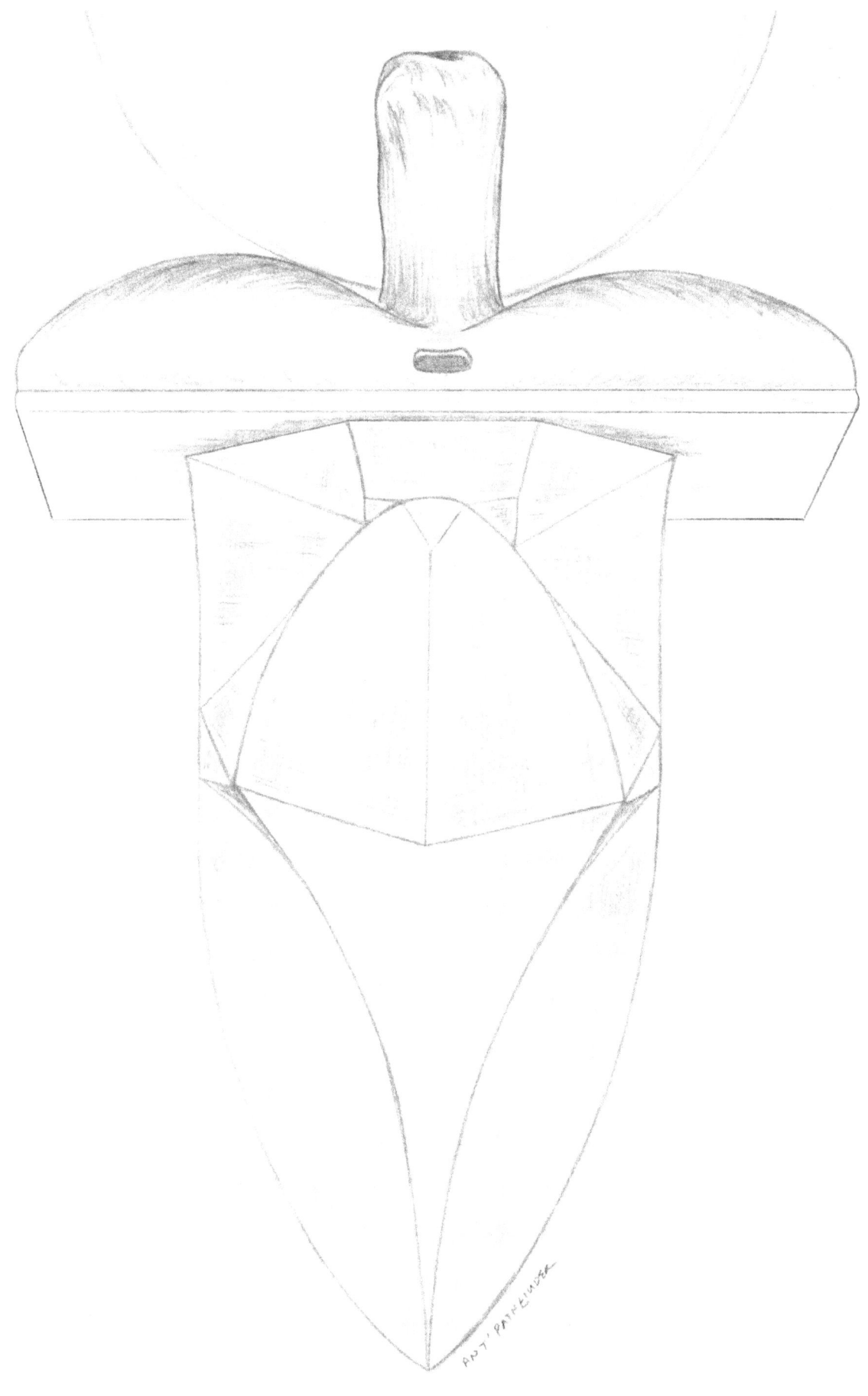

CREATION DAGGER
FOUND IN LAP OF CREATION MACHINE

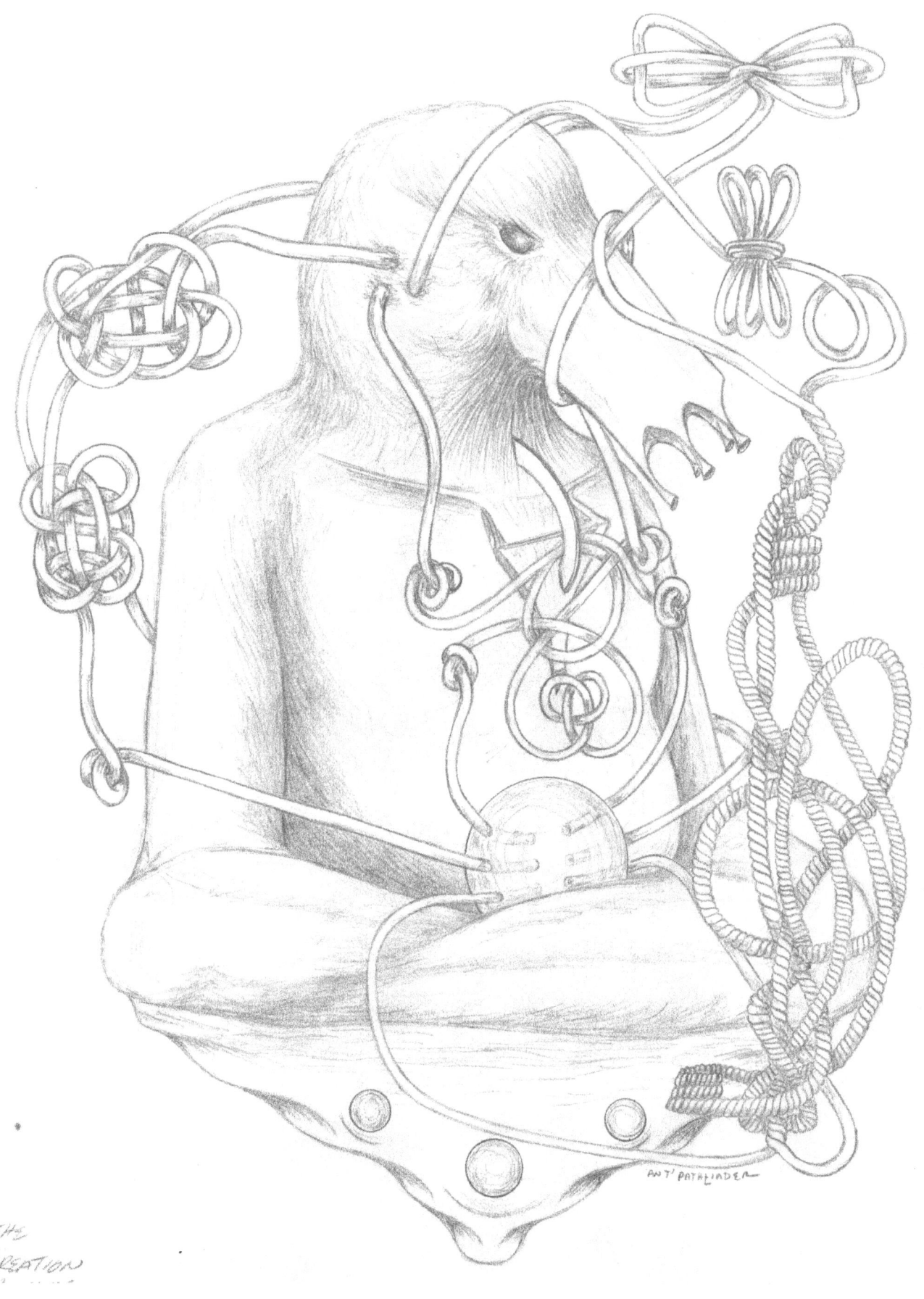

CREATION MACHINE
FOUND WITH CREATION DAGGER

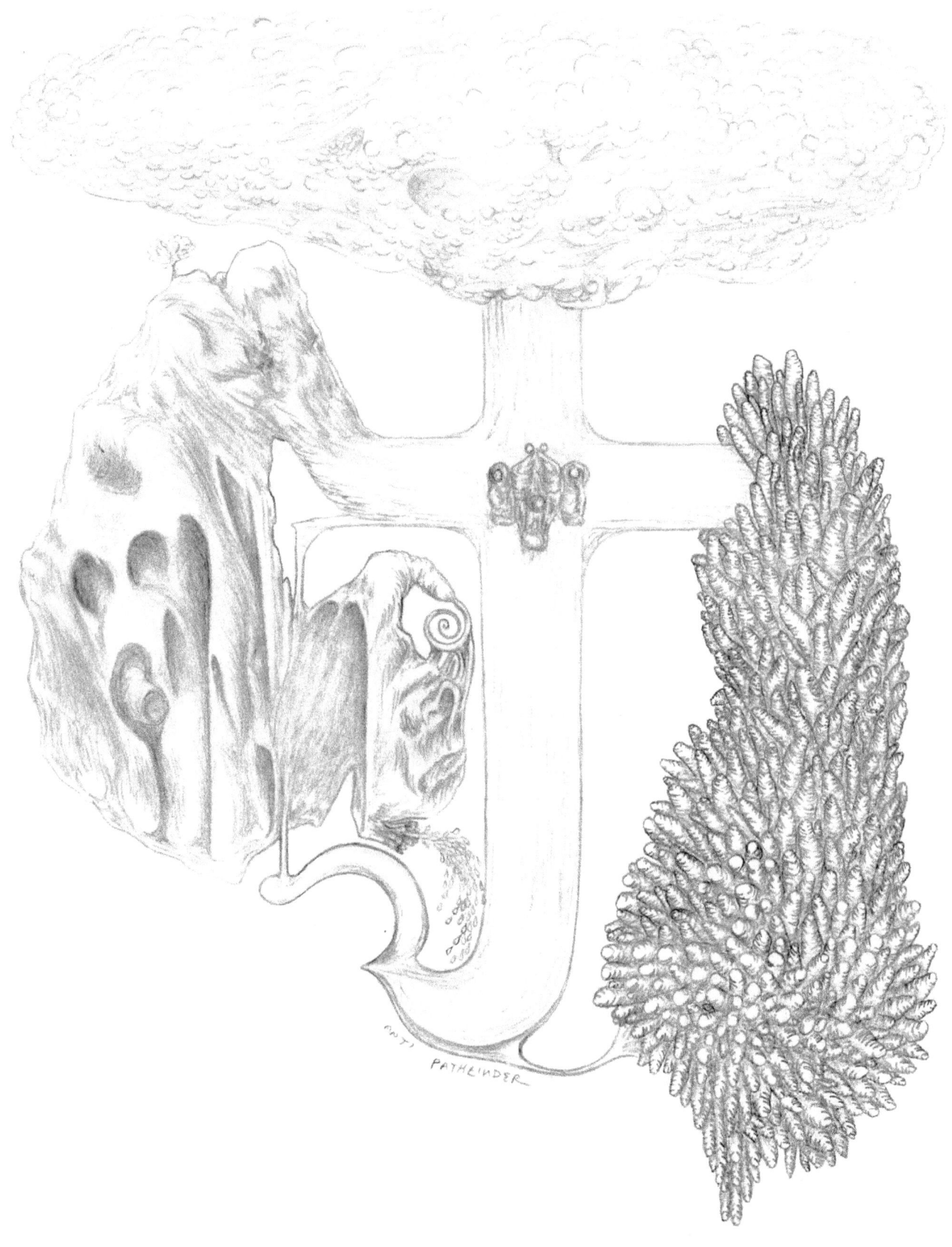

CREATIONS CROSS AKA PARADOX WOMB

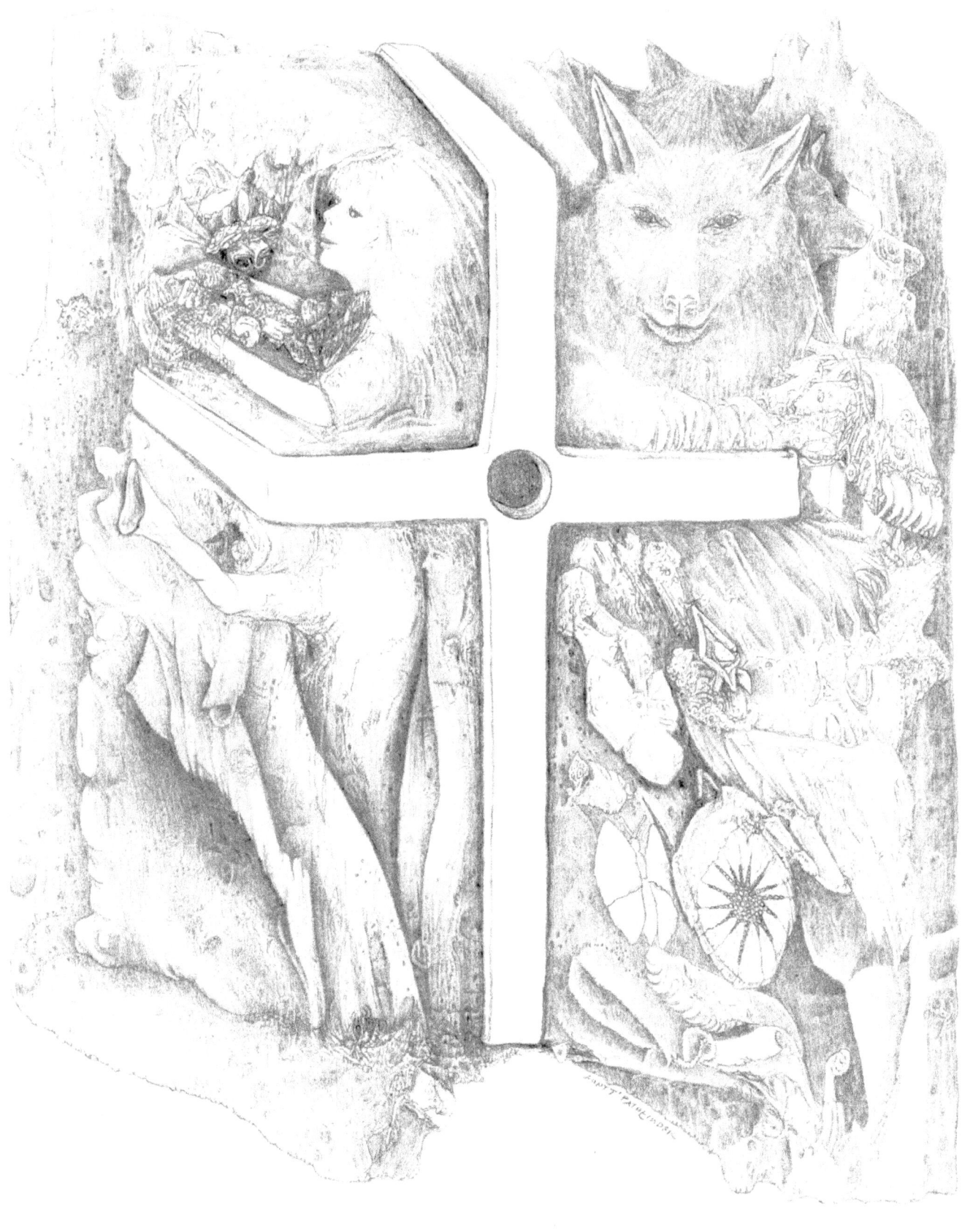

CREATIONS MUSIC BOX

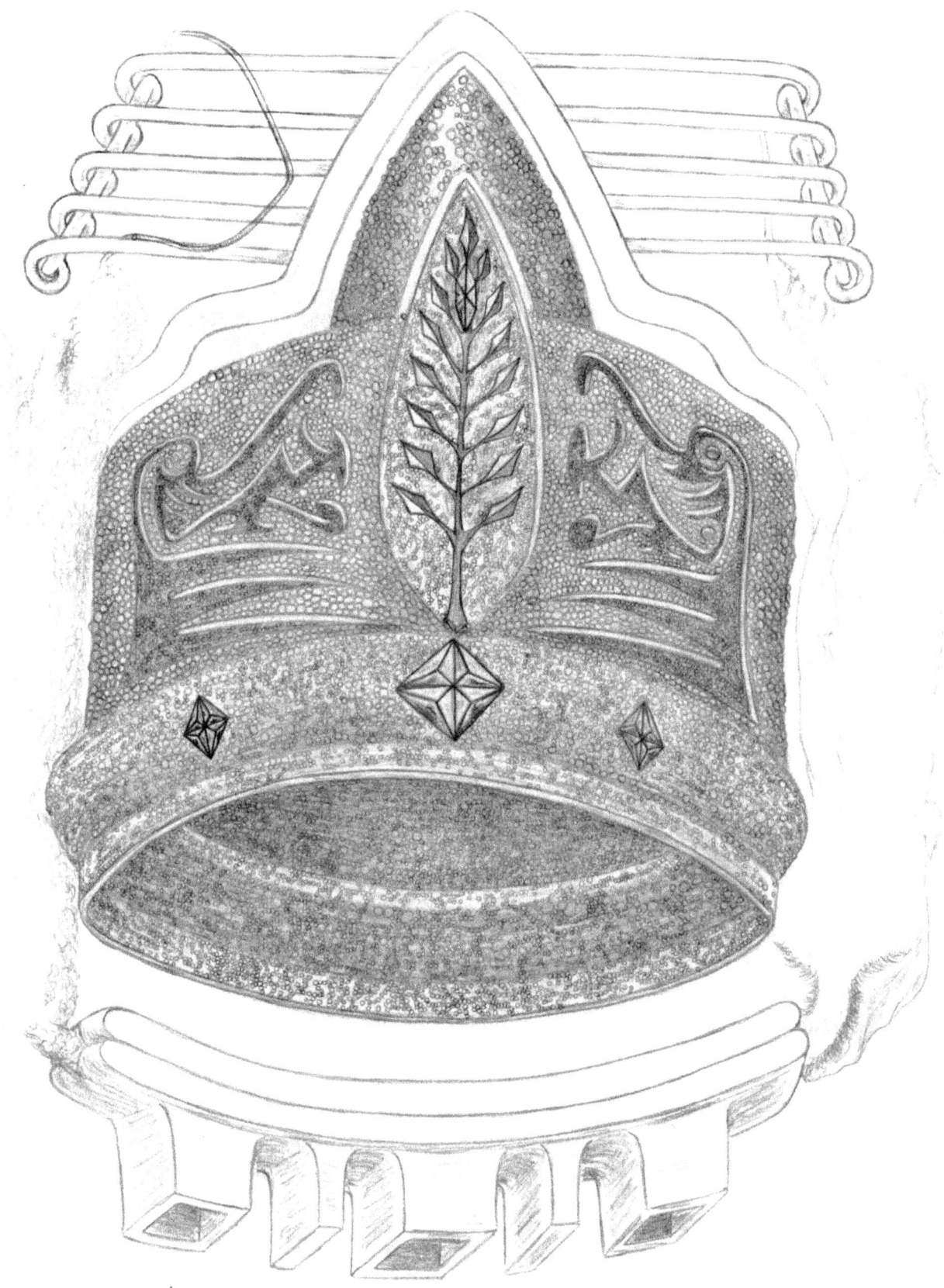

CROWN OF TIME & THRONE OF SHAPE

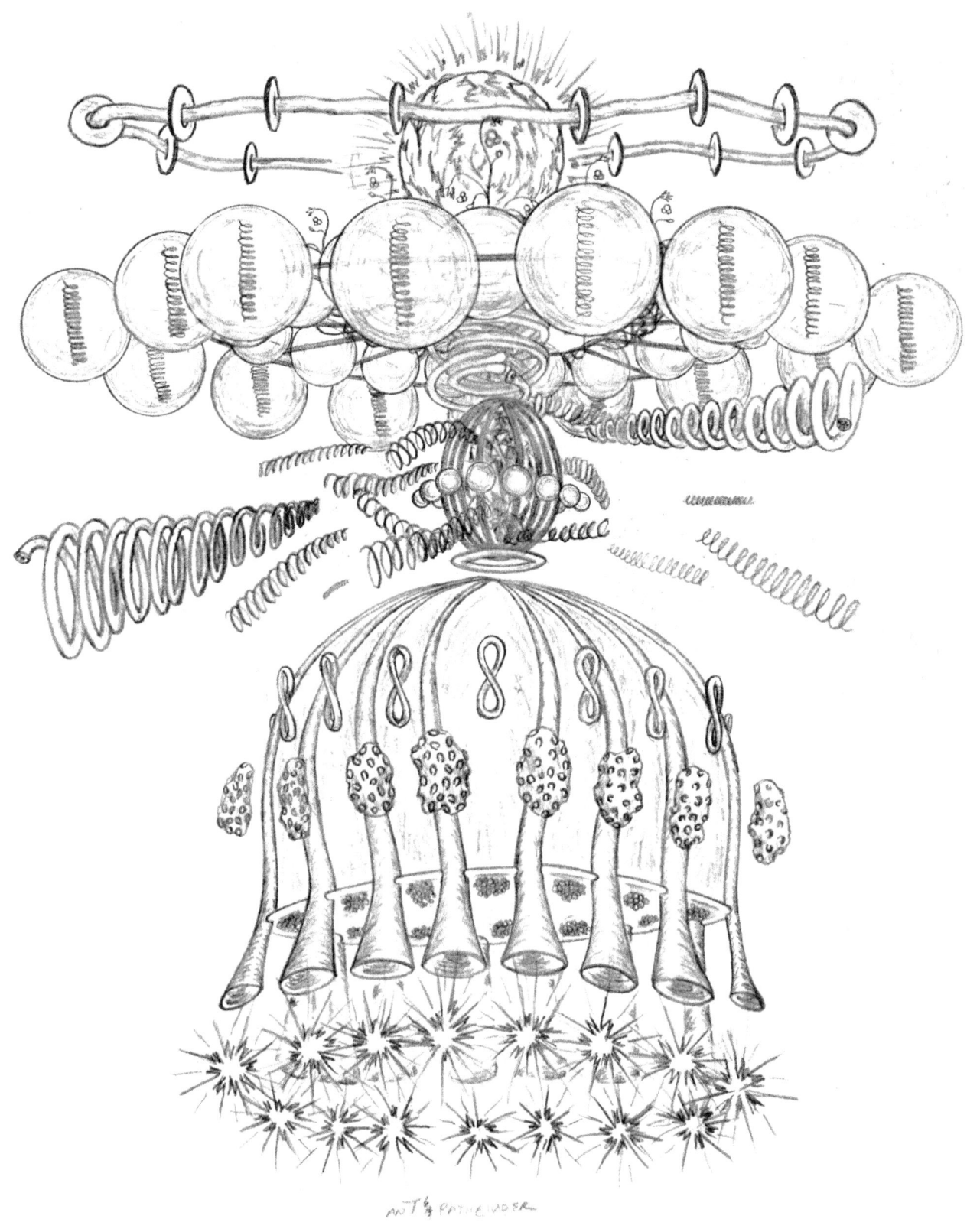

CROWN OF TRUTH

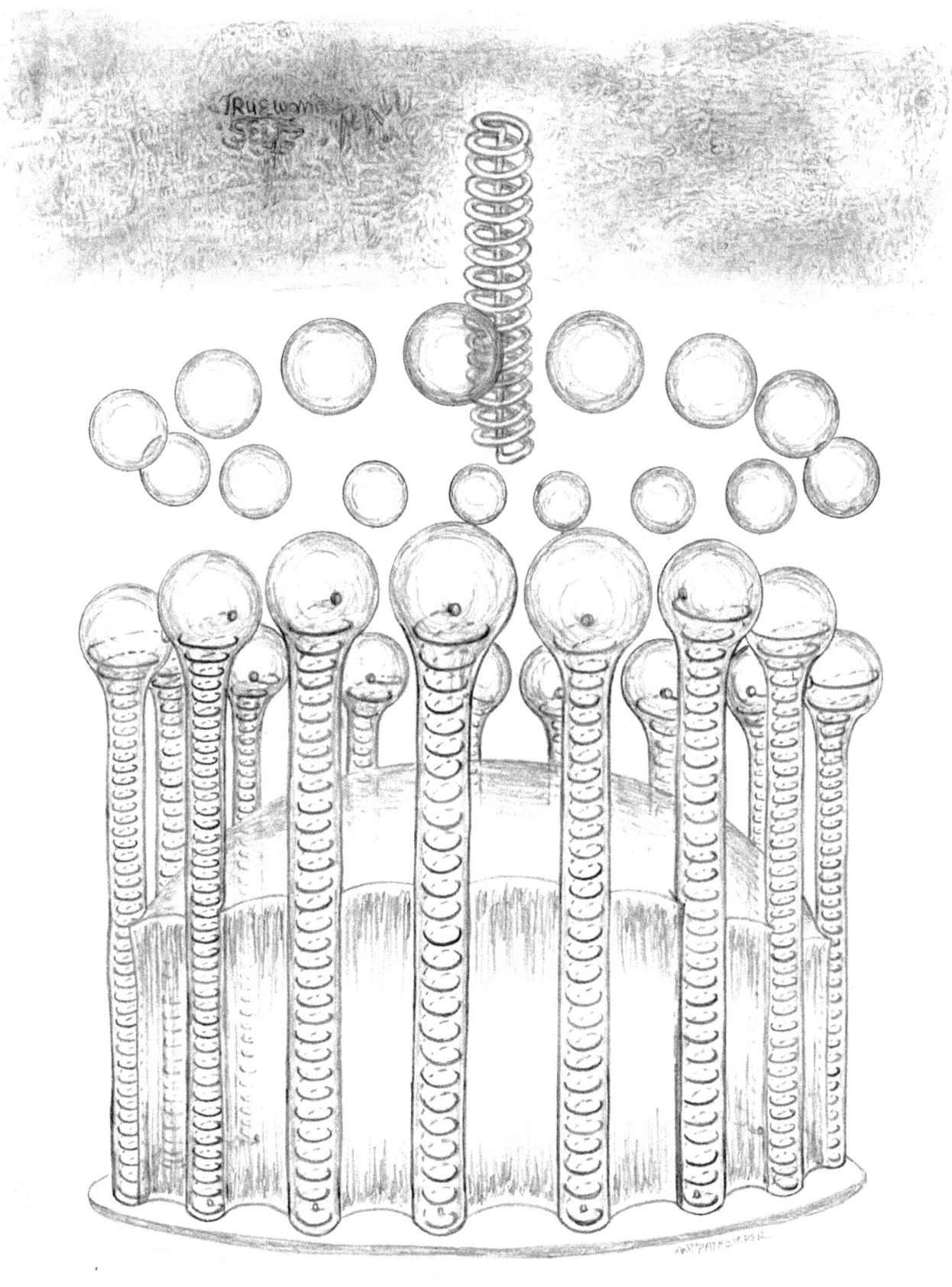

CRYSTAL WIND & CHAOS CLOUD

WILD CARDS D - E - F

D: Dark Matter aka Micro-Dust Throne; Debit Package; Destiny Wine Glass & Fountain of Truth; Destiny's Foundation Window; Destiny's Spell; DNA Transformer & Protein Guard; Dragon's Gate Highway; Dream Conduit aka Destiny's Womb; Dream Cornucopia & Glimmer Fish; Dream Funnel; Dust Key; Dust Rye Title Center.

E: Egg-Type Bone; Emotion Bone; Emotion-Bound Biscuit; Energy Stem; Essence of Magic aka Emotion Pod; Eternity Loom & Tapestry of Time.

F: Fantasy Puzzle; Final Command Cup; Final Command Lamp & Flame of Truth touched by Grace; Final Command Whistle; First Destiny Egg & Vacuum Bubble transfixed by Spear of Form &True Destiny Sword; First Womb Throne; Flame of Understanding; Foundation Cleaver & Trickster Colony; Foundation Stealth Broom.

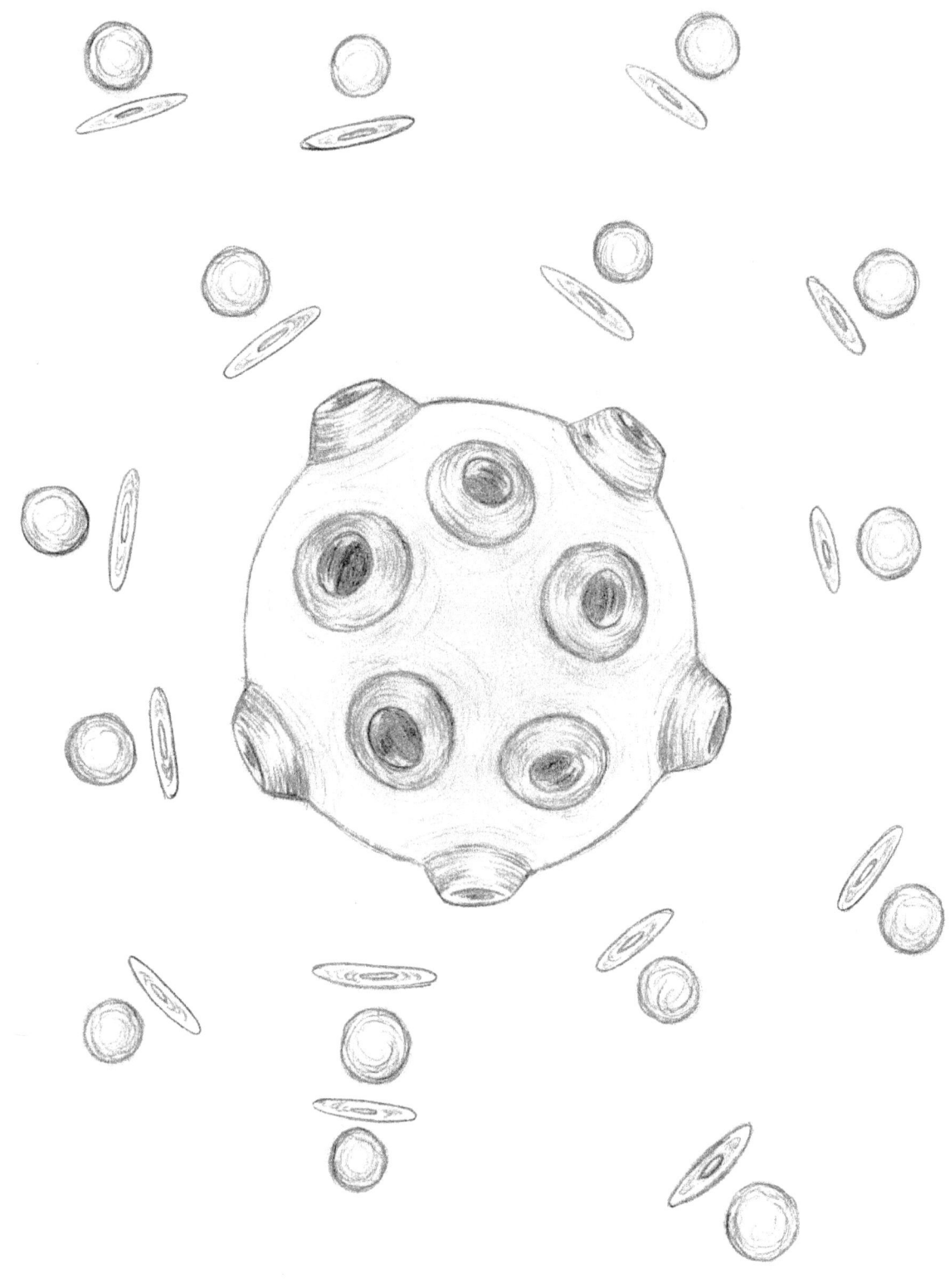
ANTIPATHFINDER

DARK MATTER AKA MICRO-DUST THRONE

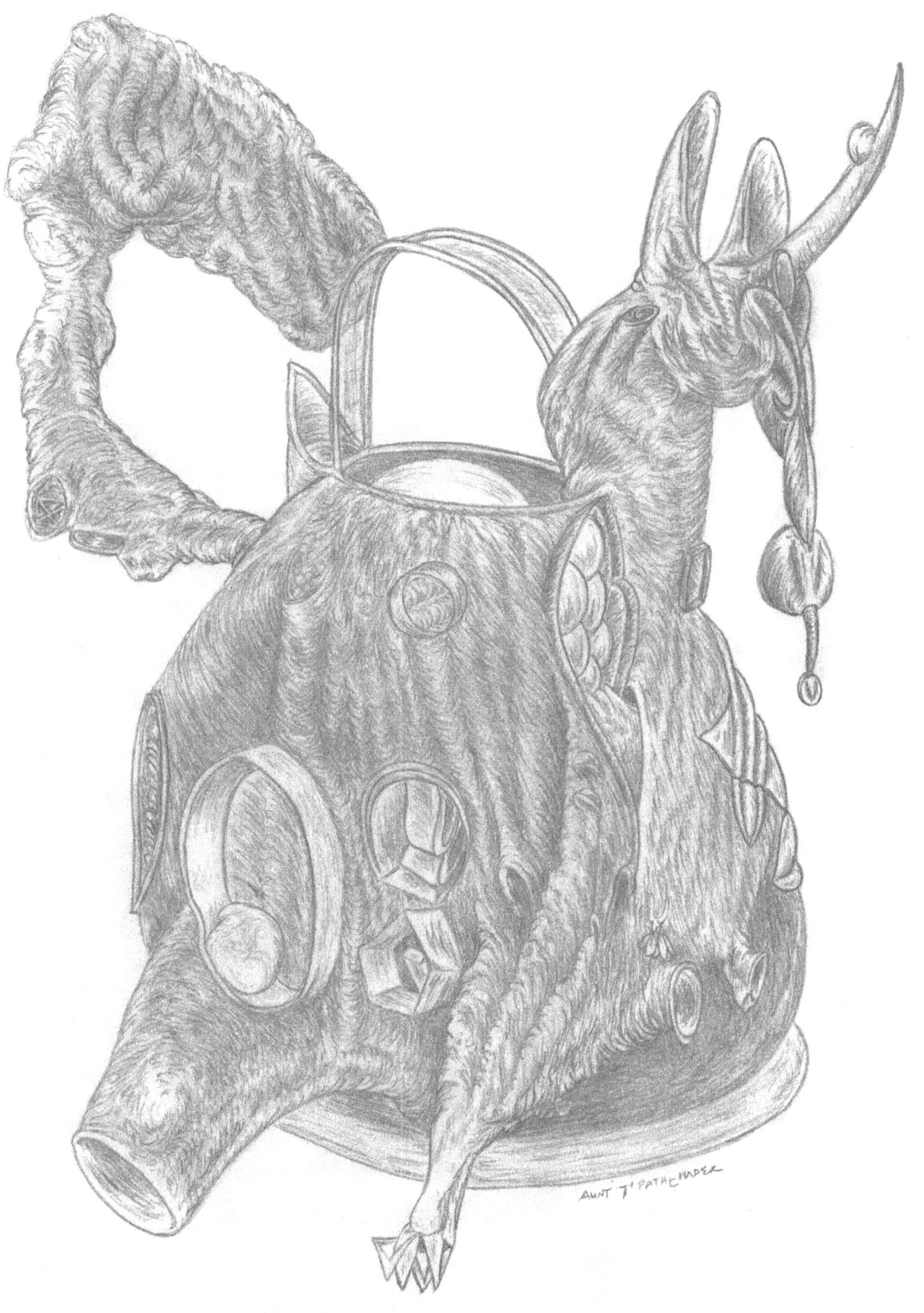

DEBIT PACKAGE

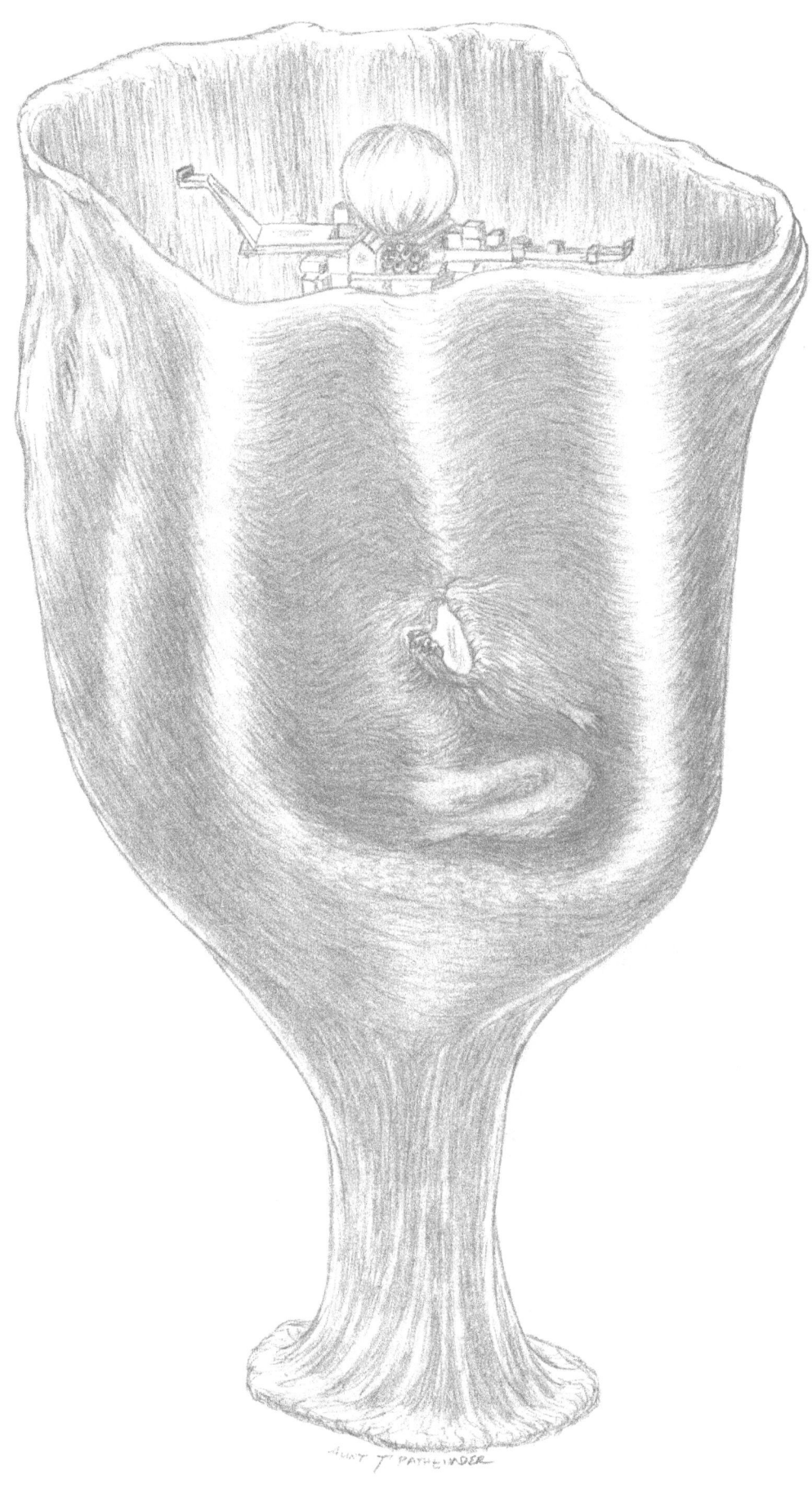

DESTINY WINE GLASS & FOUNTAIN OF TRUTH

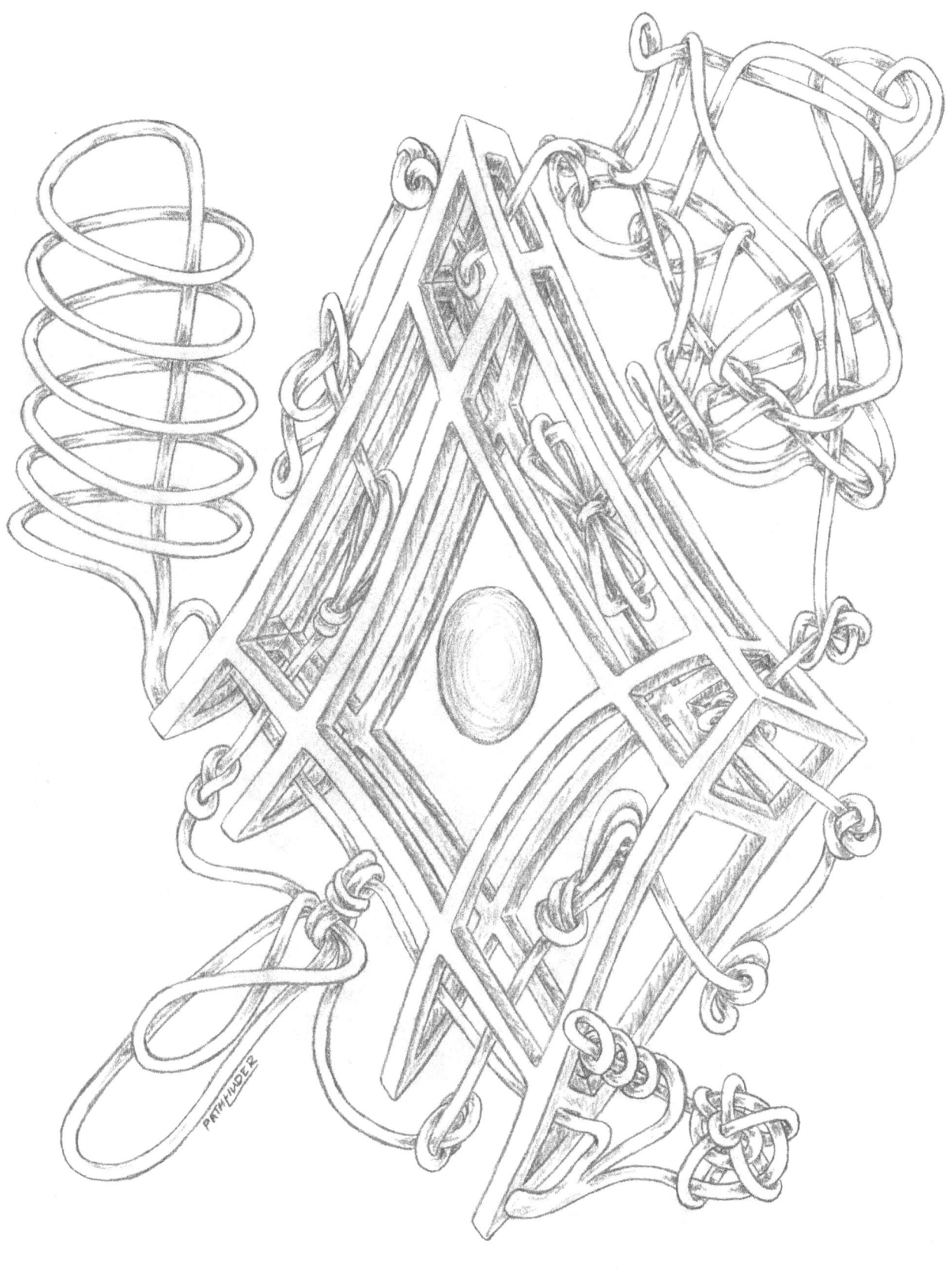

DESTINY'S FOUNDATION WINDOW

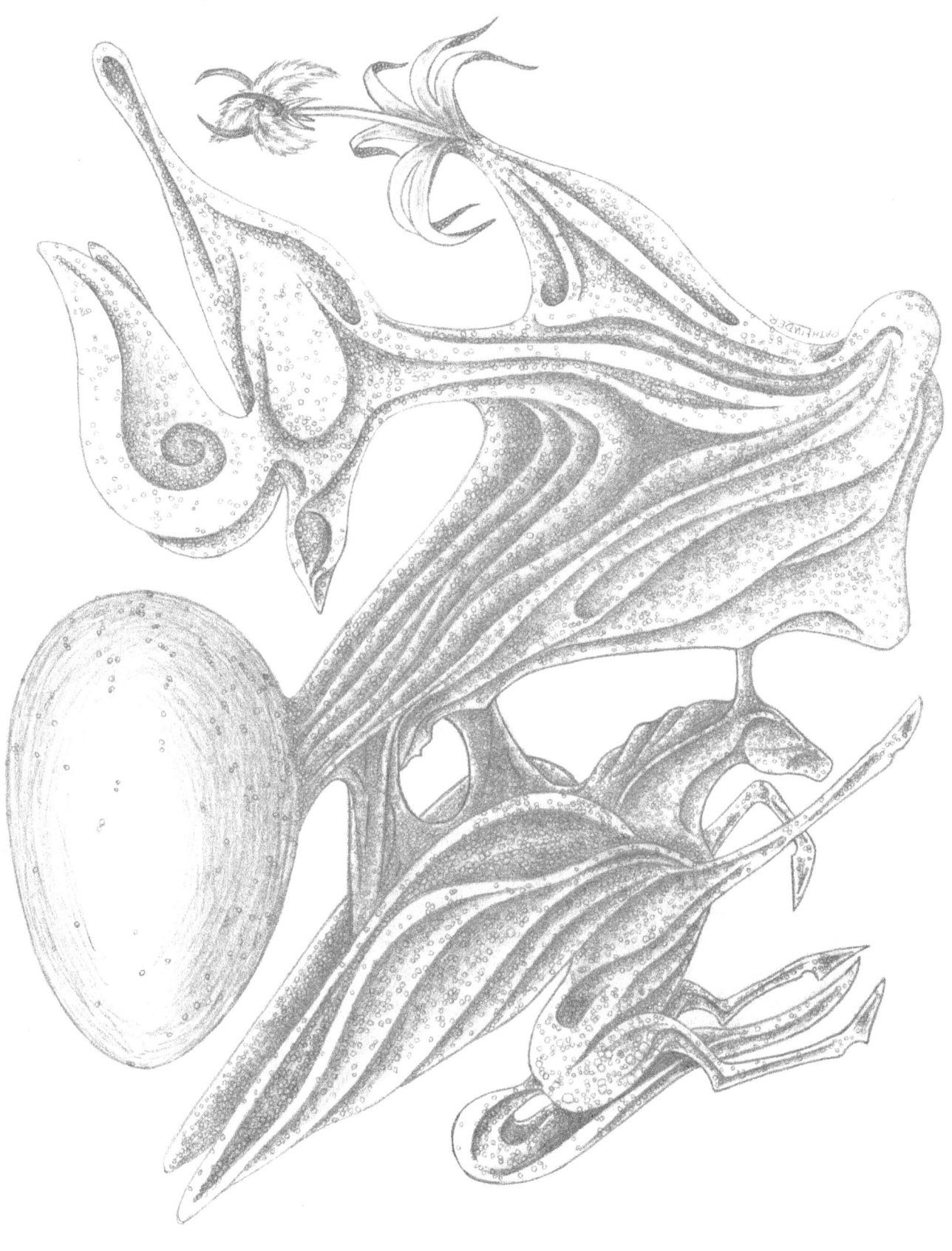

DESTINY'S SPELL
← BOTTOM

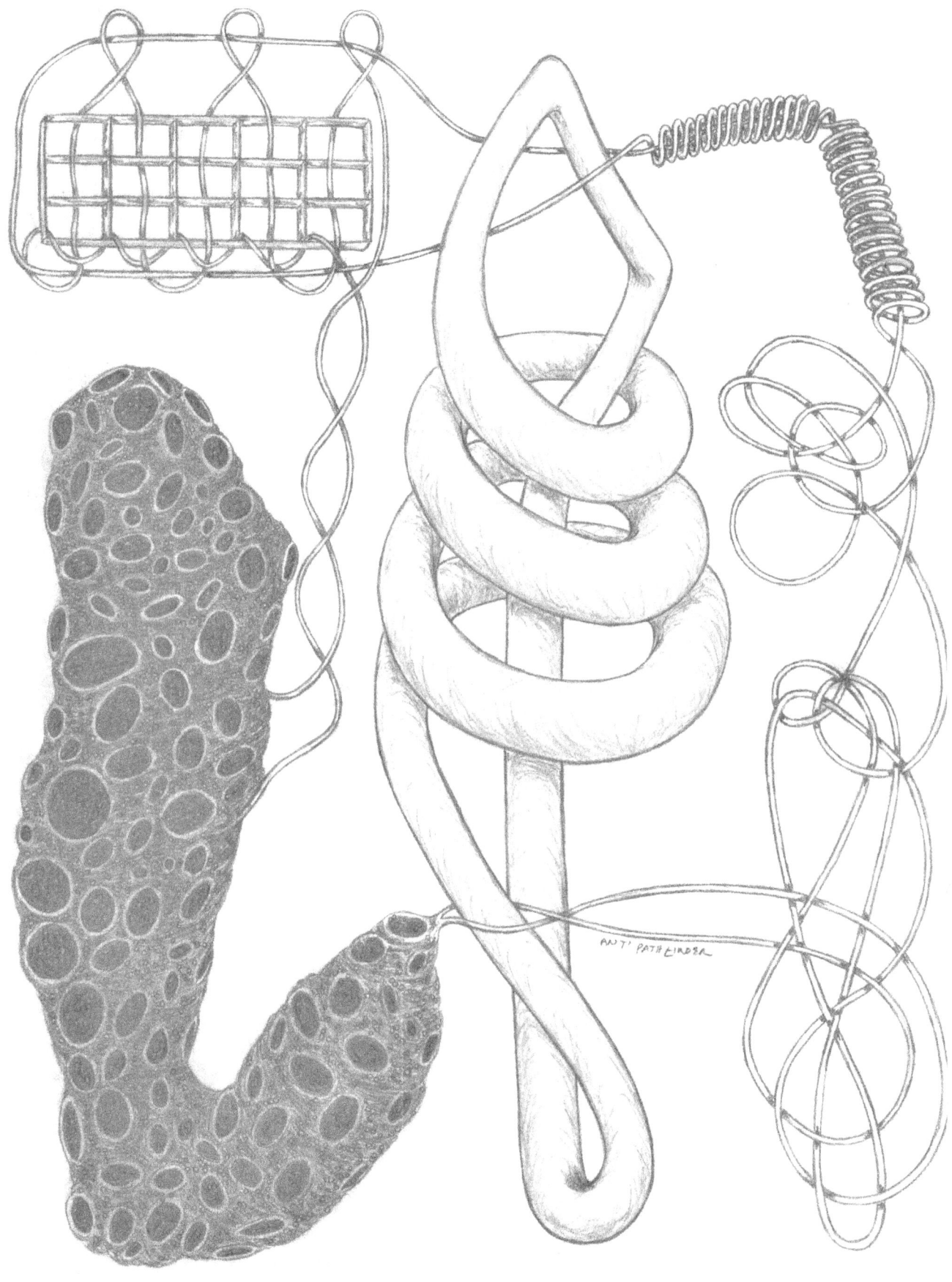

DNA TRANSFORMER & PROTEIN GUARD

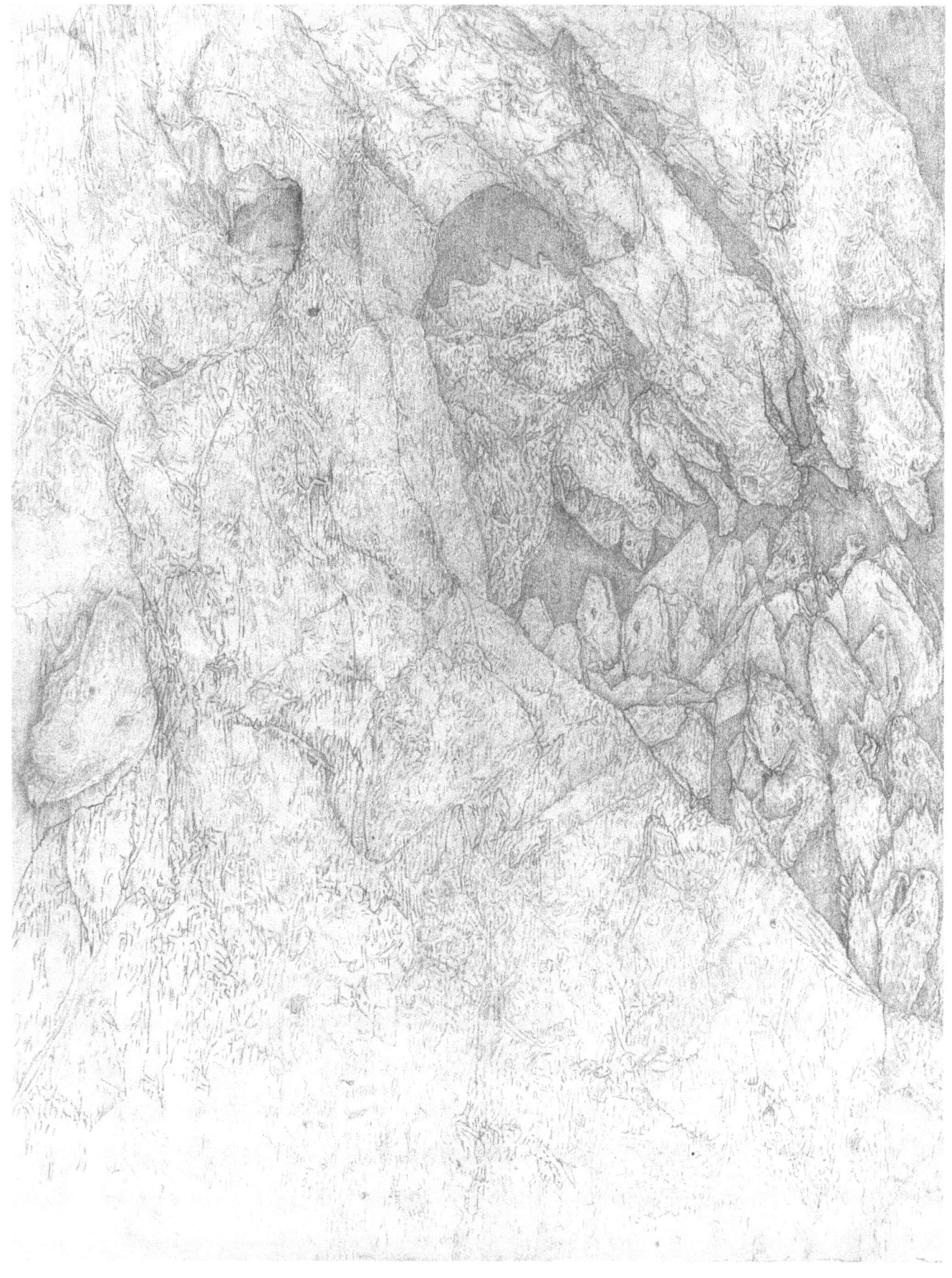

DRAGON'S GATE HIGHWAY

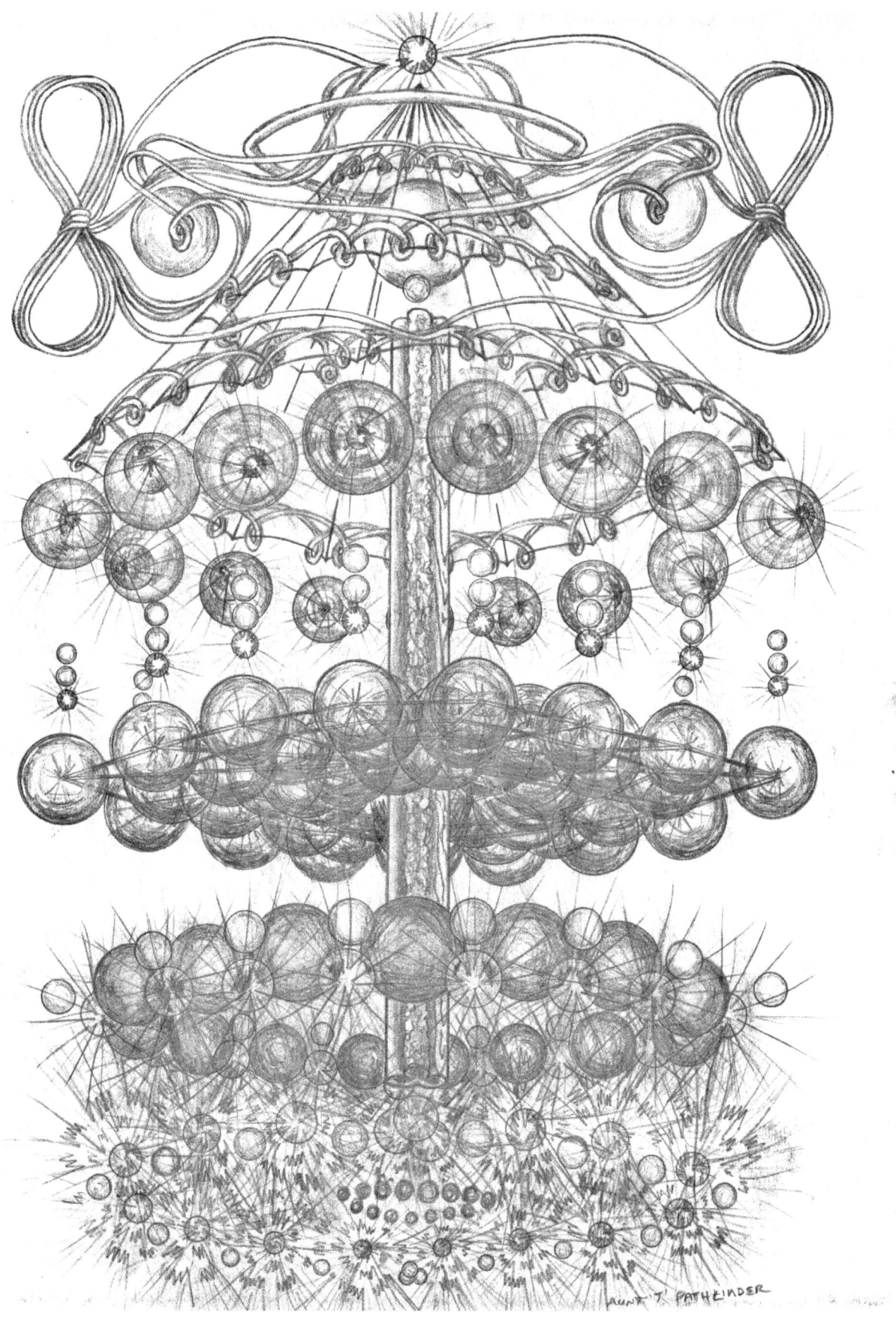

DREAM CONDUIT AKA DESTINY'S WOMB

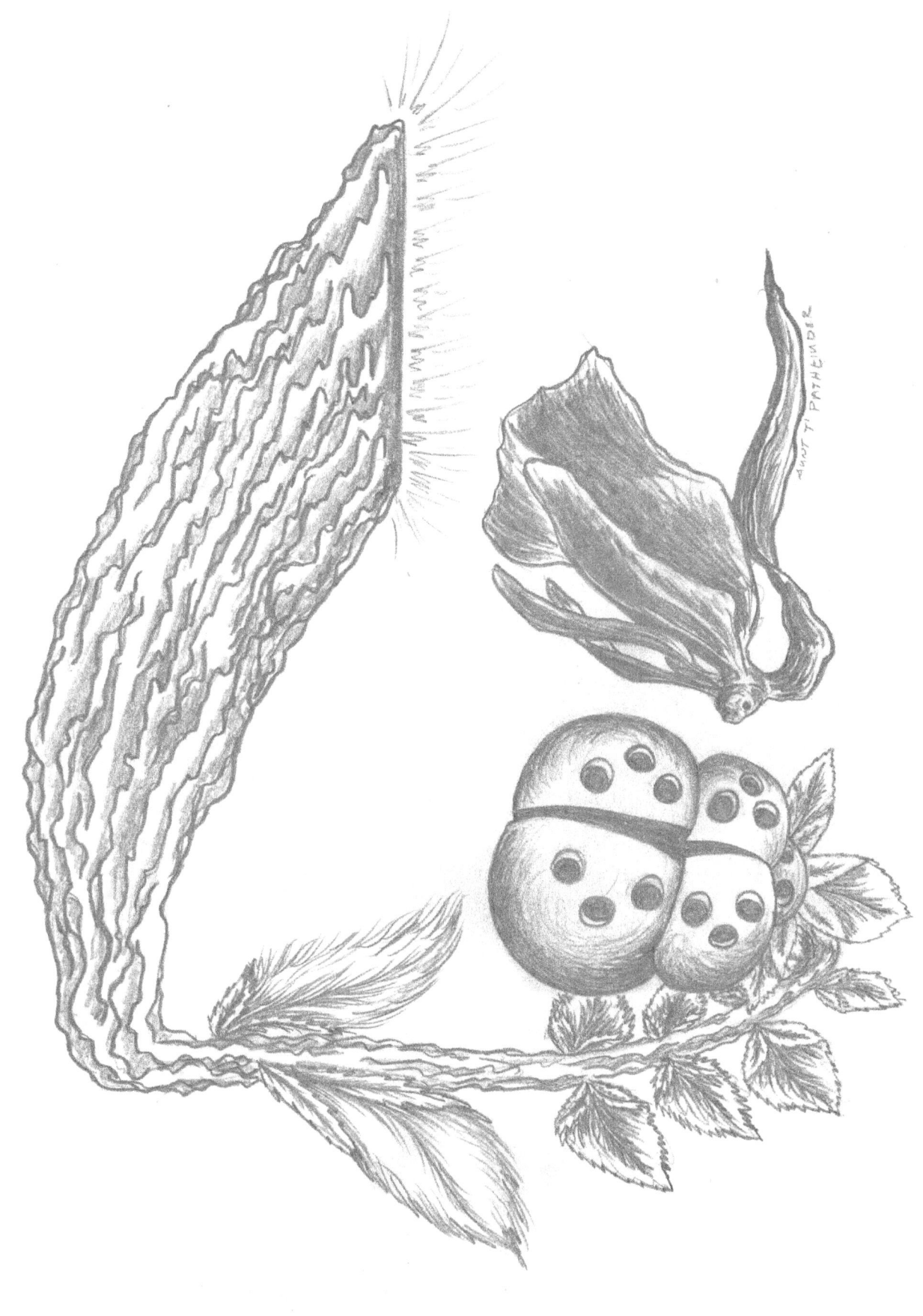

DREAM CORNUCOPIA & GLIMMER FISH
← BOTTOM

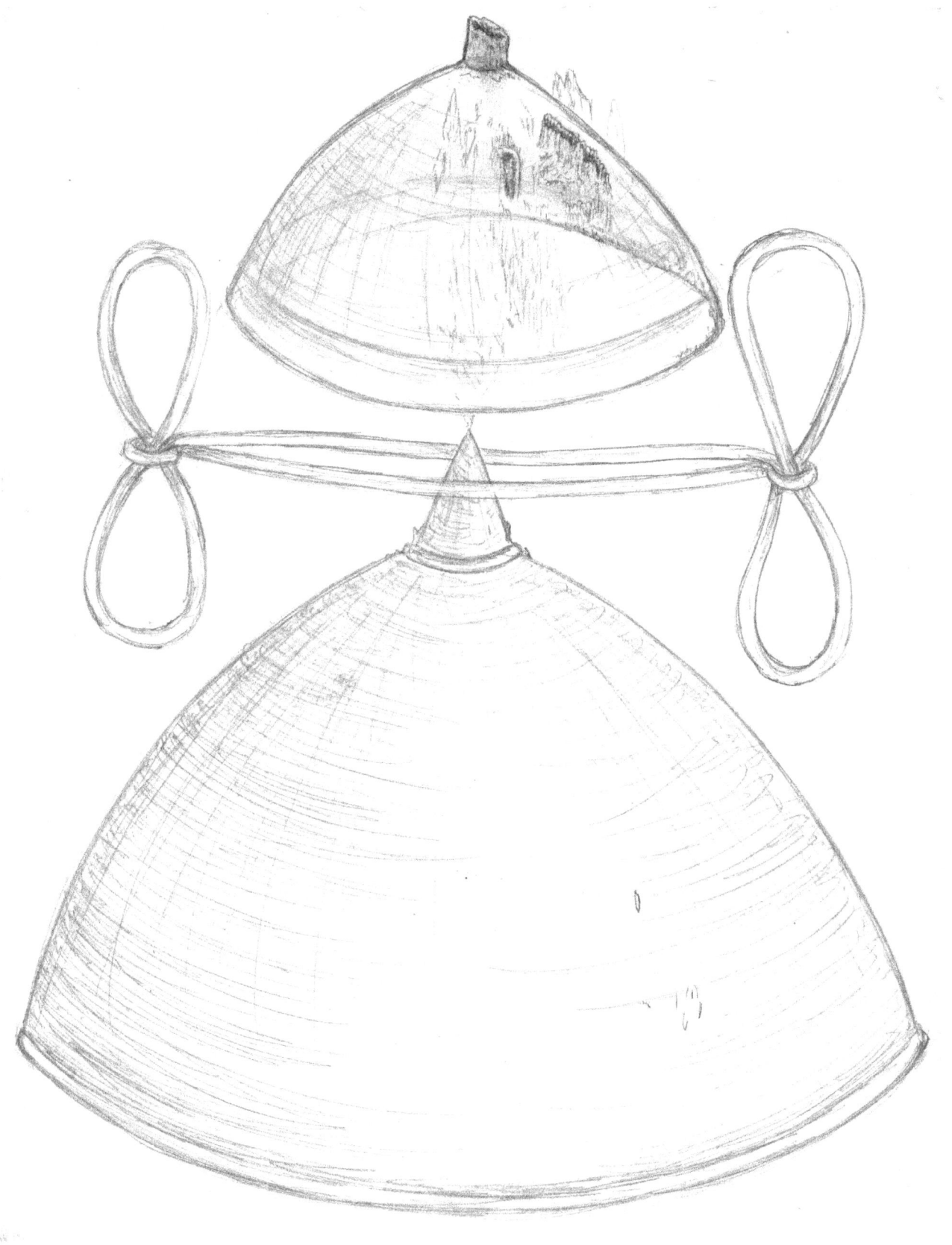

DREAM FUNNEL

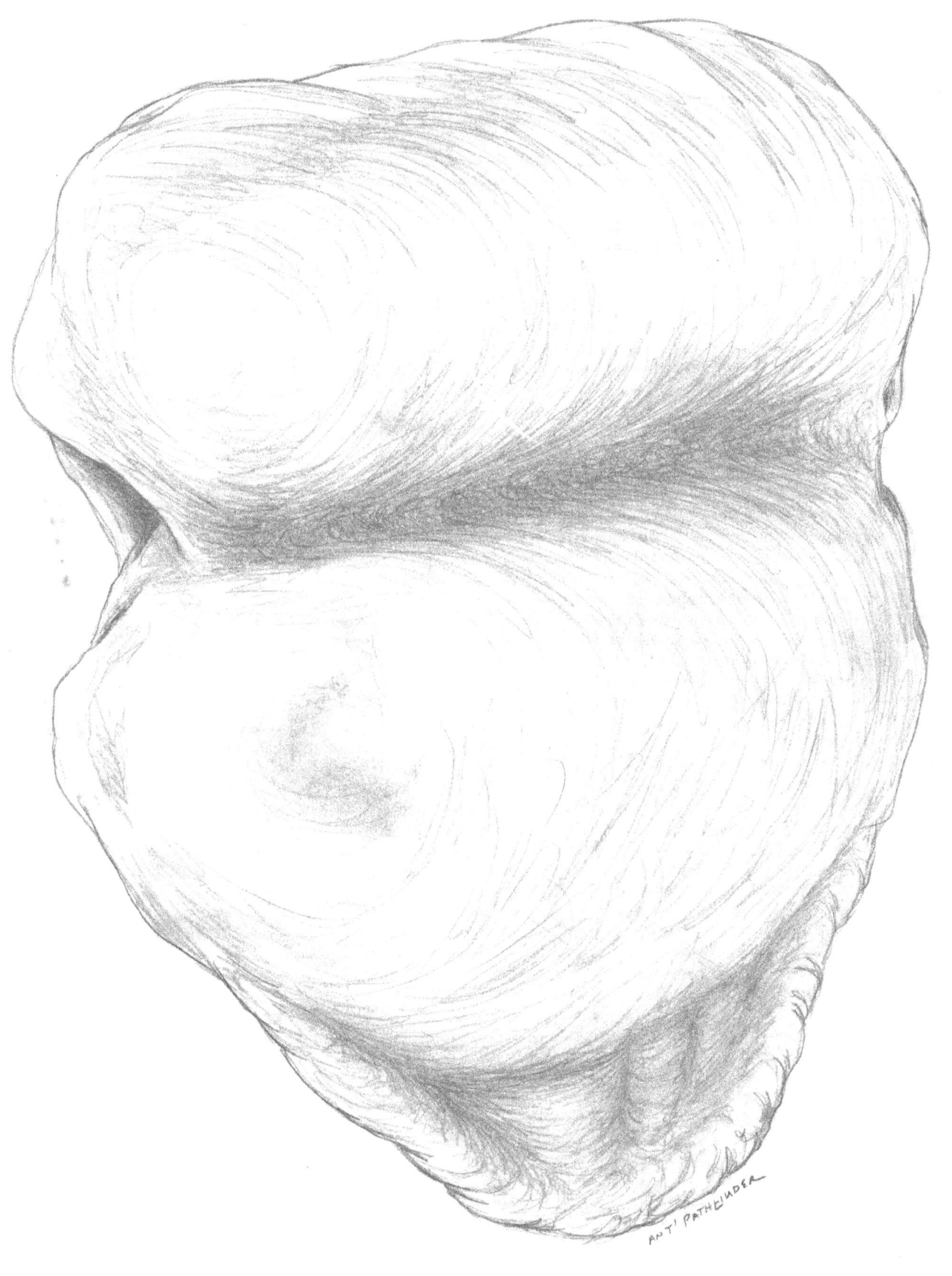

DUST KEY

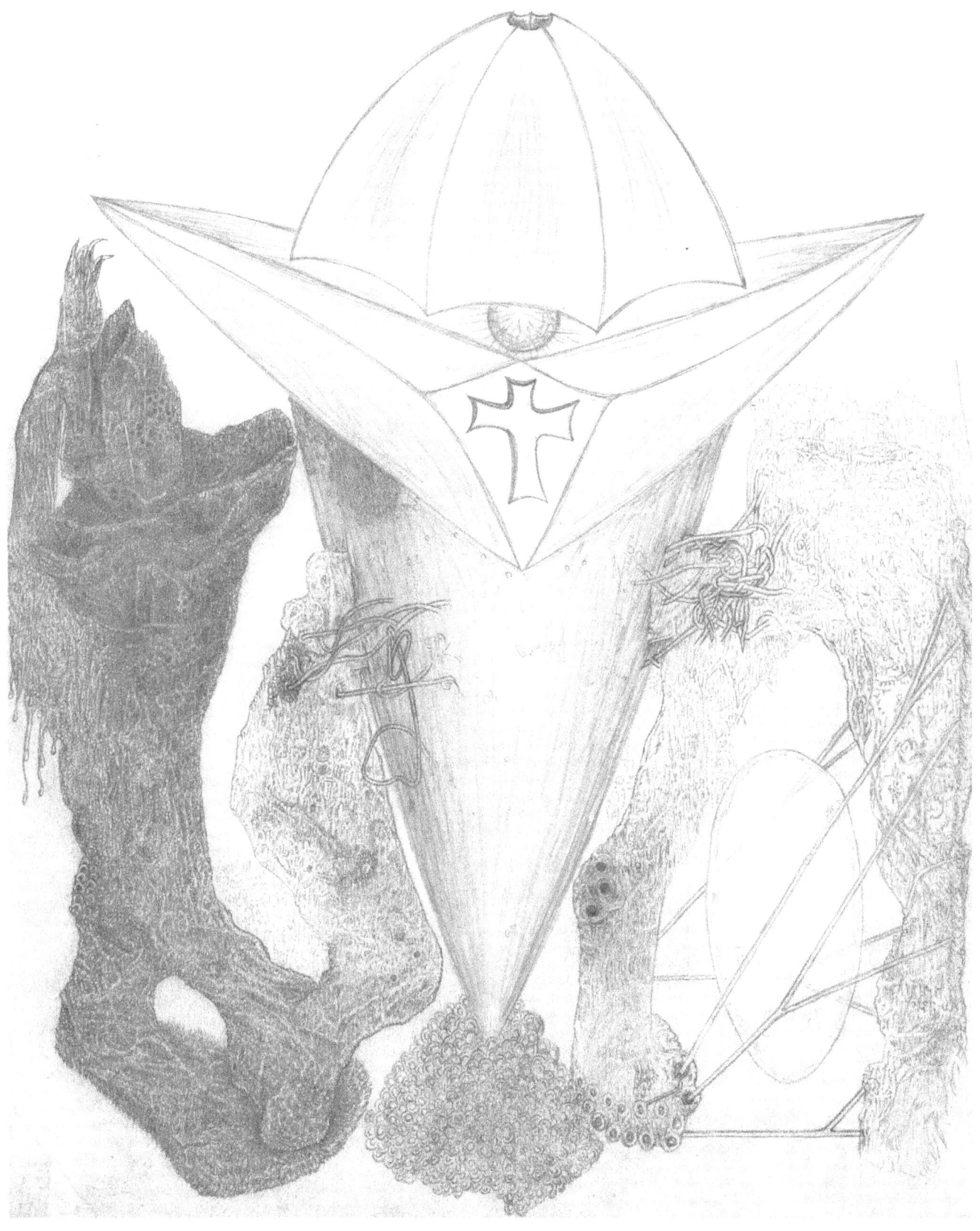

DUST RYE TITLE CENTER

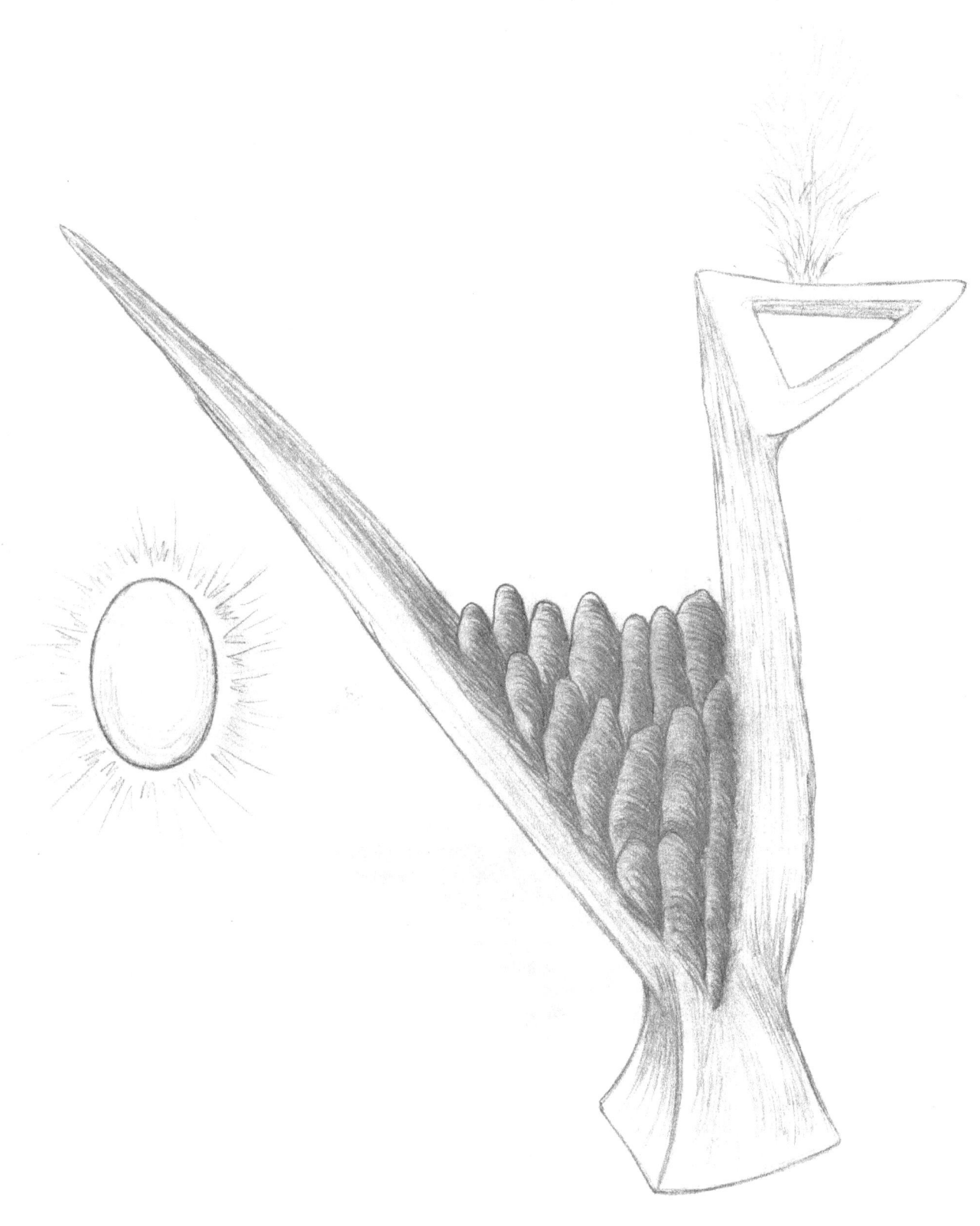

EGG-TYPE BONE

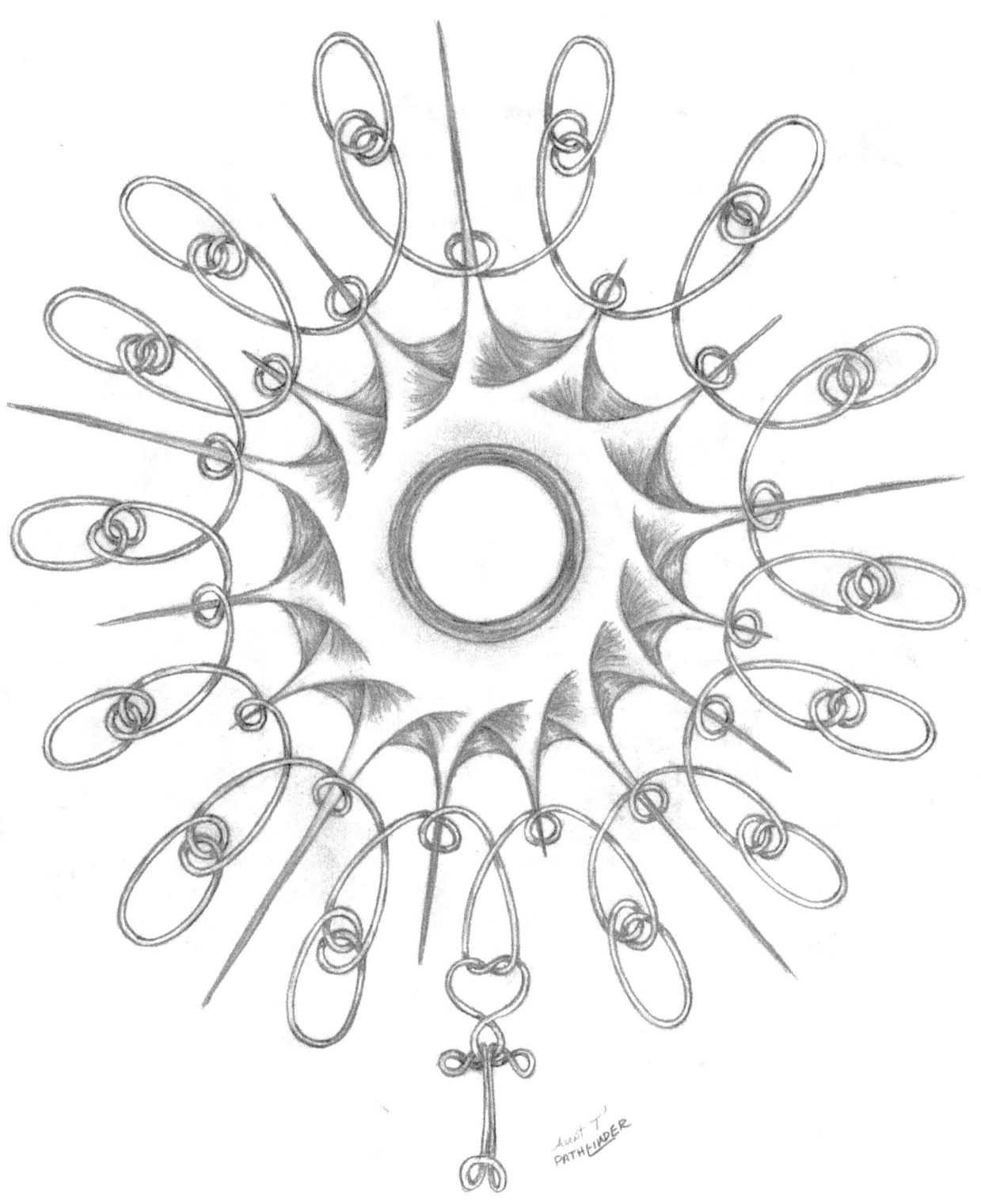

EMOTION BONE

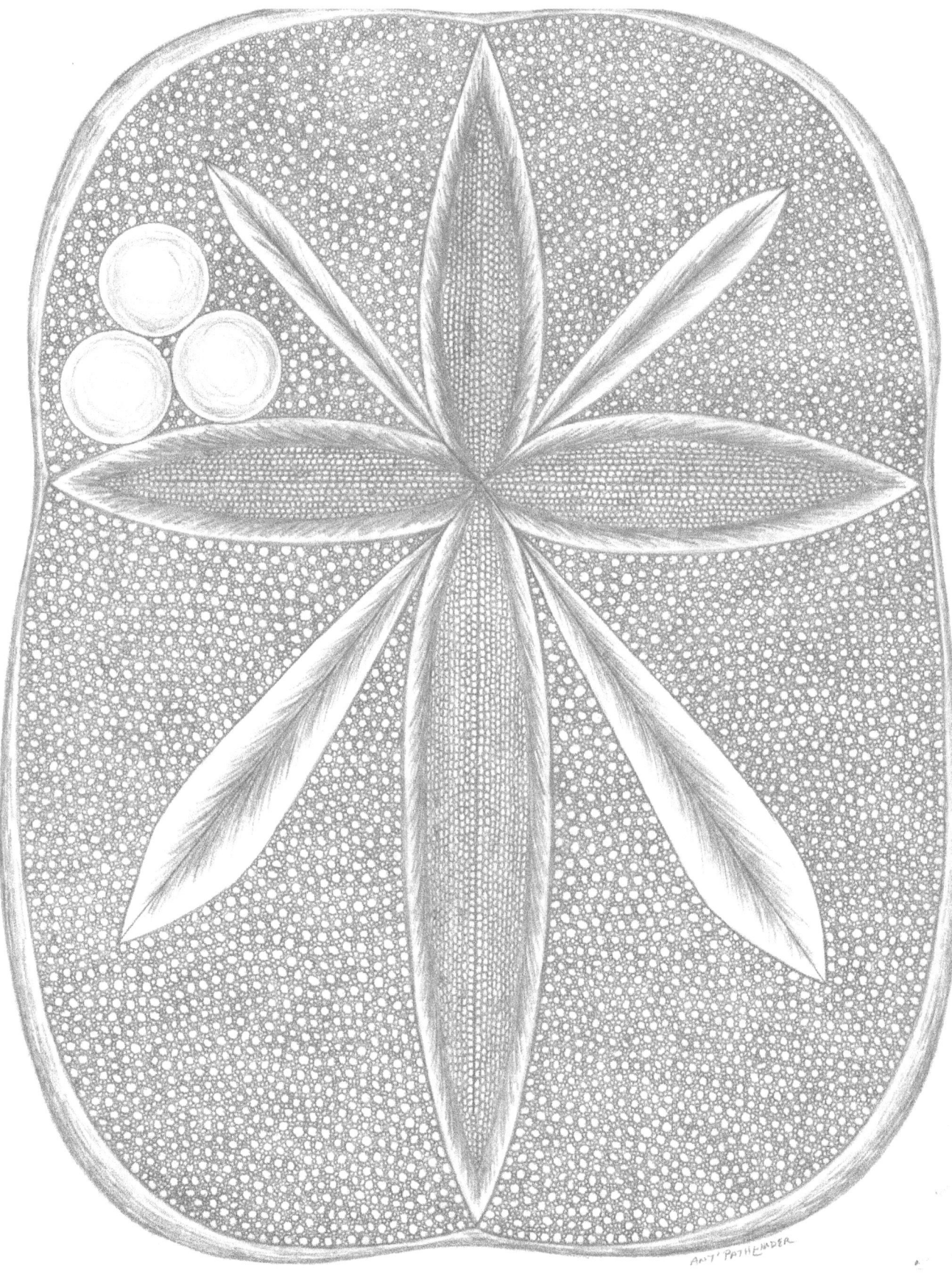

EMOTION-BOUND BISCUIT

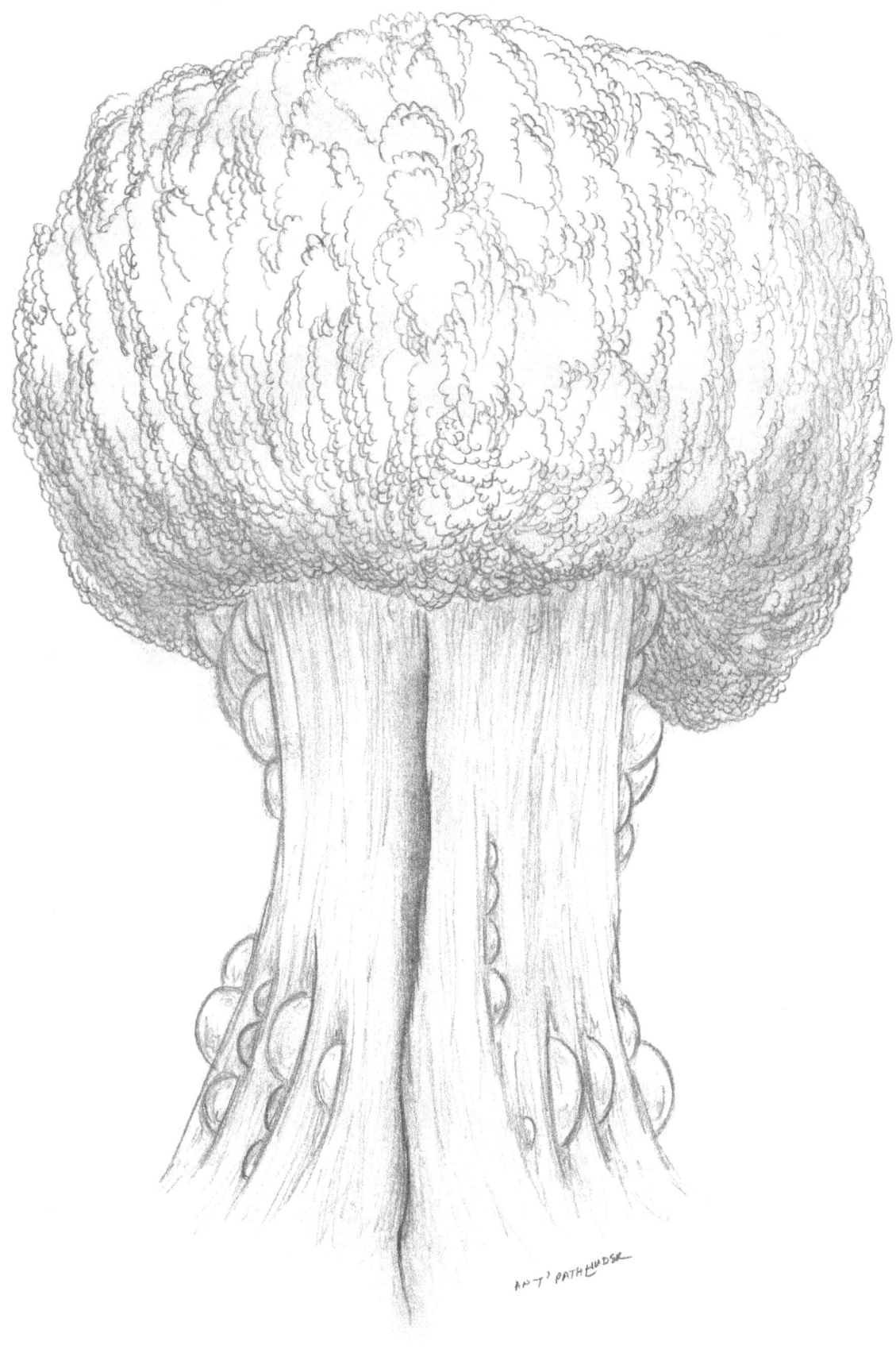

ENERGY STEM

WILD CARDS FOR YOUR SOUL

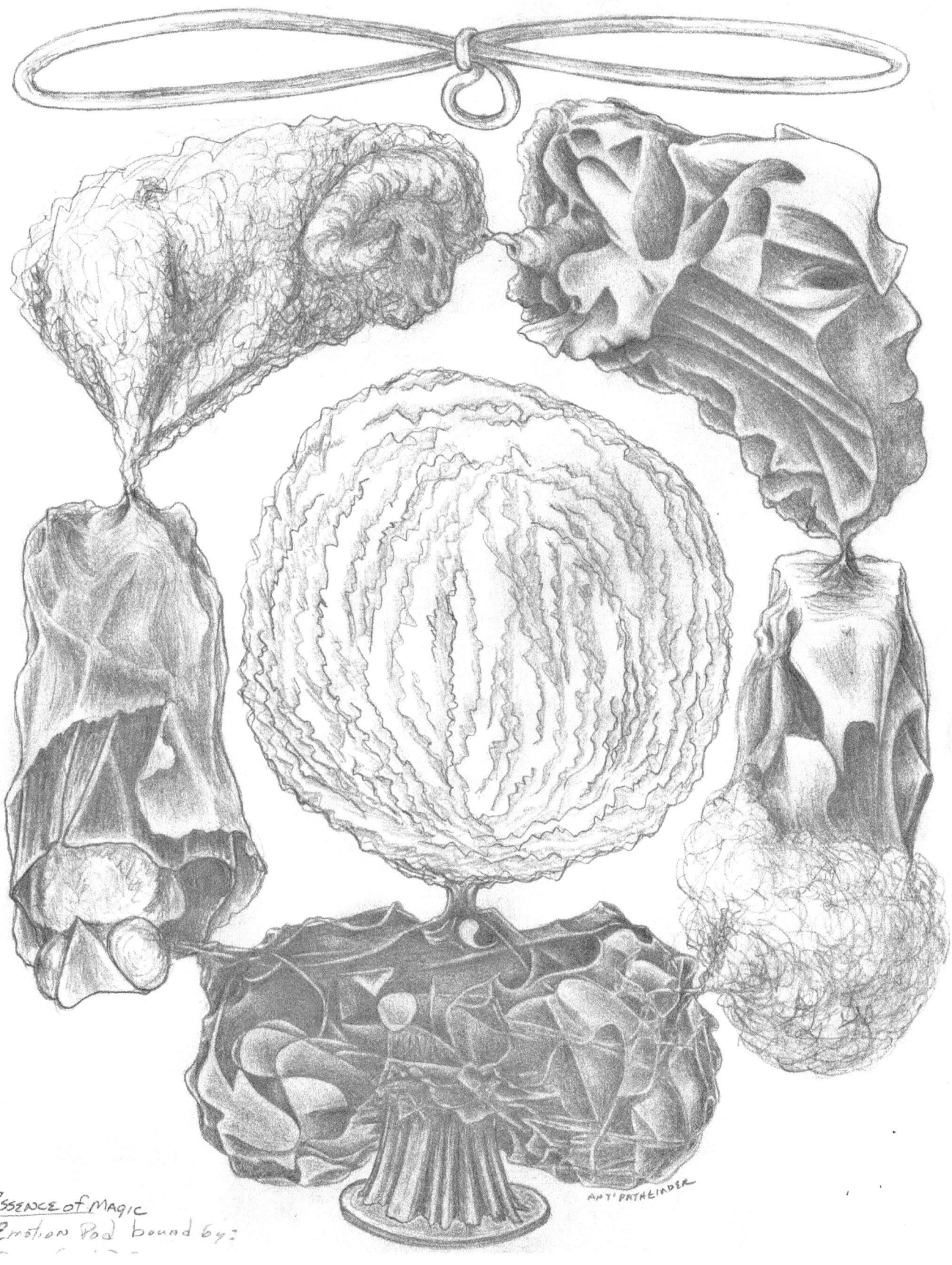

ESSENCE OF MAGIC AKA EMOTION POD

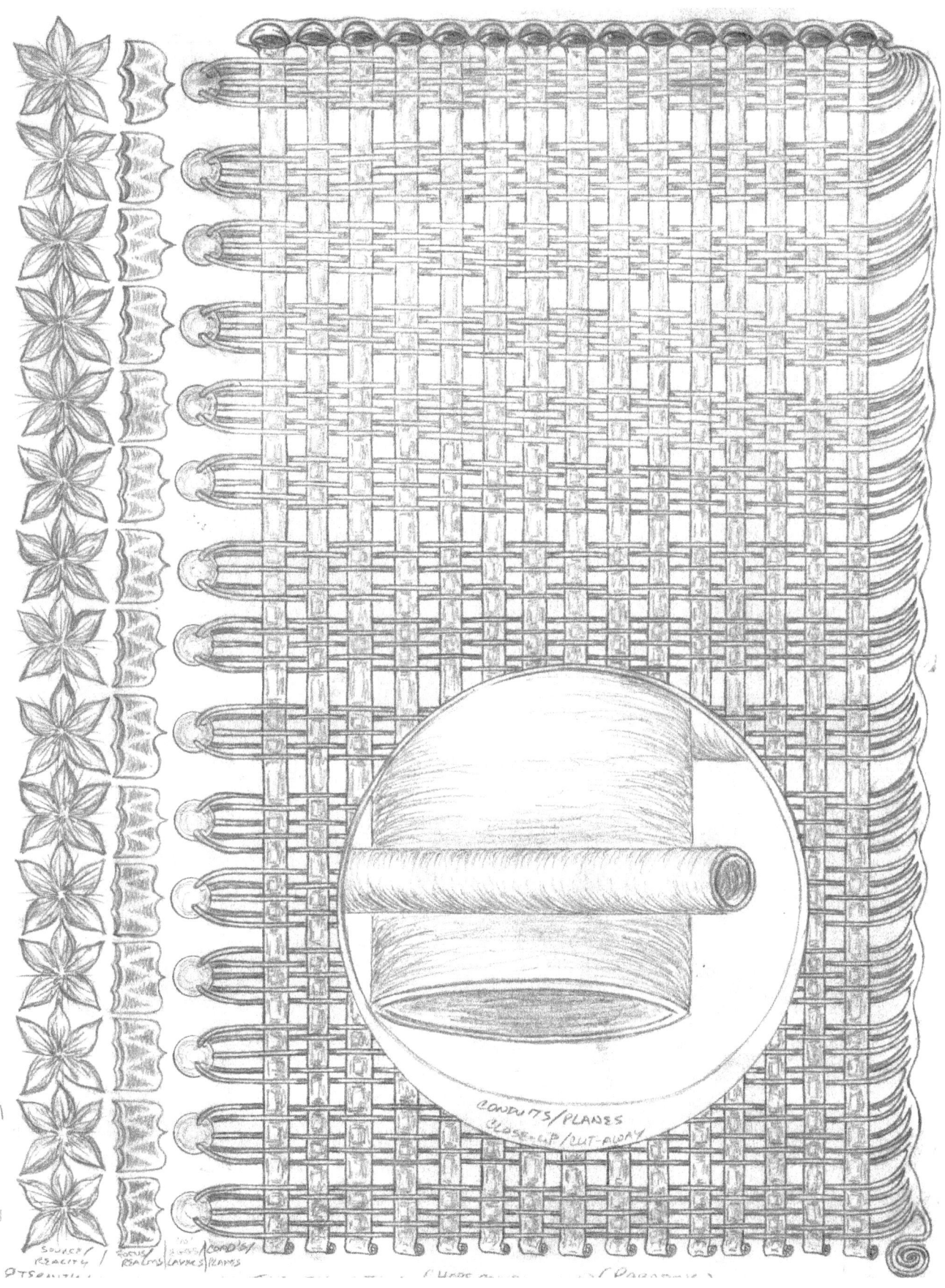

ETERNITY LOOM & TAPESTRY OF TIME

FANTASY PUZZLE

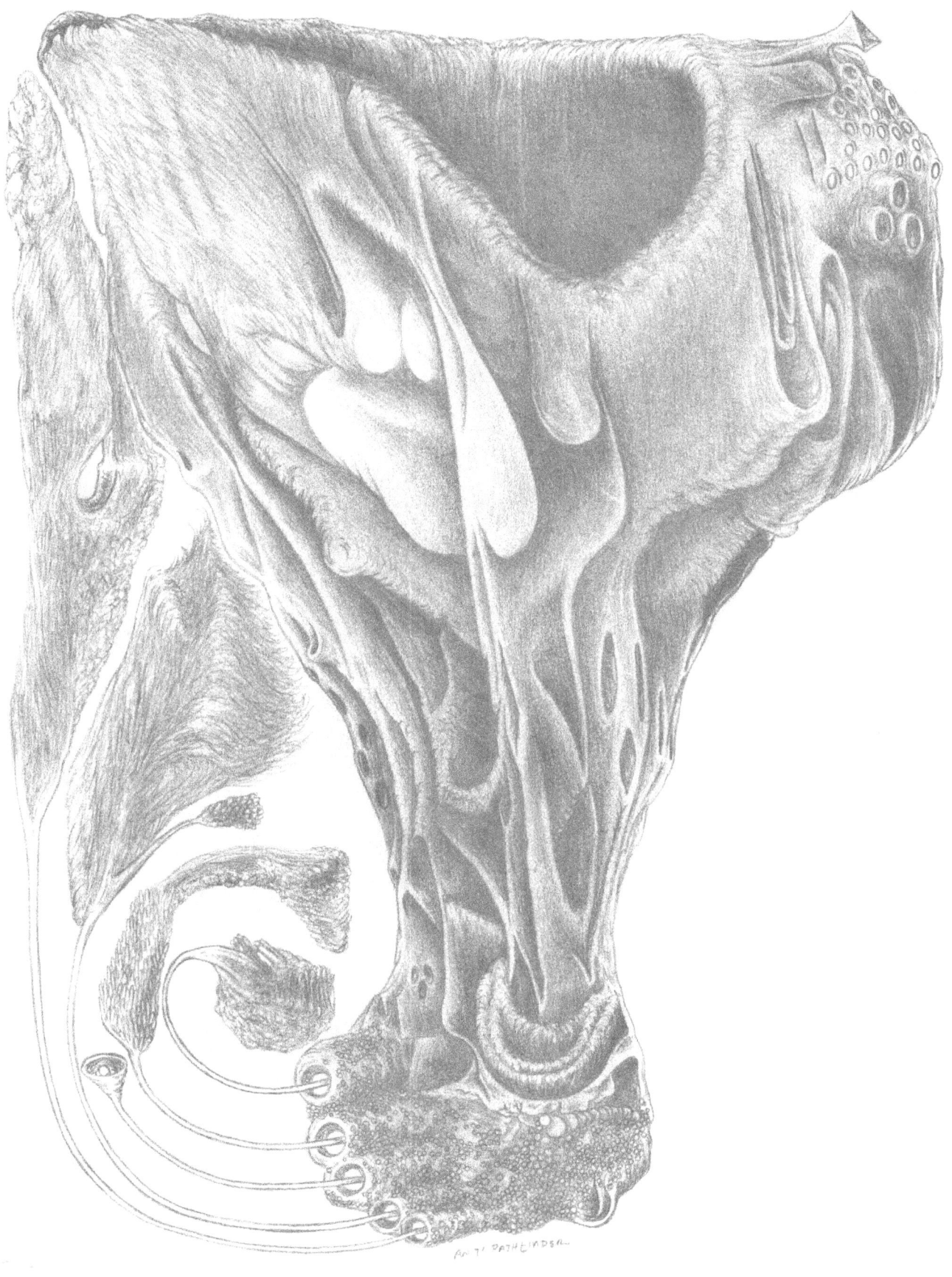

FINAL COMMAND CUP

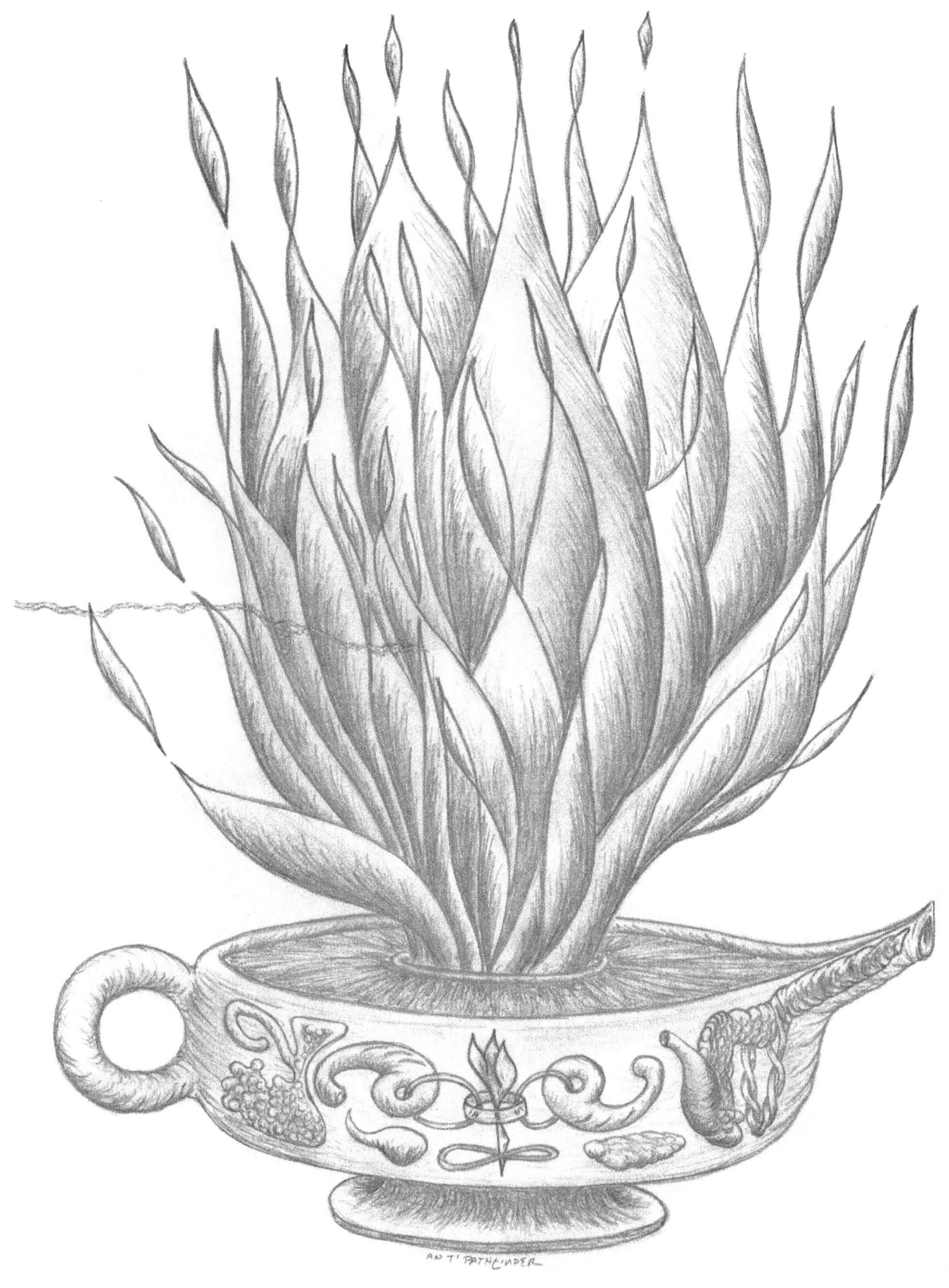

FINAL COMMAND LAMP & FLAME OF TRUTH TOUCHED BY GRACE

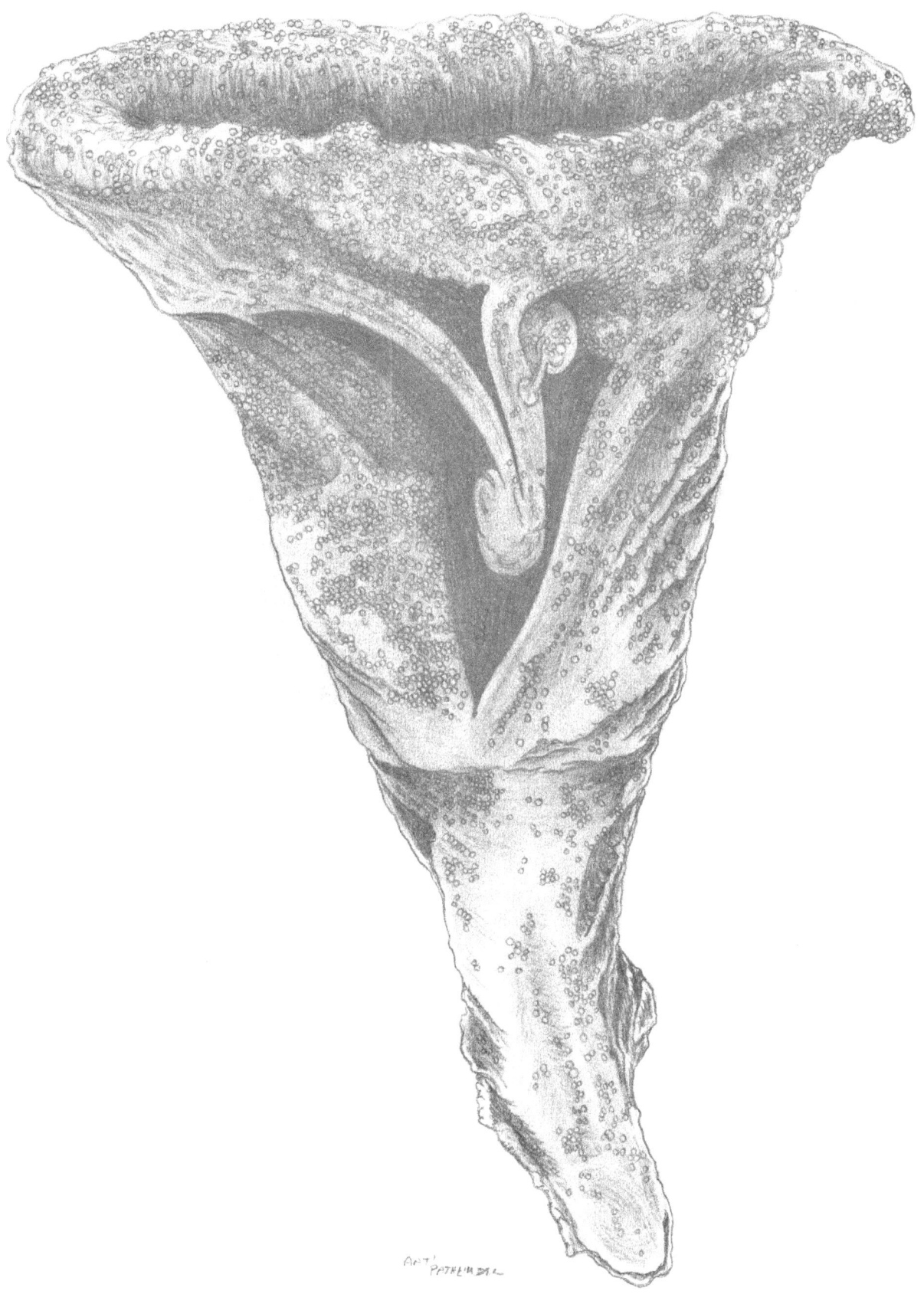

FINAL COMMAND WHISTLE

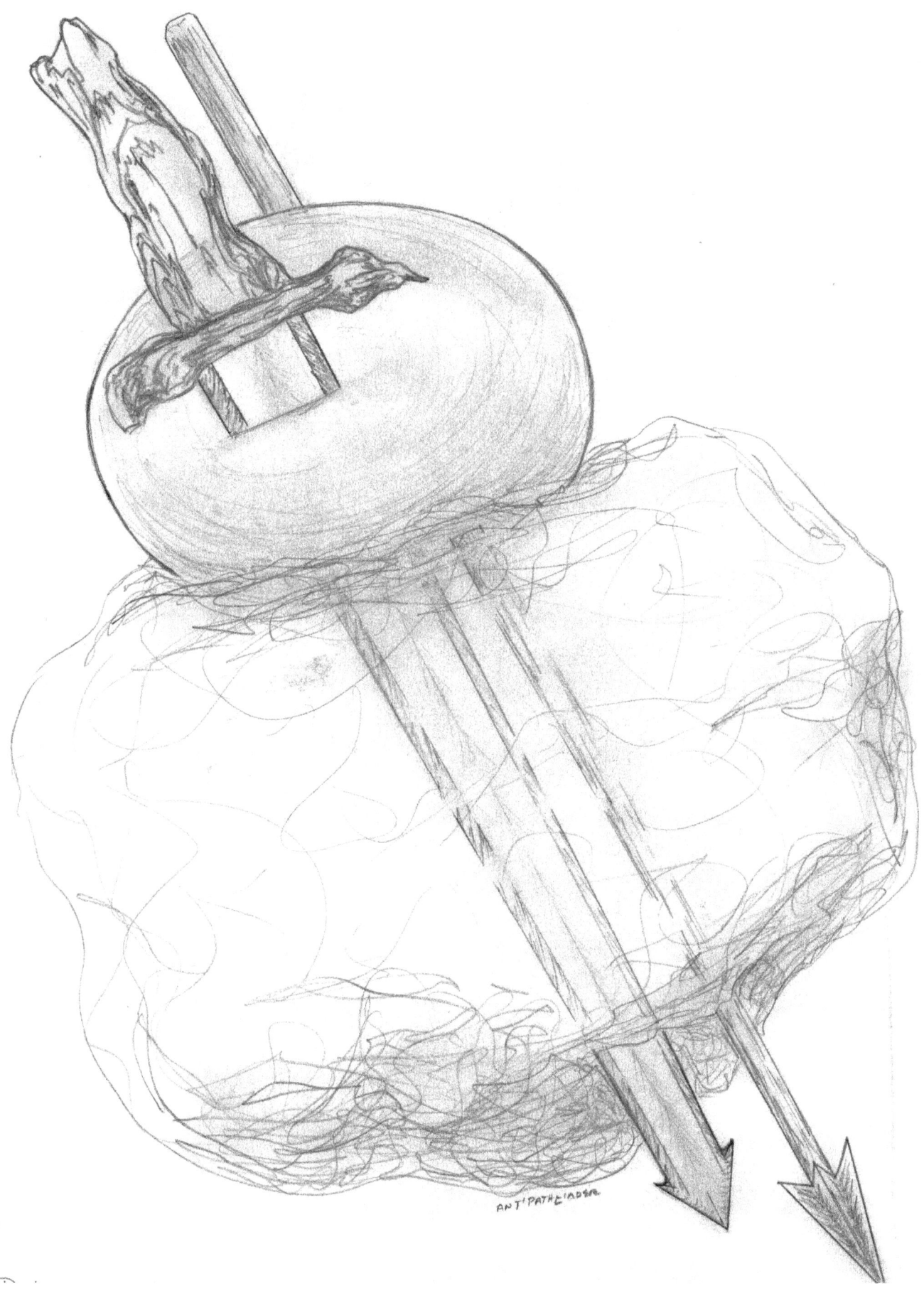

FIRST DESTINY EGG & VACUUM BUBBLE
TRANSFIXED BY SPEAR OF FORM & TRUE DESTINY SWORD

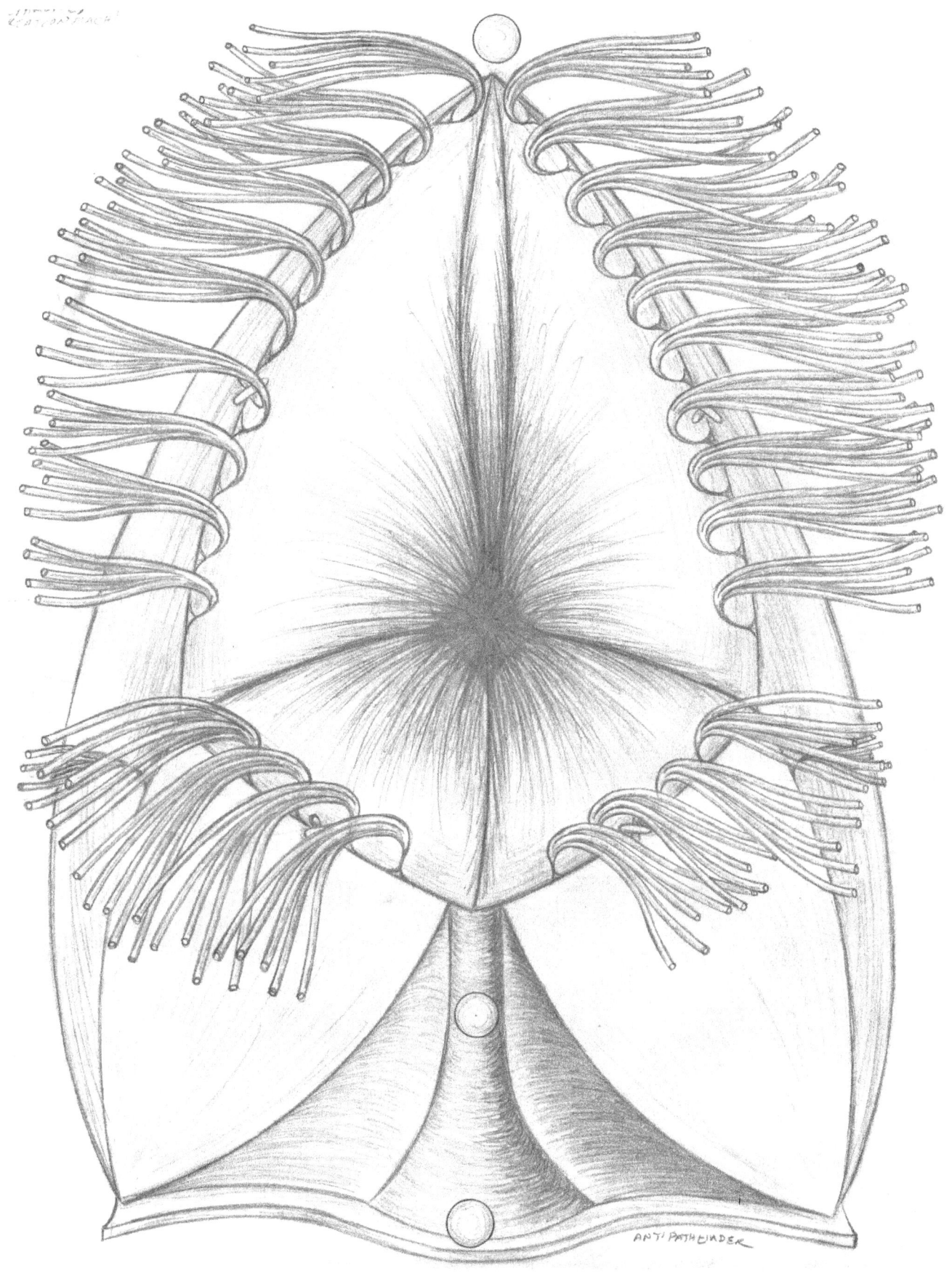

FIRST WOMB THRONE

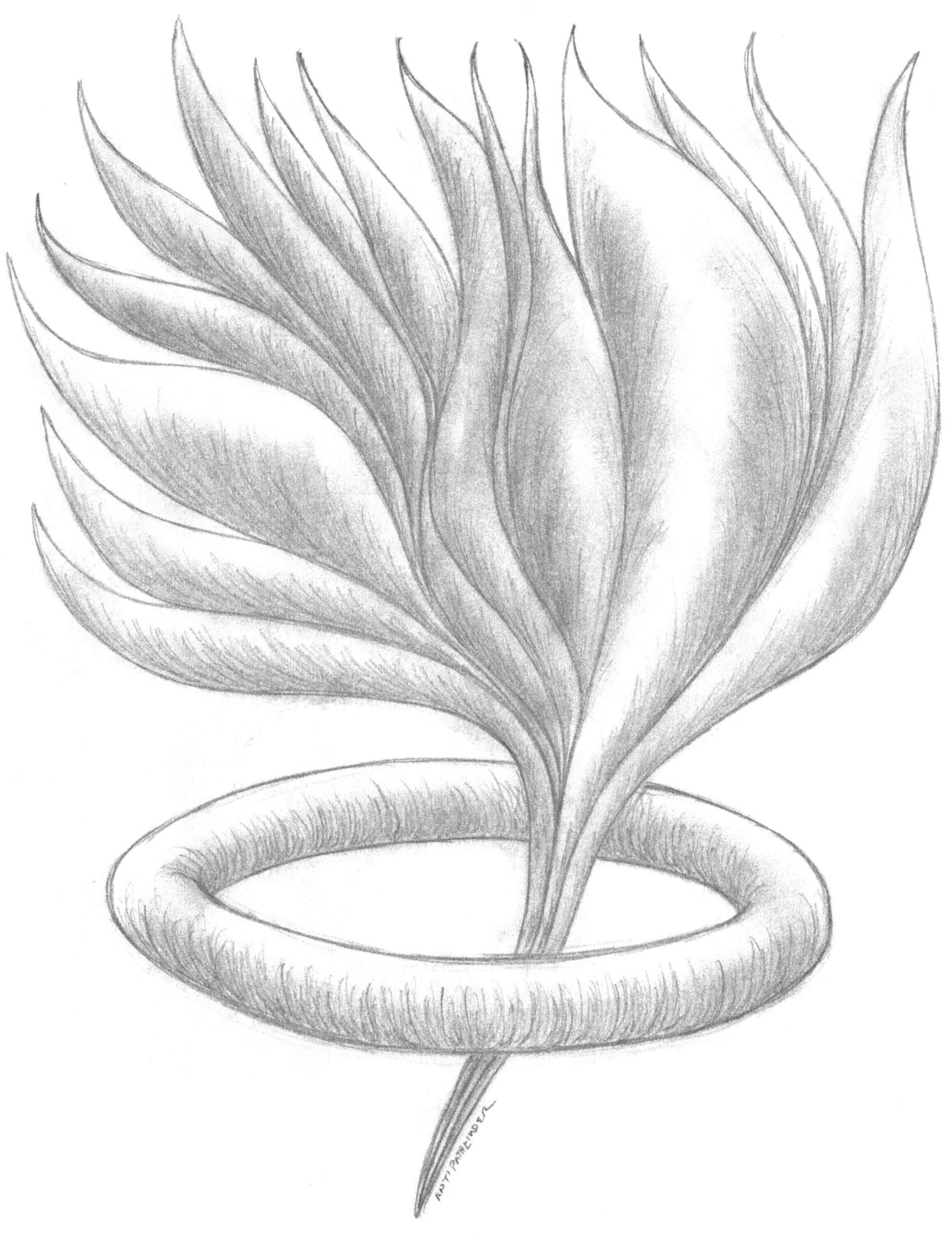

FLAME OF UNDERSTANDING

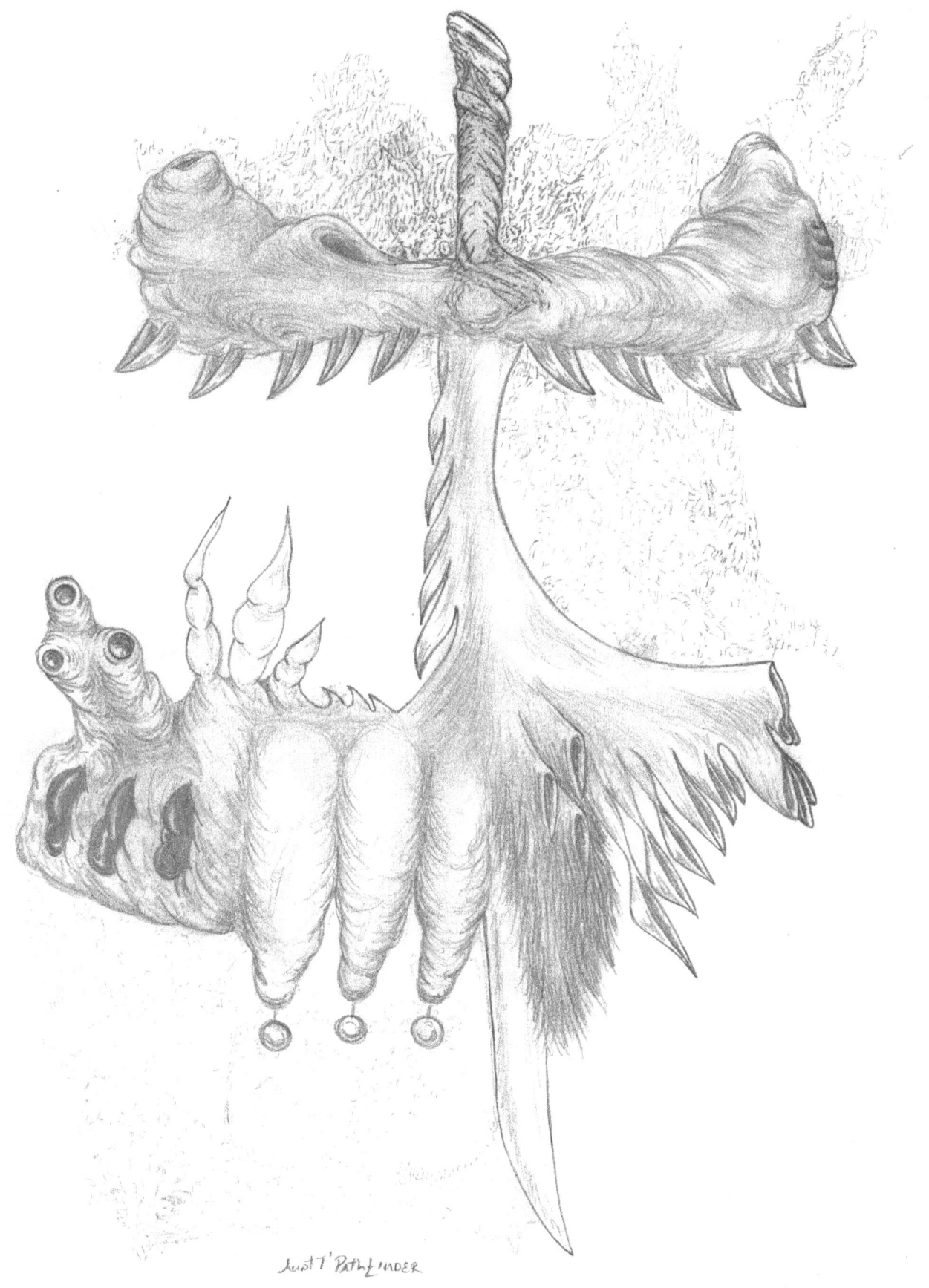

FOUNDATION CLEAVER & TRICKSTER COLONY

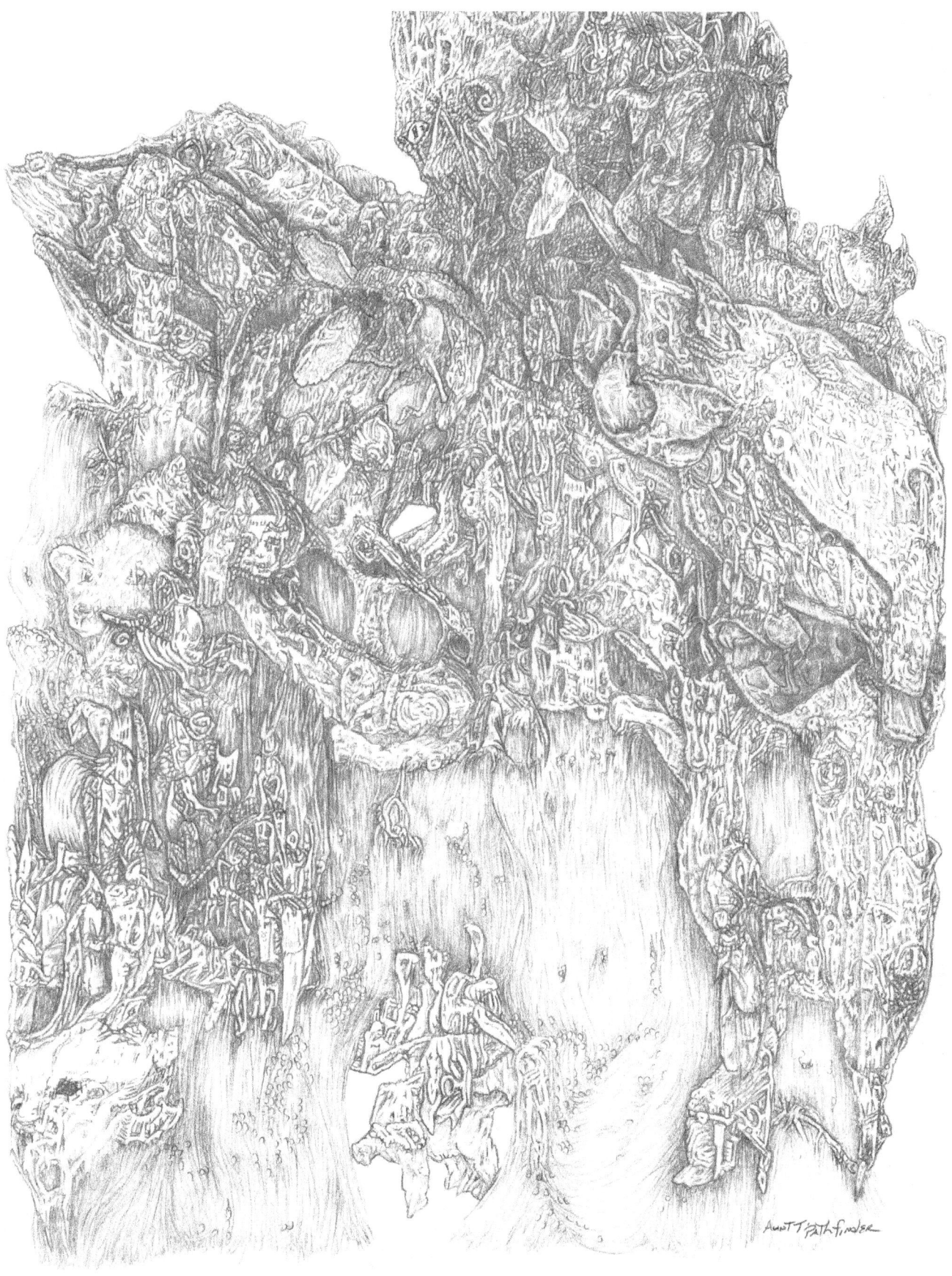

FOUNDATION STEALTH BROOM

WILD CARDS G – H – I – J – K – L

G: Great Black Shark & 'Coccus Parasite; Greater Brain & Power Crystal; Guardian Cake; Guardian Pipes aka First Power Conduit found with Staff of Law.

H: Healing Gate; Heart of Spells & Power Guard Knots; Heritage Egg; Hero Mountain aka Mount Batmoore; Hope's Flower aka Seed of Hope.

I: Implosion Jar & True Destiny Egg; Inner Guardian & Children's Conduit; Inner Womb; Intruder Pick; Isatone Veins; Ivory Tower aka Crystal Womb found with Control Room.

J: J'hair Camouflage.

K: Karmic Form; Karmic Path; Karmic Sensor; Karmic Spell; Karmic Spindle.

L: Leadership Bowl; Life Armor aka Material Womb turned Inside Out; Life Dagger; Living Crown found in Control Room; Love Creation Machine; Lovers Harp.

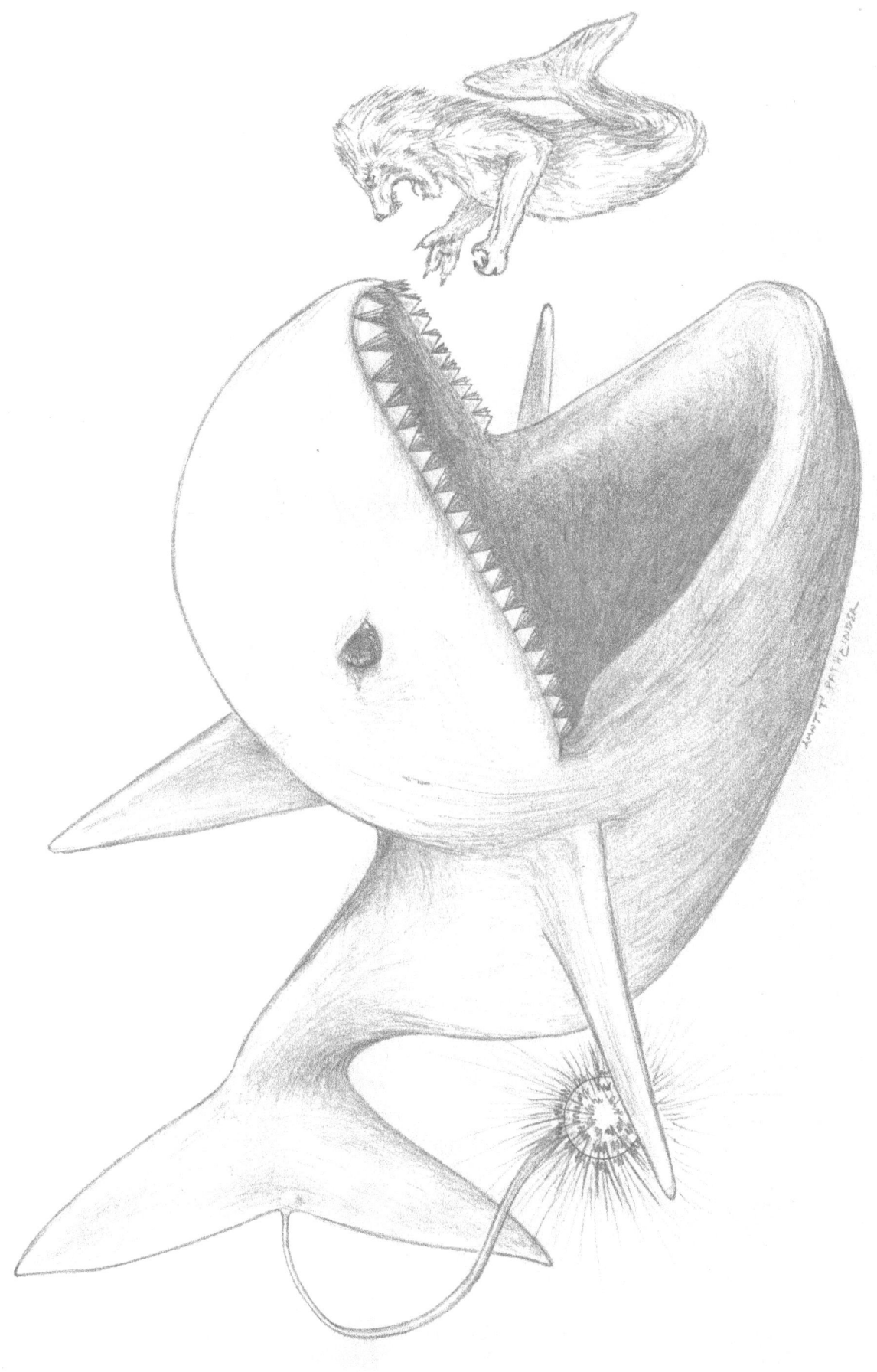

GREAT BLACK SHARK & 'COCCUS PARASITE

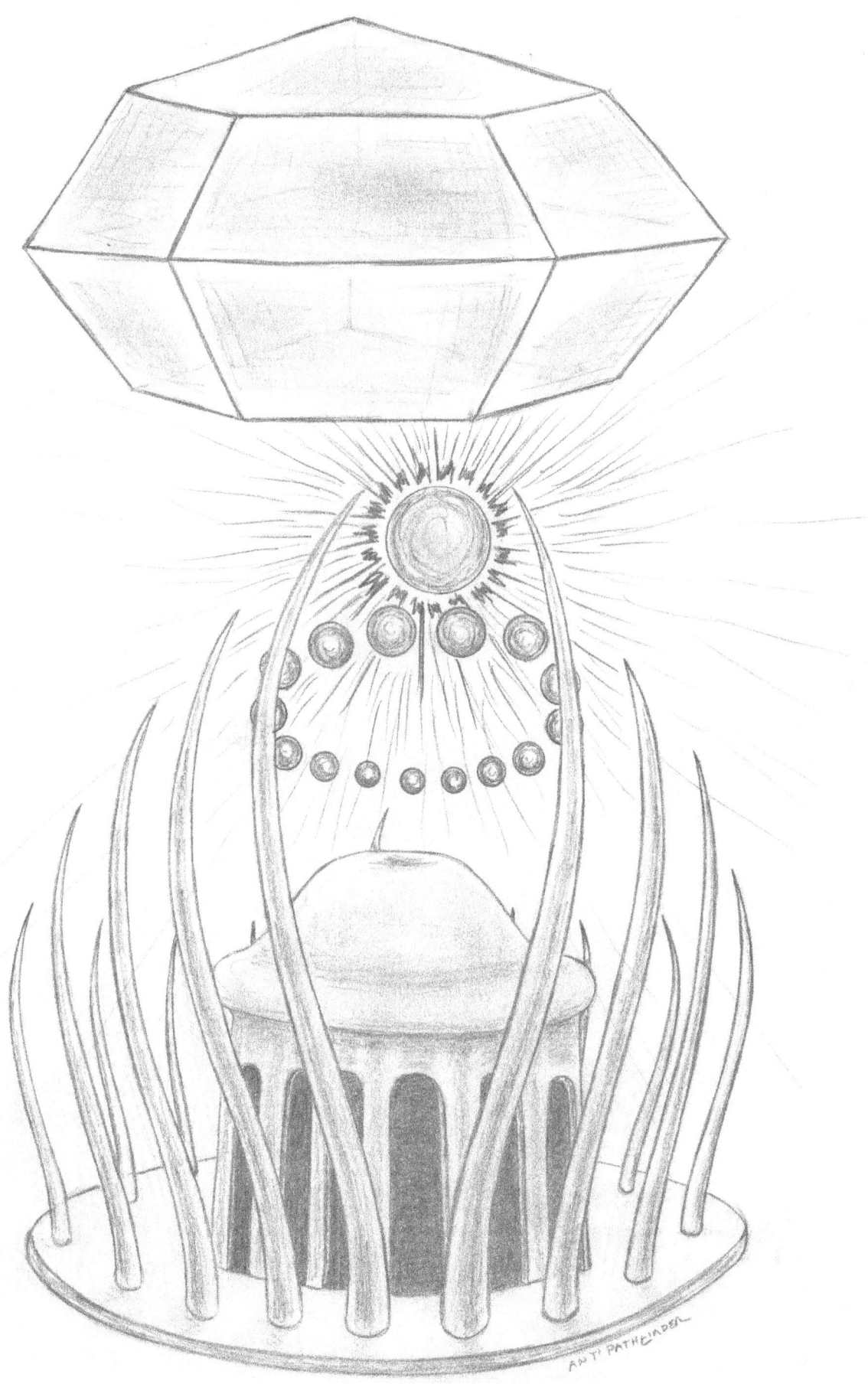

GREATER BRAIN & POWER CRYSTAL

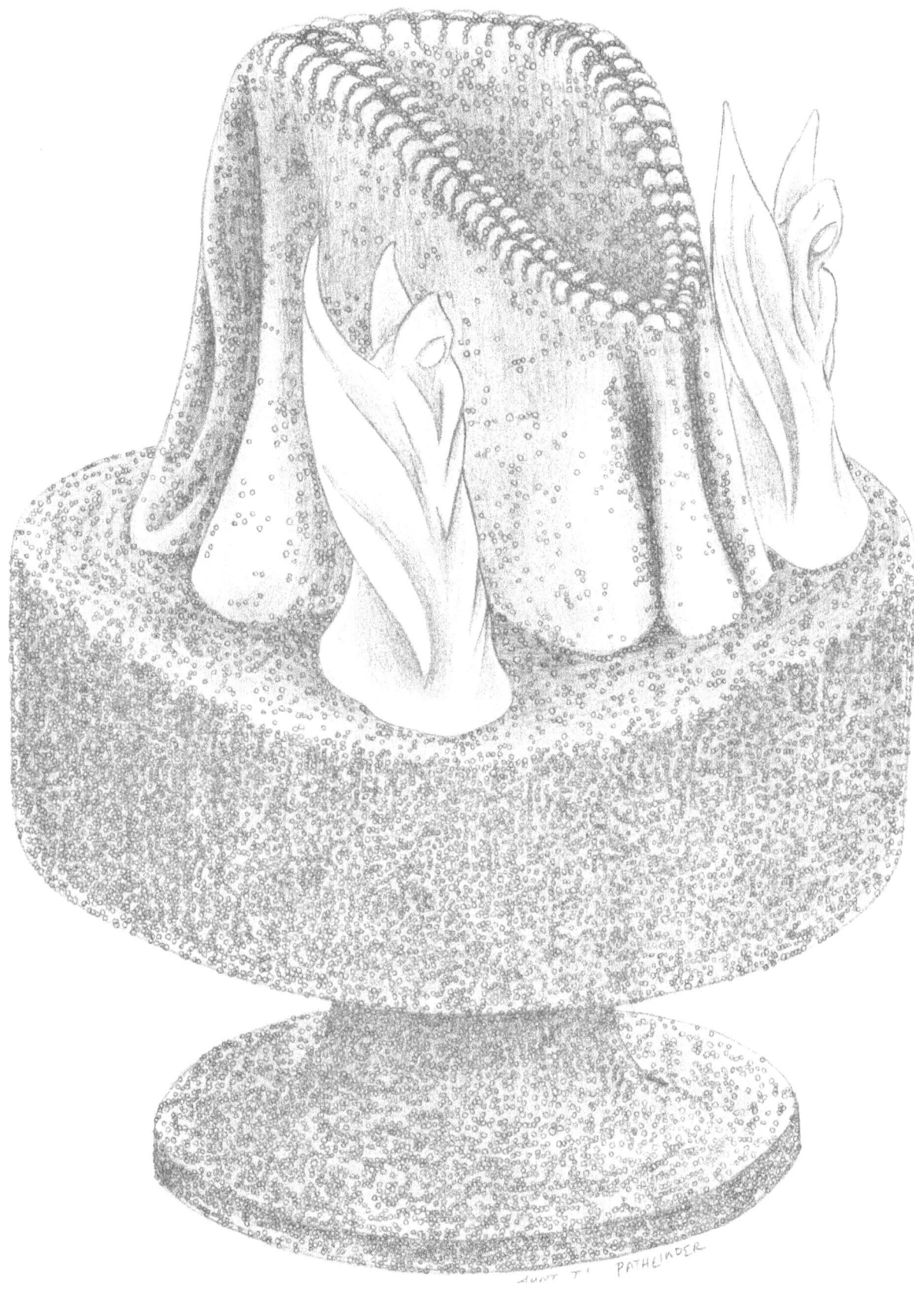

GUARDIAN CAKE

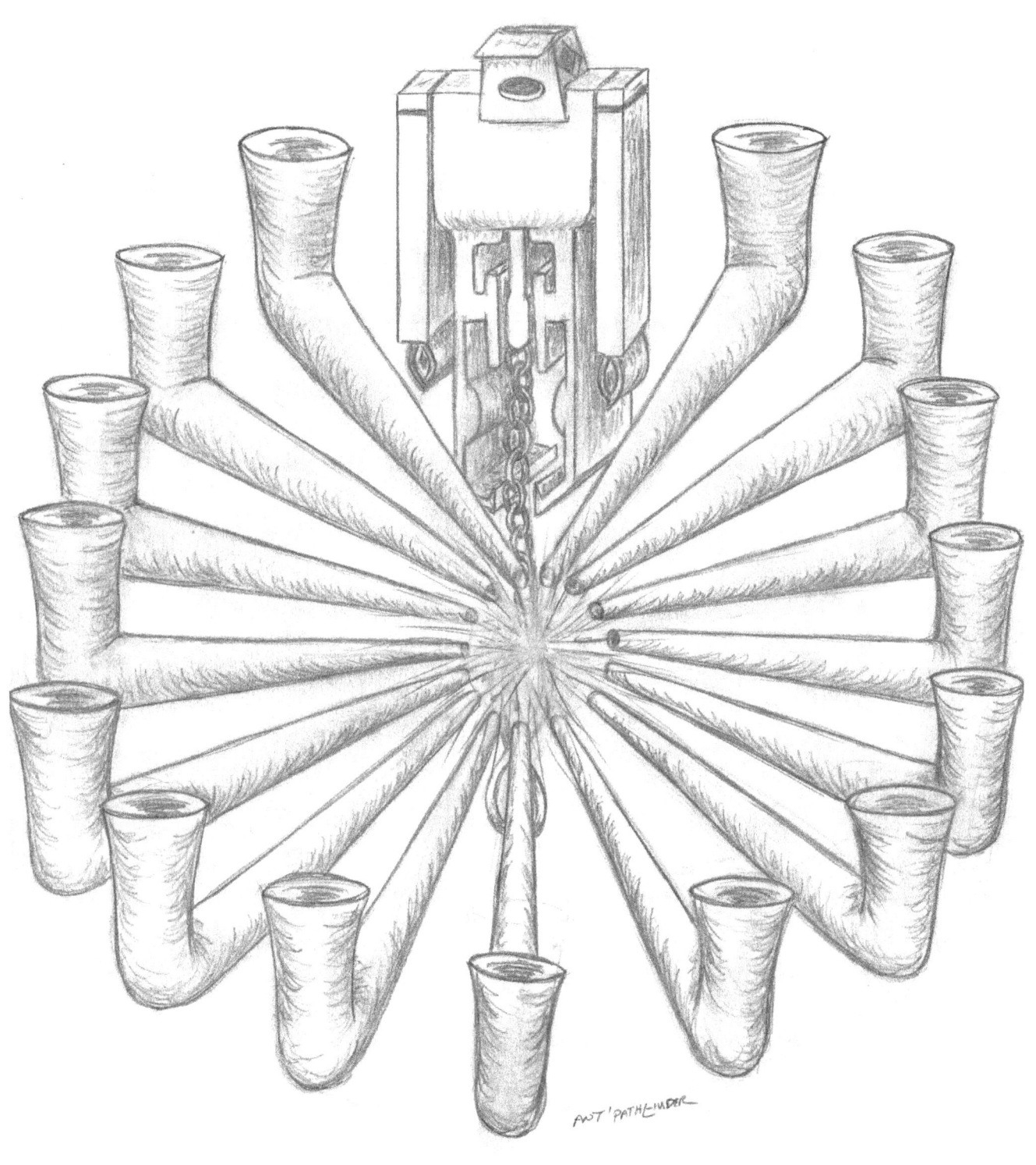

GUARDIAN PIPES AKA FIRST POWER CONDUIT FOUND WITH STAFF OF LAW

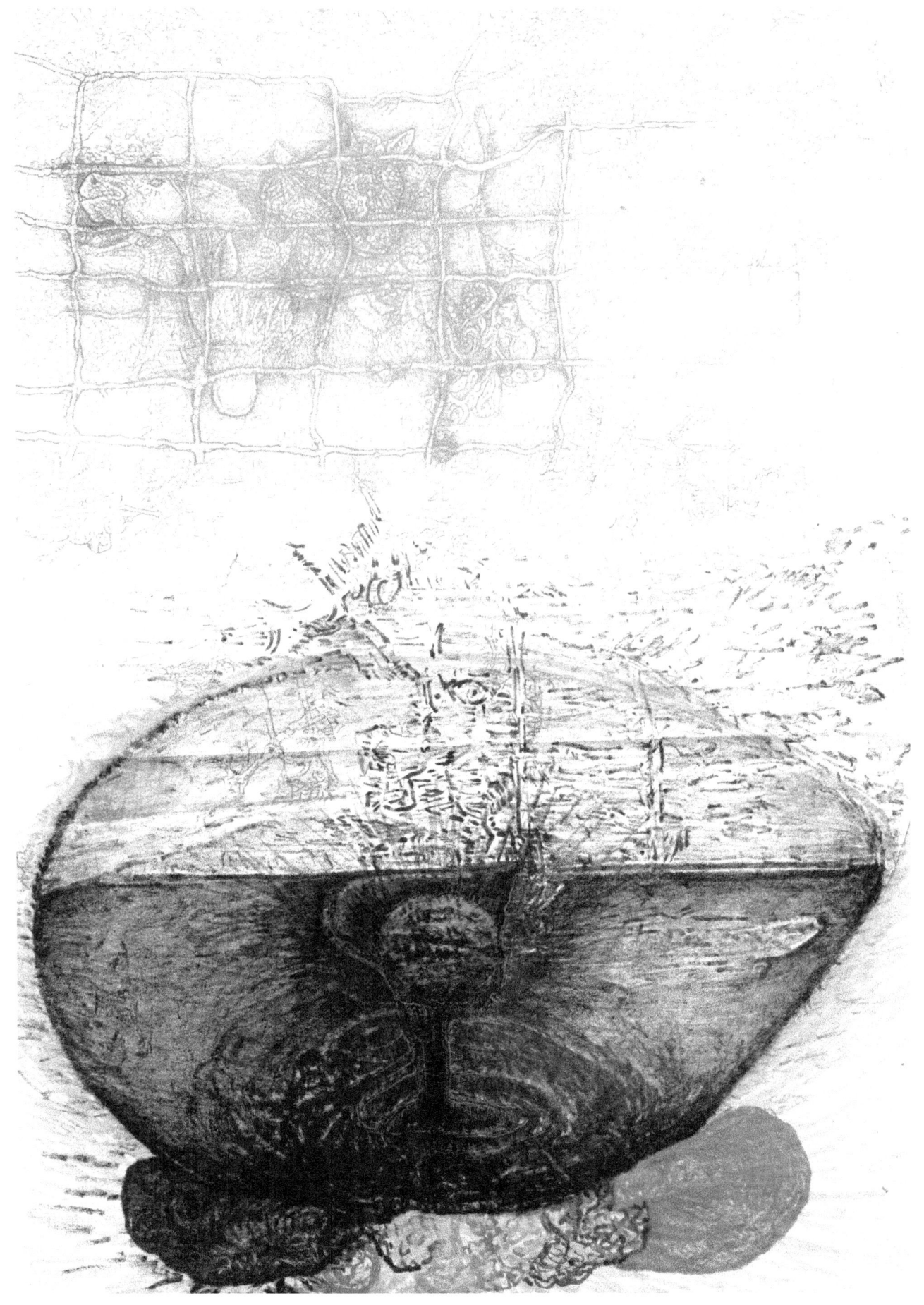

HEALING GATE
(ONLY COLORED ONE)

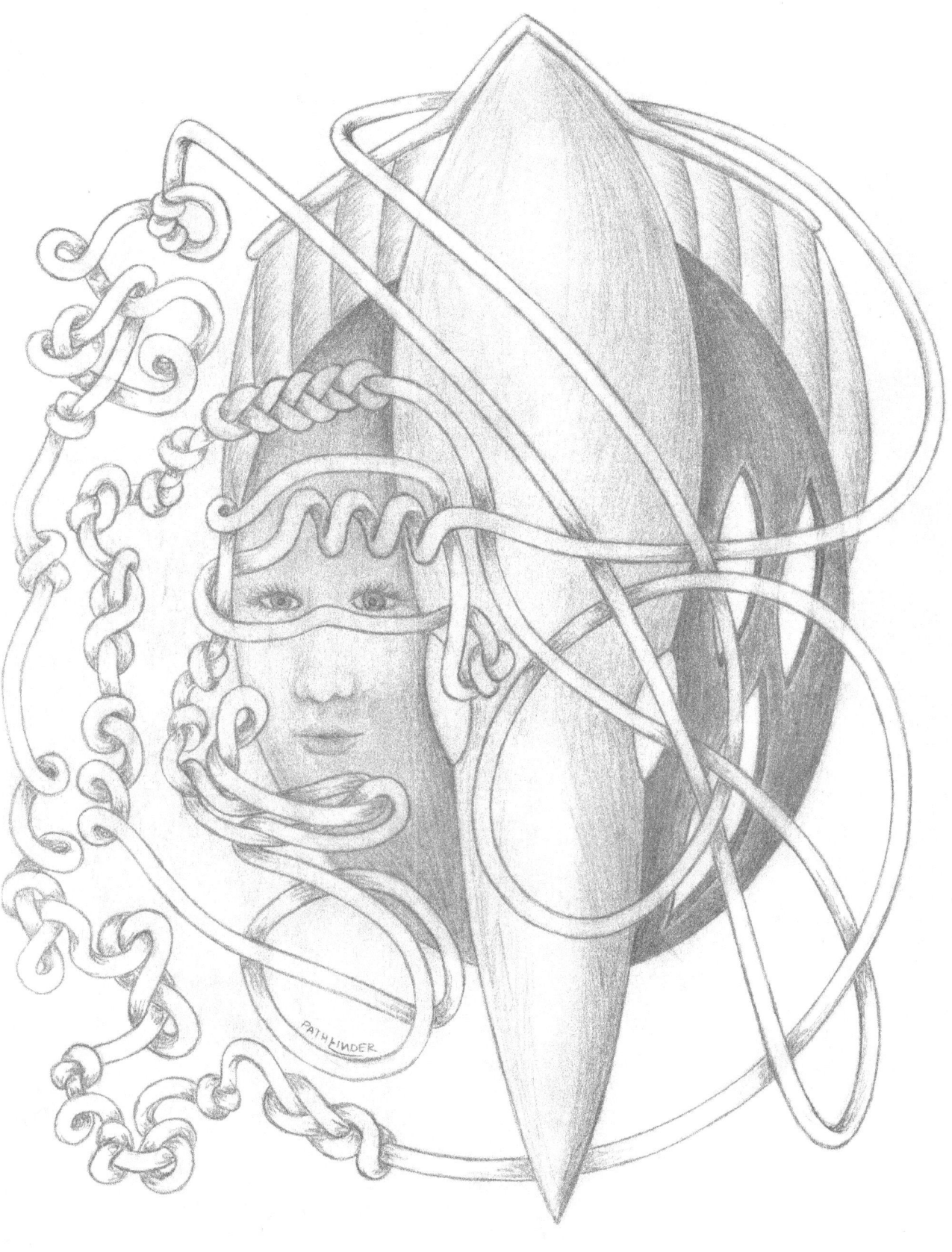

HEART OF SPELLS & POWER GUARD KNOTS

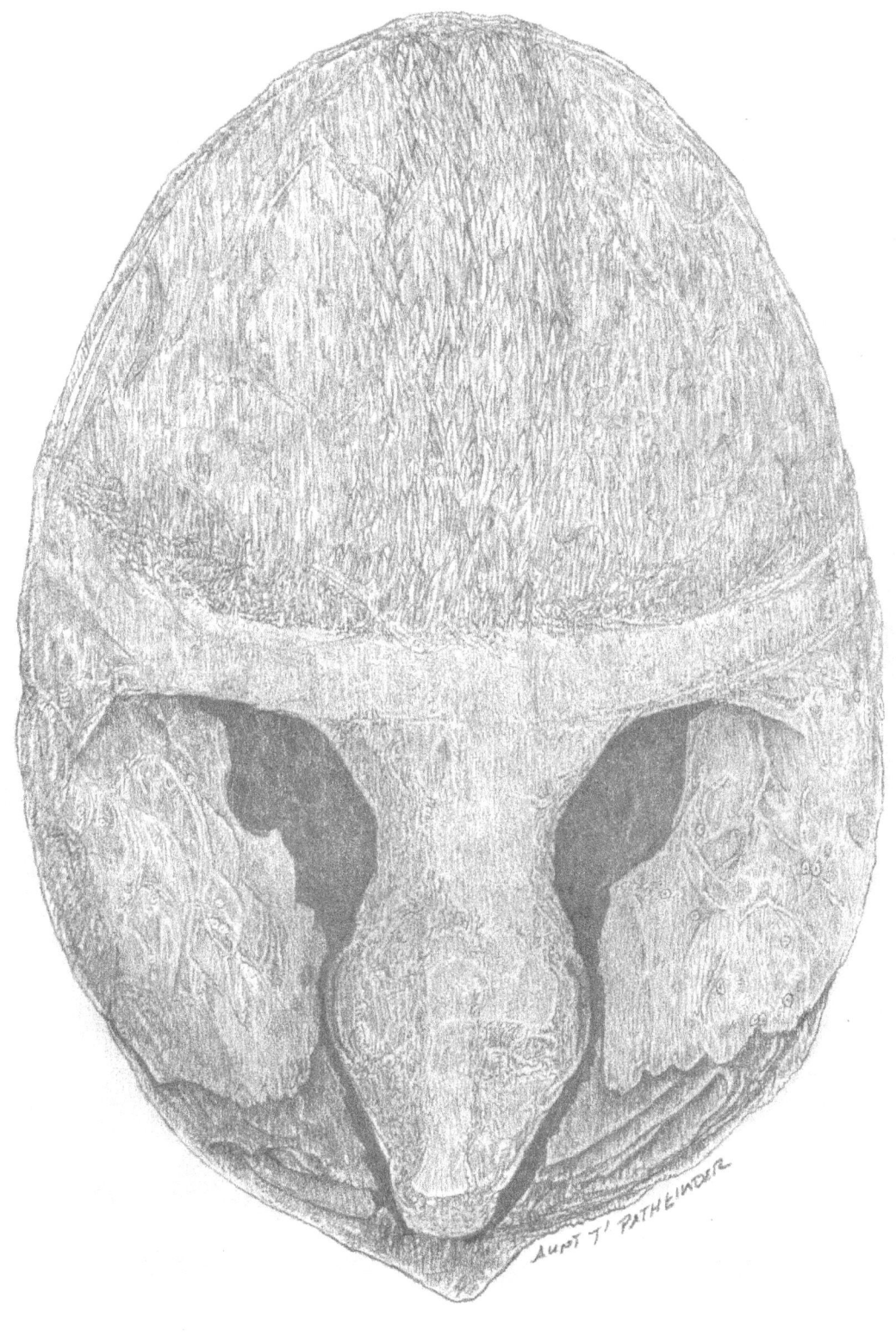

HERITAGE EGG

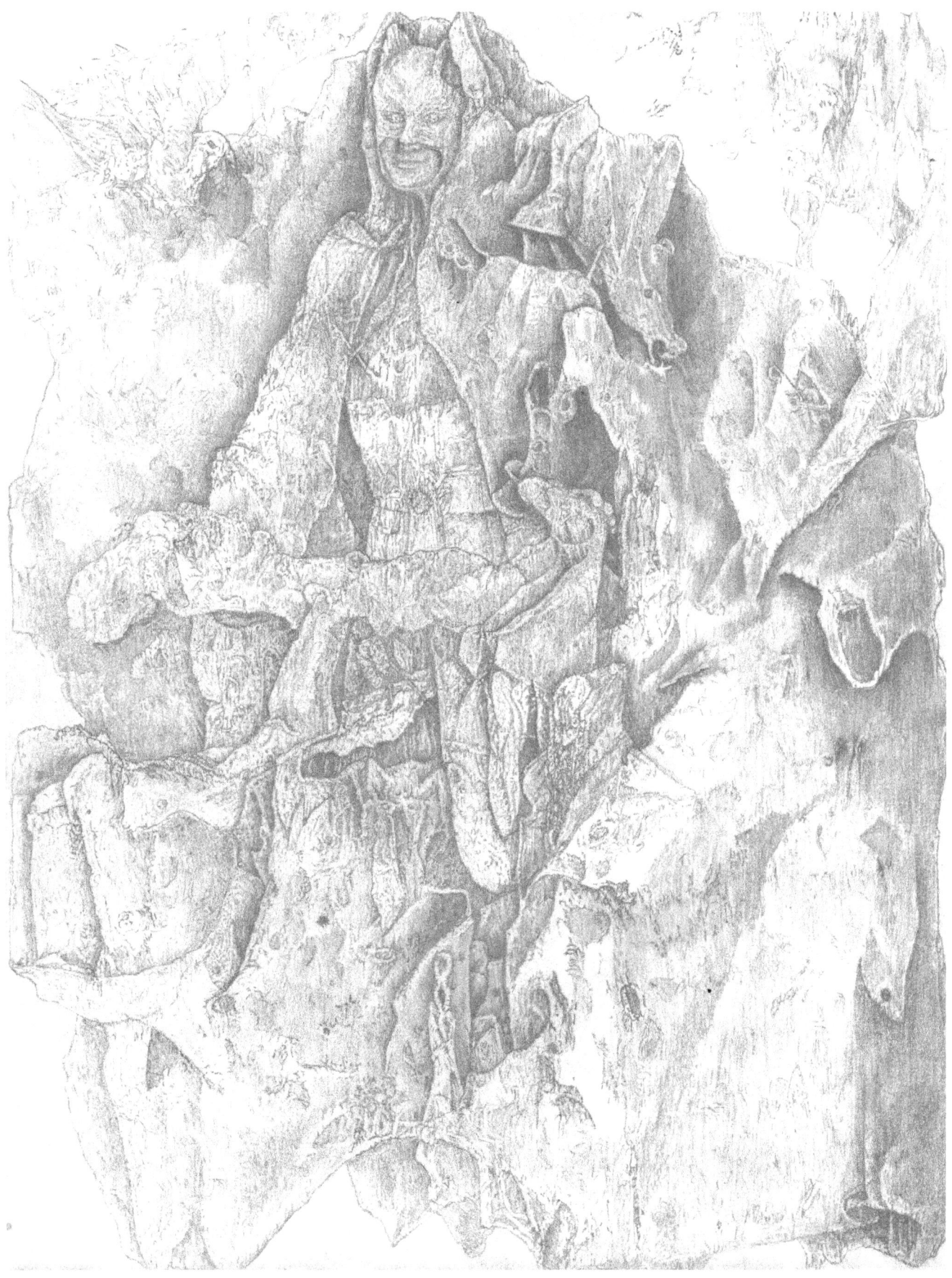

HERO MOUNTAIN AKA MOUNT BATMOORE

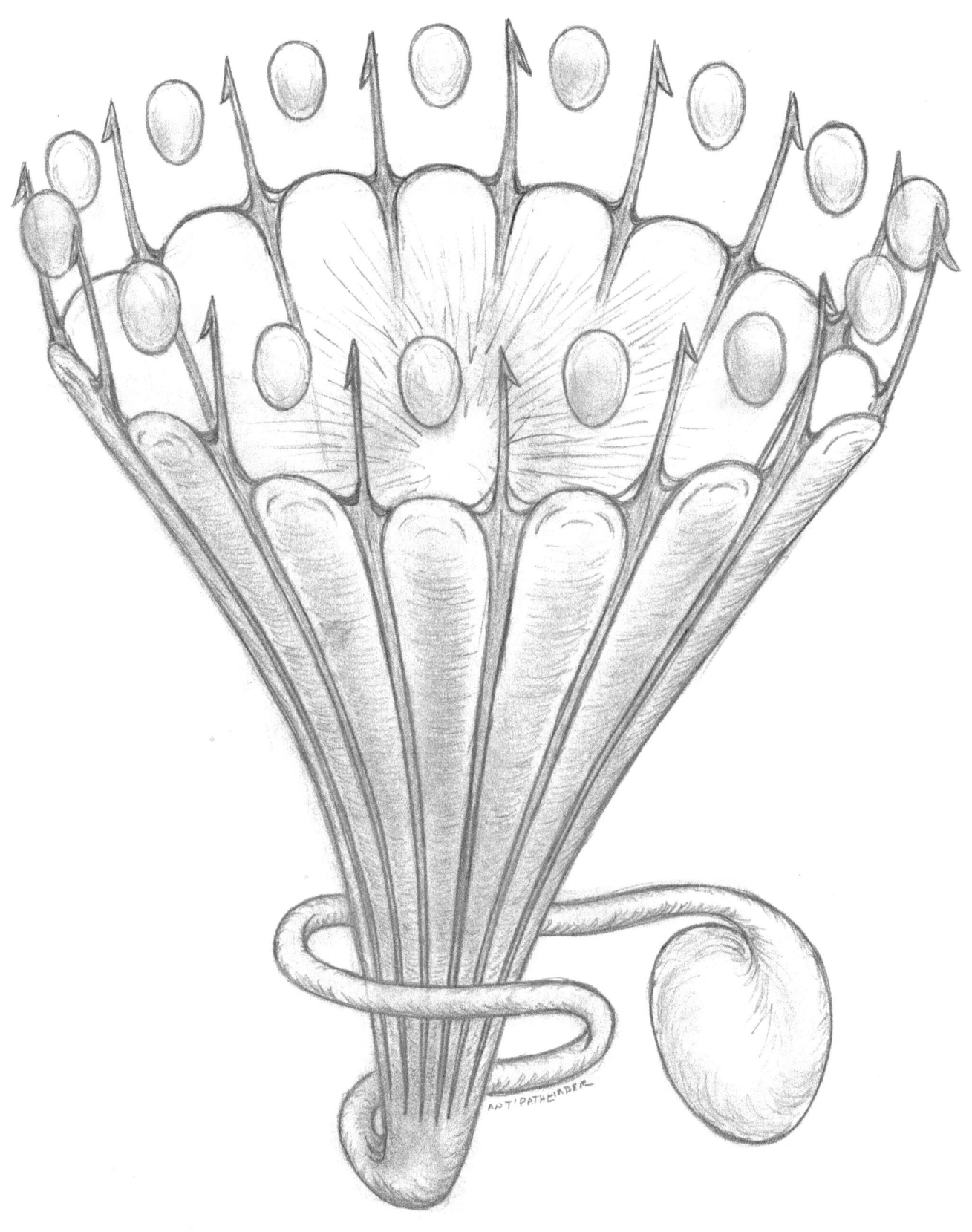

HOPE'S FLOWER AKA SEED OF HOPE

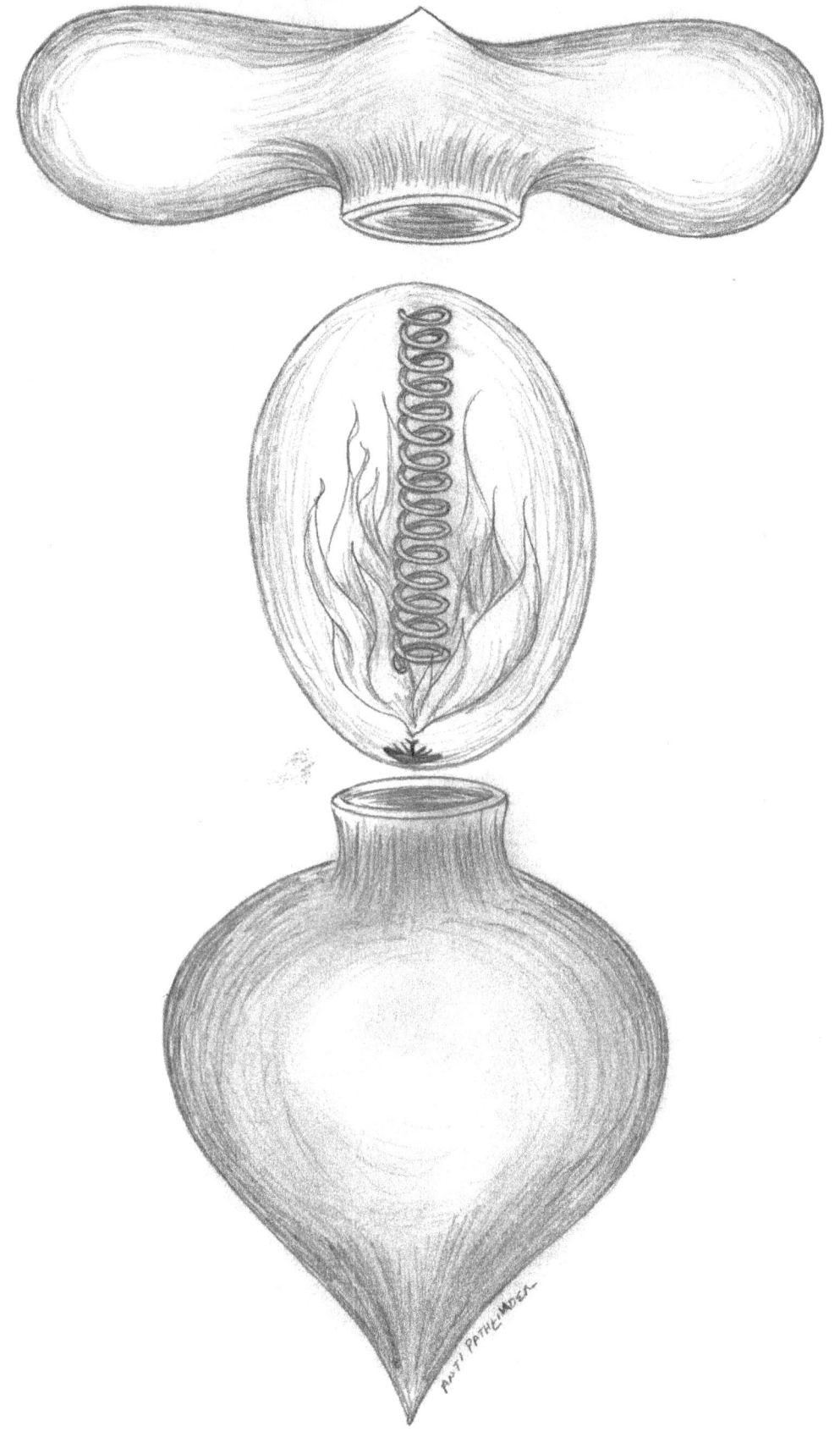

IMPLOSION JAR & TRUE DESTINY EGG

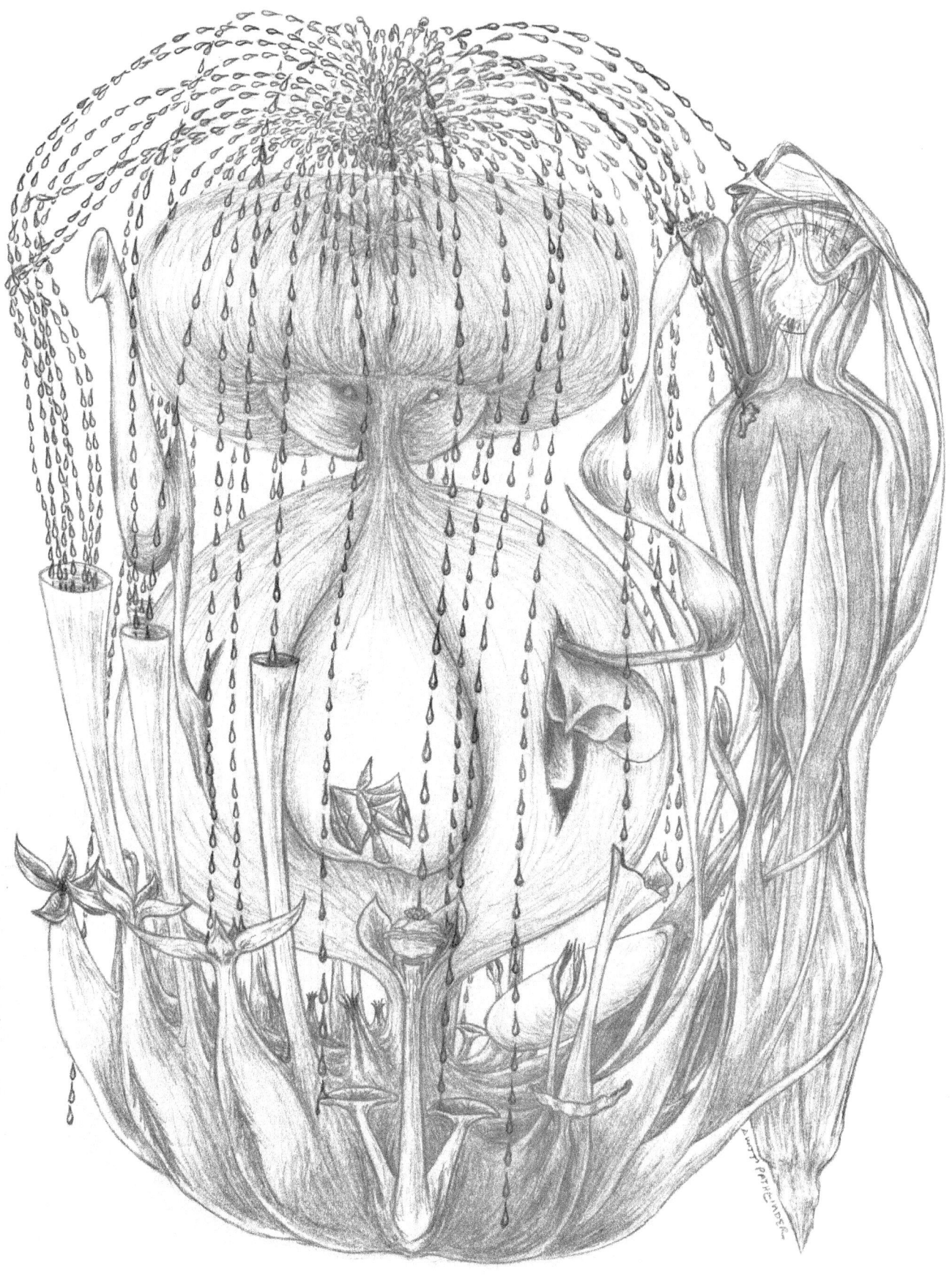

INNER GUARDIAN & CHILDREN'S CONDUIT

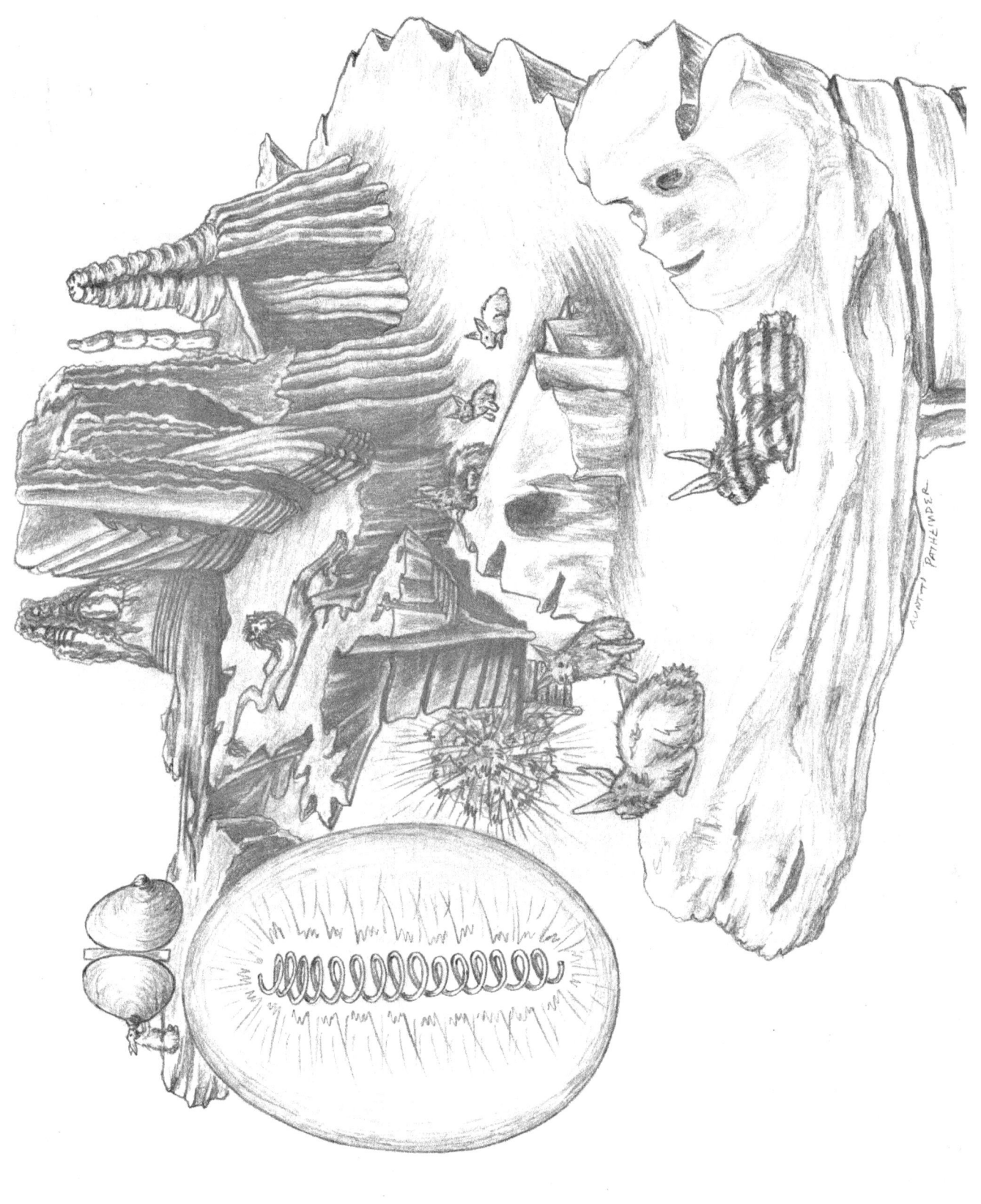

INNER WOMB

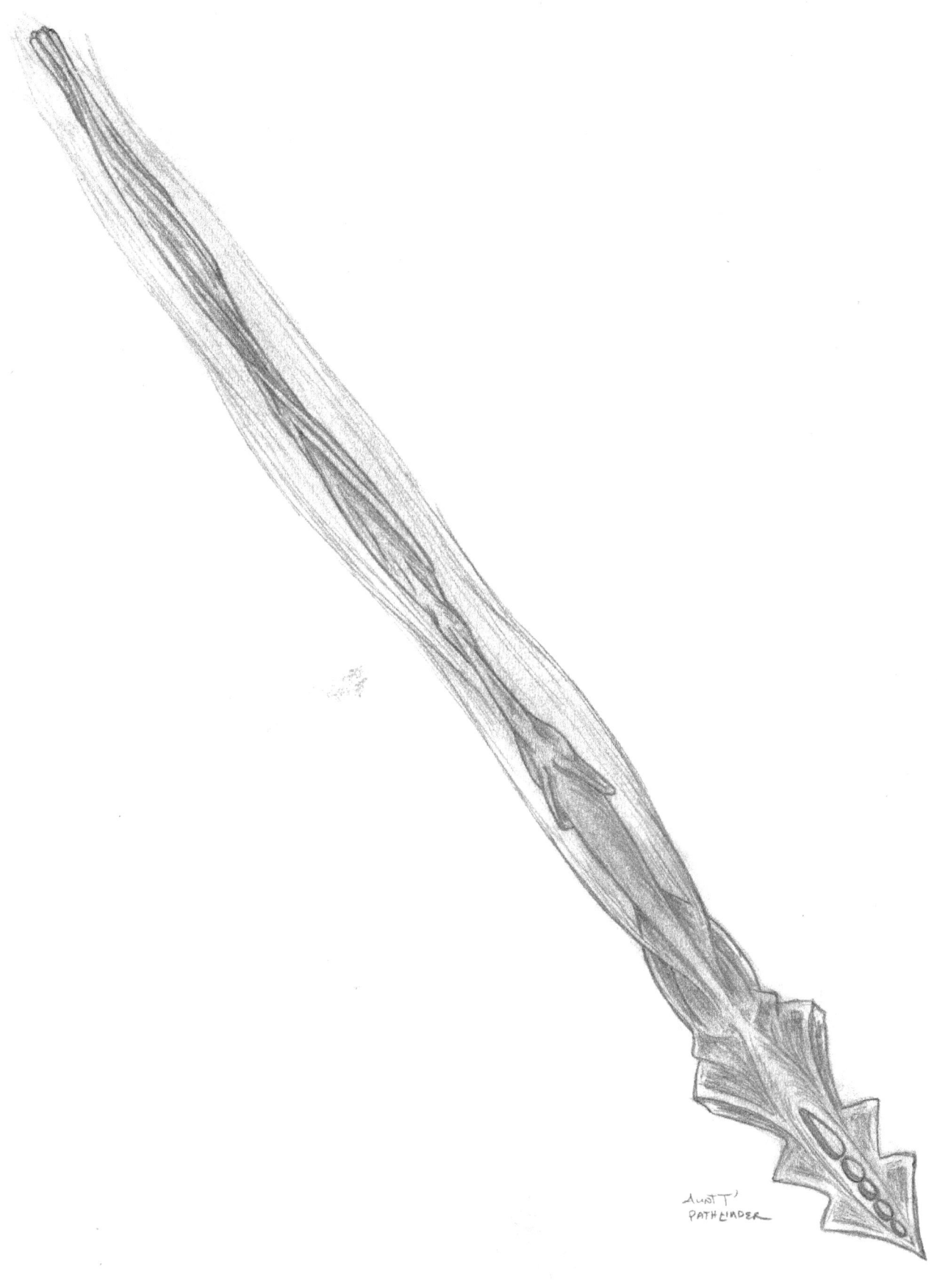

INTRUDER PICK

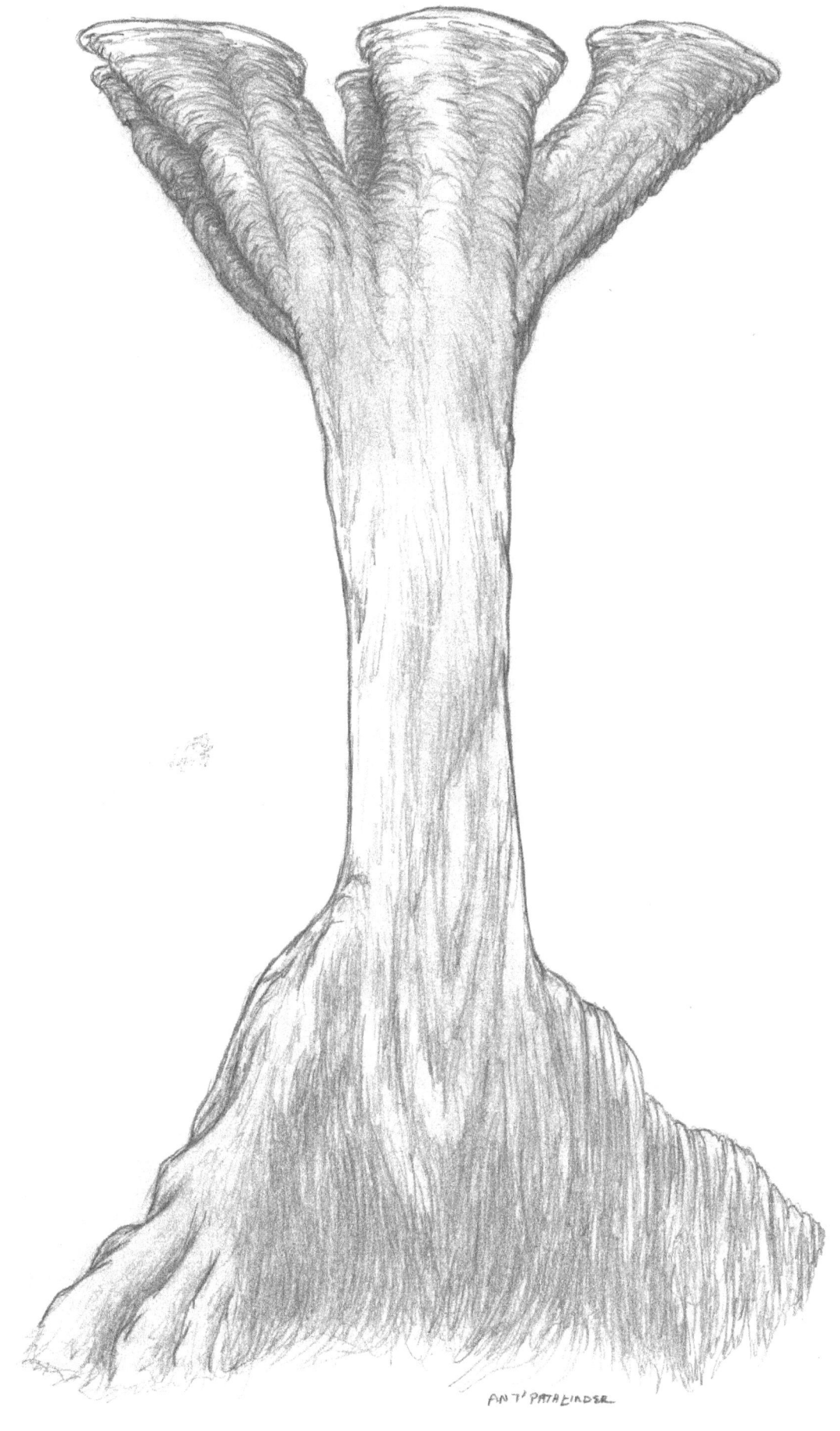

ISATONE VEINS
(CORRECT SPELLING)

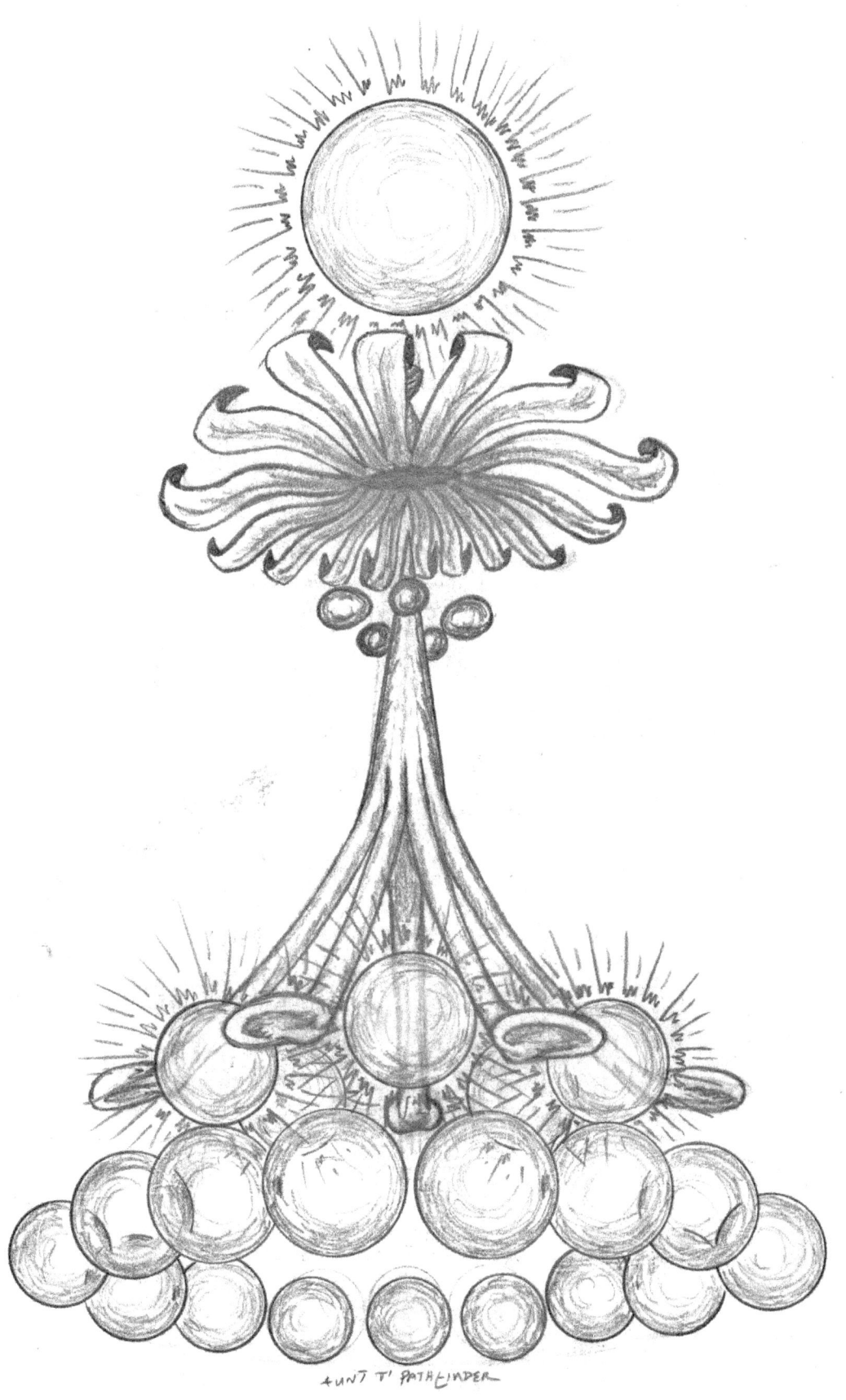

IVORY TOWER AKA CRYSTAL WOMB

FOUND WITH CONTROL ROOM

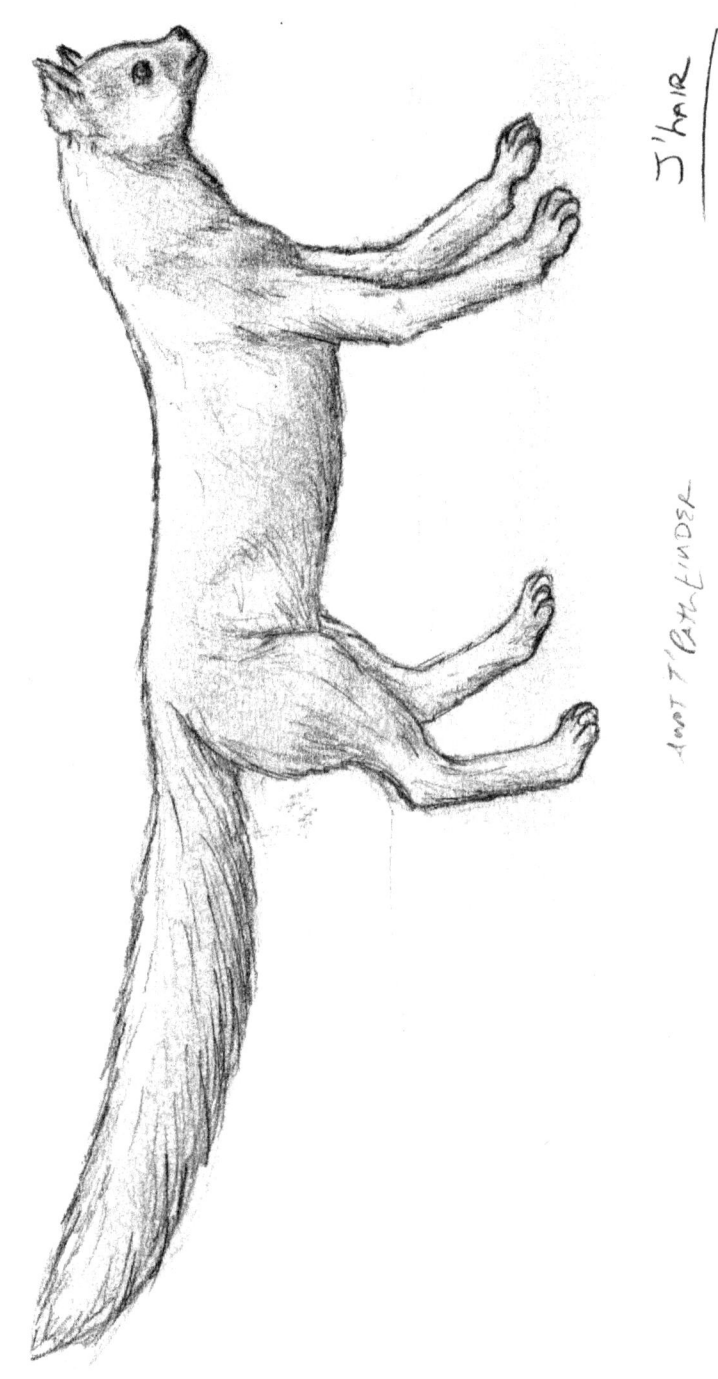

J'HAIR CAMOUFLAGE
← BOTTOM

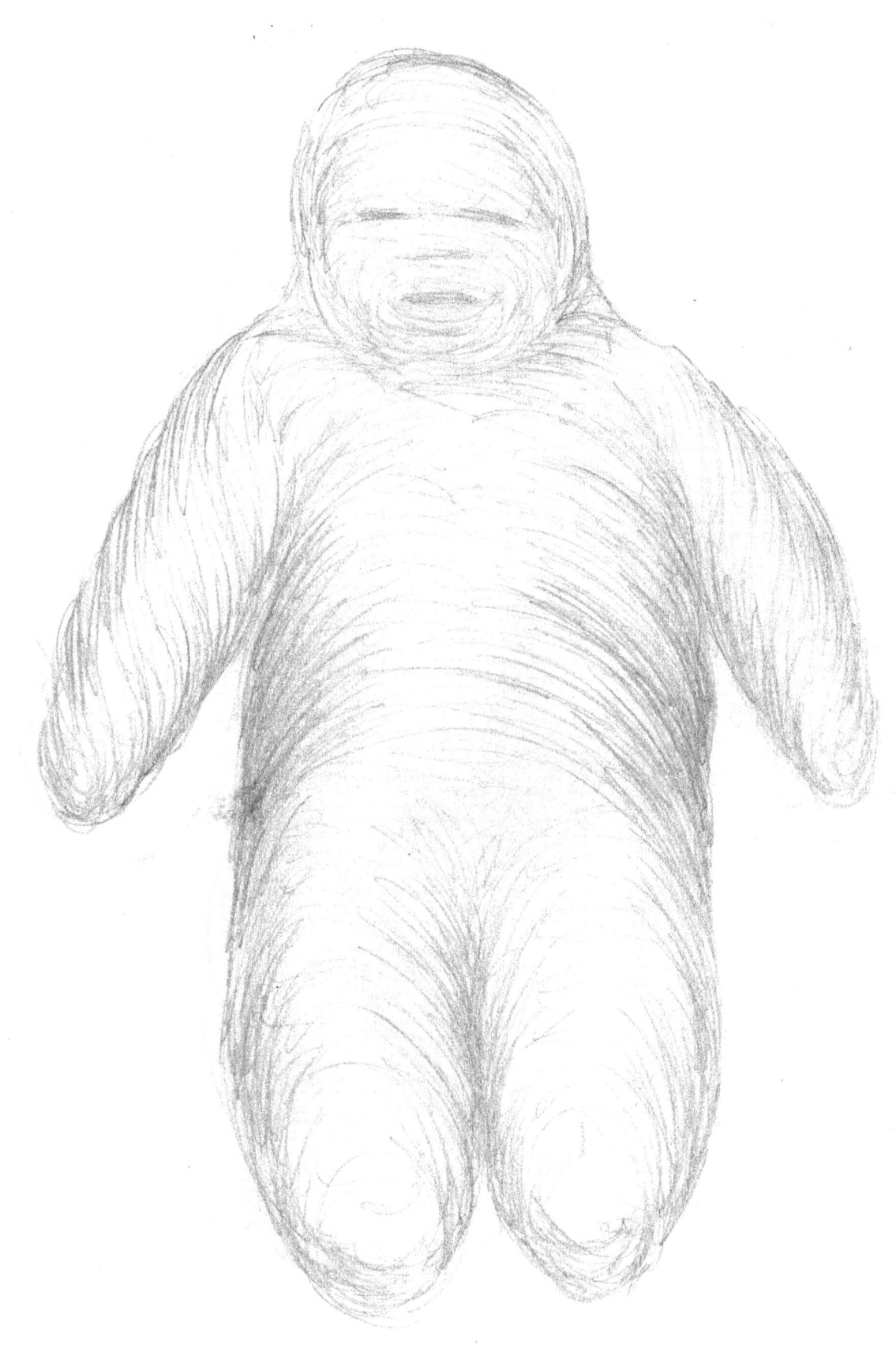

KARMIC FORM

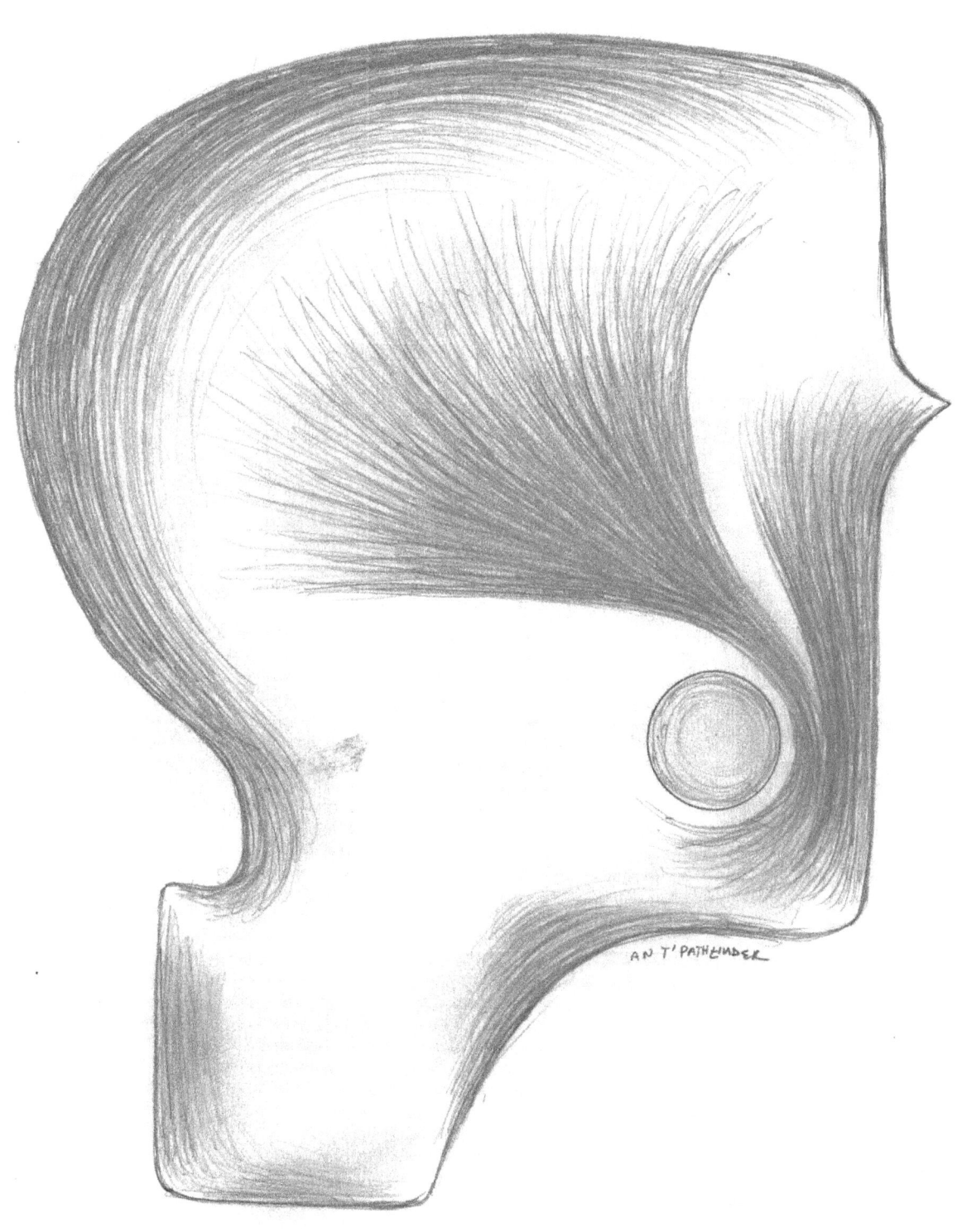

KARMIC PATH

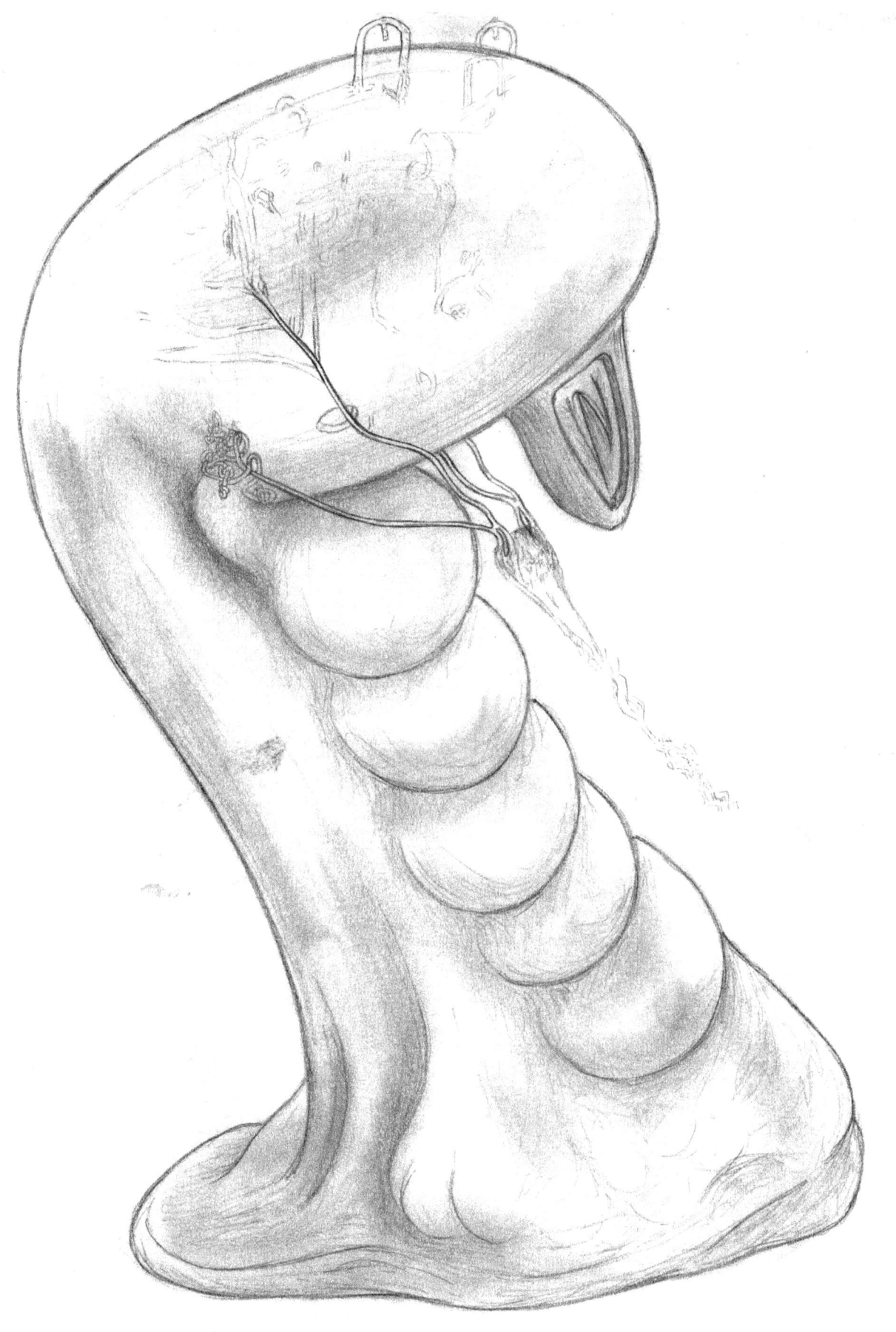

KARMIC SENSOR

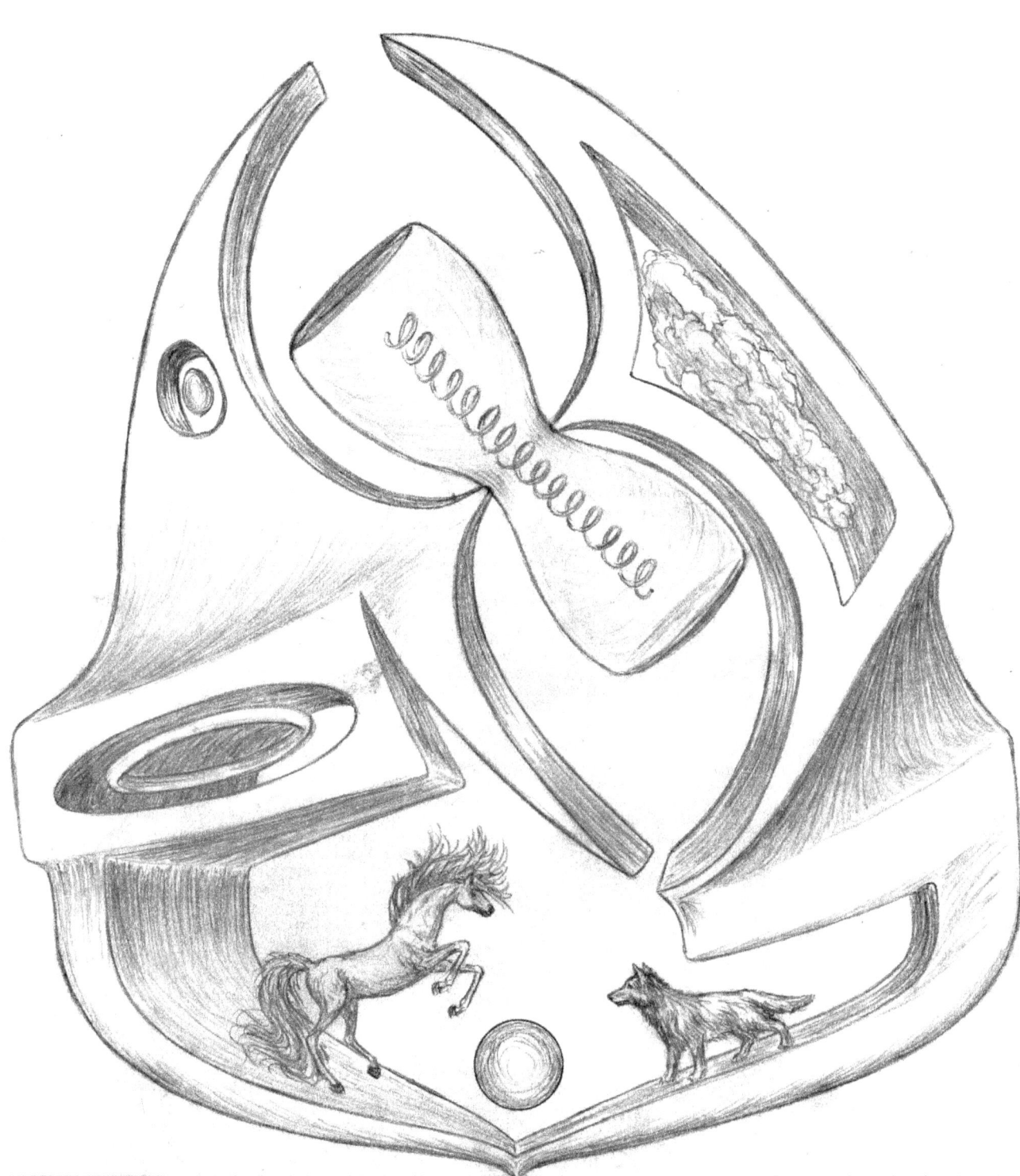

When the Ring of Law is bound to an Egg of Existence already bound to the Cloud of Paradox, the Balance of Karma can only be achieved by love for the parts all children play in the greater whole.

Ant' Pathfinder

KARMIC SPELL
[WHEN THE RING OF LAW IS BOUND TO AN EGG OF EXISTENCE, ALREADY BOUND TO THE CLOUD OF PARADOX, THE BALANCE OF KARMA CAN ONLY BE ACHIEVED BY LOVE FOR THE PARTS ALL CHILDREN (BEINGS) PLAY IN THE GREATER WHOLE]

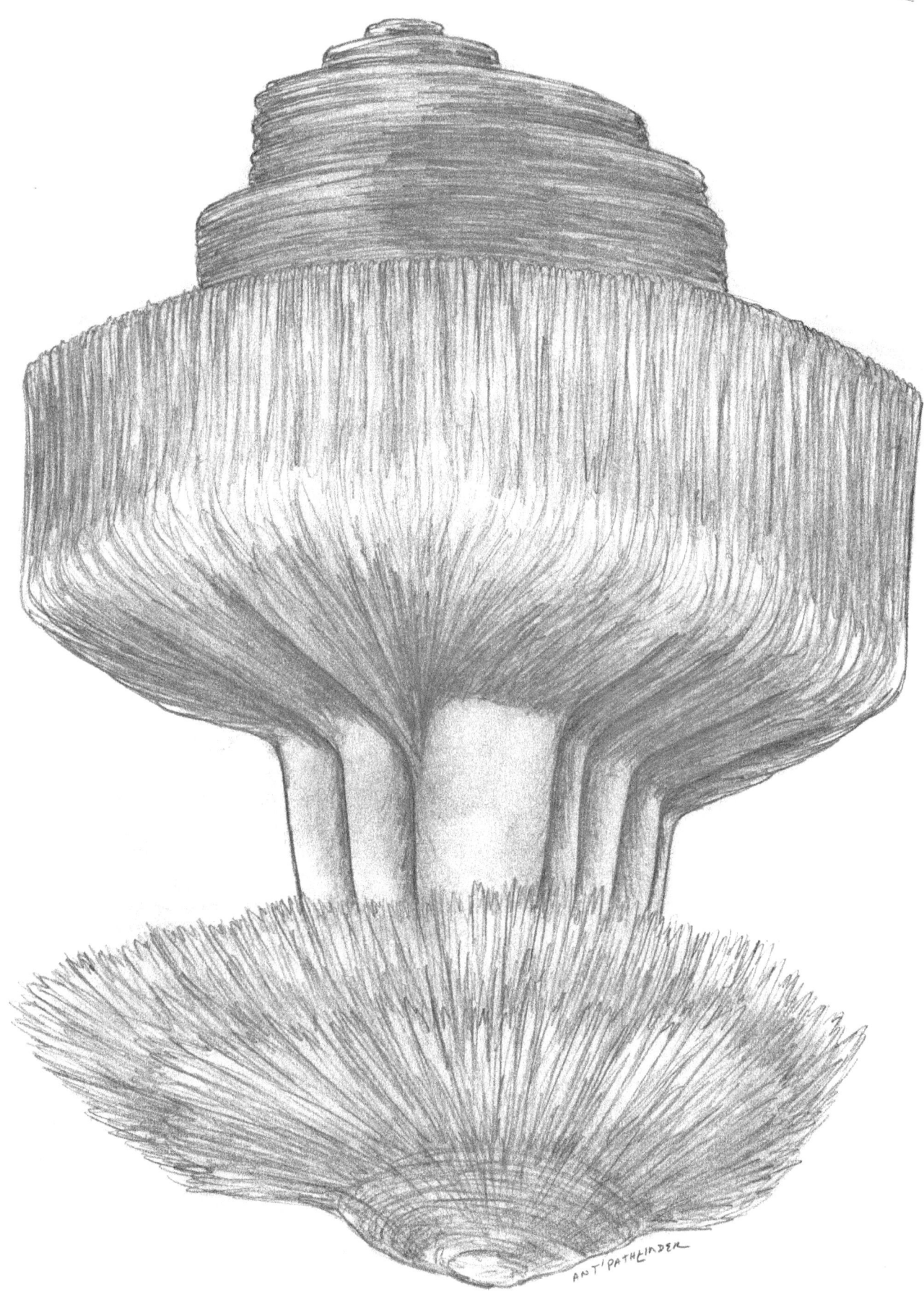

KARMIC SPINDLE

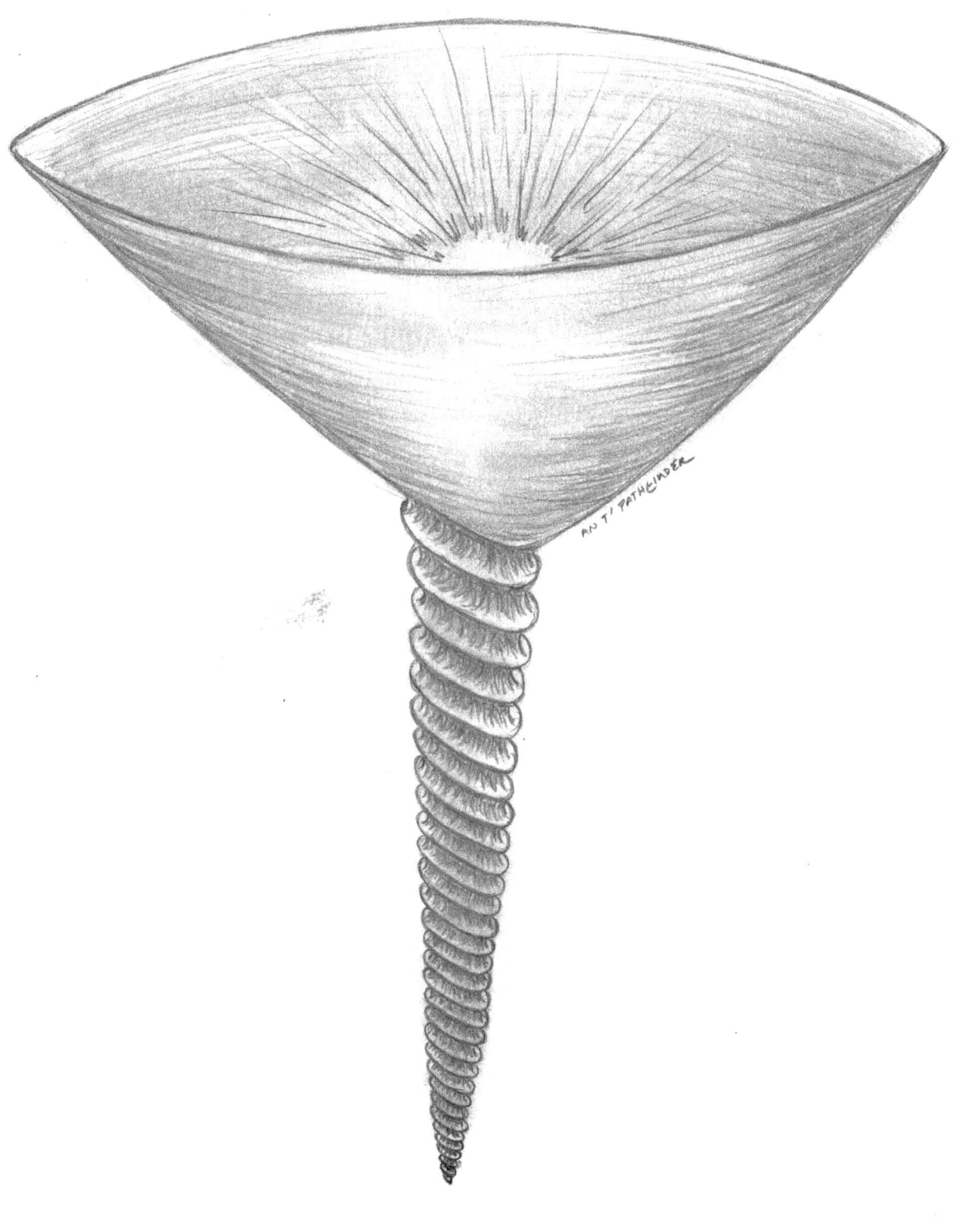

LEADERSHIP BOWL

LIFE ARMOR AKA MATERIAL WOMB
TURNED INSIDE OUT
← BOTTOM

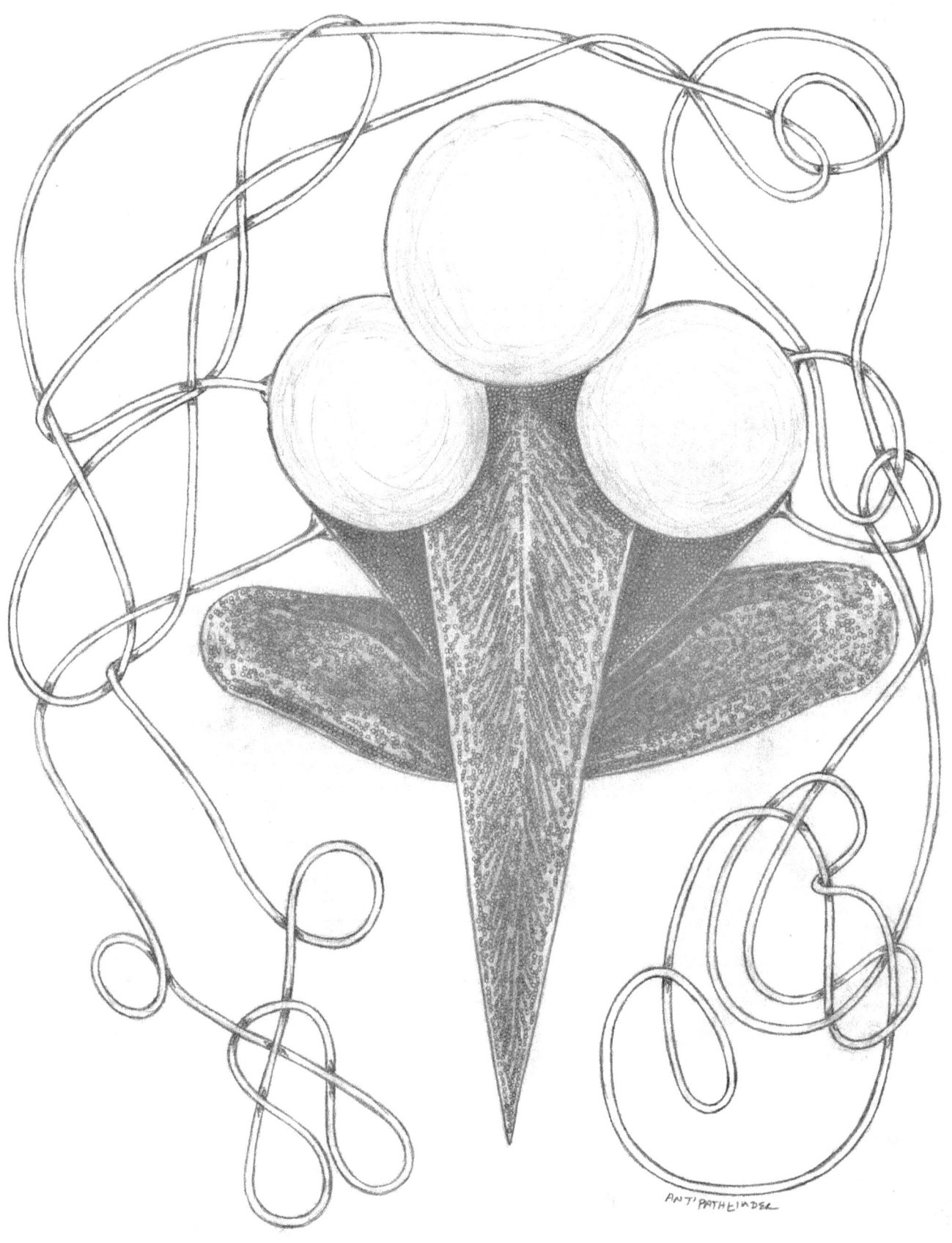

LIFE DAGGER

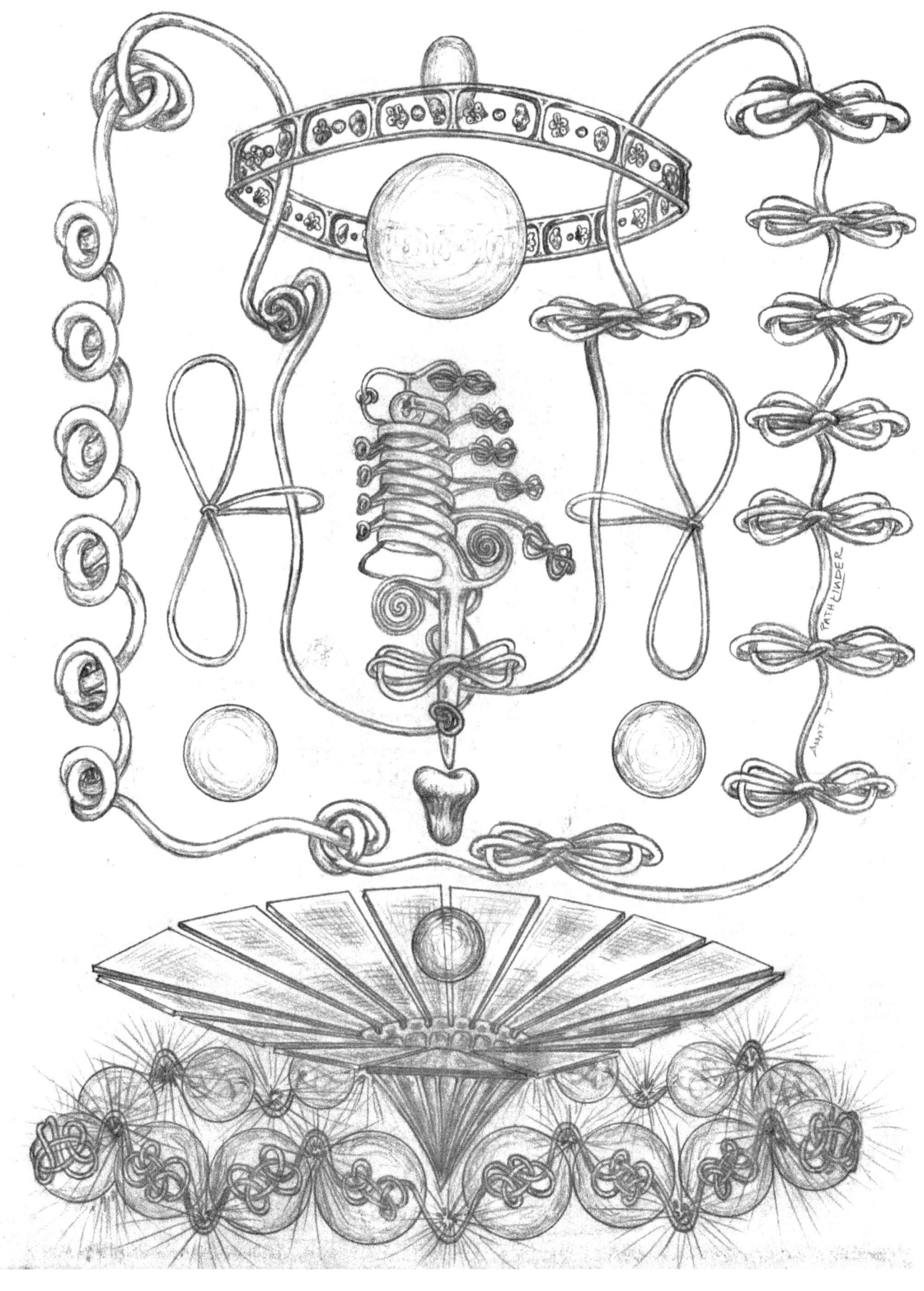

LIVING CROWN
FOUND IN CONTROL ROOM

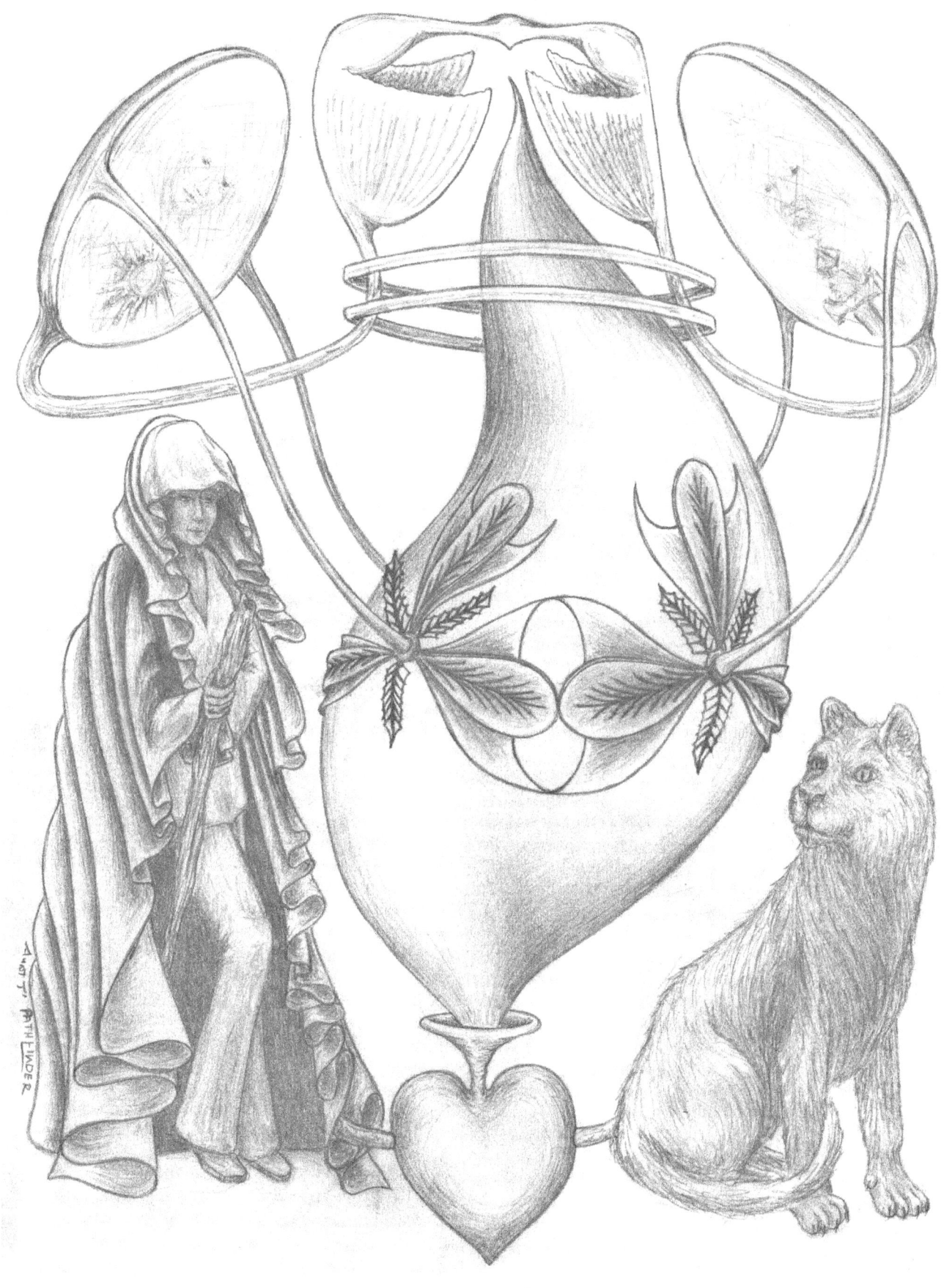

LOVE CREATION MACHINE

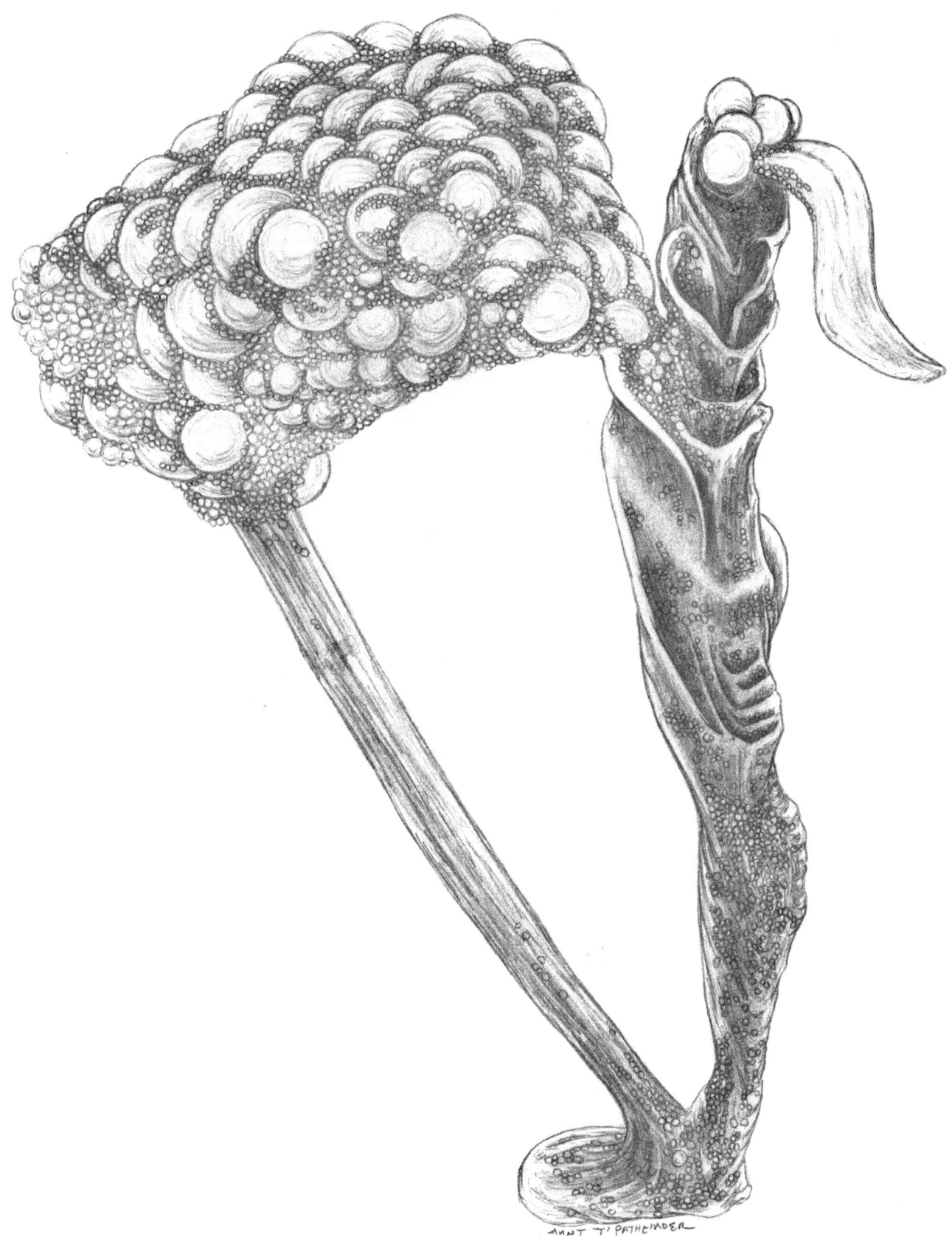

LOVERS HARP

WILD CARDS M - N

M: Magic Hook & Emotion Conduit; Magic Key is 1/3 forming Triple Key unlocking Title Center; Magic Tripod & Sibling Beings; Magic Womb aka Awareness Laws inside Love Orbs of Prayer conduit; Manorah of the Trilogy aka Lights of Hope; Martyr's Key is 1/3 forming Triple Key unlocking Title Center; Mate Hook; Material Funnel & Recycle Tubes; Material Horn & Wind Guard; Material Magnet; Material Trash Channel; Memory Bridge aka Inner Balance Armor; Mind Hook; Mitochondrial Conduit Tree; Mortal Fountain; Mortal Trash Bin; Mother Star; Mundane Cape; Mundane Guardian Armor; Mundane Tree; Mushroom of Life.

N: Nightmare Realm Armor.

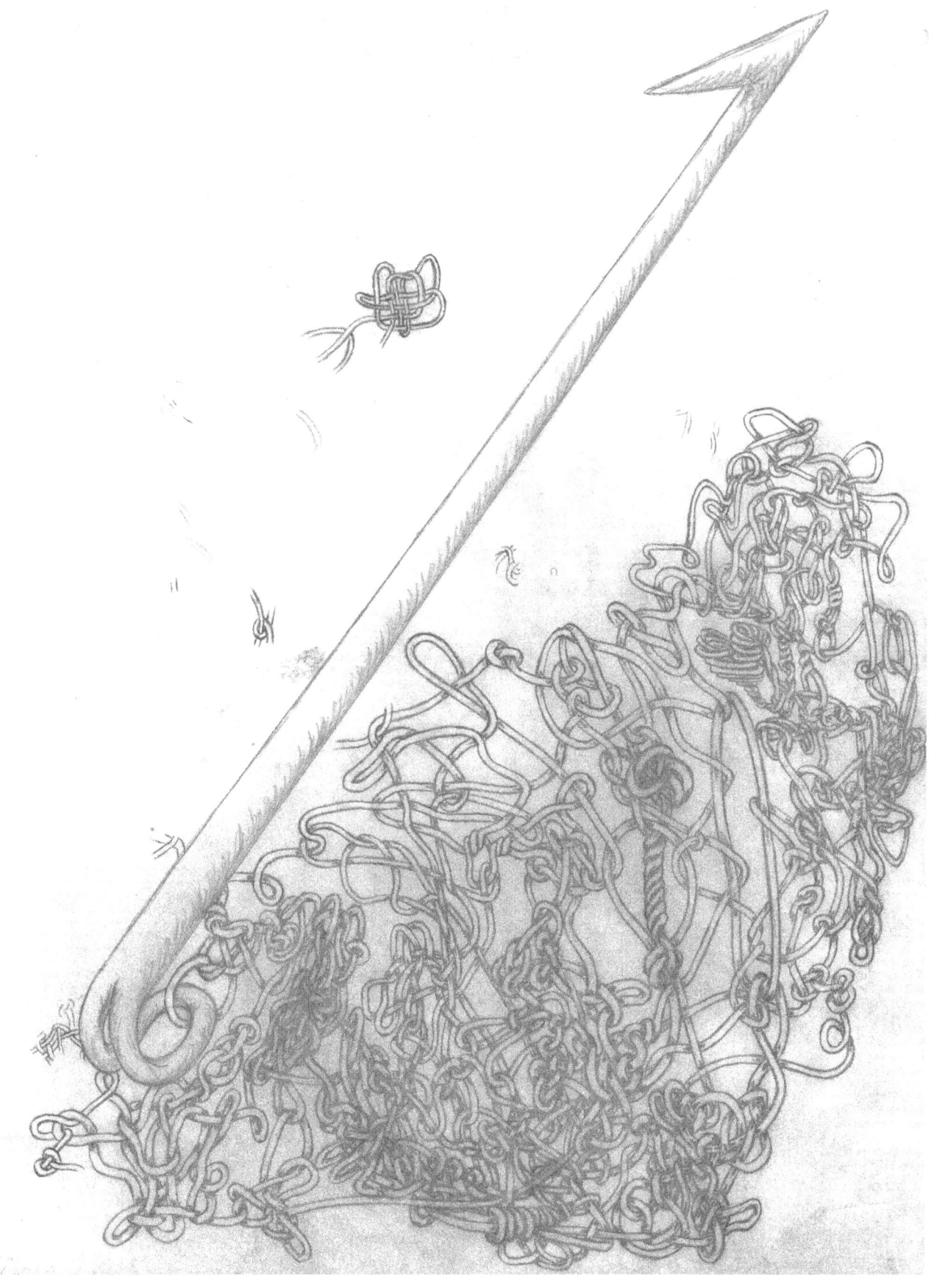

MAGIC HOOK & EMOTION CONDUIT

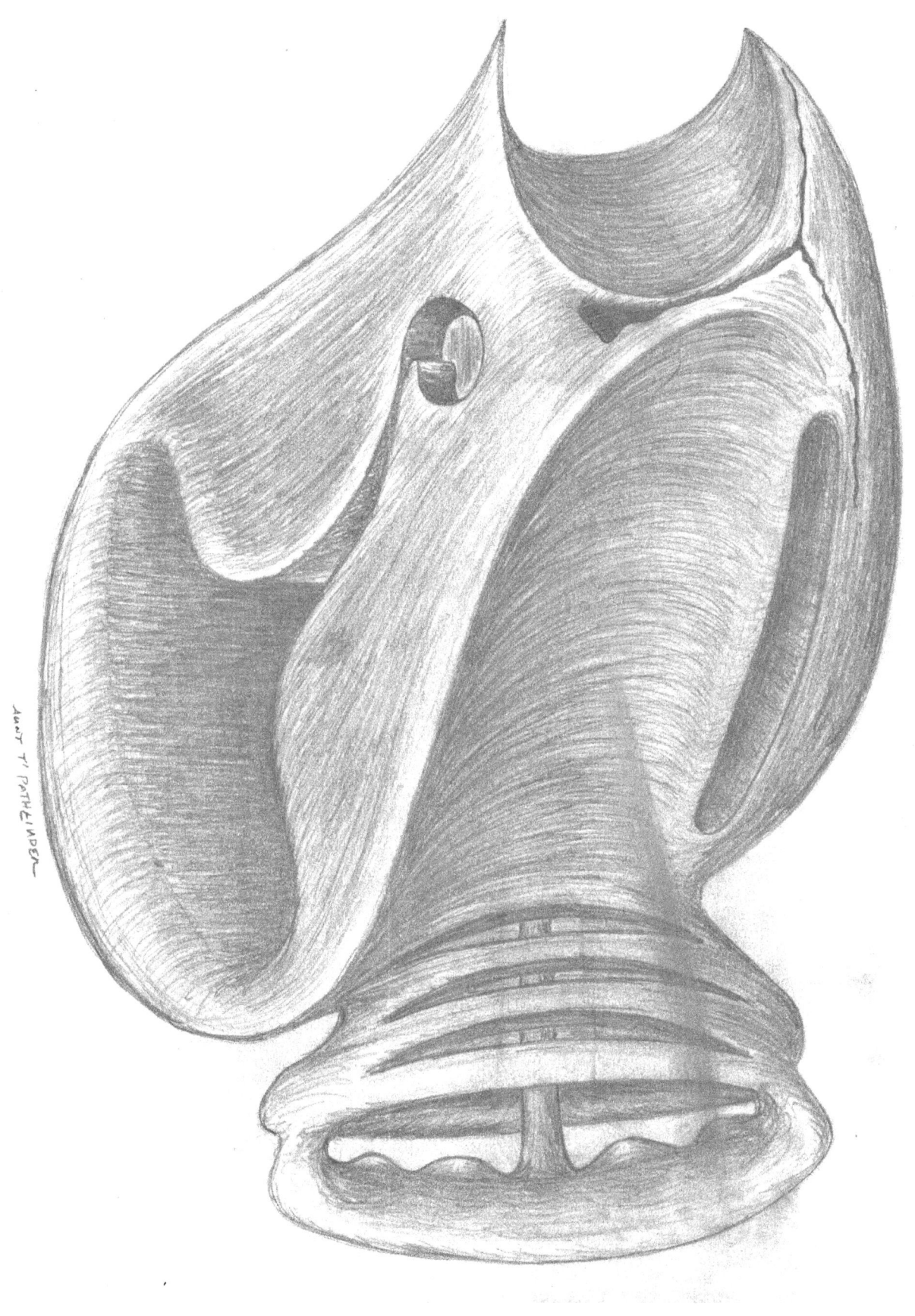

MAGIC KEY
1/3 OF TRINITY KEY
UNLOCKS TITLE CENTER

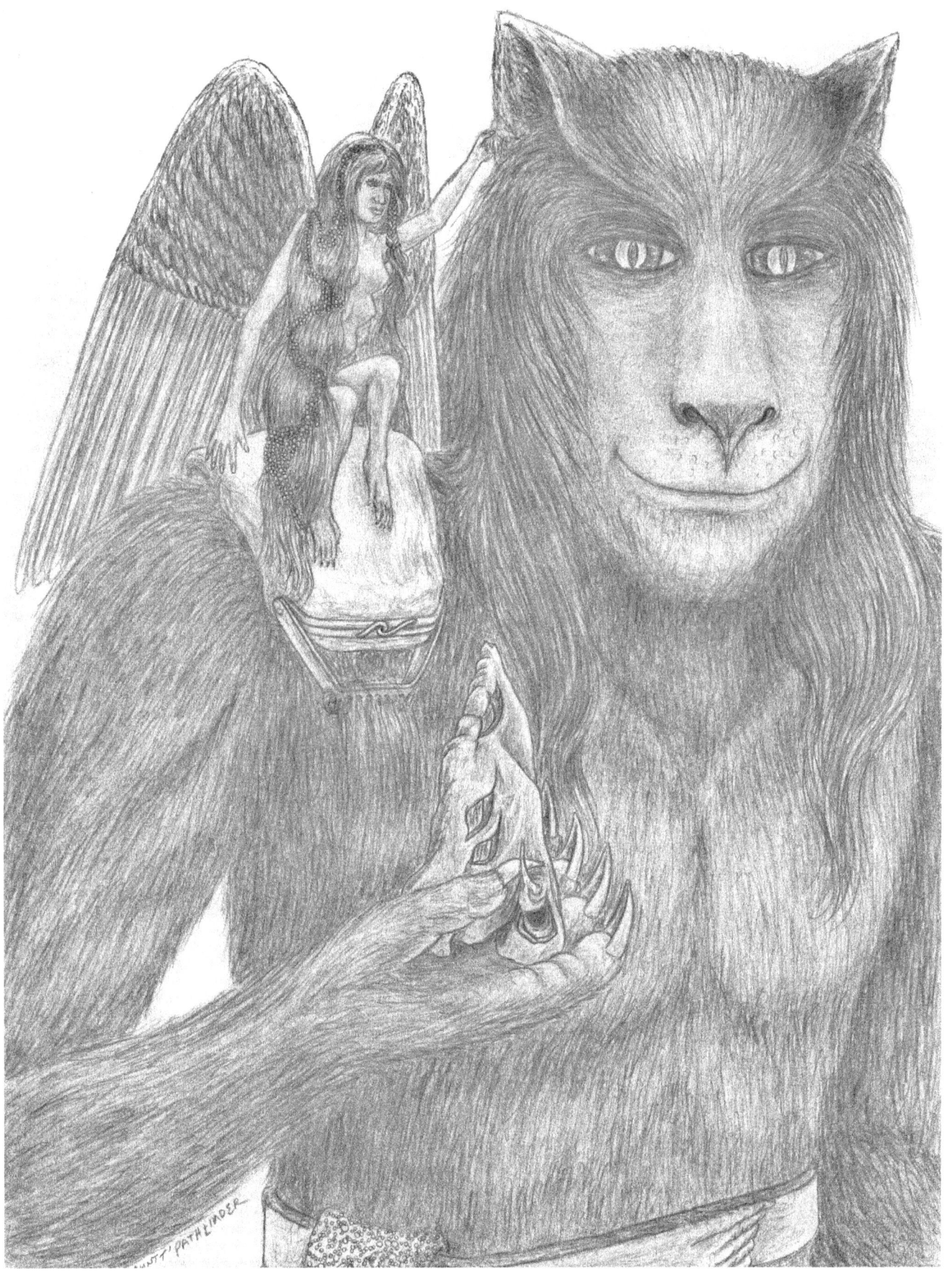

MAGIC TRIPOD & SIBLING BEINGS

WILD CARDS FOR YOUR SOUL

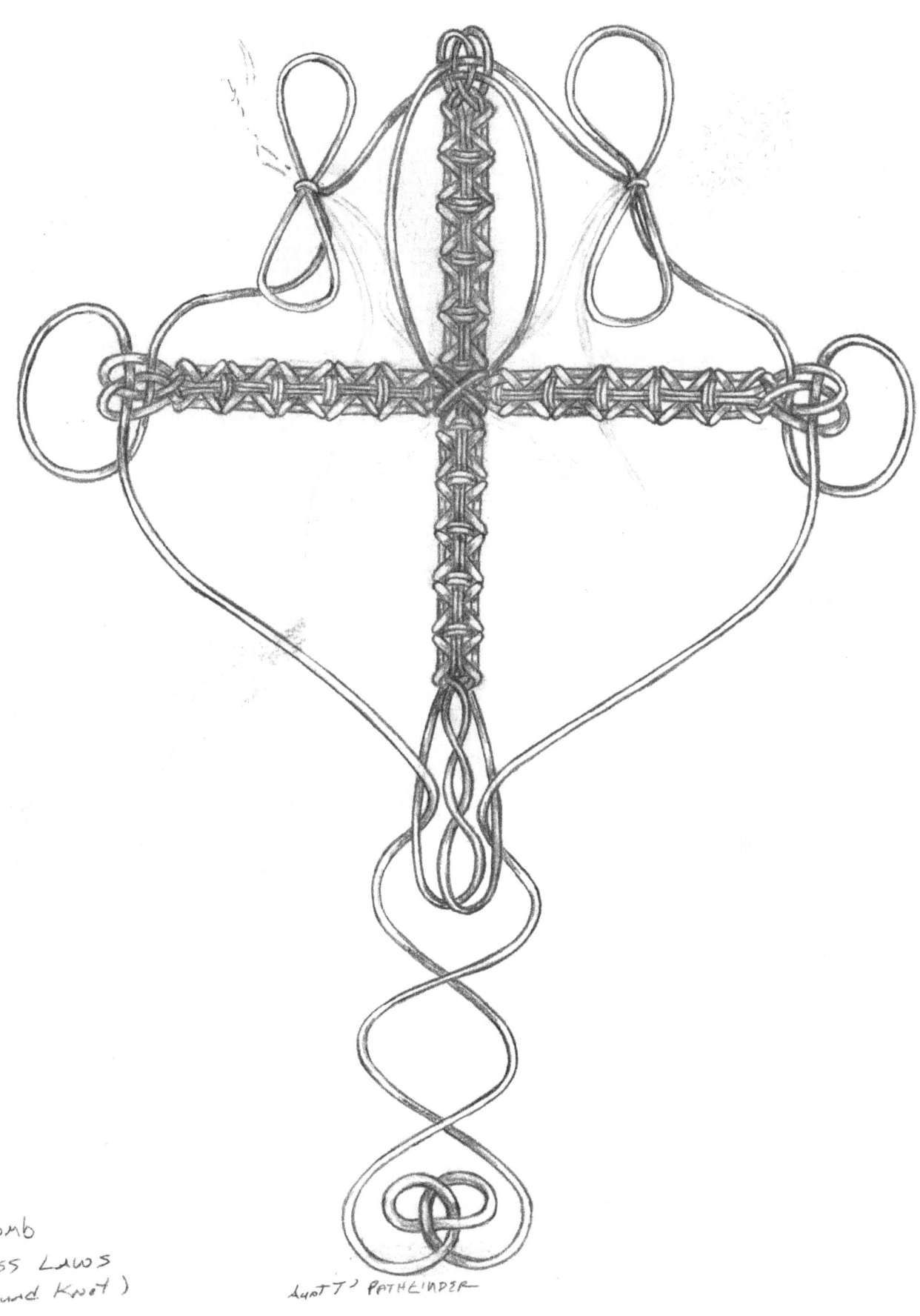

MAGIC WOMB AKA AWARENESS LAWS INSIDE LOVE ORBS OF PRAYER CONDUIT

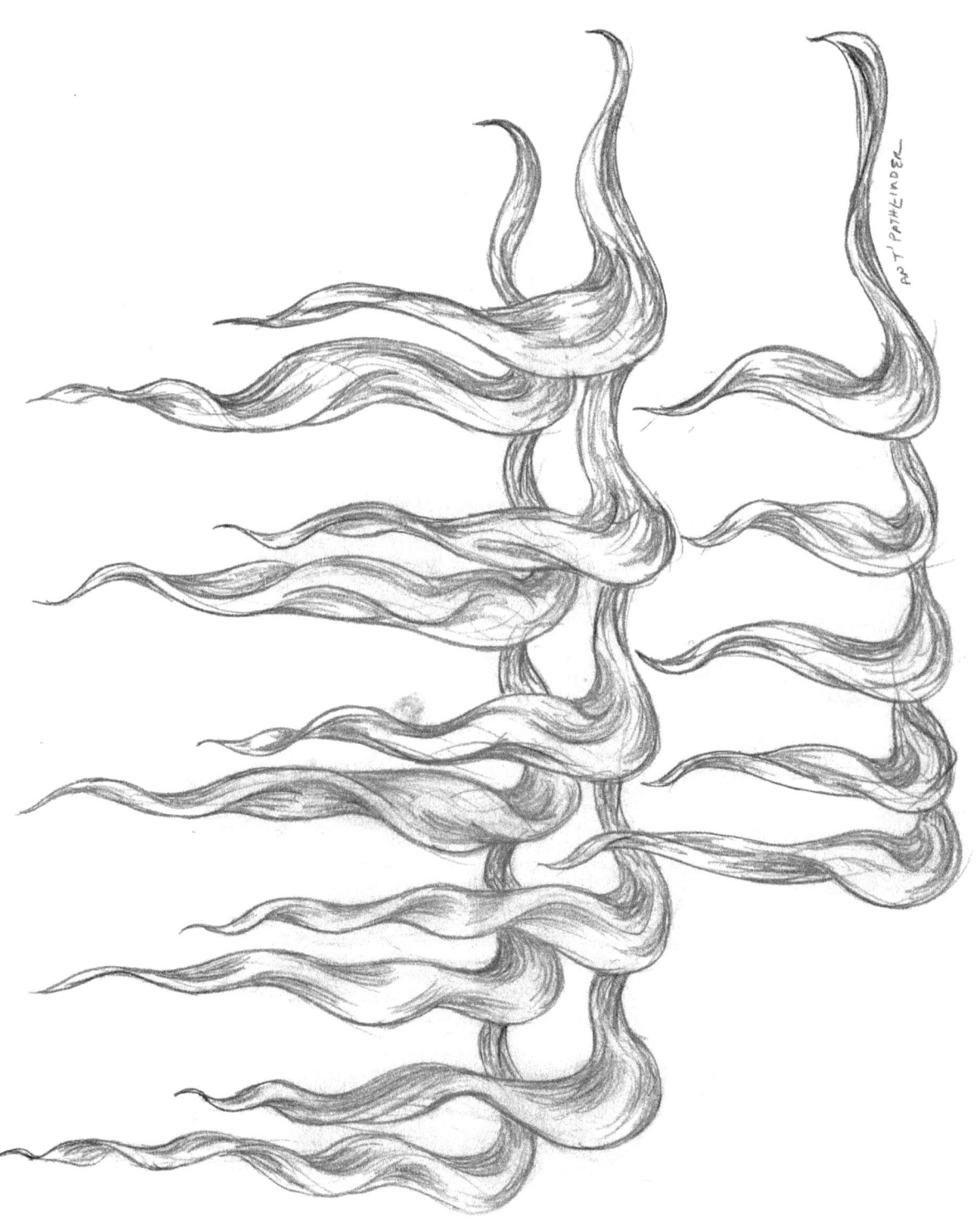

MANORAH OF THE TRINITY AKA LIGHTS OF HOPE
← BOTTOM
(MANORAH IS CORRECT SPELLING)

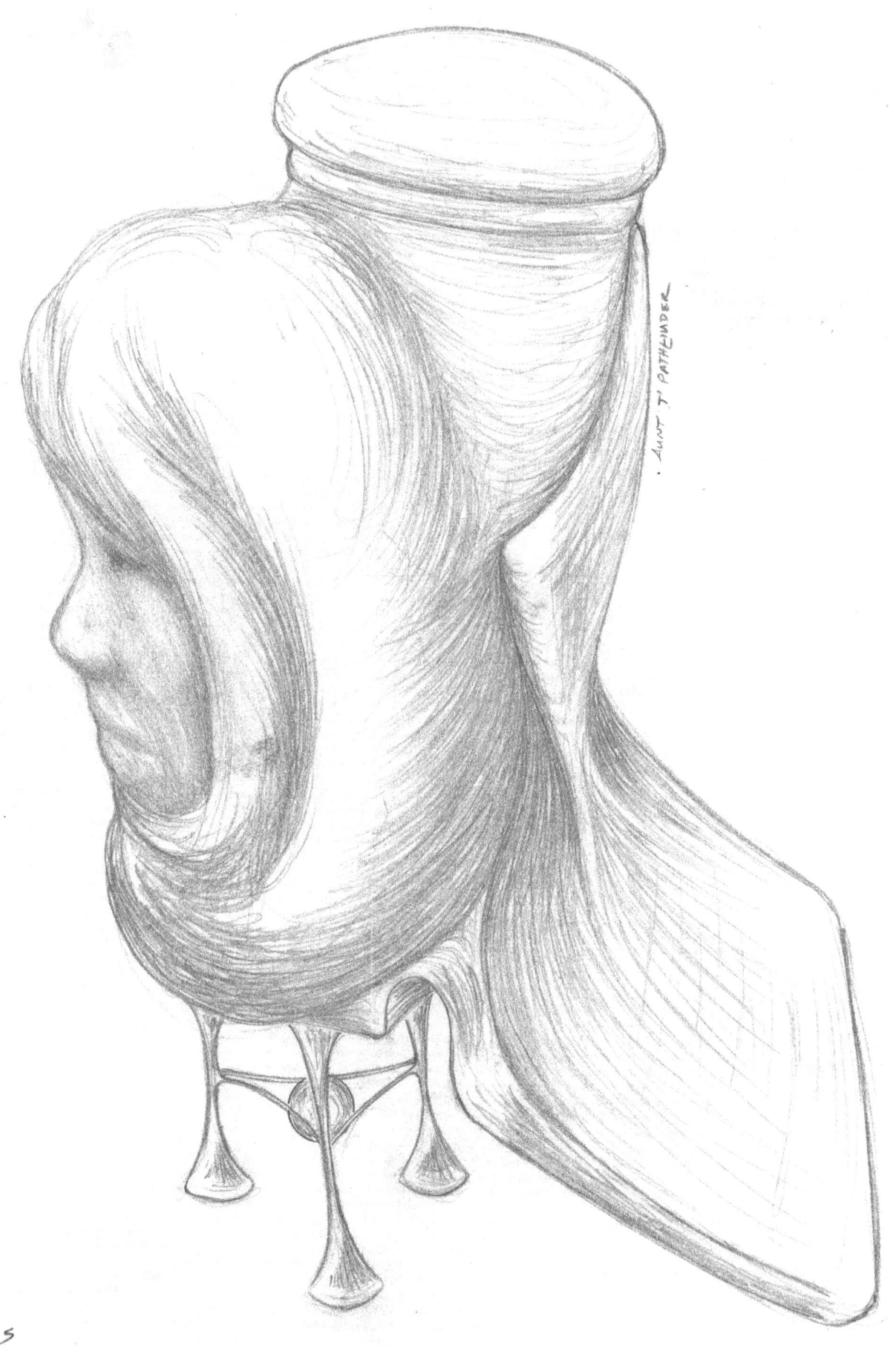

MARTYR'S KEY
1/3 OF TRIPLE KEY
UNLOCKS TITLE CENTER

MATE HOOK

WILD CARDS FOR YOUR SOUL

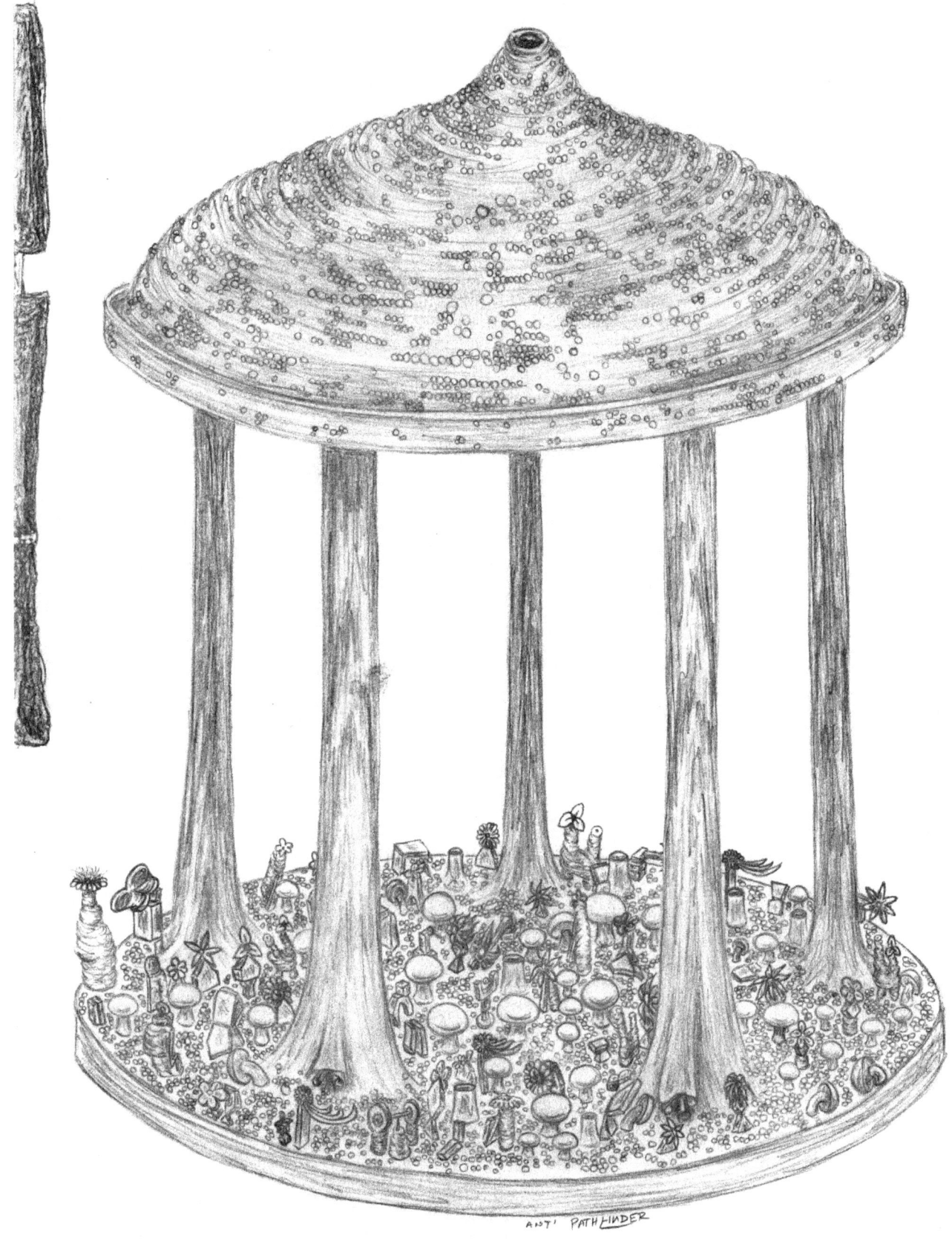

MATERIAL FUNNEL & RECYCLE TUBES

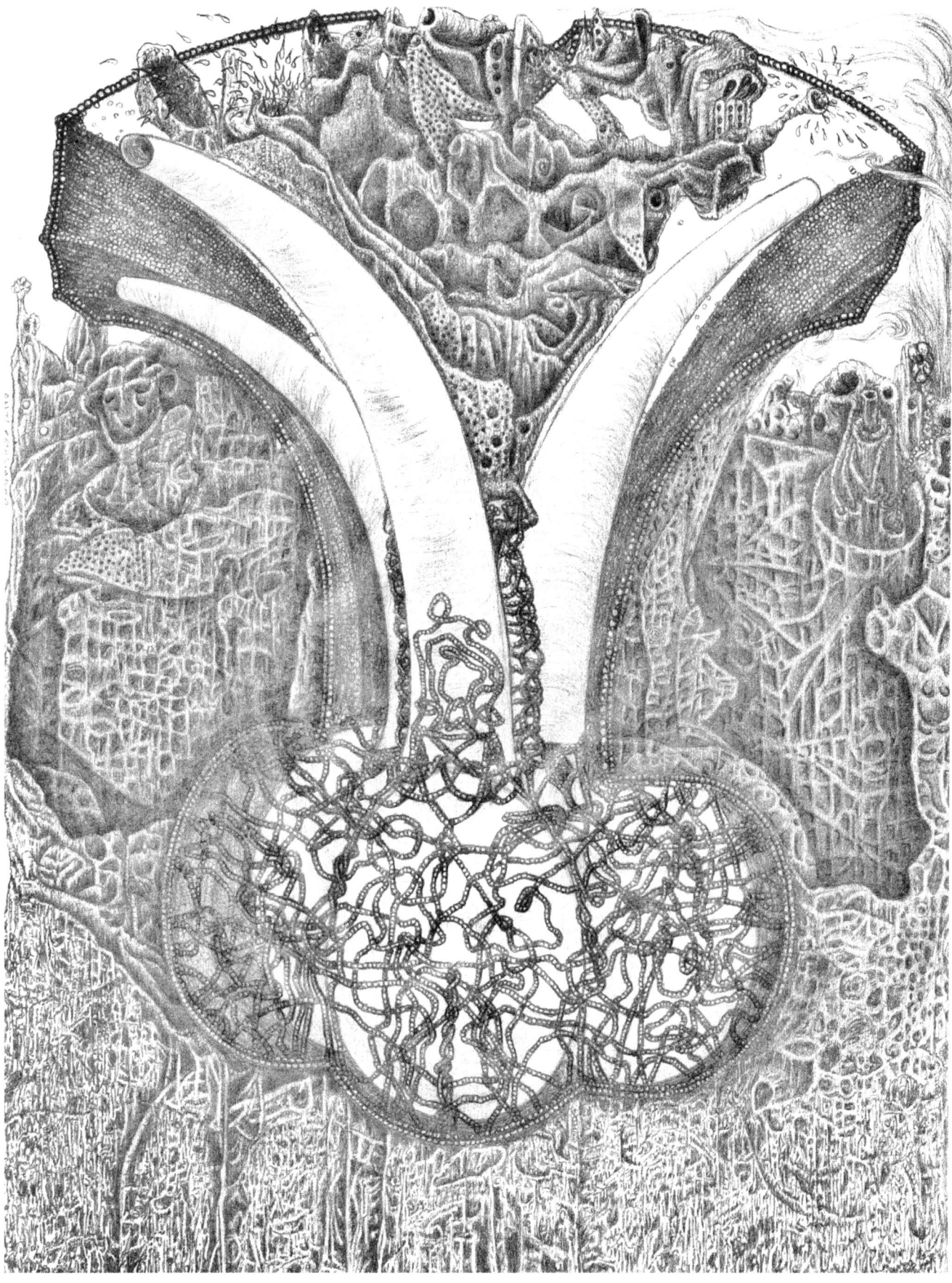

MATERIAL, HORN & WIND GUARD

WILD CARDS FOR YOUR SOUL

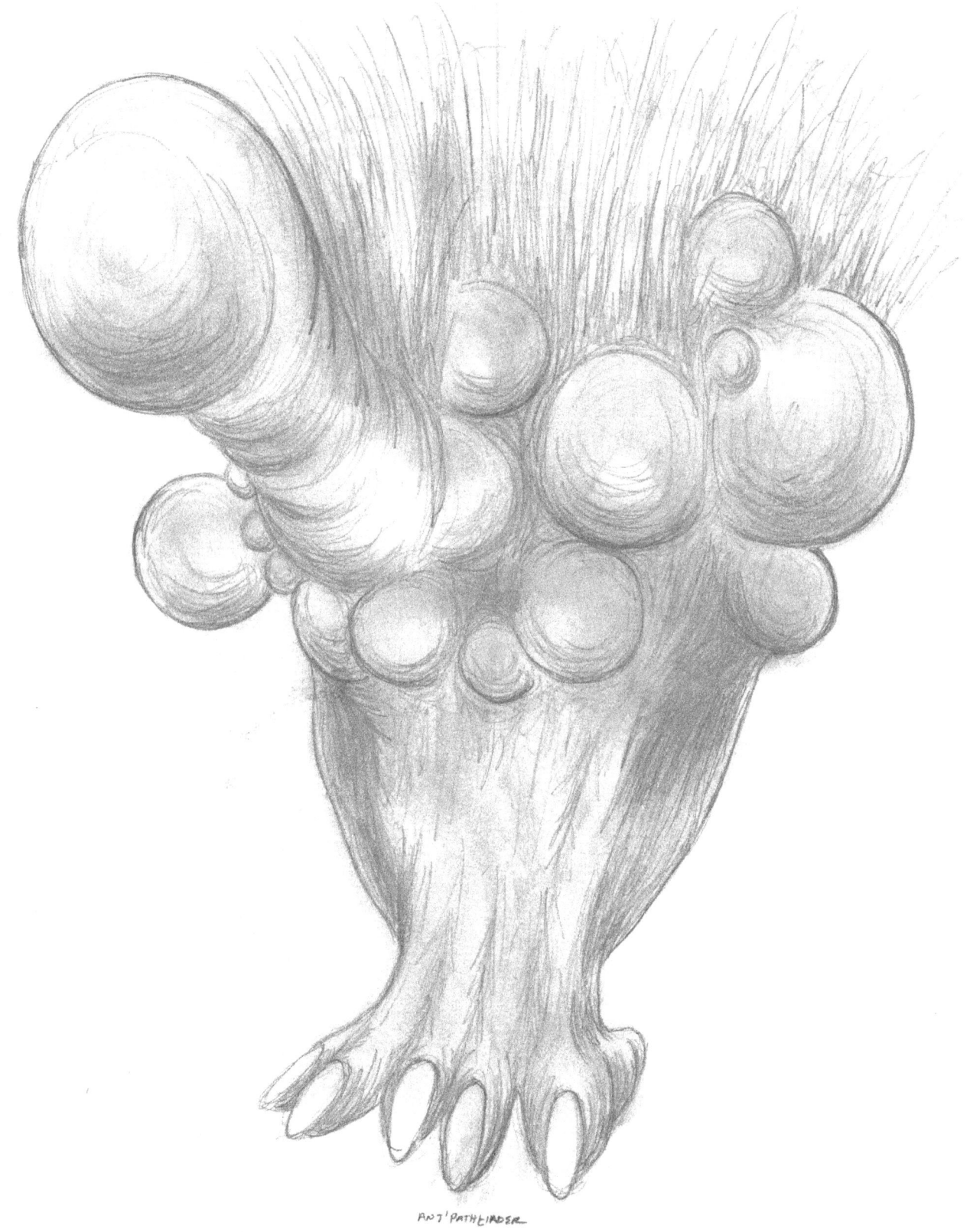

ANTIPATHFINDER

MATERIAL MAGNET

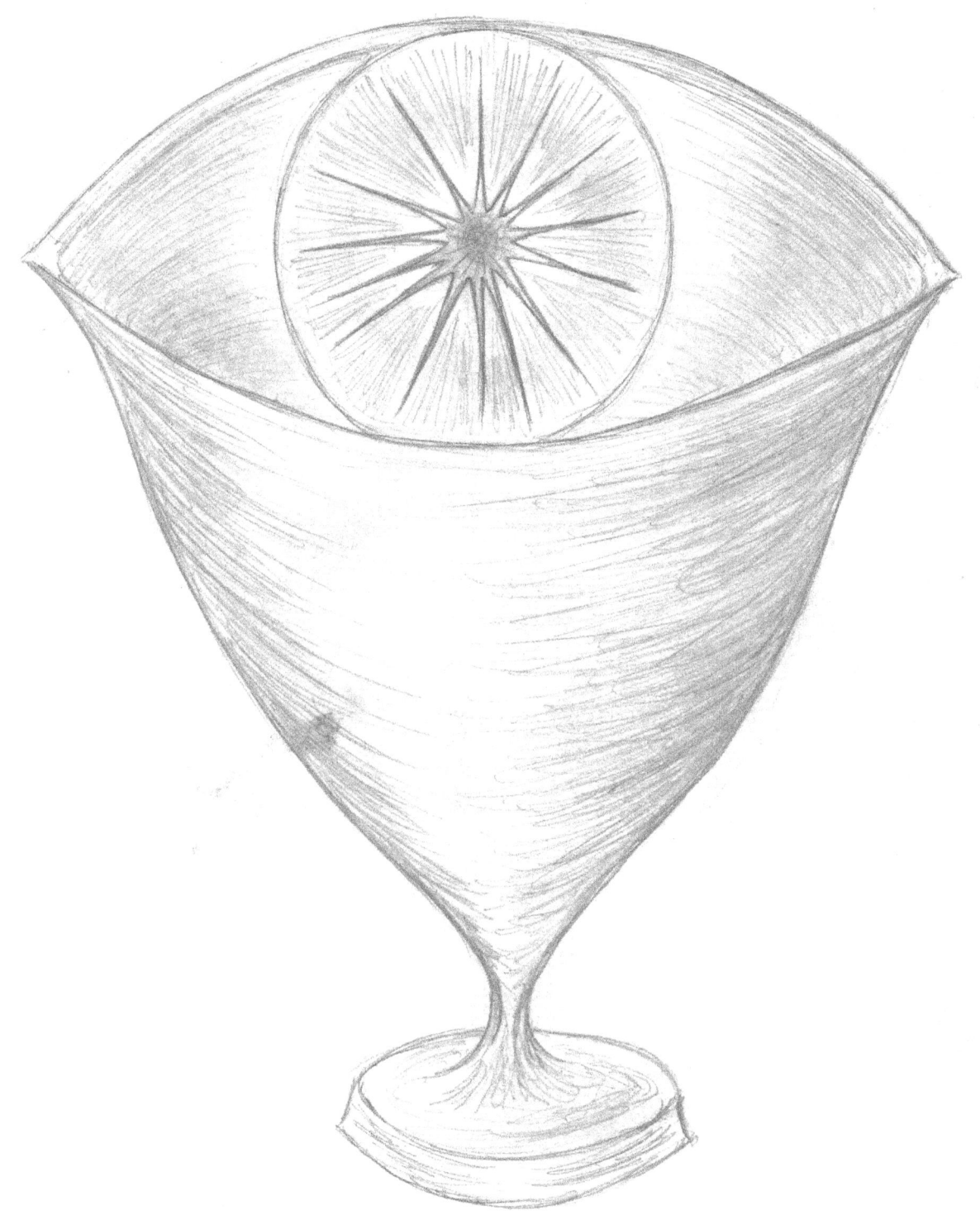

MATERIAL TRASH CHANNEL

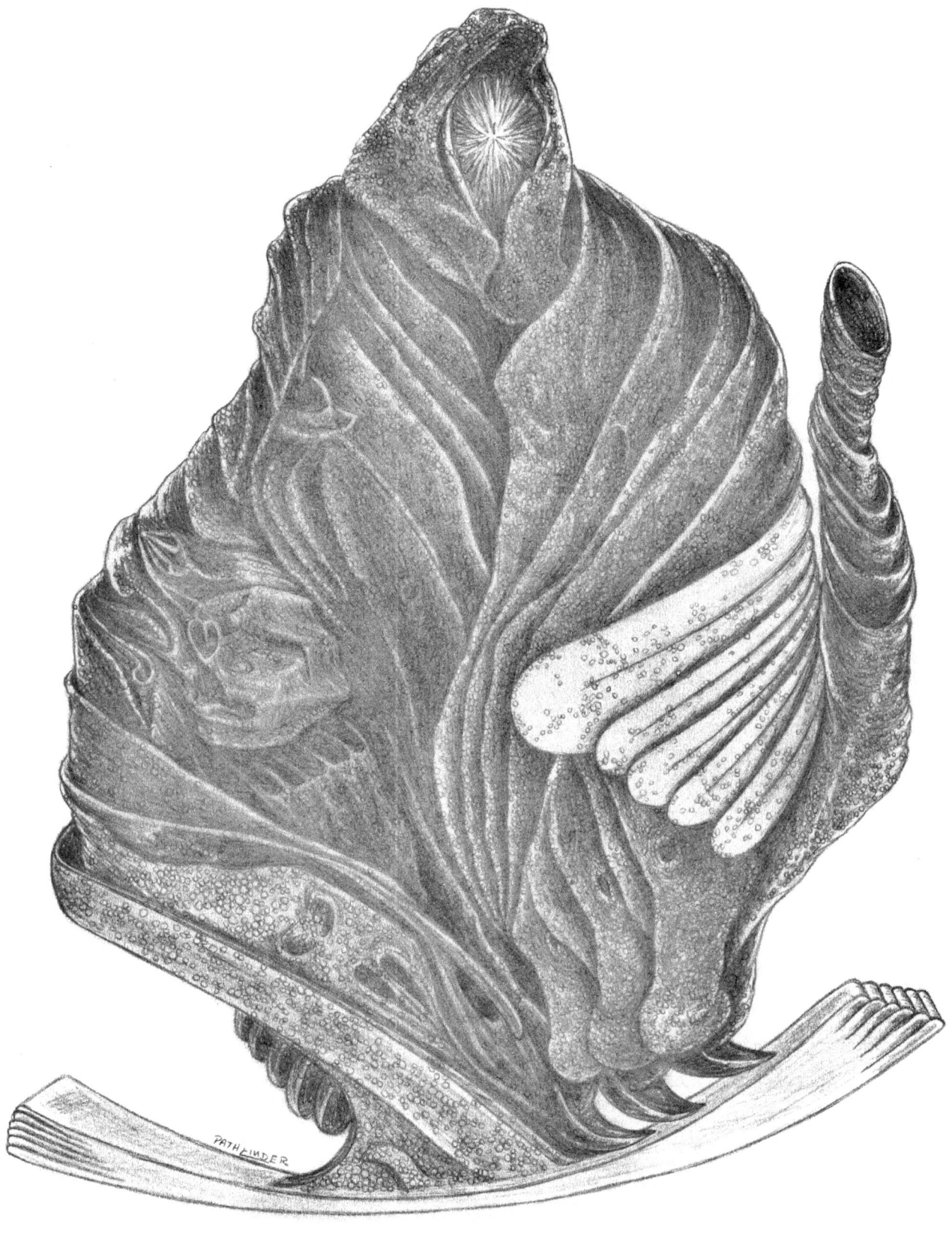

MEMORY BRIDGE AKA INNER BALANCE ARMOR

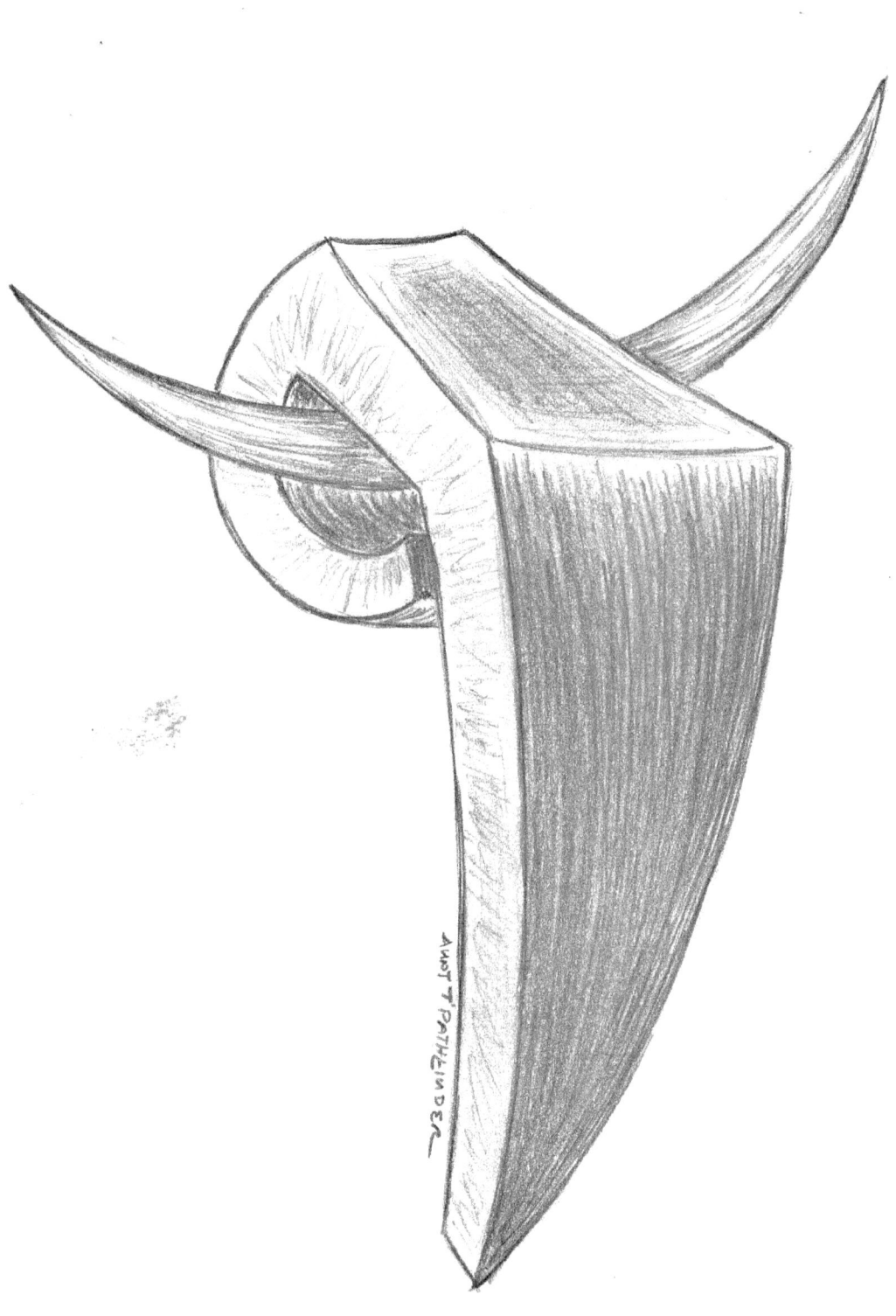

MIND HOOK

WILD CARDS FOR YOUR SOUL

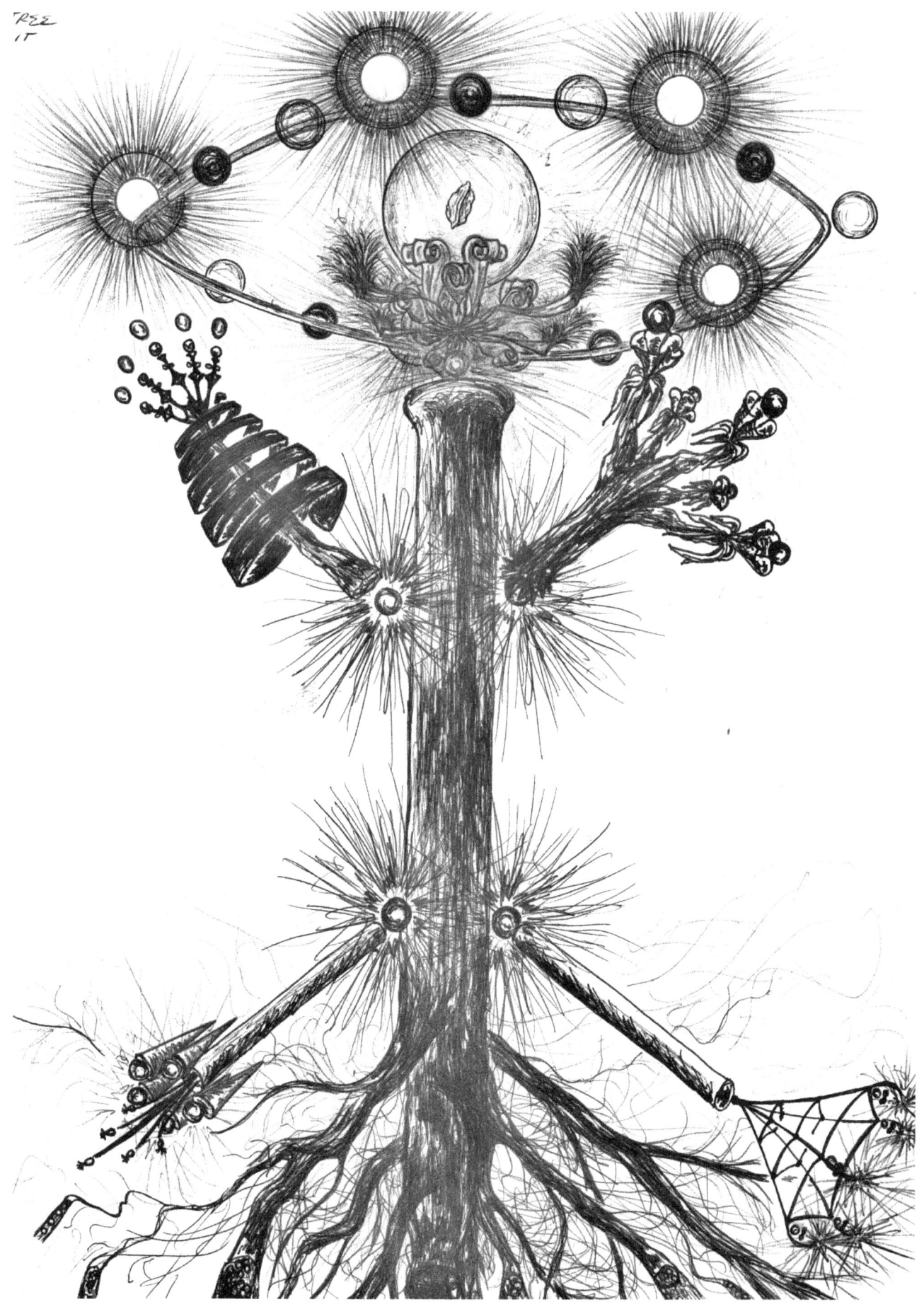

MITOCHONDRIAL CONDUIT TREE

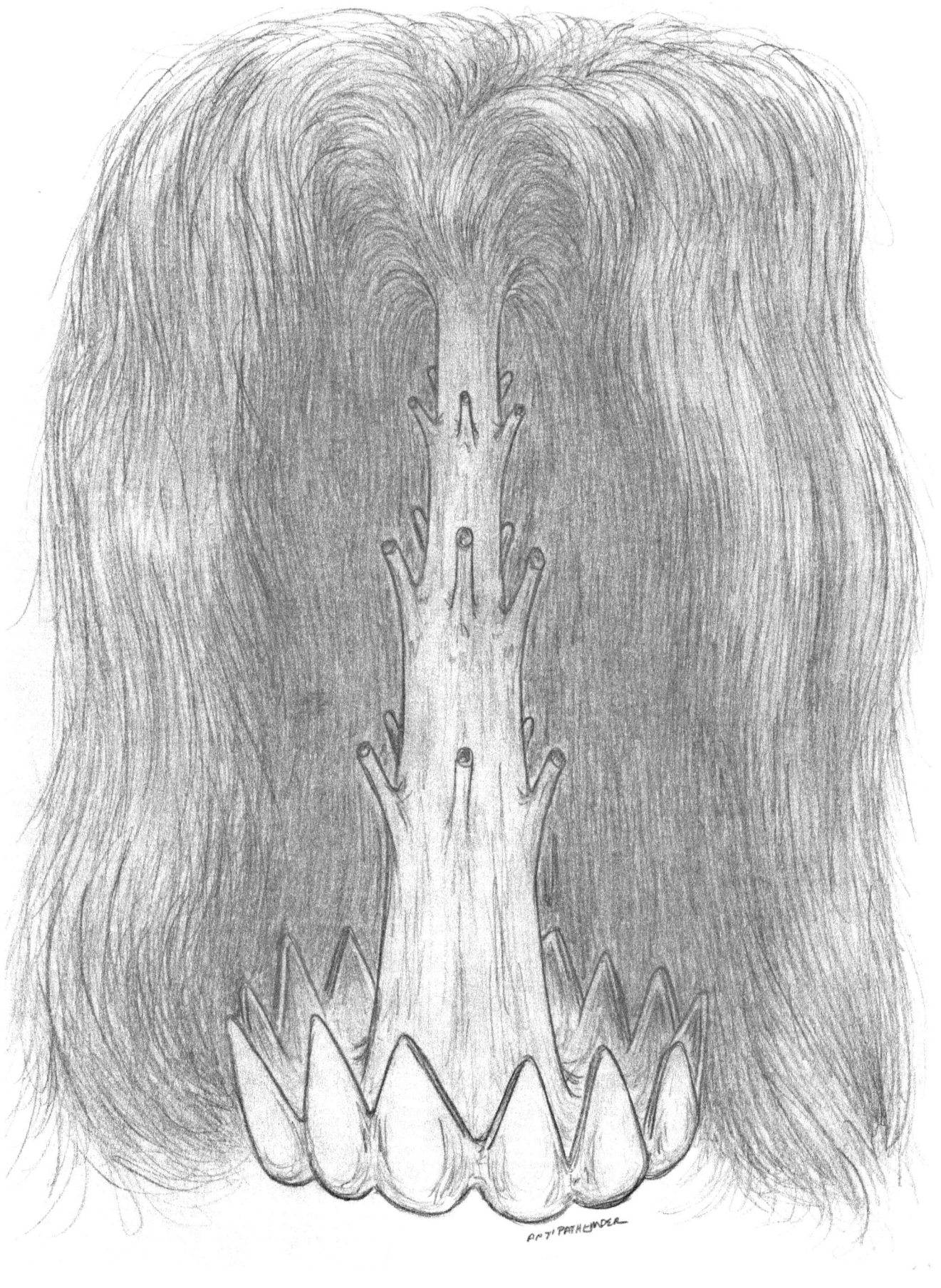

MORTAL FOUNTAIN

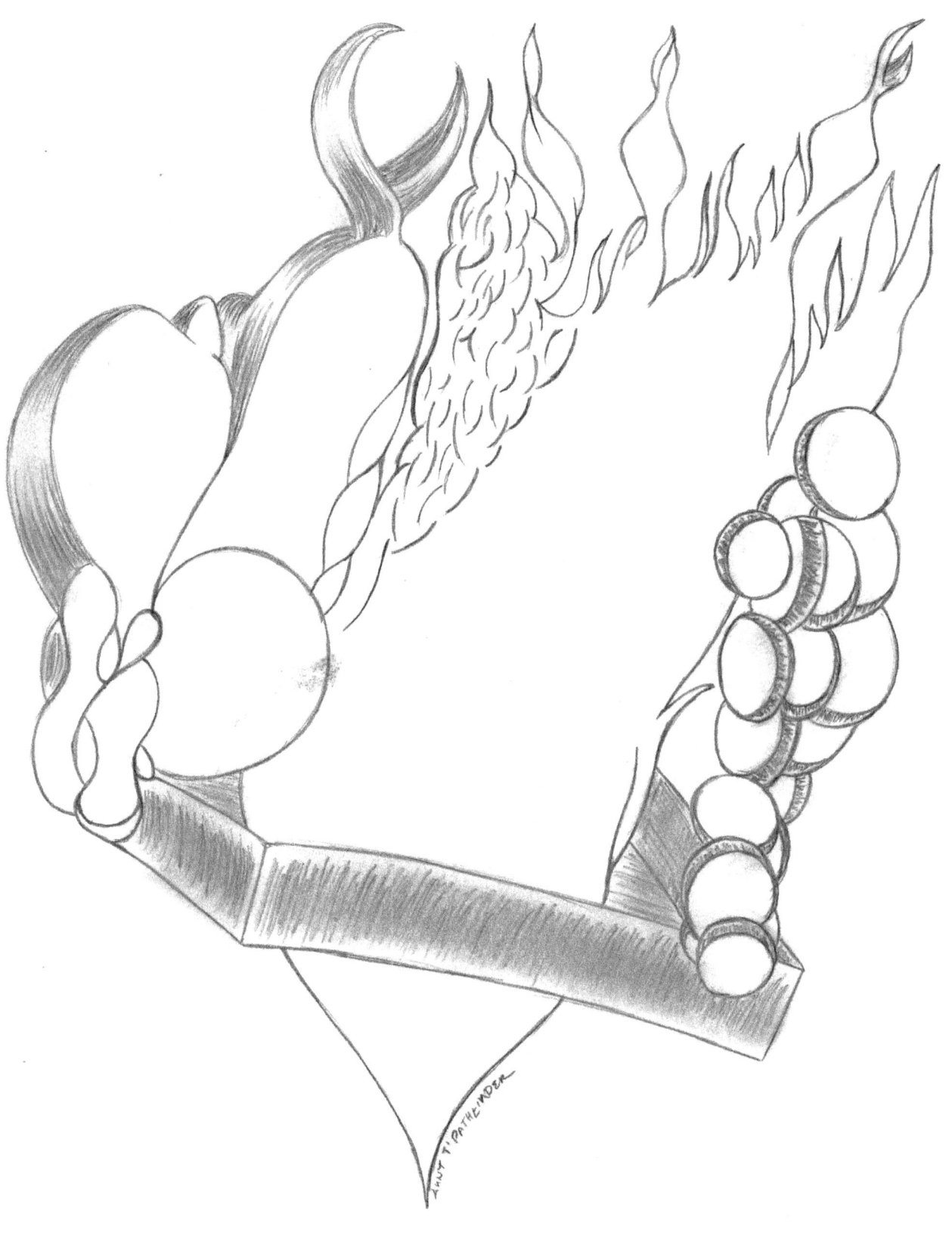

MORTAL TRASH BIN

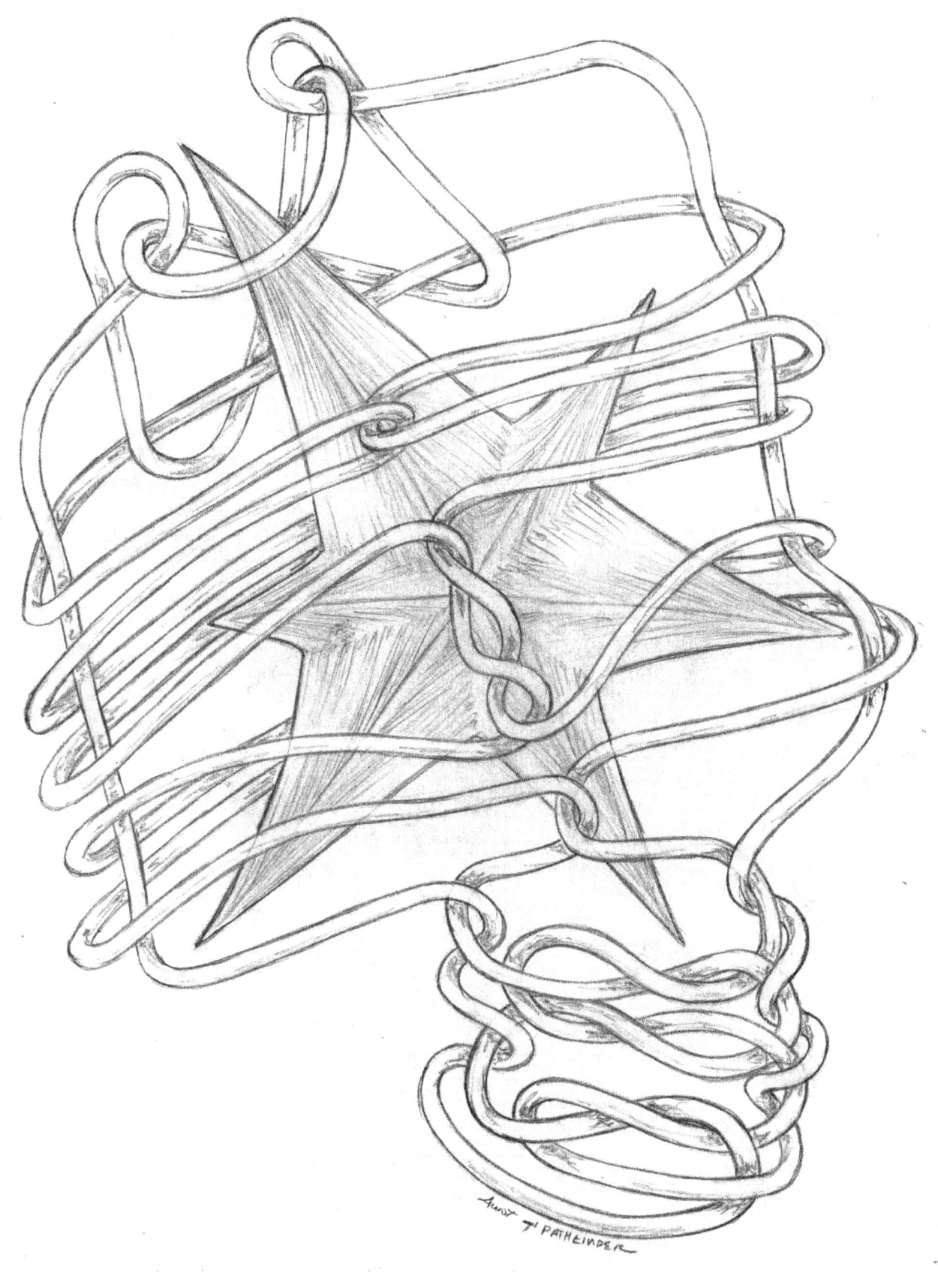

MOTHER STAR

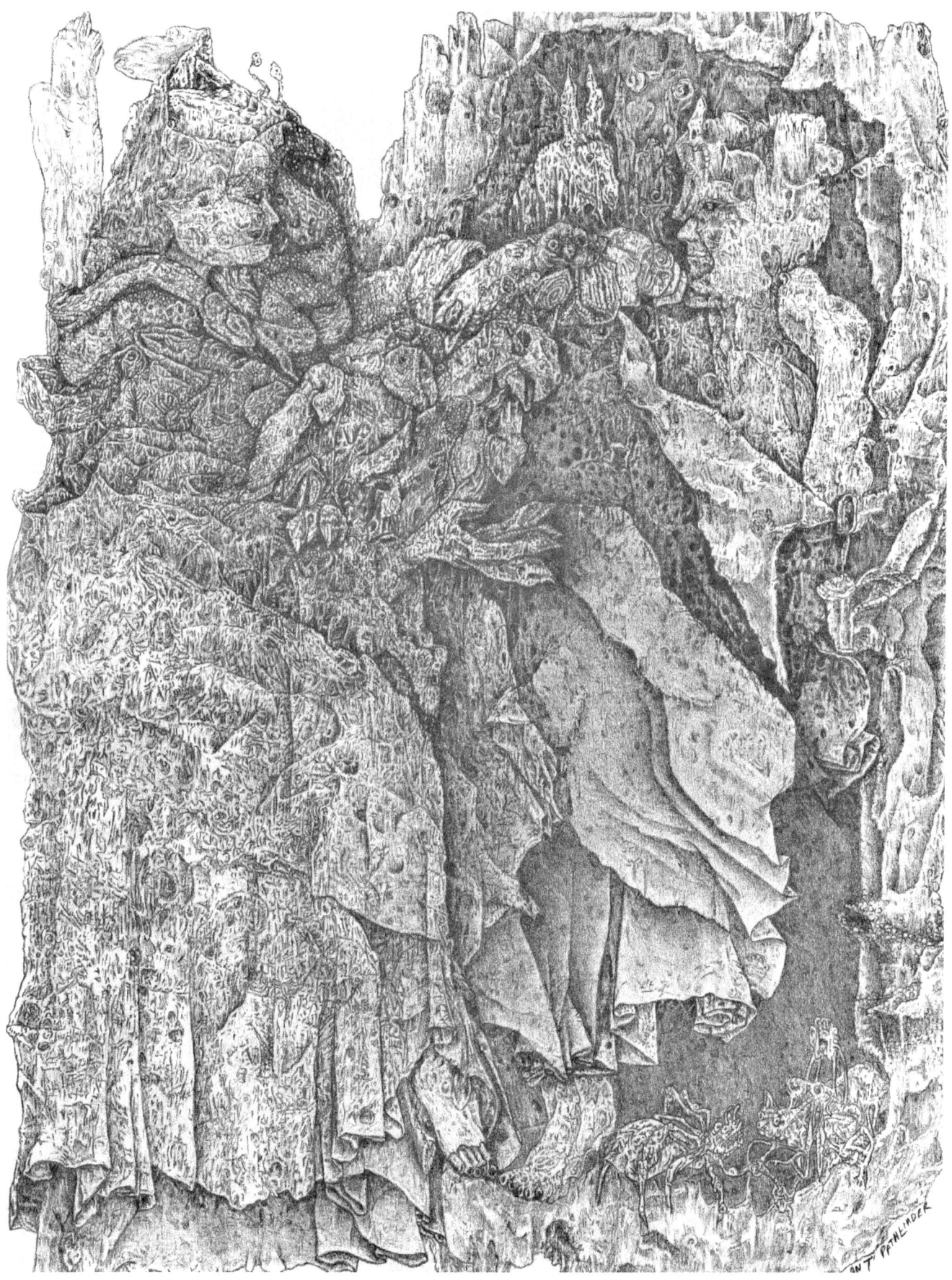

MUNDANE CAPE

WILD CARDS FOR YOUR SOUL

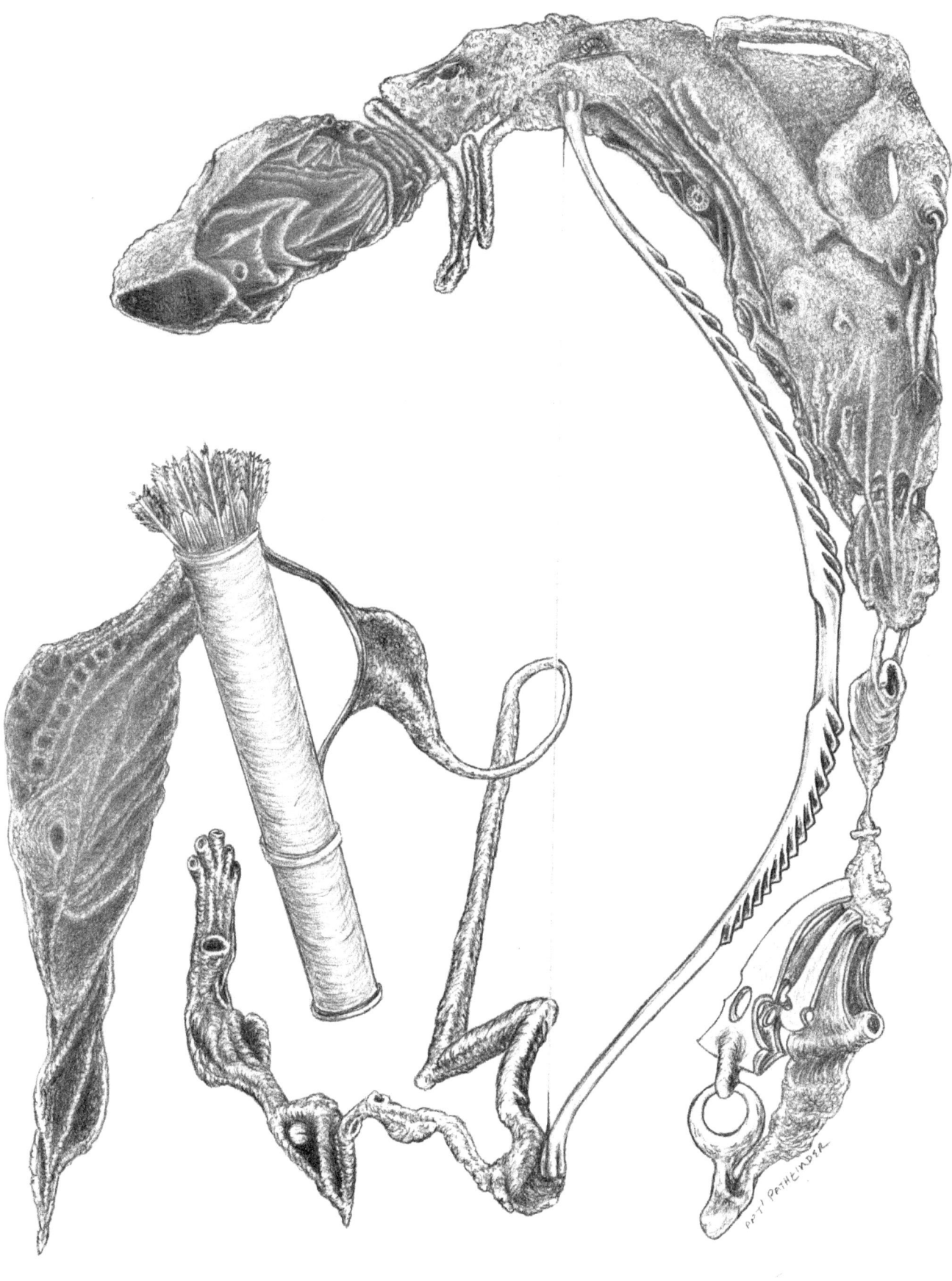

MUNDANE GUARDIAN ARMOR

WILD CARDS FOR YOUR SOUL

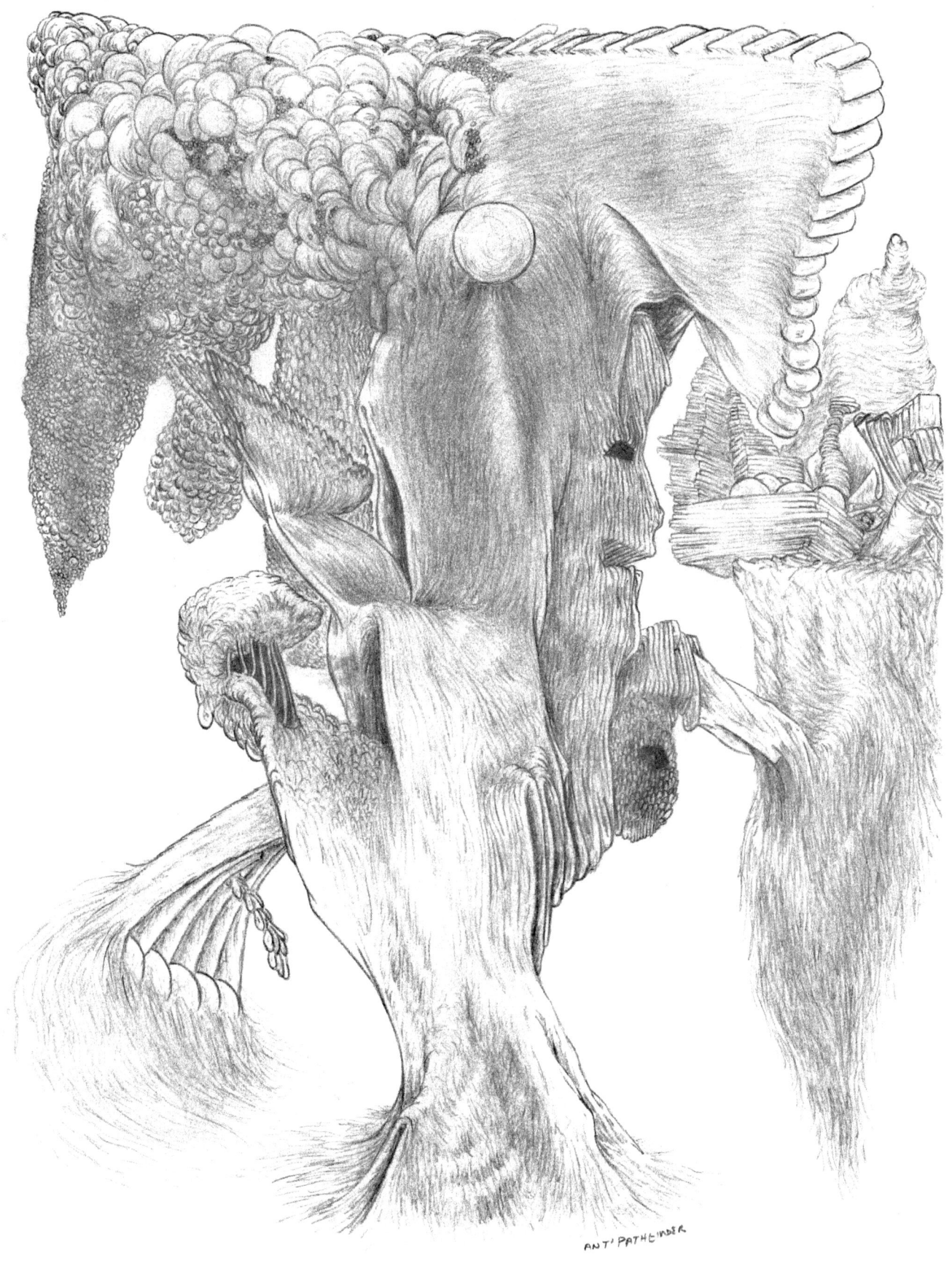

MUNDANE TREE

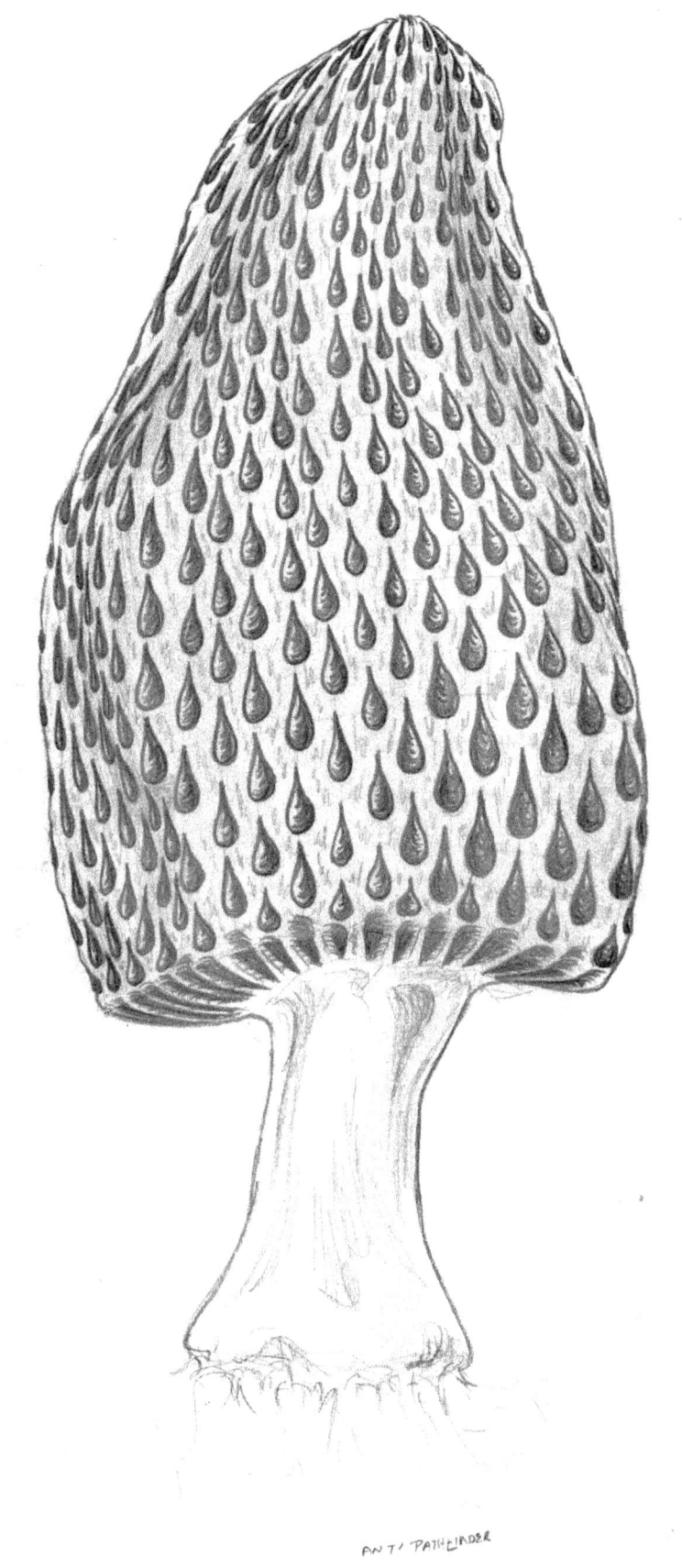

MUSHROOM OF LIFE

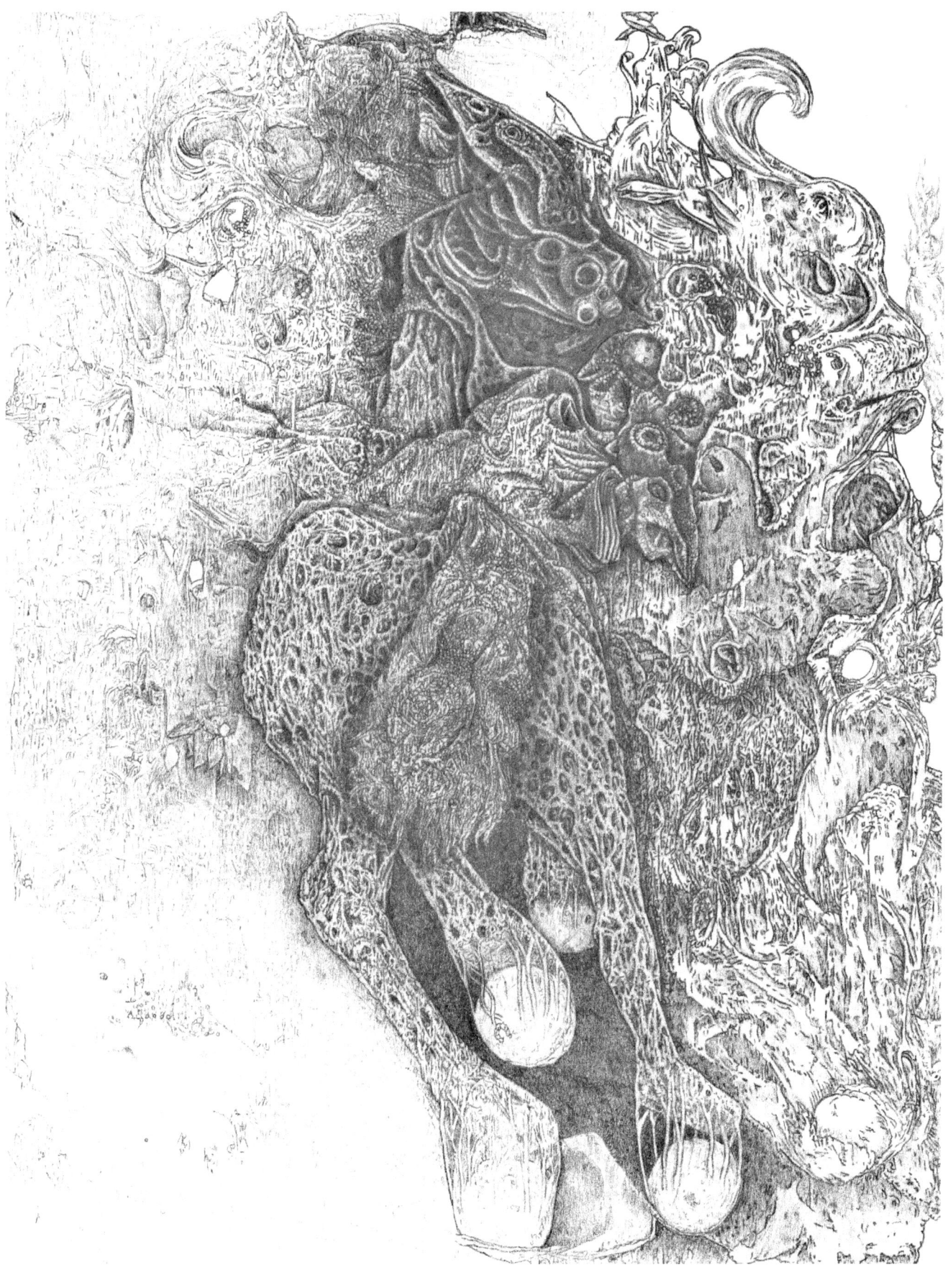

NIGHTMARE REALM ARMOR

WILD CARDS (NO O) P - Q

O: None

P: Paradox Blades; Paradox-Bound Knots aka Ezekiel's Wheel inside Paradox Pods of Prayer Conduit; Paradox Box; Paradox Conduit; Paradox Key is 1/3 forming Triple Key which unlocks Title Center; Paradox Sphere; Paradox Sword inside base of Inner Guardian; Passion Flower & Life Sack; Penthar Creature Child aka Captain of Shape; Pod of Cleansing; Portrait of Shape; Power Knot Chalice in Prayer Conduit; Power Point; Power Refined; Power Unrefined; Prayer Conduit found with many things; Pride's Belt Buckle; Proto-Type Destiny Egg Trio & Realities Orb; Psychic Probe.

Q: Quark Ecosystem with Dhakhas & Dorges 'Coccus; Quicksilver Nugget aka JC's Credit Card.

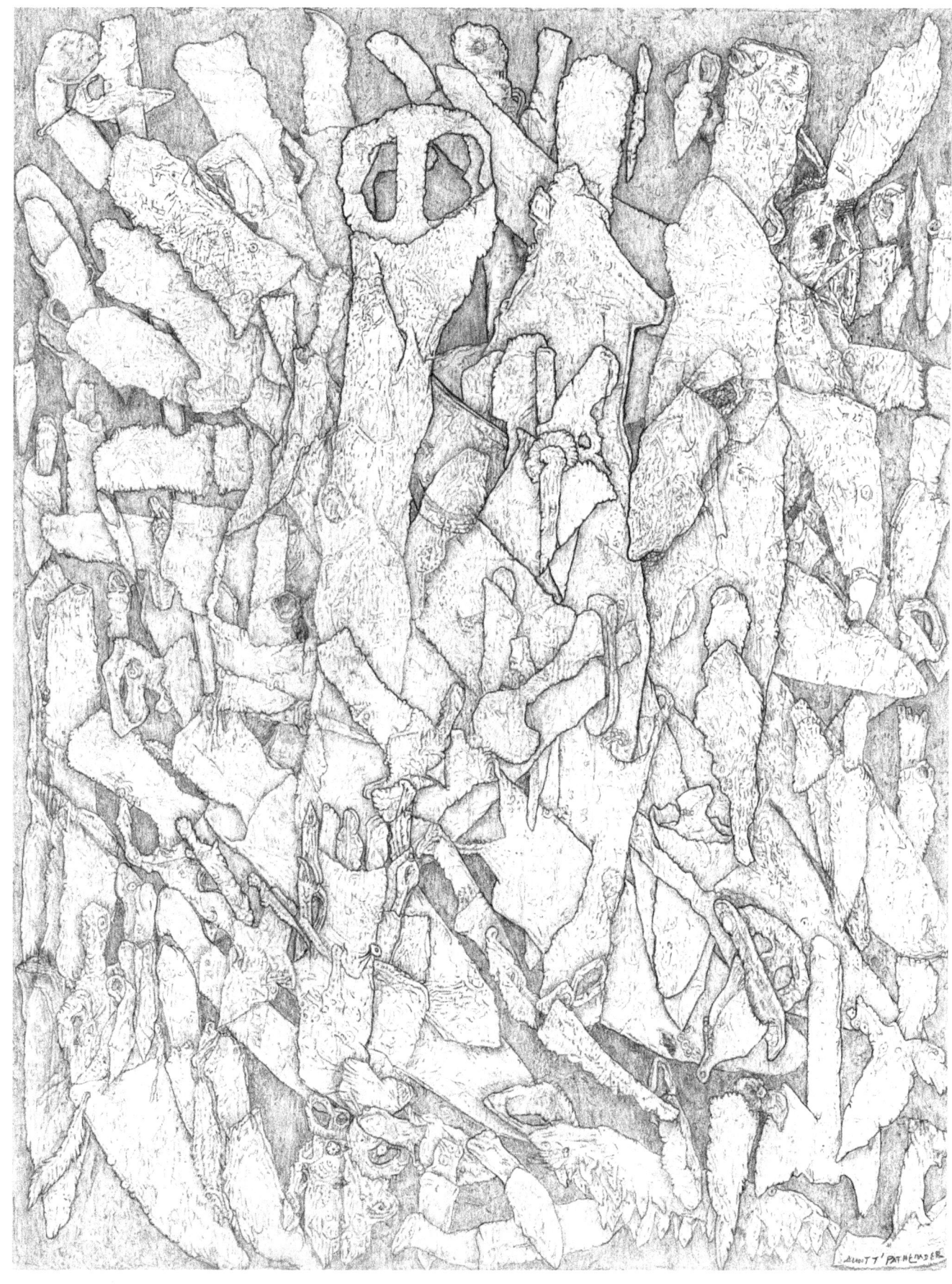

PARADOX BLADES

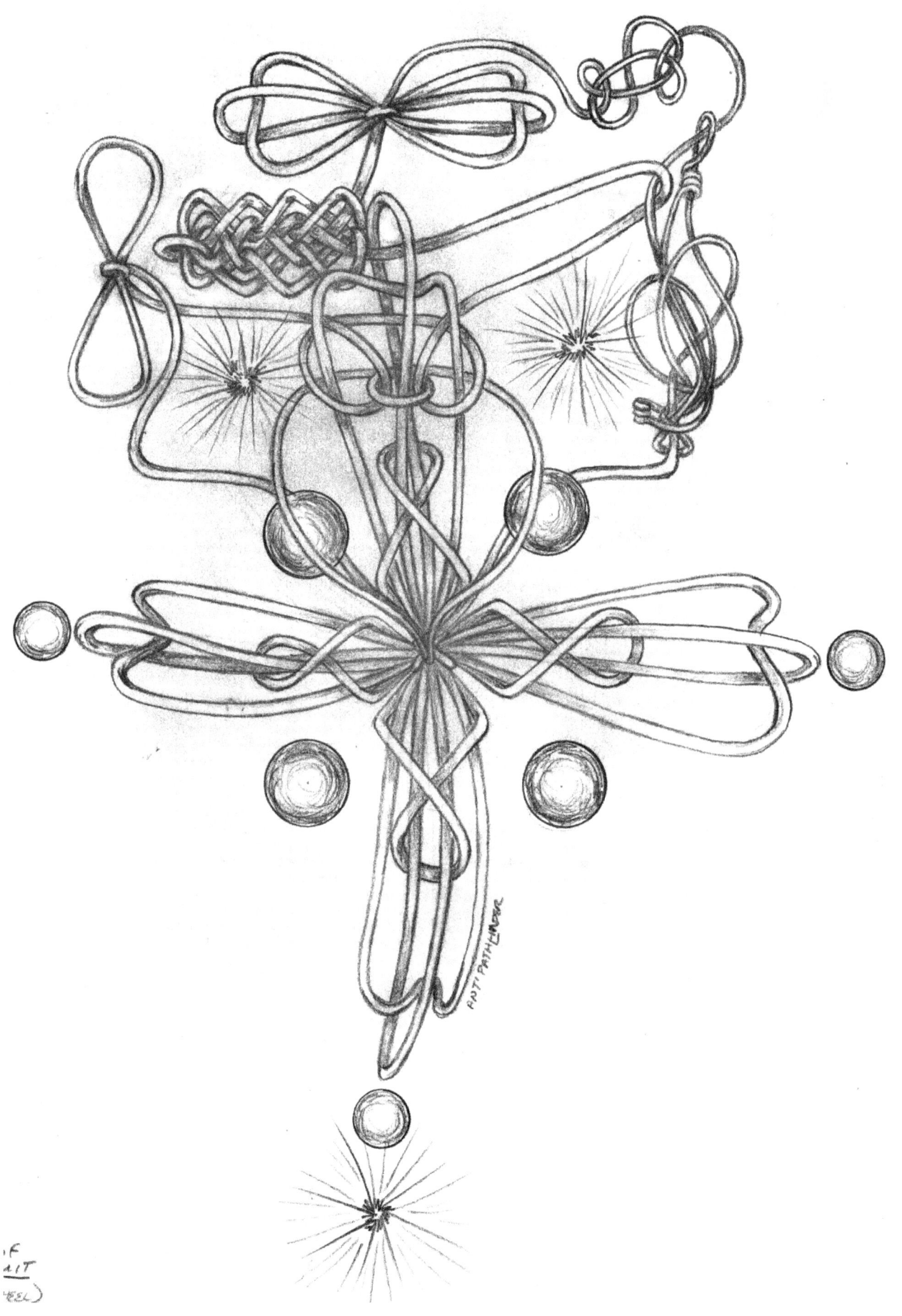

PARADOX BOUND KNOTS AKA EZEKIEL'S WHEEL, FOUND INSIDE PARADOX PODS OF PRAYER CONDUIT

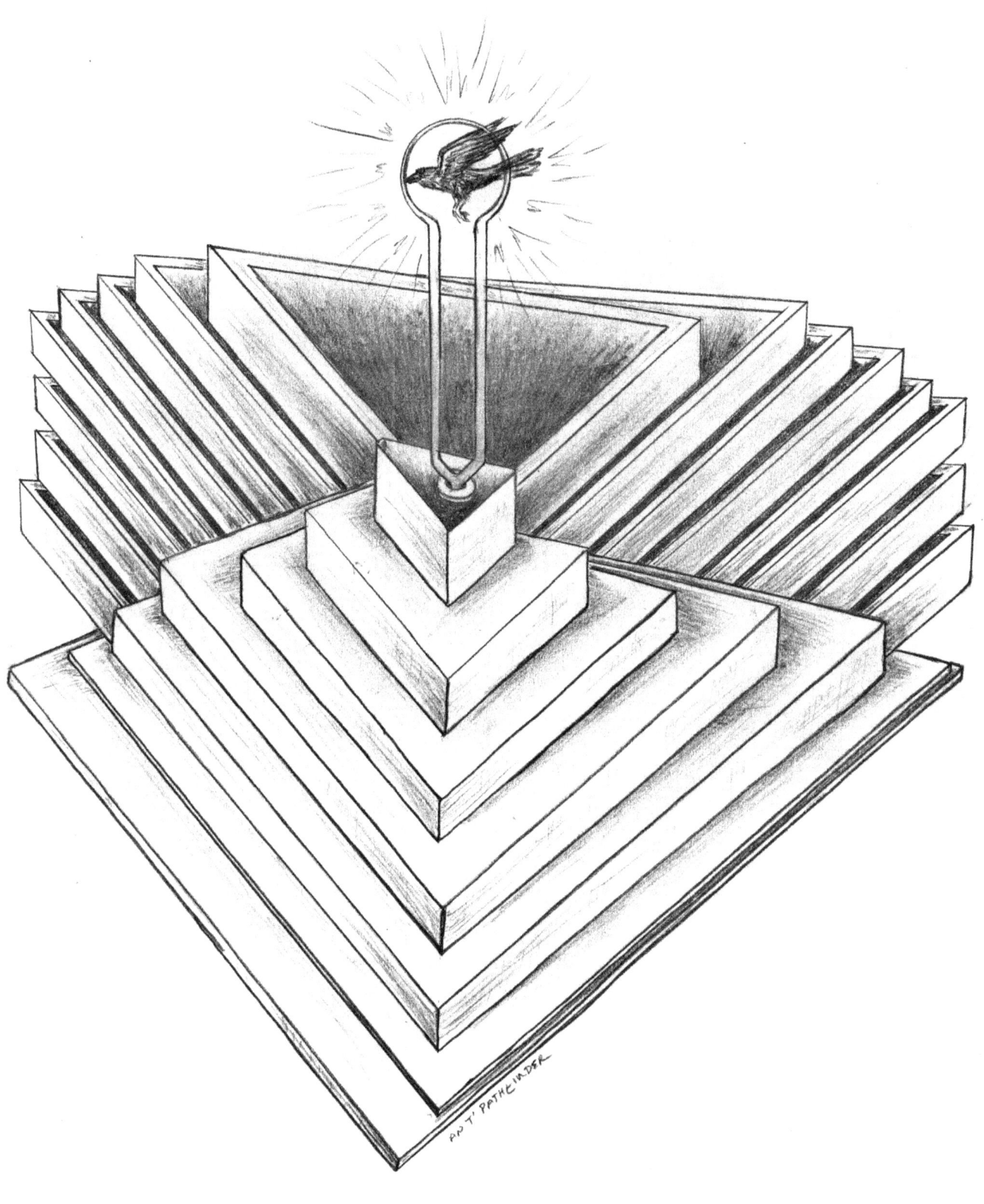

PARADOX BOX

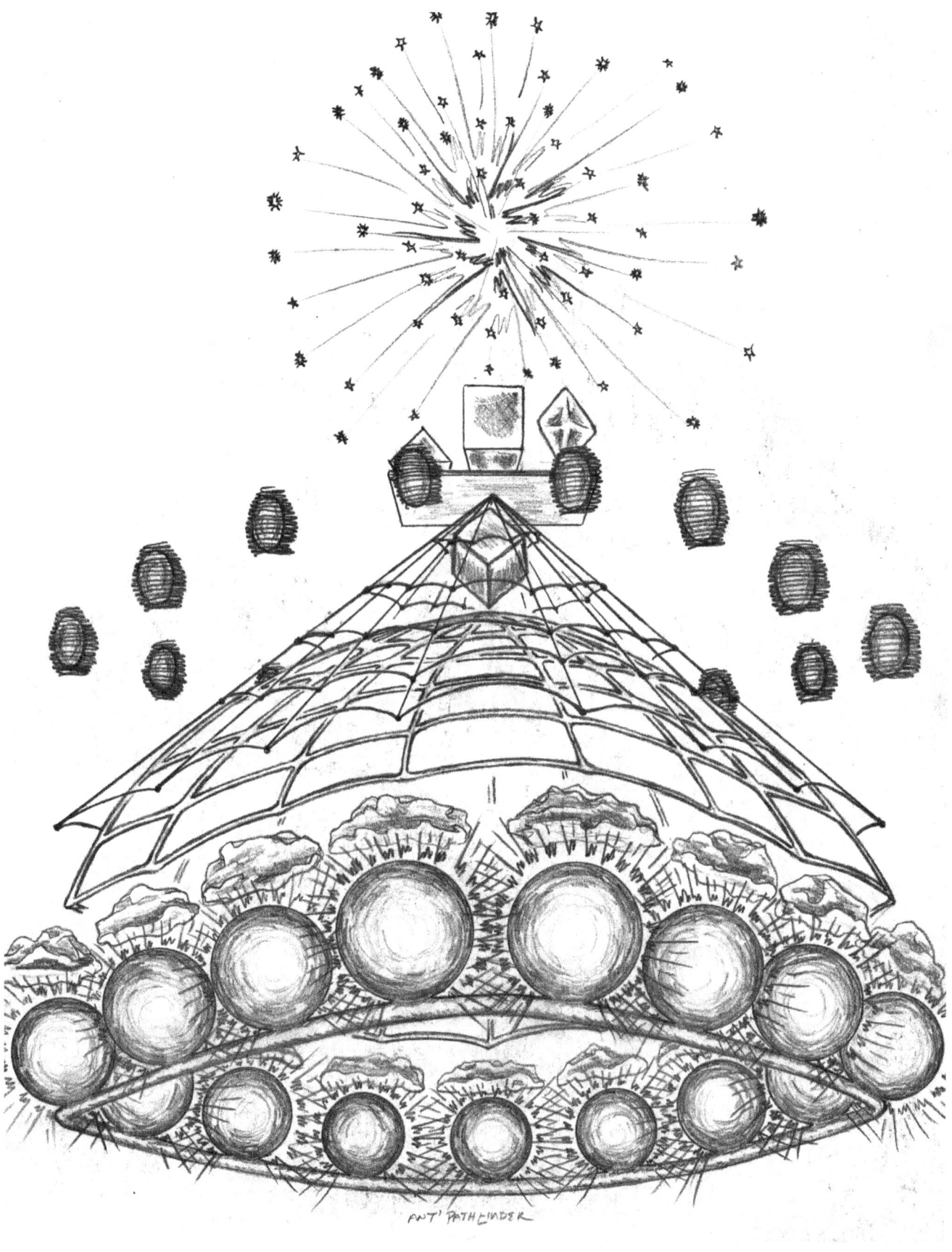

PARADOX CONDUIT

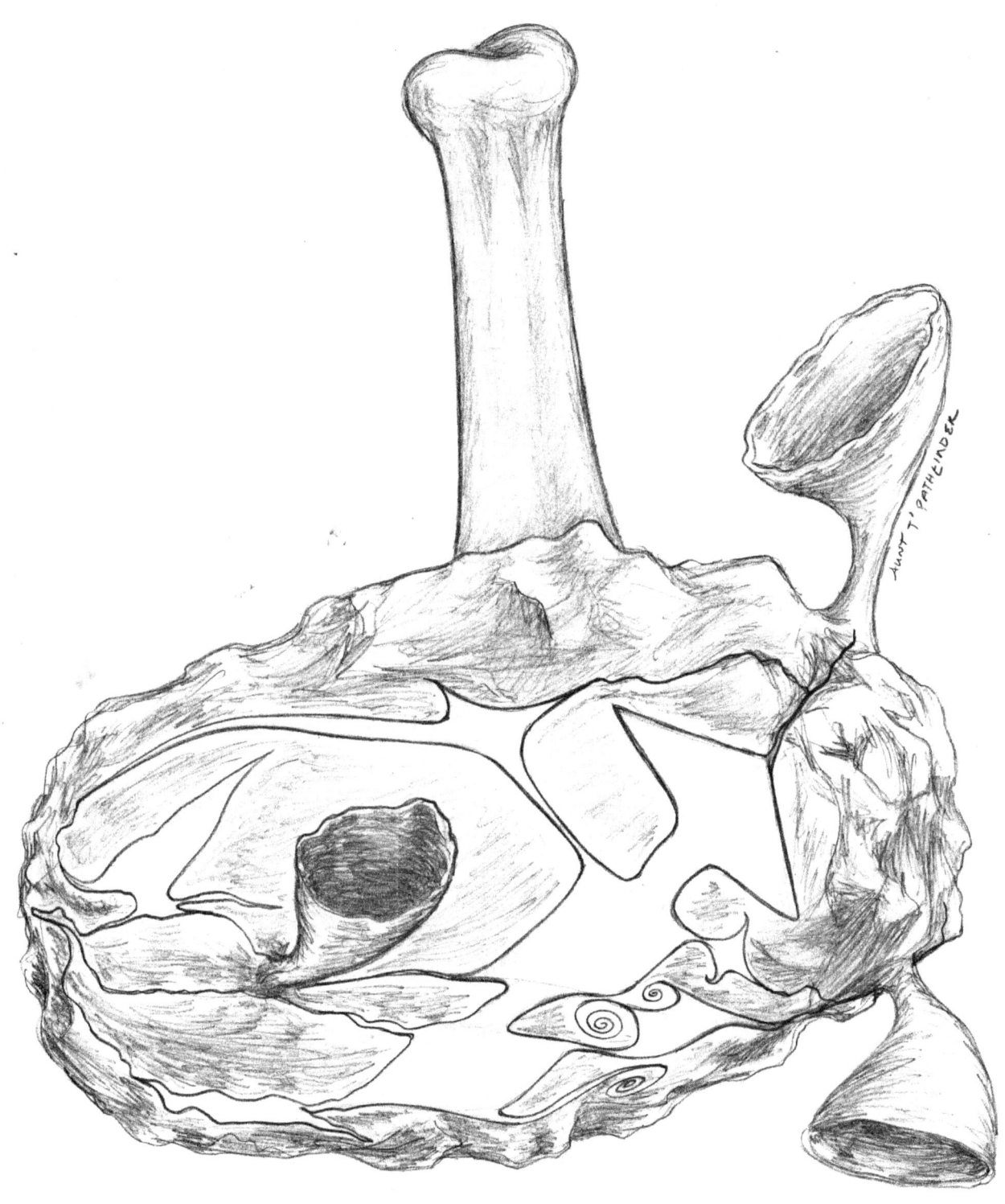

PARADOX KEY
1/3 OF TRIPLE KEY
WHICH UNLOCKS TITLE CENTER
← BOTTOM

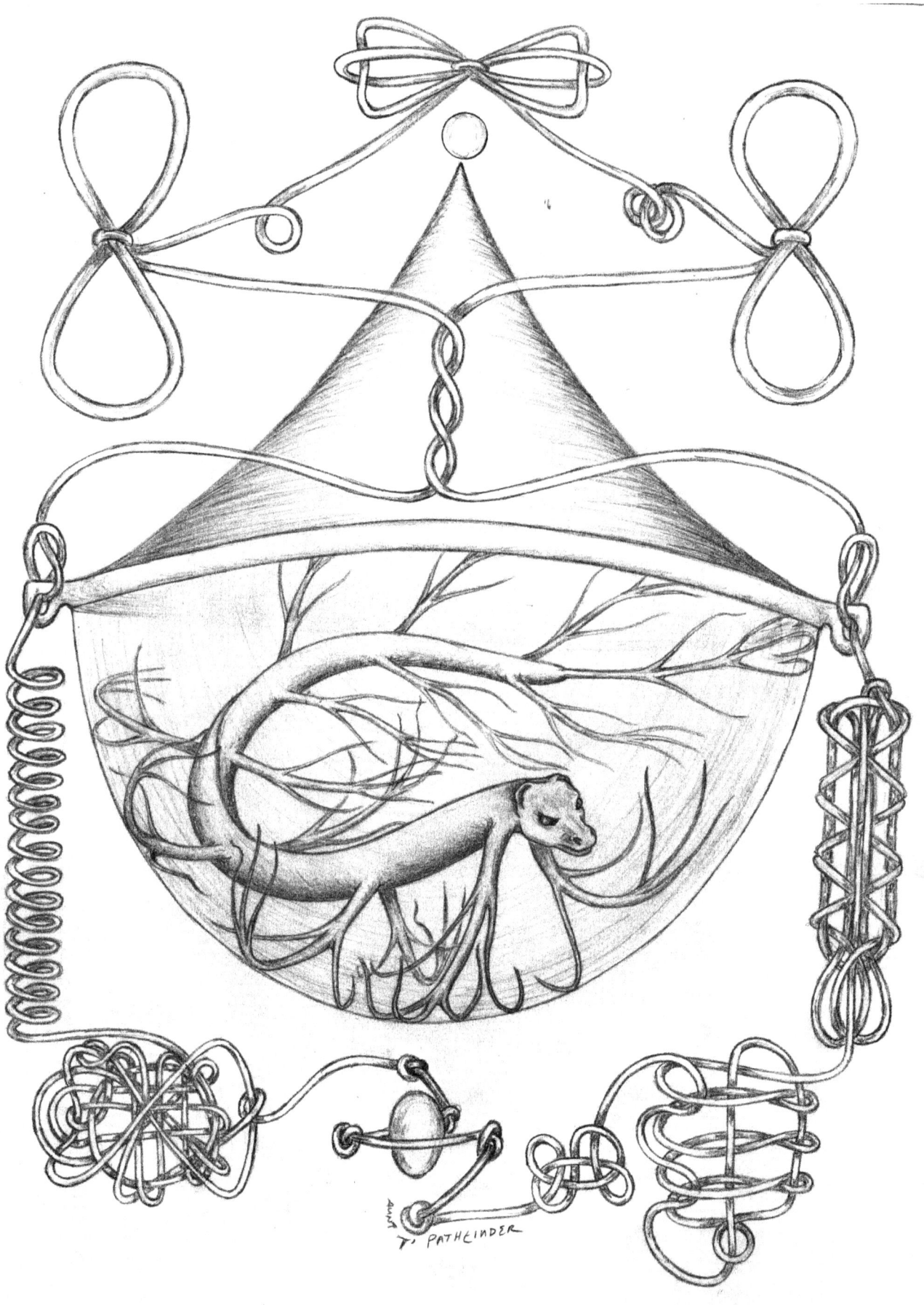

PARADOX SPHERE

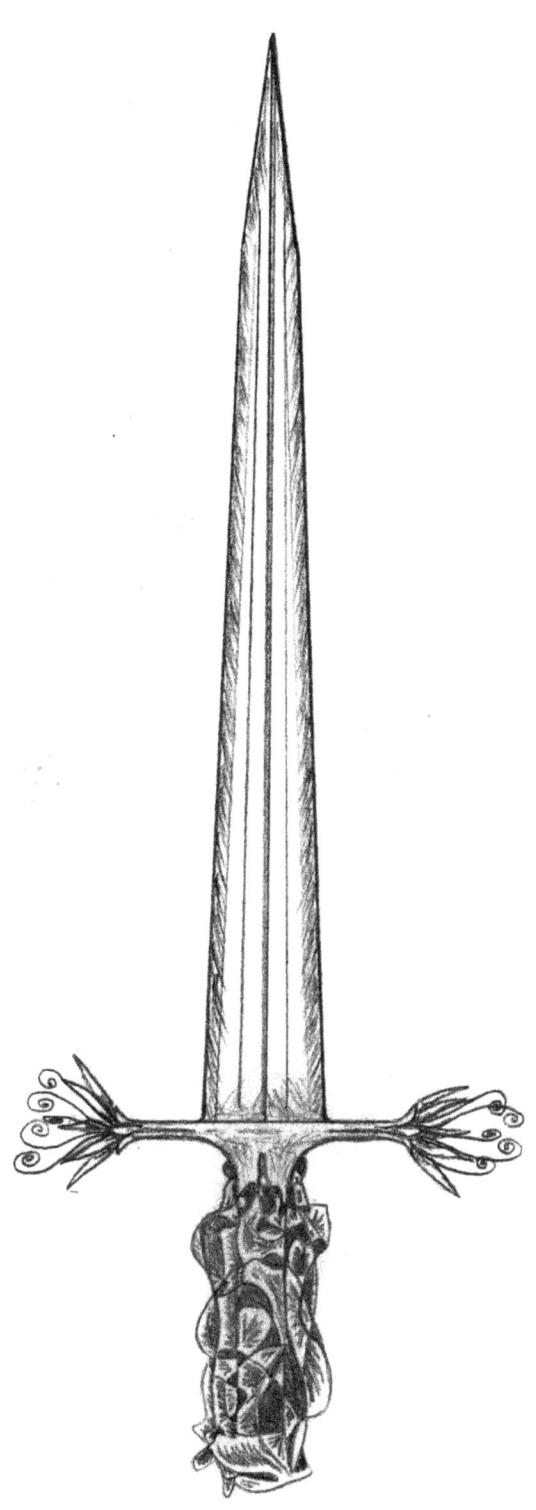

ANT'PATHFINDER

PARADOX SWORD
INSIDE BASE OF INNER GUARDIAN

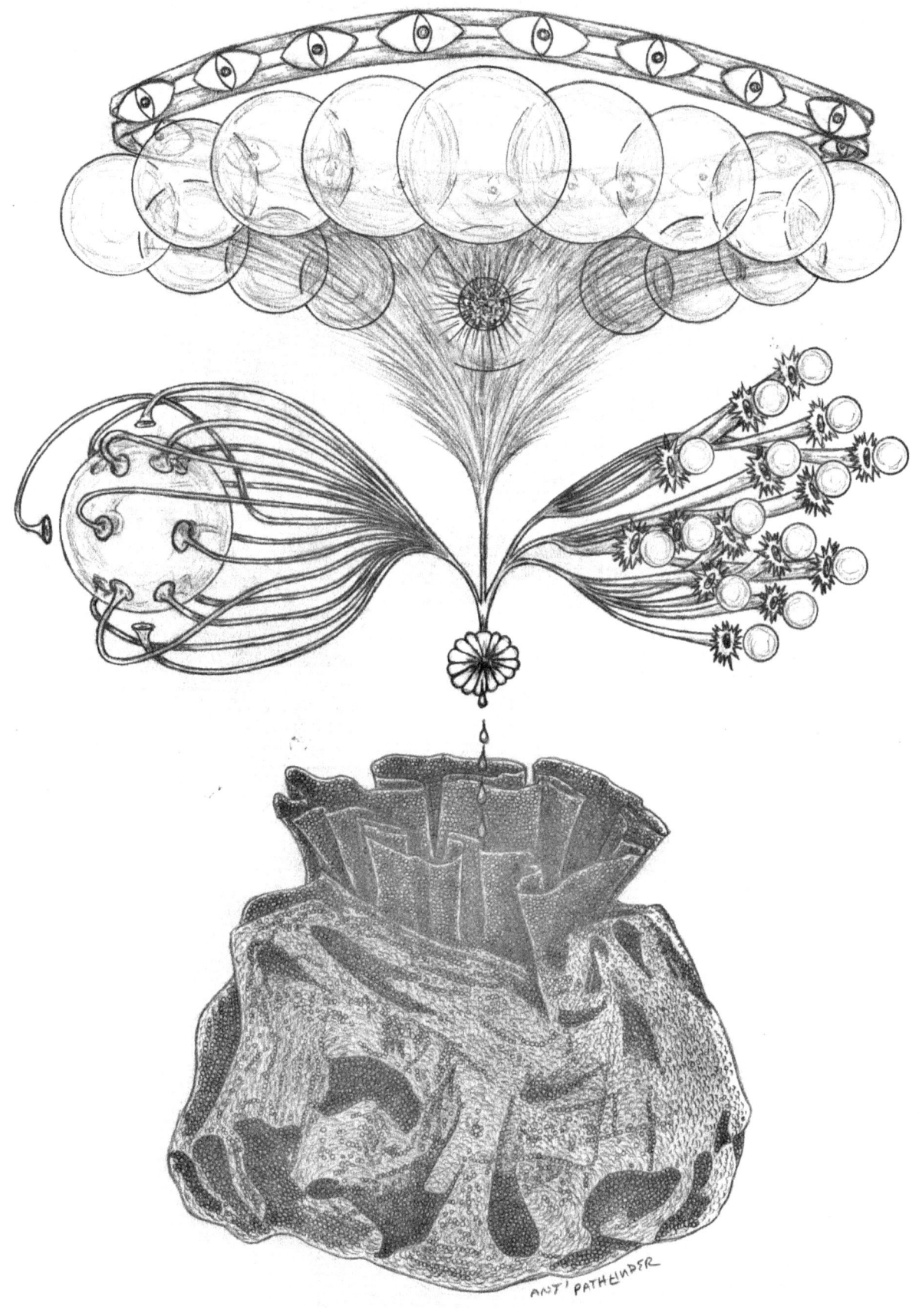

PASSION FLOWER & LIFE SACK

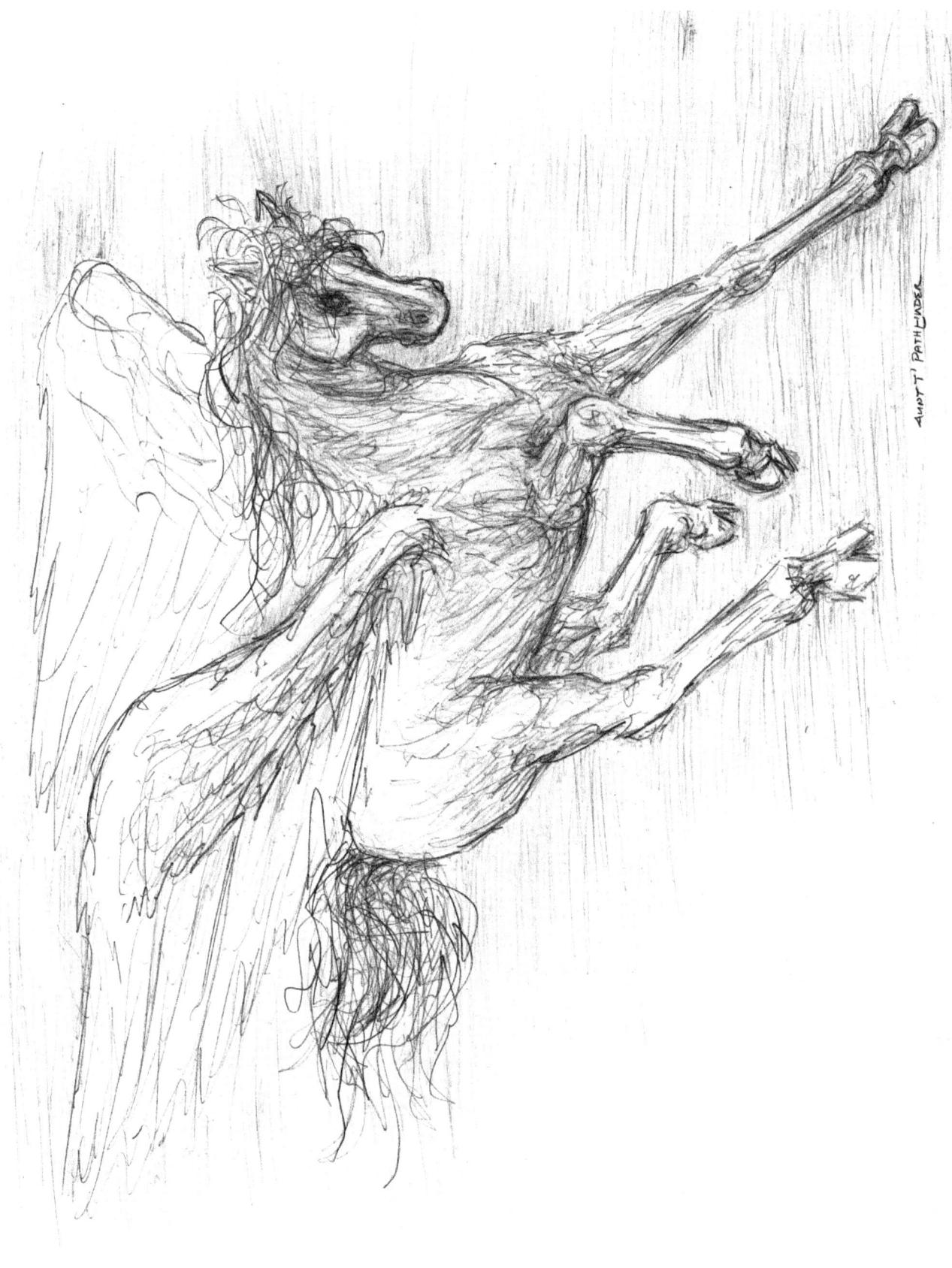

PENTHAR CREATURE CHILD AKA CAPTAIN OF SHAPE

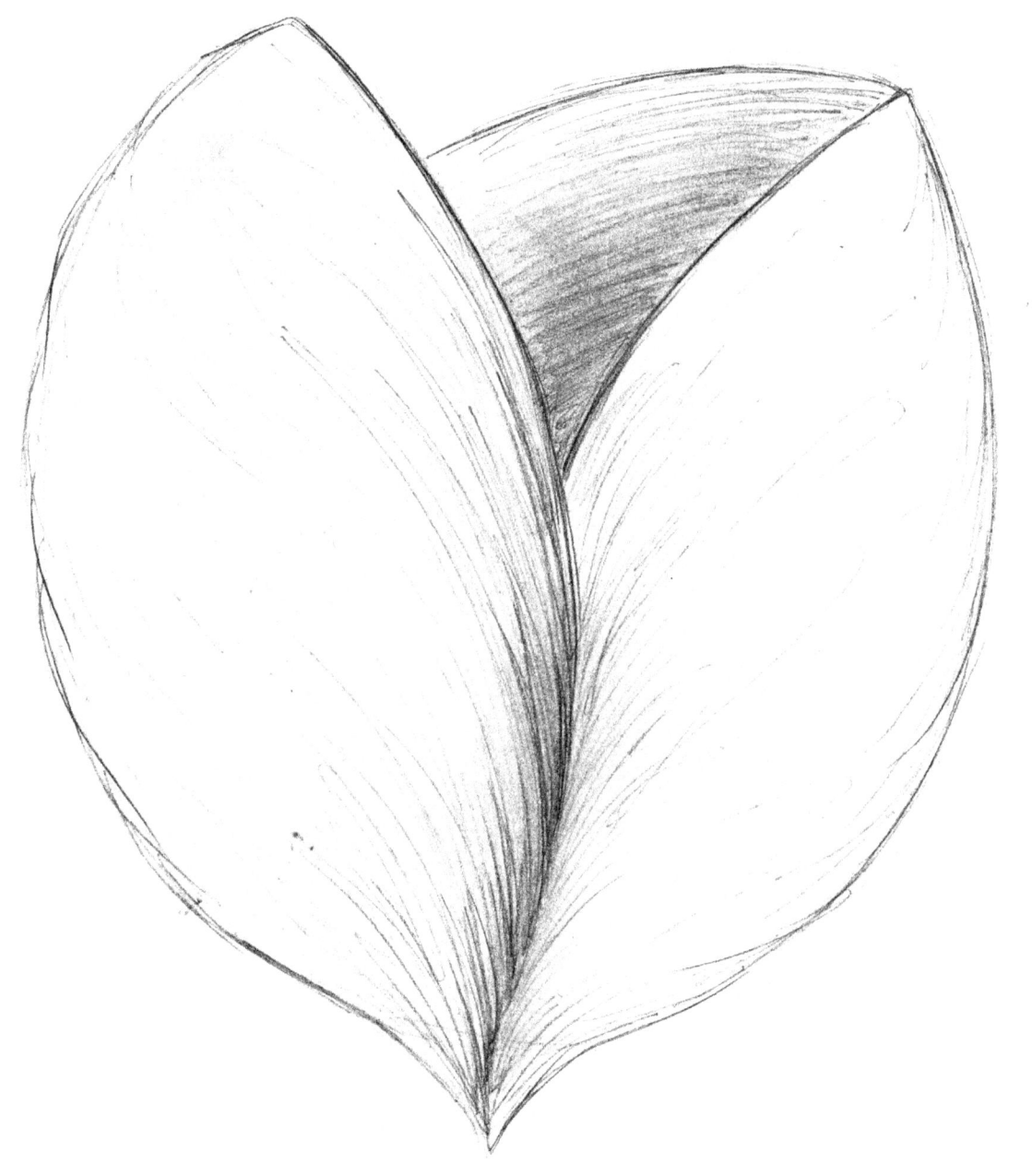

POD OF CLEANSING

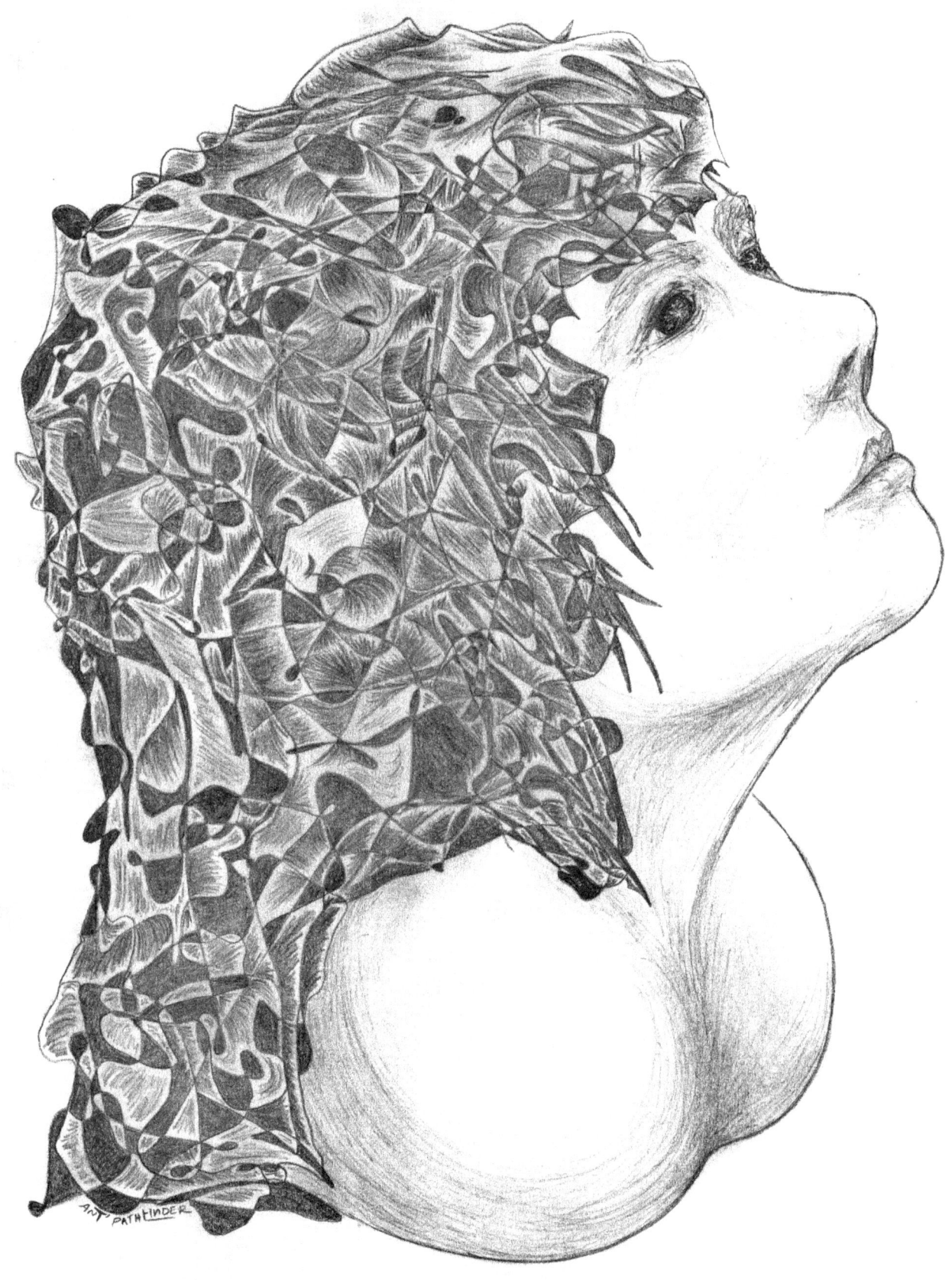

PORTRAIT OF SHAPE

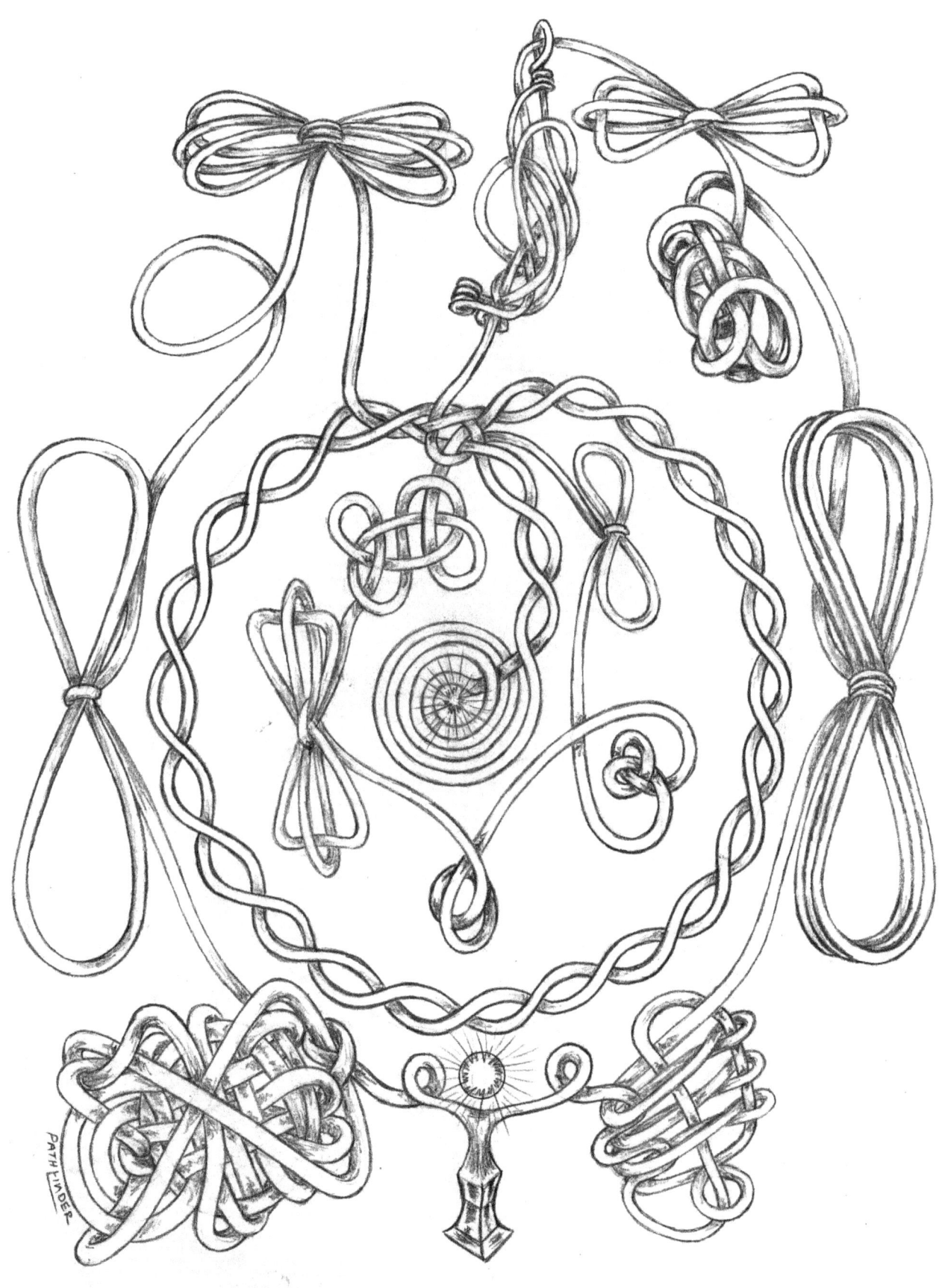

POWER KNOT CHALICE
FOUND INSIDE PRAYER CONDUIT

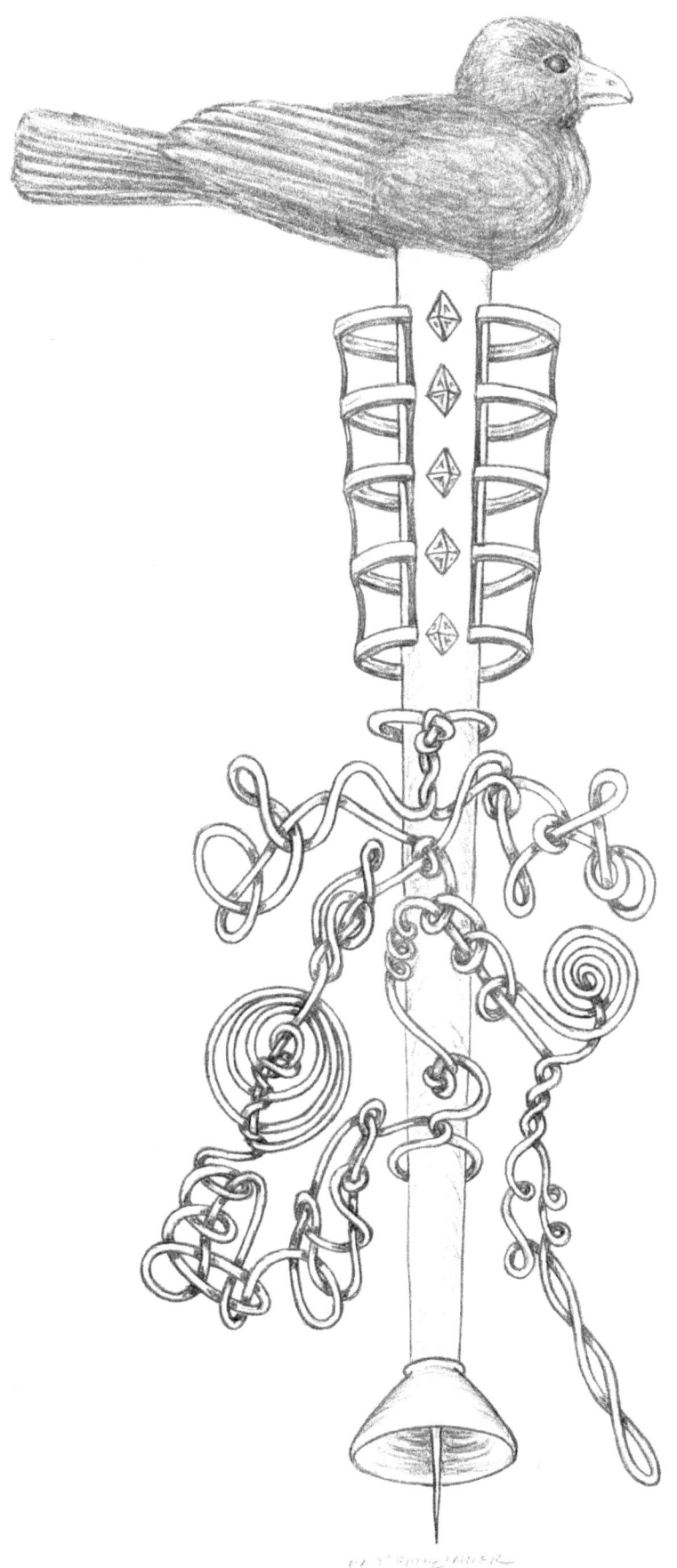

POWER POINT

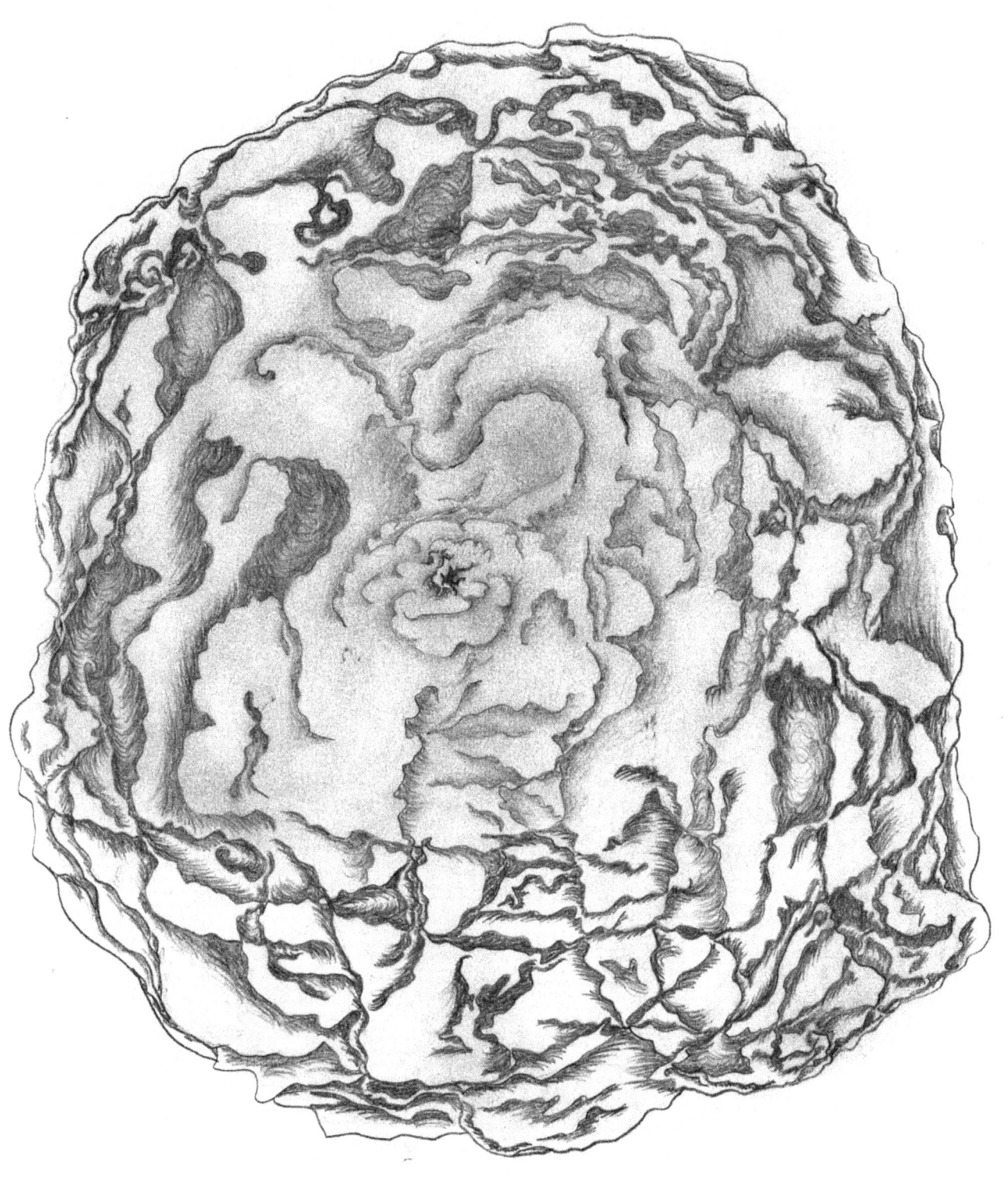

POWER REFINED

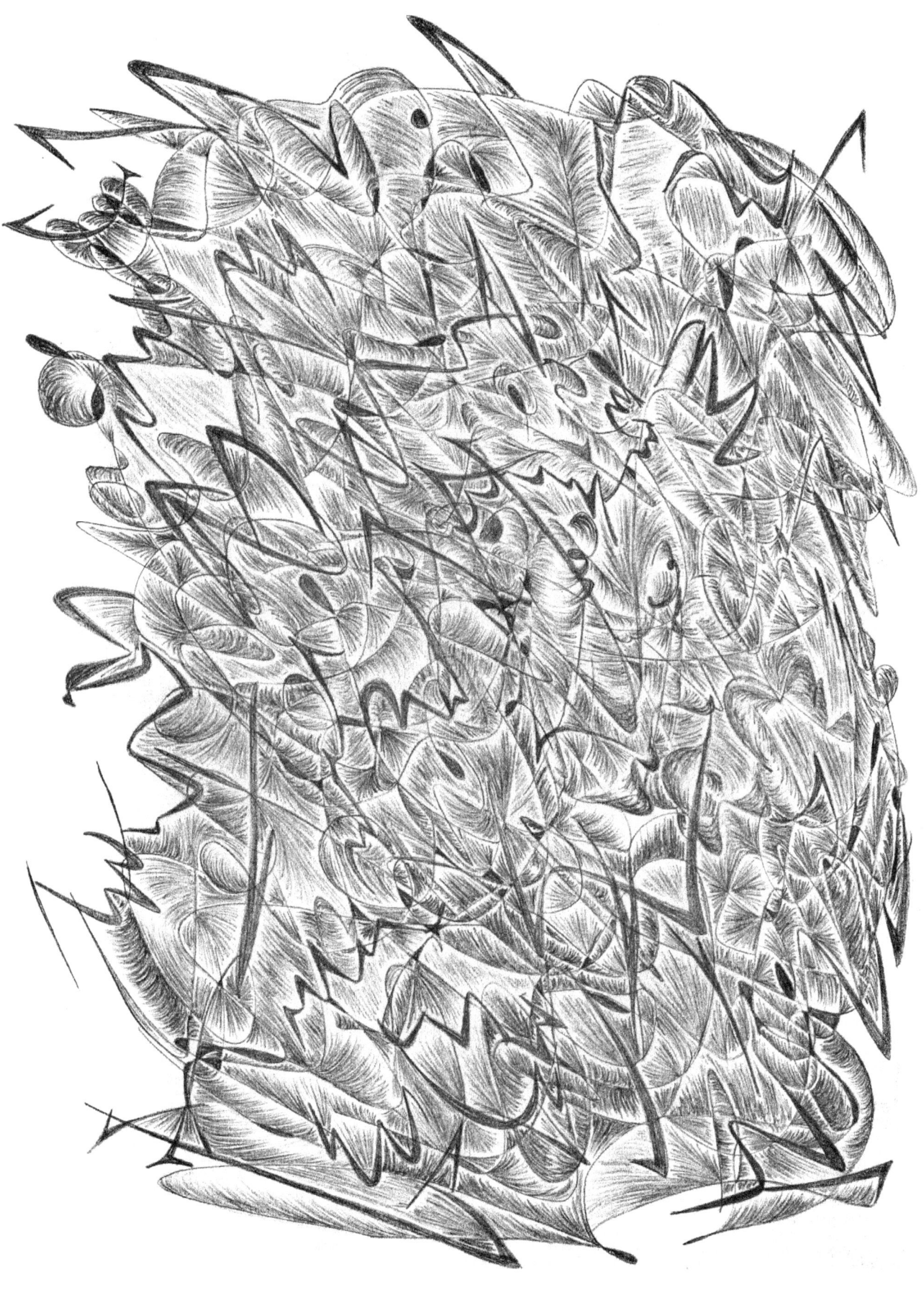

POWER UNREFINED

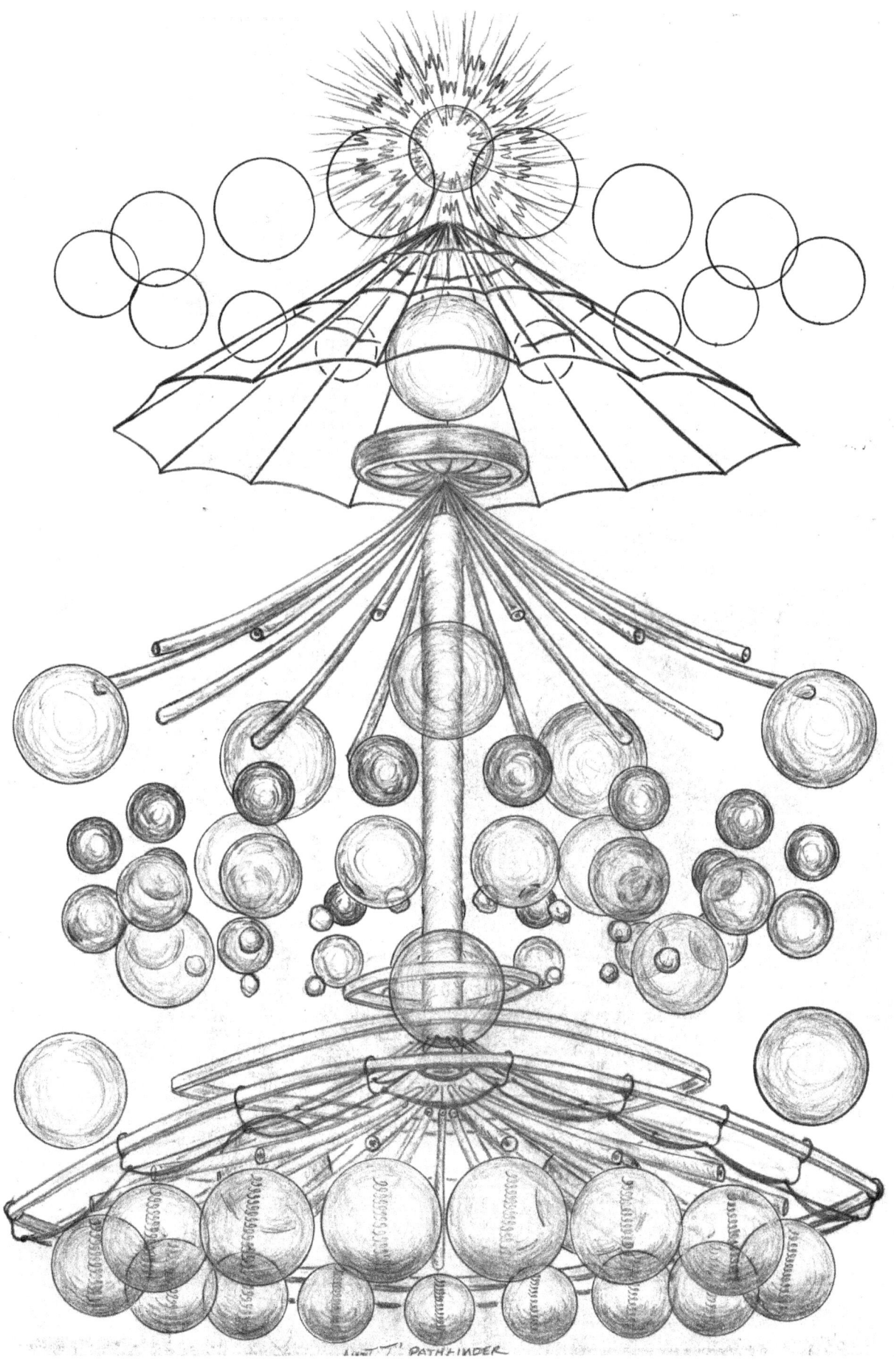

PRAYER CONDUIT
FOUND WITH MANY THINGS

PRIDE'S BELT BUCKLE

PROTO-TYPE DESTINY EGG TRIO & REALITIES ORB

PSYCHIC PROBE

QUARK ECOSYSTEM
WITH DHAKHAS & DORGES 'COCCUS

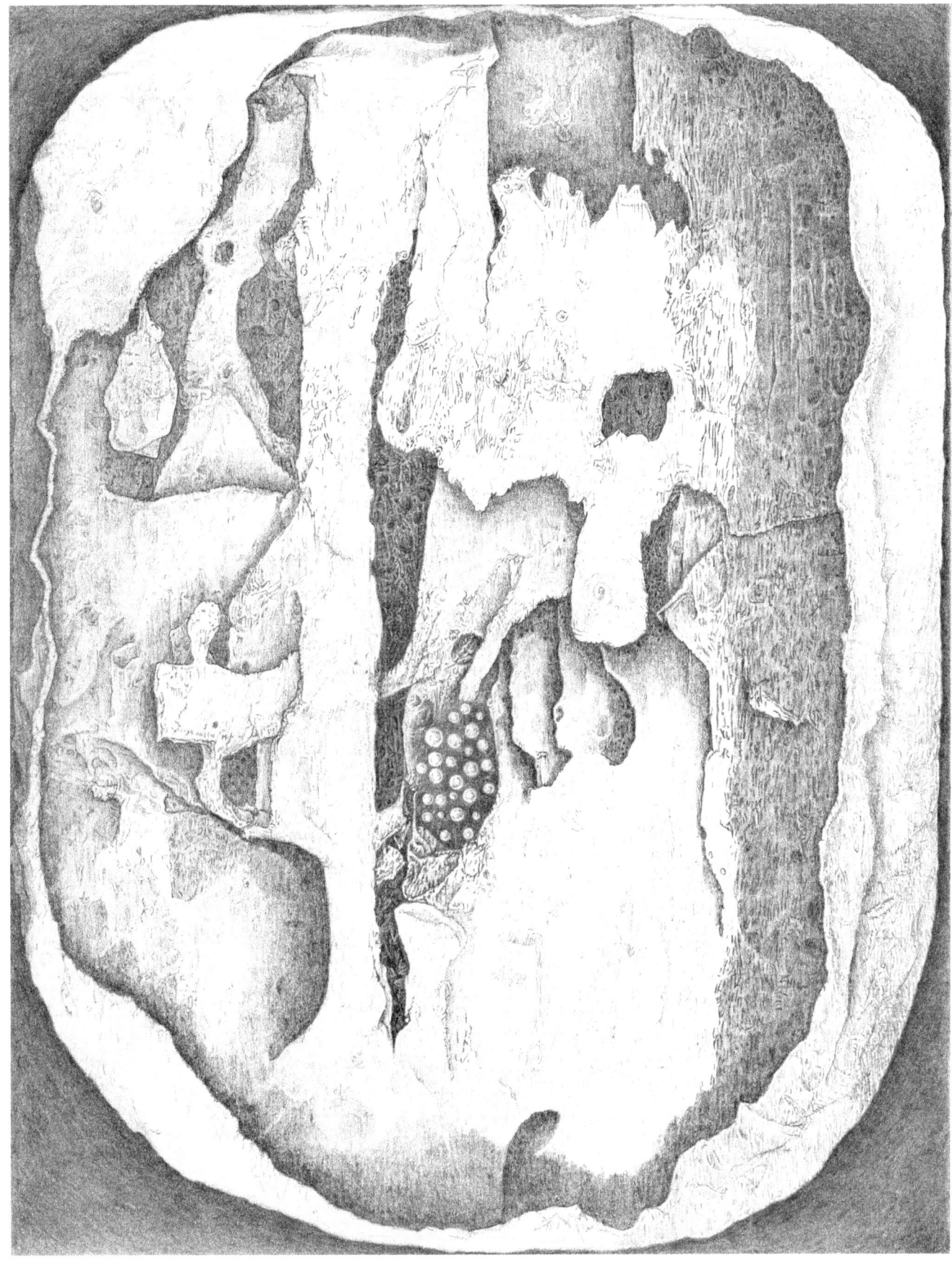

QUICKSILVER NUGGET AKA JC'S CREDIT CARD

WILD CARDS R - S

R: Raven of Magic; Raw Power Saw with Zio Orbs; Reactive Mind aka Intruder Trap; Reality Conduit; Reaper Armor & Guard Bird; Ring of Binding Command; Rye Seed Canal.

S: Scars Barrow Masks; Scroll of Life; Seat of Justice aka Dream Catcher; Self-Command Flame; Sentinel's Tower aka Scales of Desire aka Antiquity's Blood Fountain; Soul's Lead Window; Space Knot Orbs in Prayer Conduit; Splinter Scoop aka 2^{nd} Generation Channel; Sponge Doll; Staff of Form; Staff of Law & Command Cap found with Guardian Pipes; Stallion of Balance; Starch Tree; Sub-Atomic Command Lamps; Sub-Quark Ecosystem & 'Coccus Grazer.

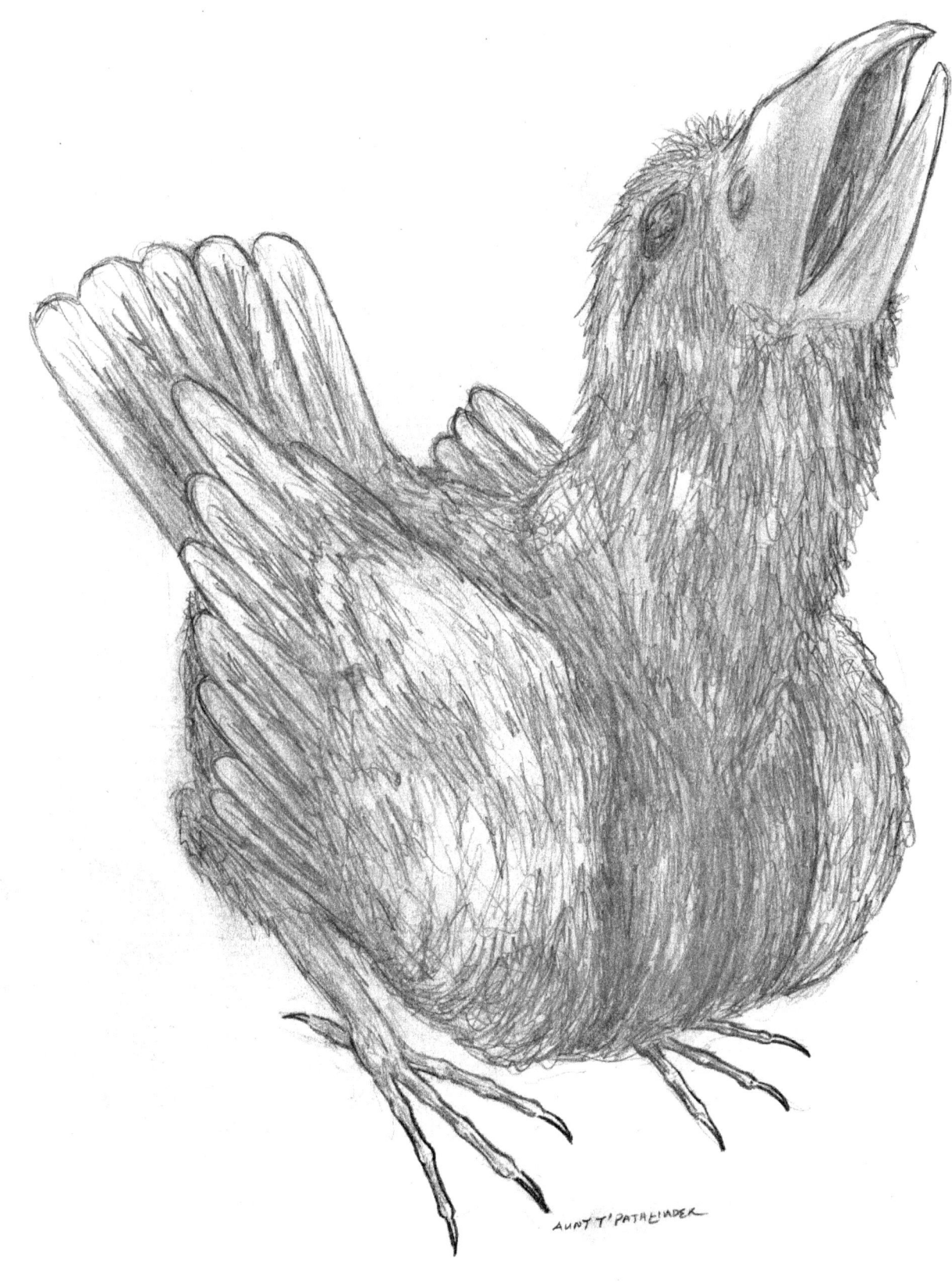

RAVEN OF MAGIC

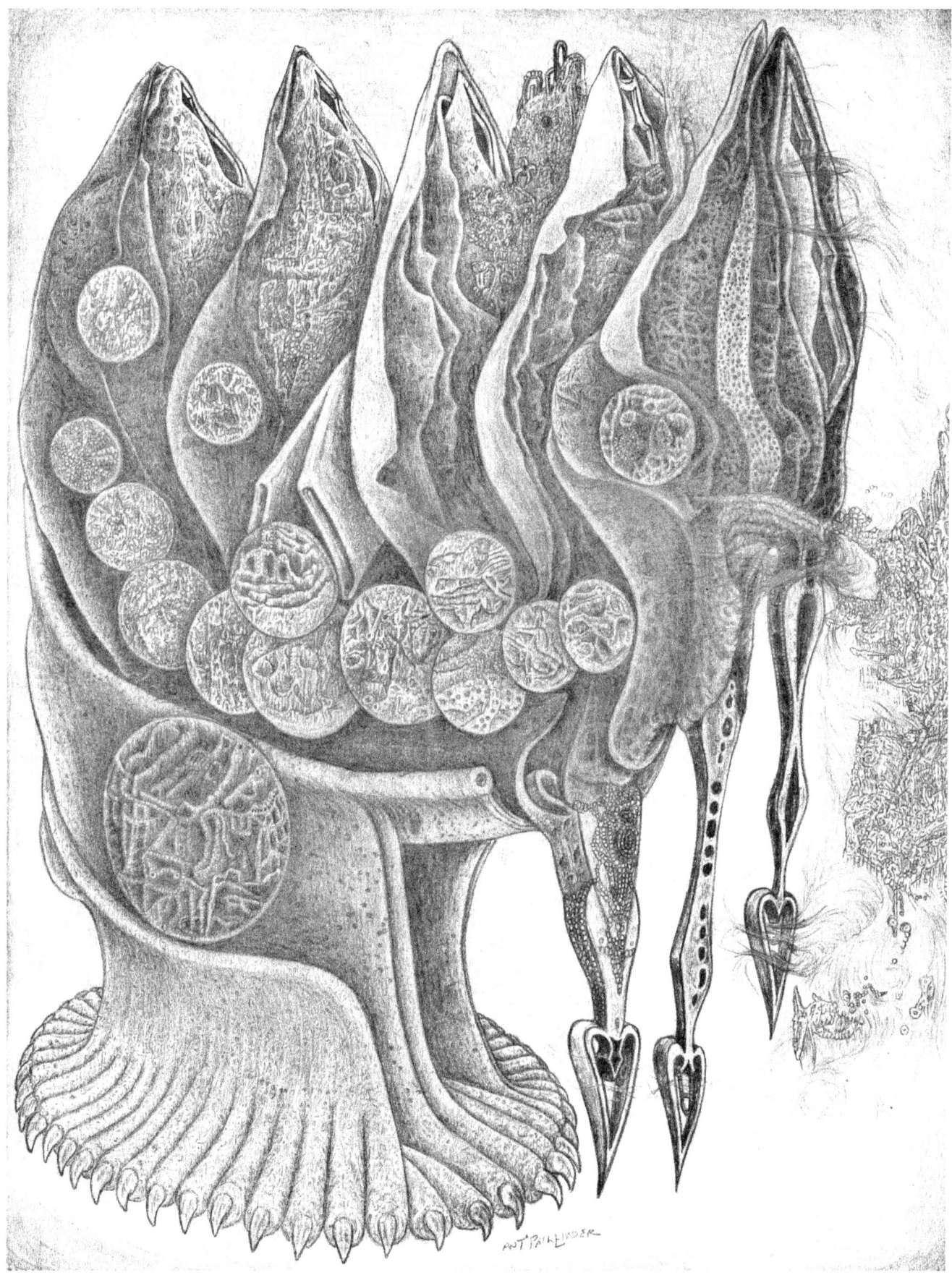

RAW POWER SAW WITH ZIO CRYSTALS

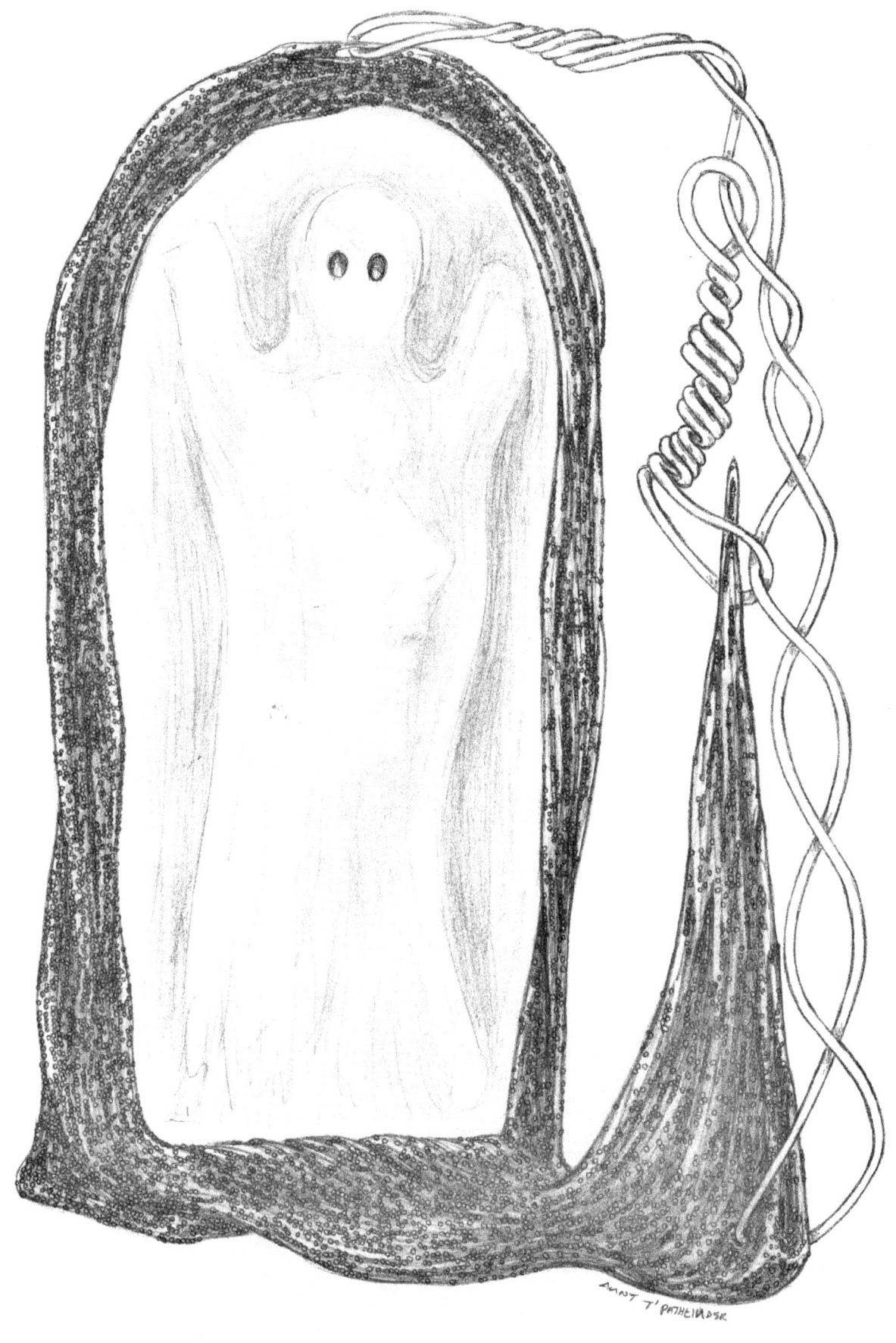

REACTIVE MIND AKA INTRUDER TRAP

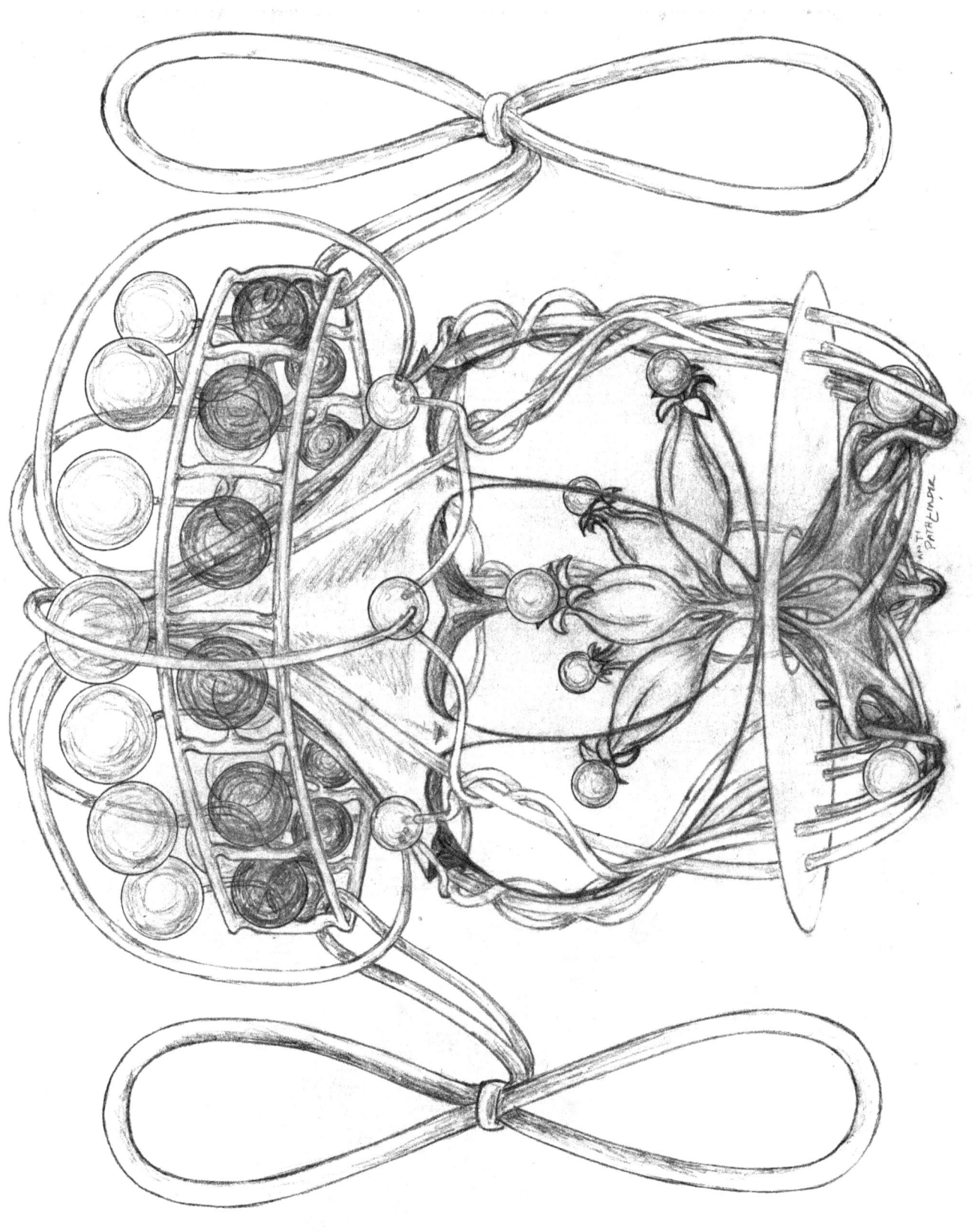

REALITY CONDUIT
← BOTTOM

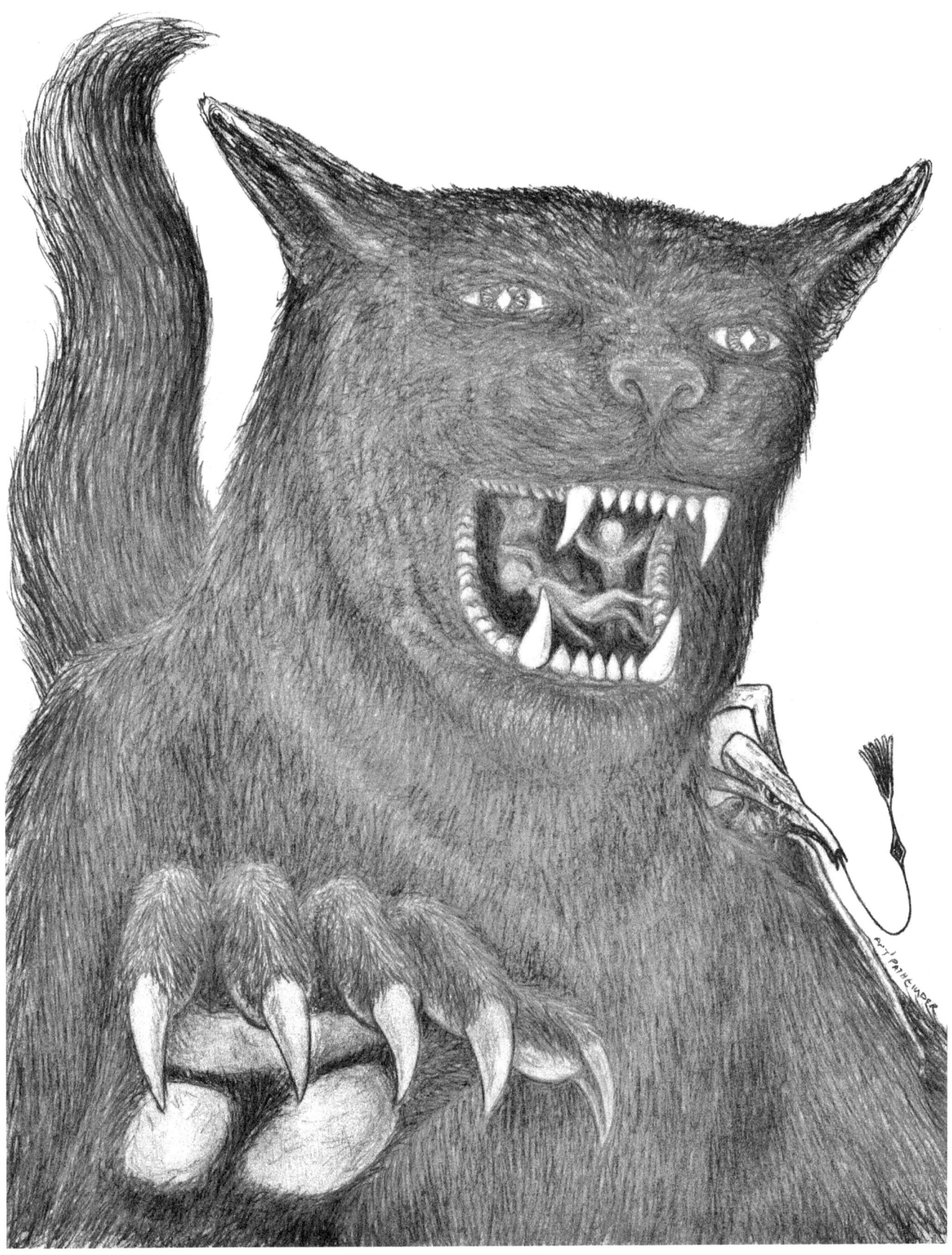

REAPER ARMOR & GUARD BIRD

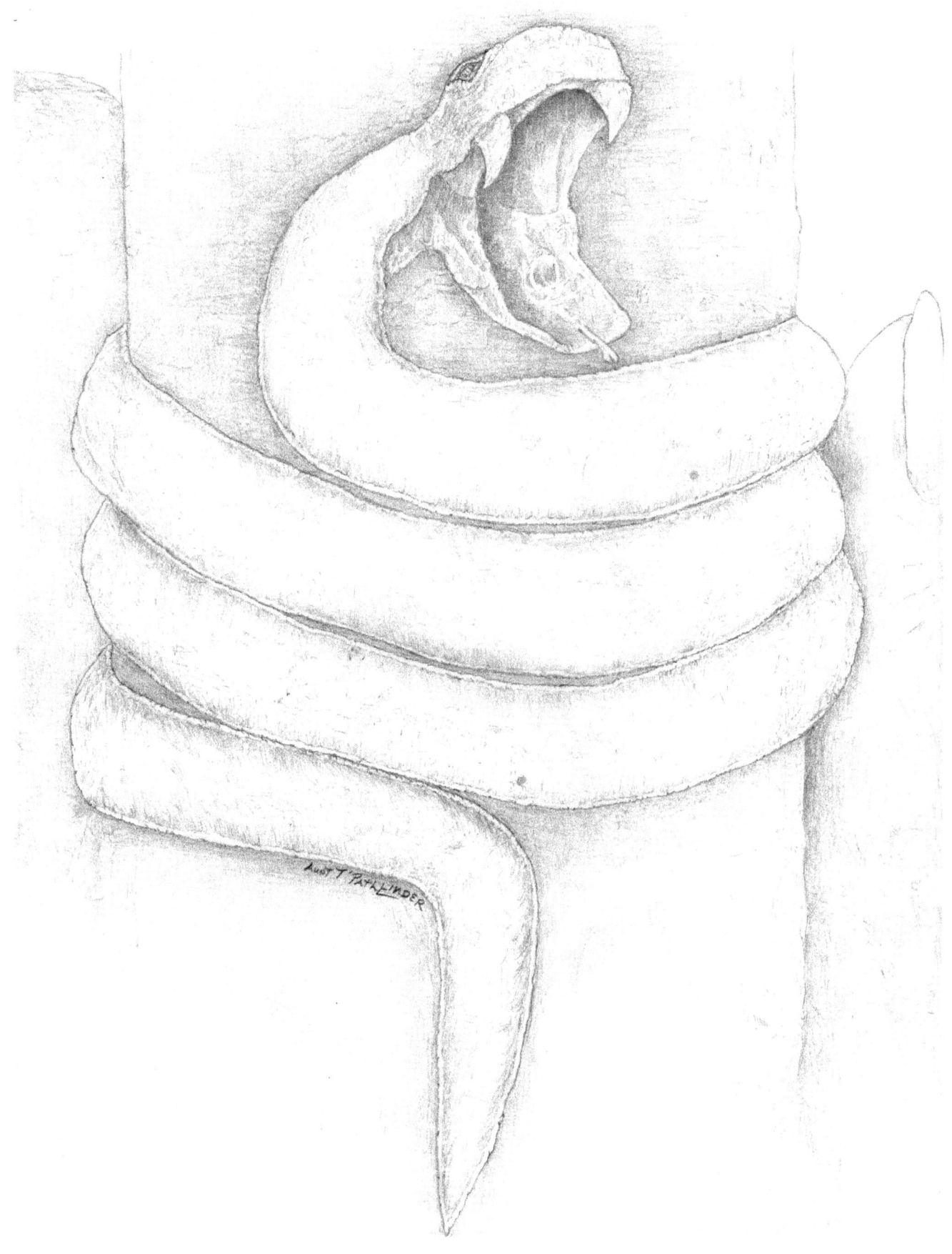

RING OF BINDING COMMAND

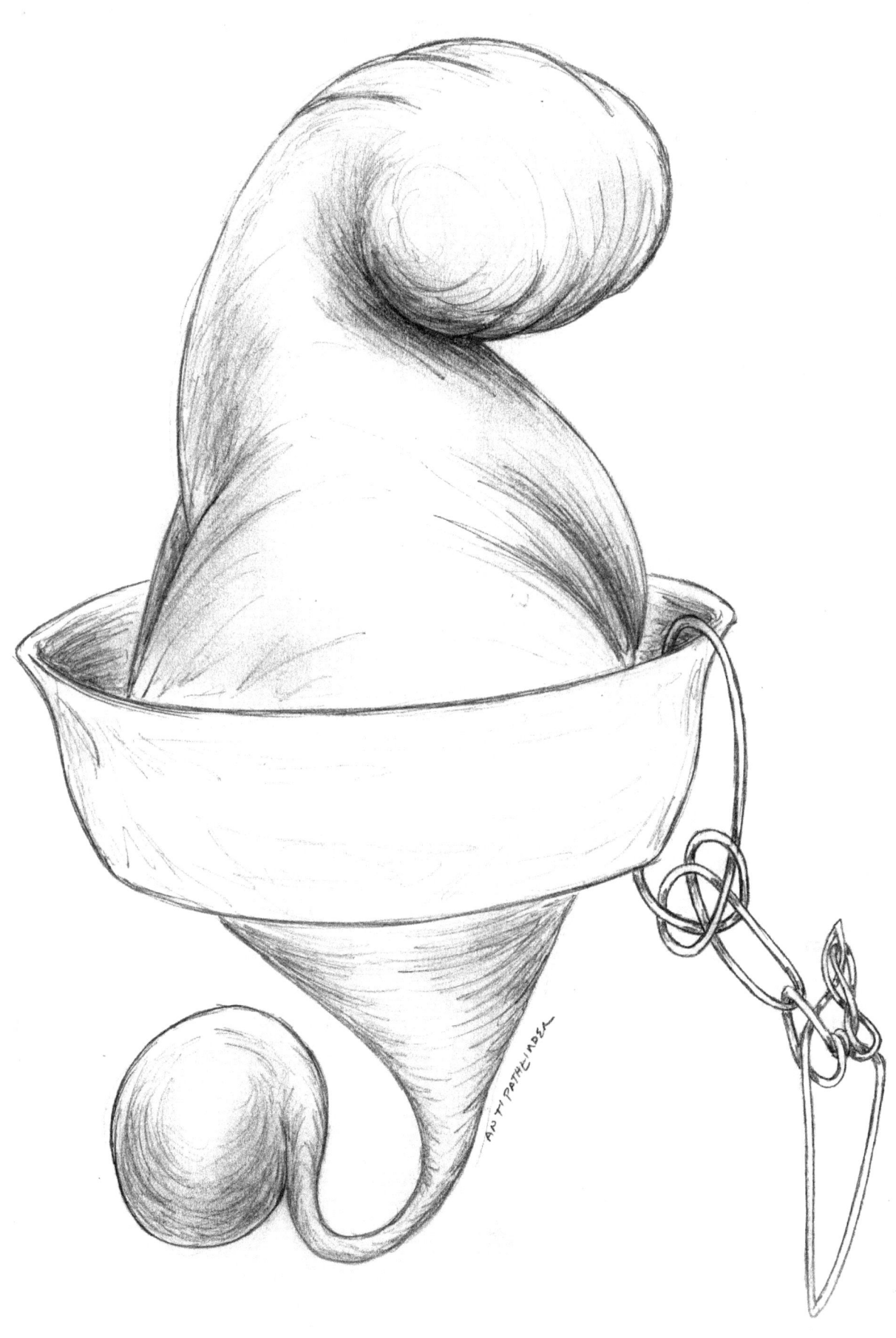

RYE SEED CANAL

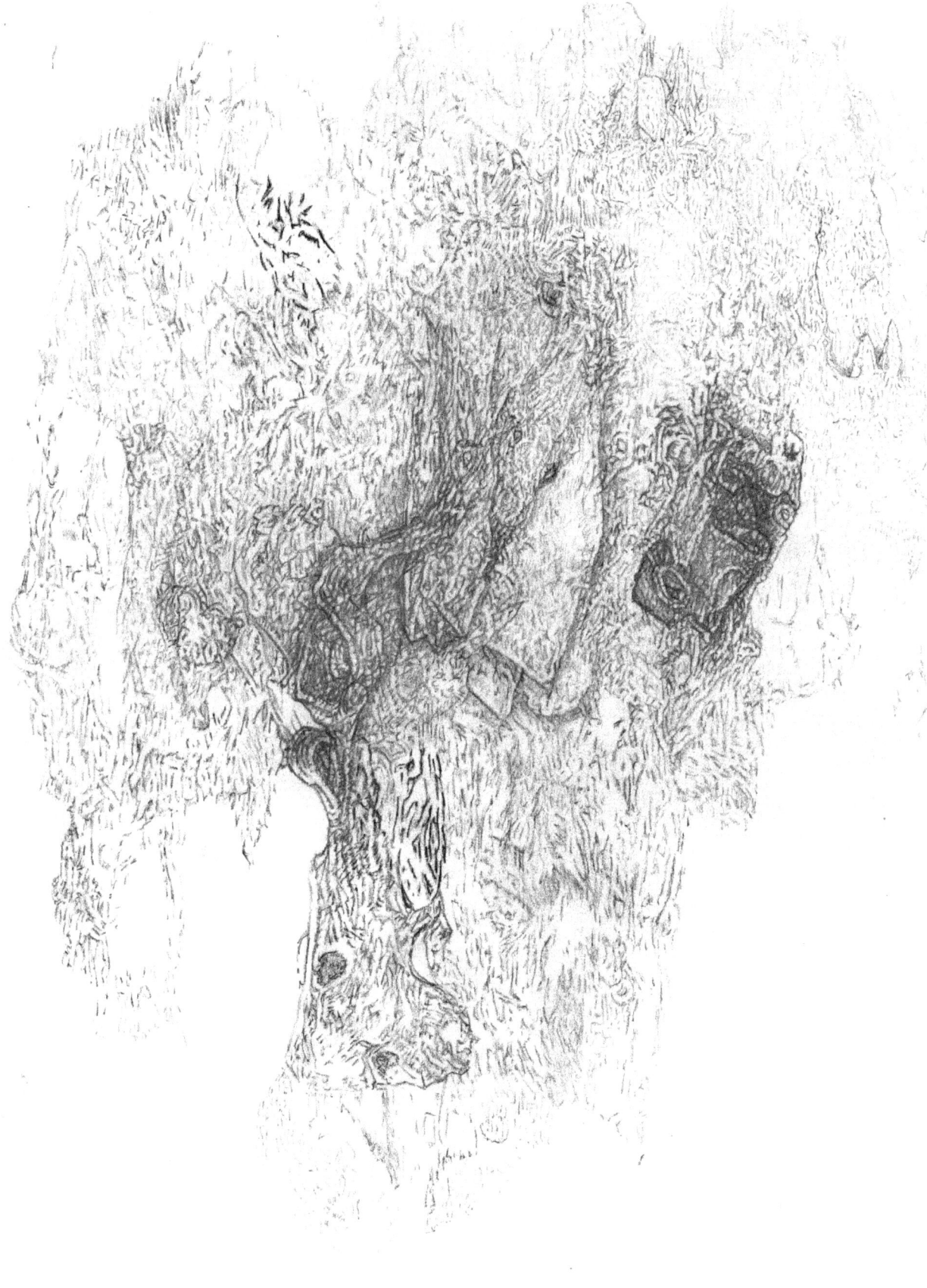

SCARS BARROW MASKS

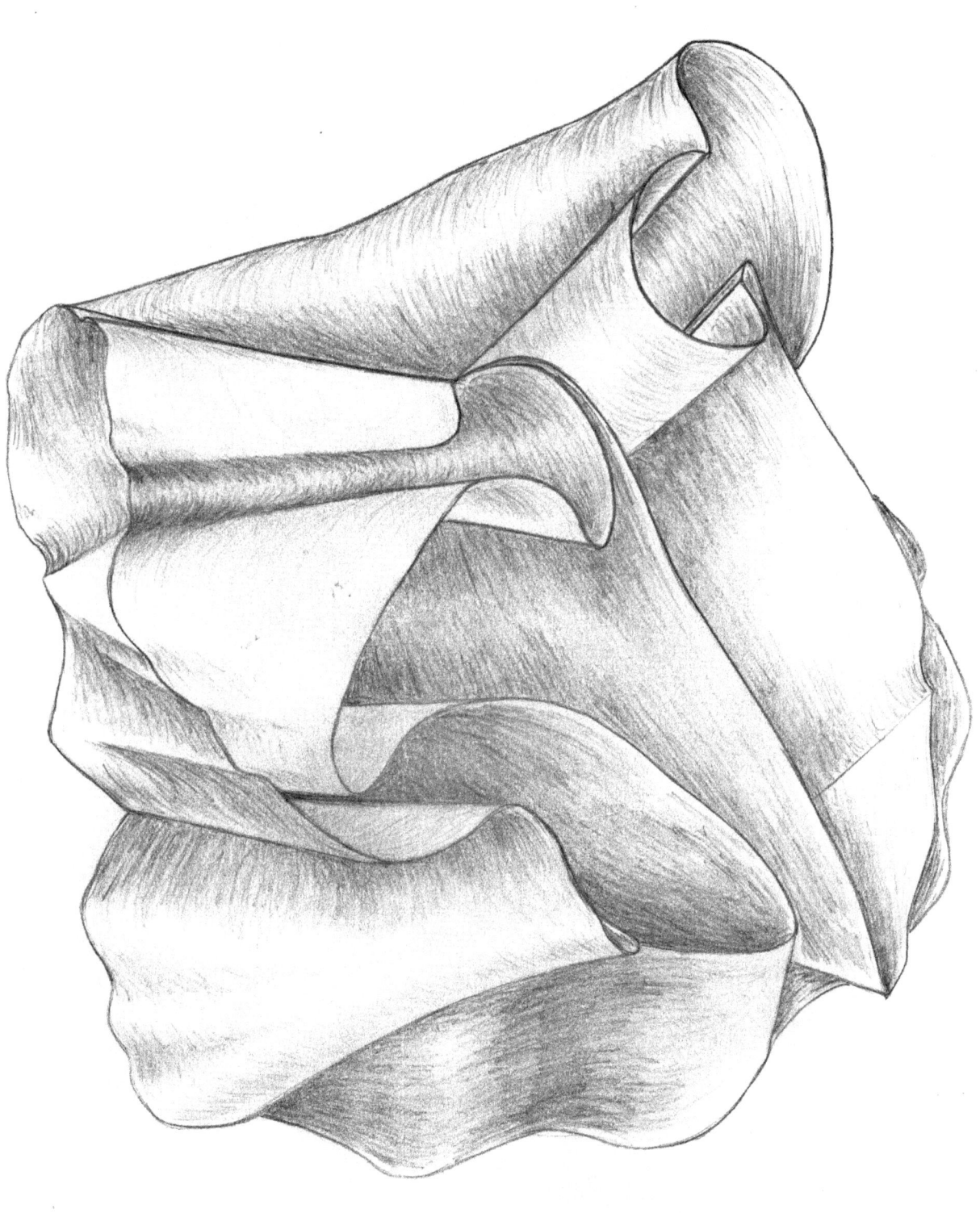

SCROLL OF LIFE

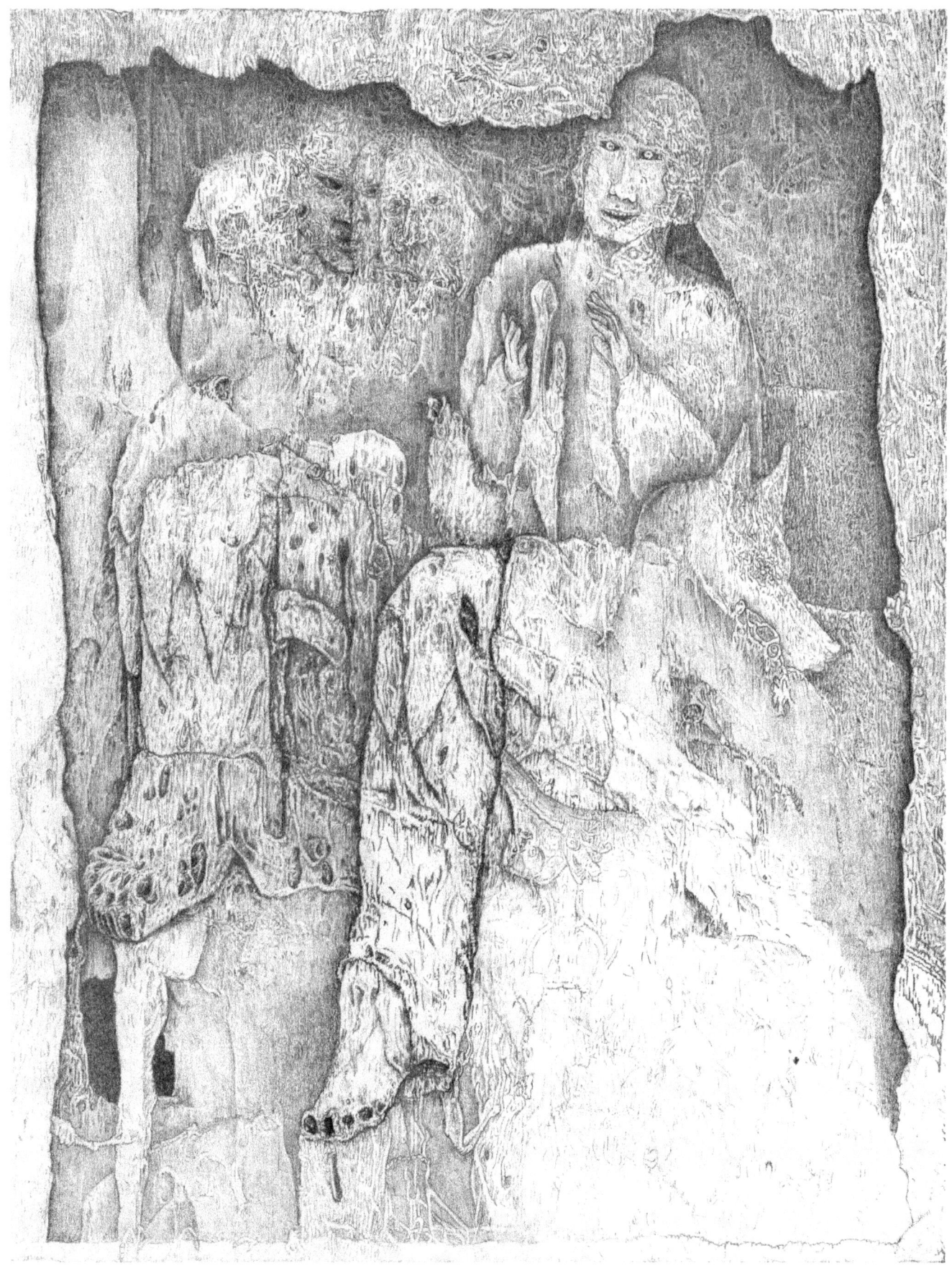

SEAT OF JUSTICE AKA DREAM CATCHER

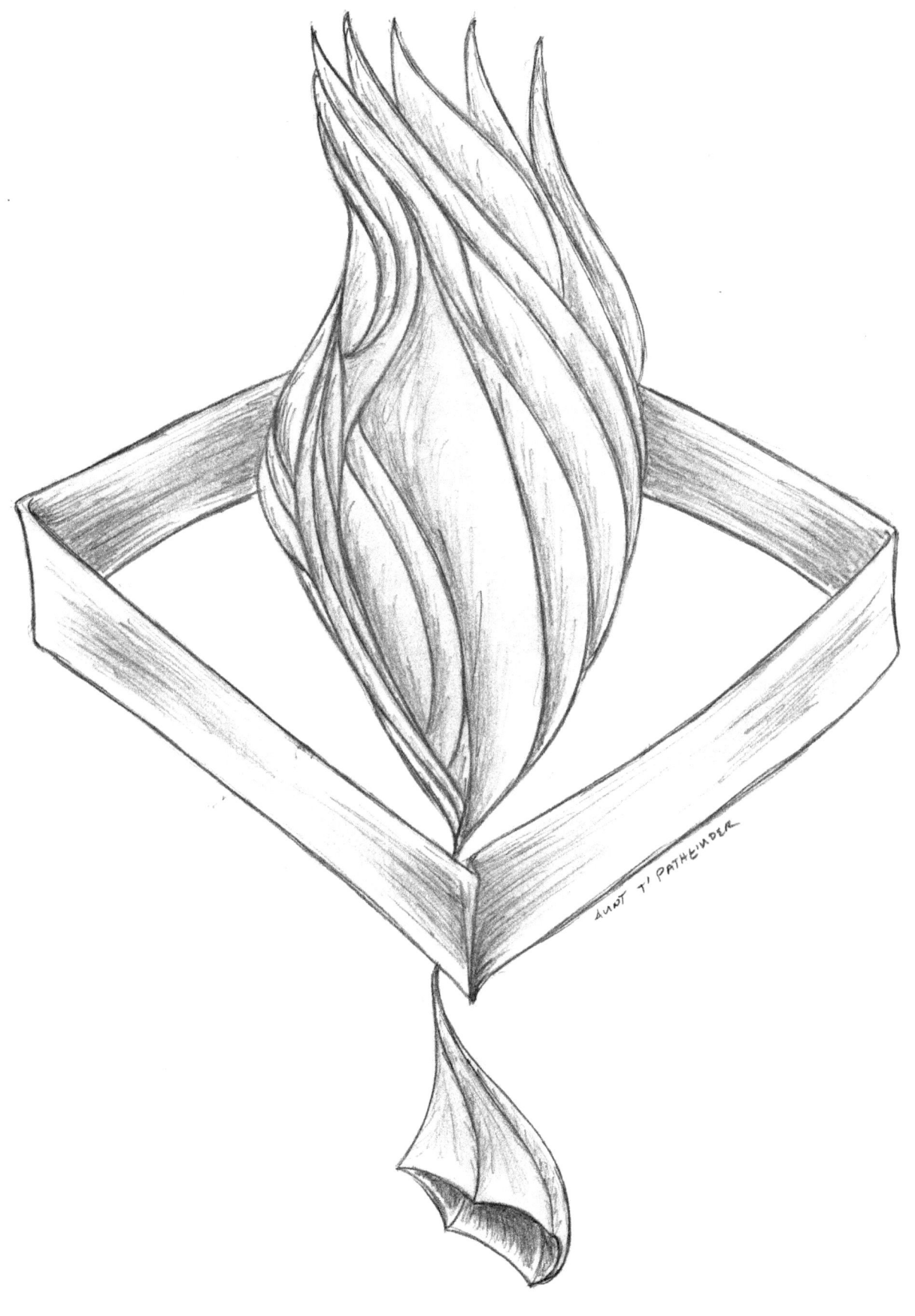

SELF-COMMAND FLAME

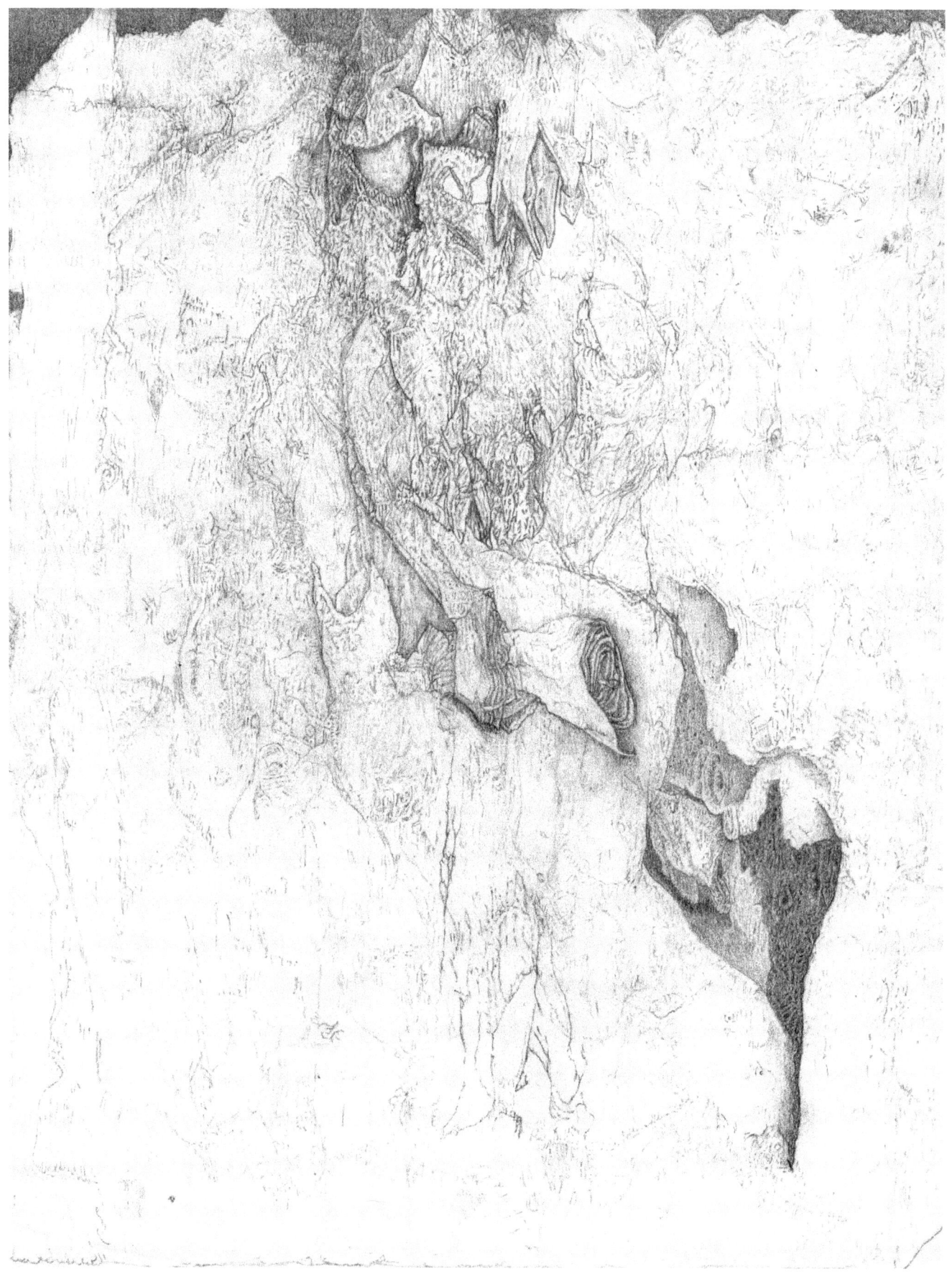

SENTINEL'S TOWER AKA SCALES OF DESIRE AKA ANTIQUITY BLOOD FOUNTAIN

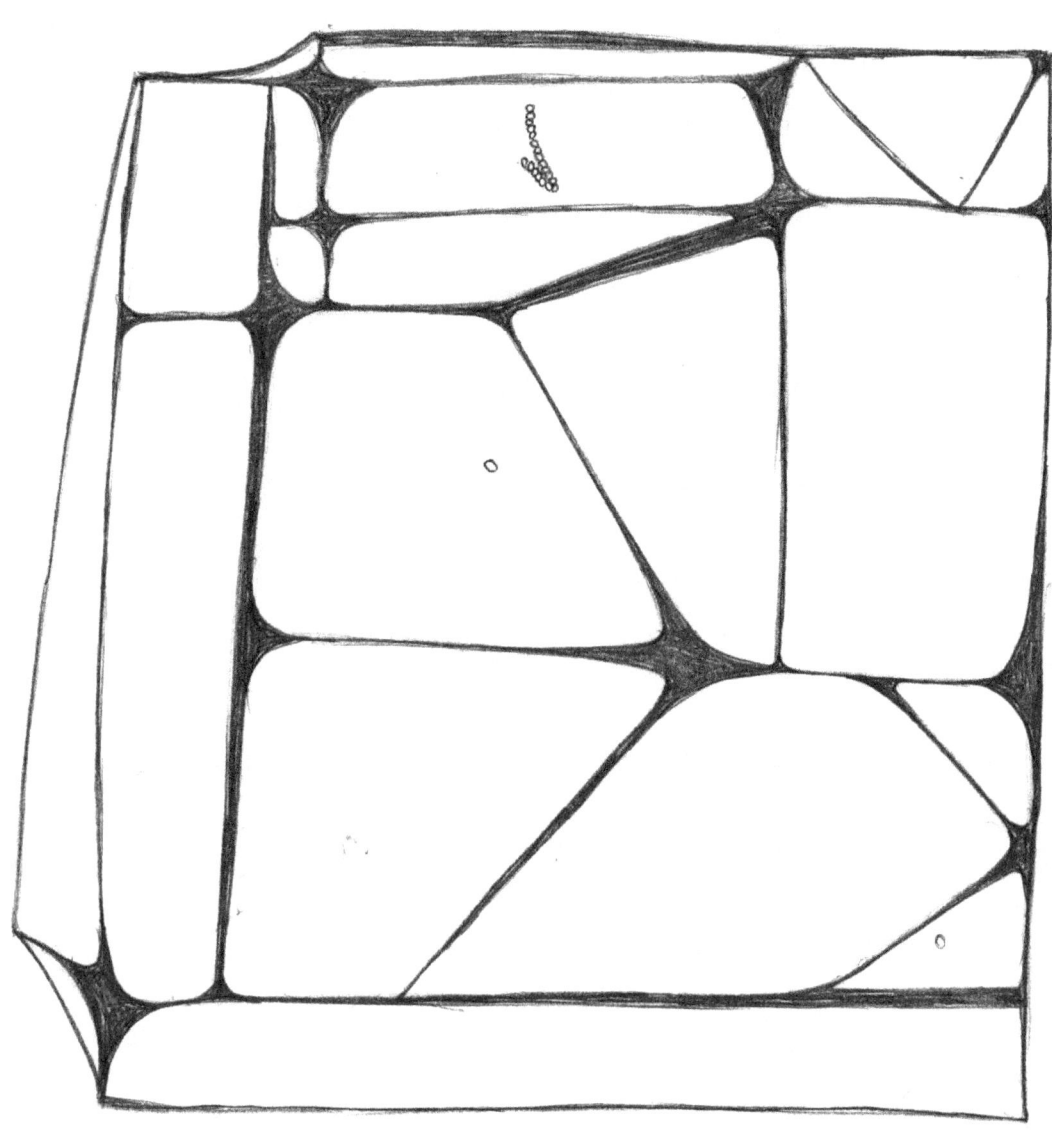

SOUL'S LEAD WINDOW

WILD CARDS FOR YOUR SOUL

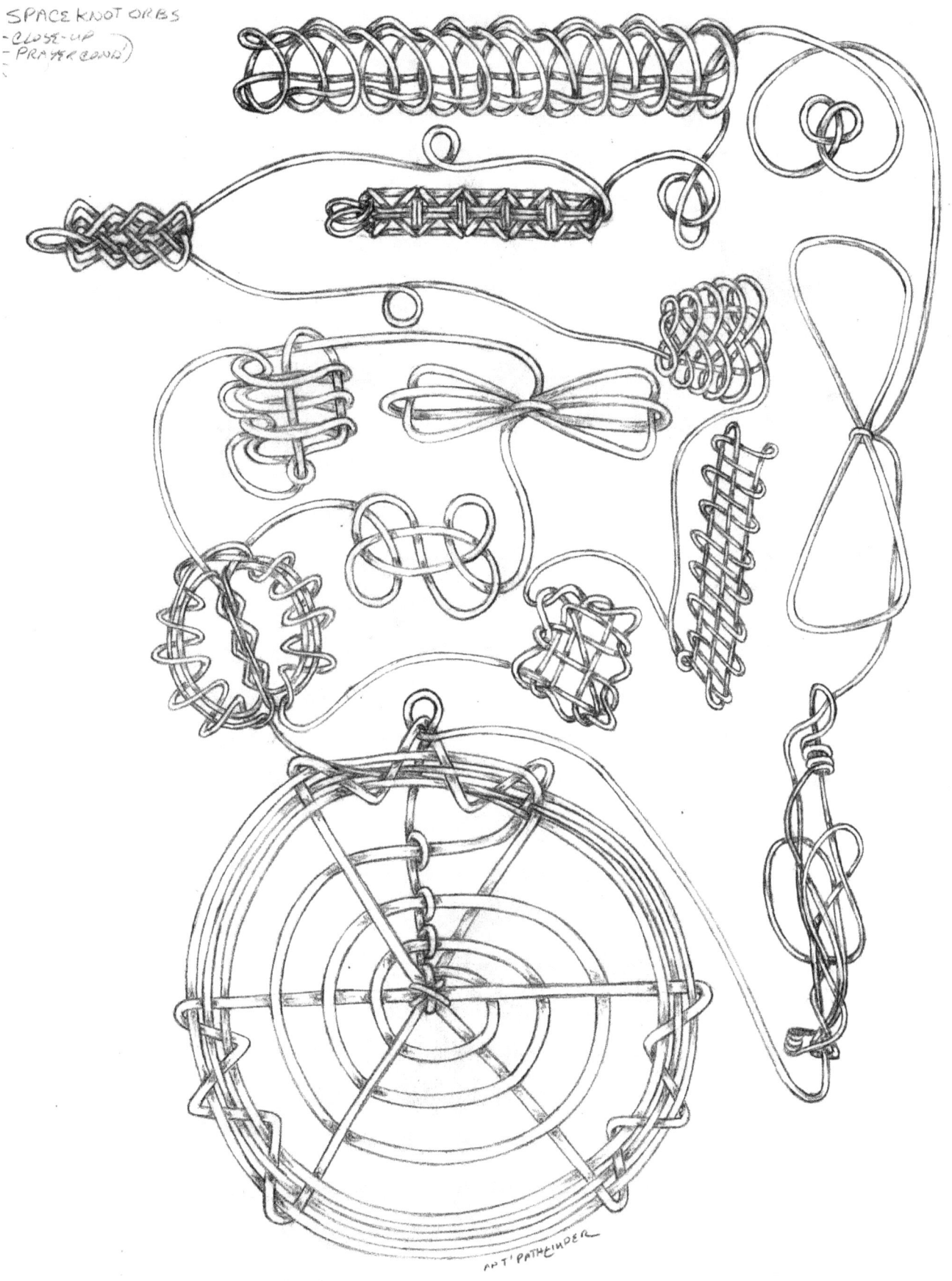

SPACE KNOT ORBS
FOUND IN PRAYER CONDUIT

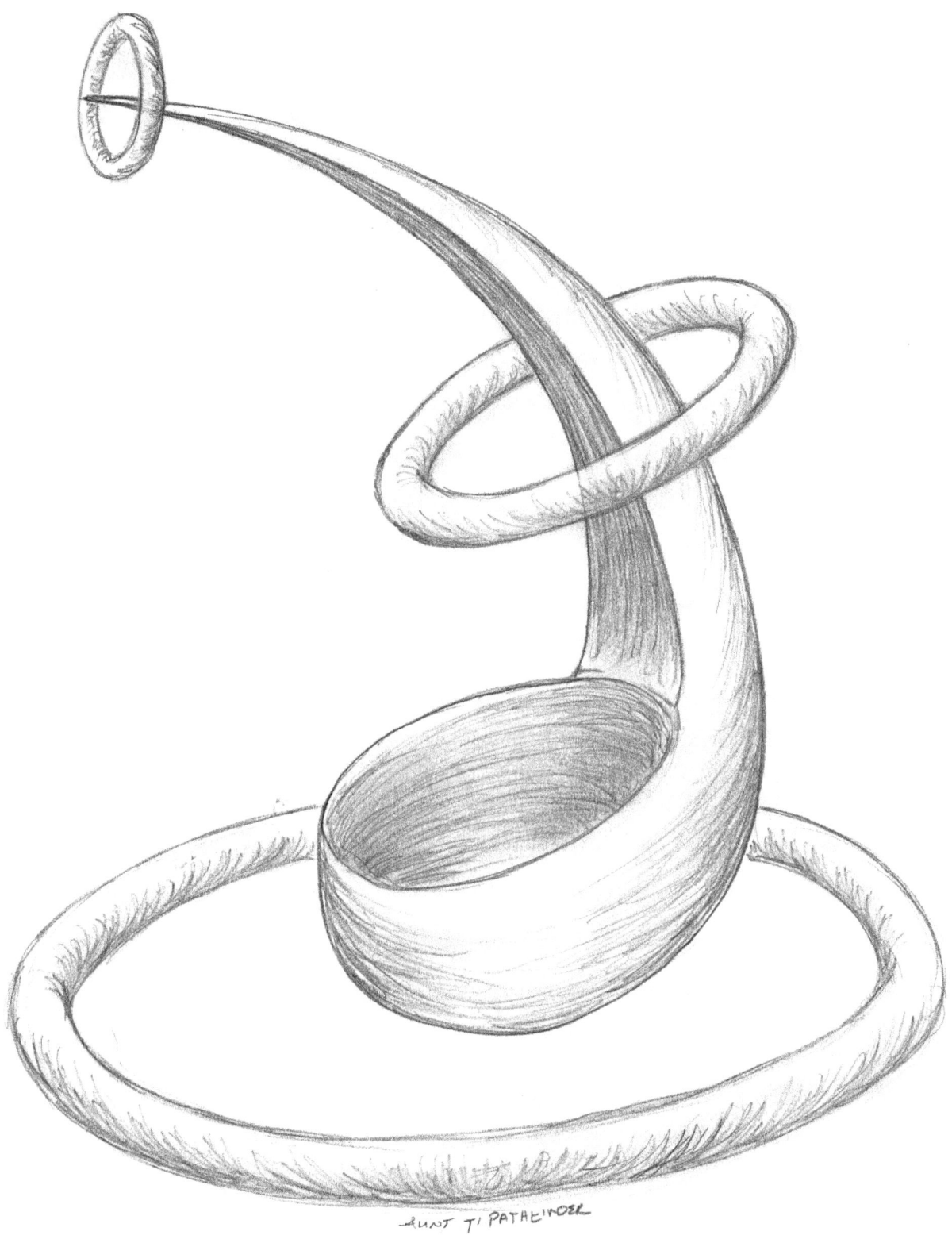

SPLINTER SCOOP AKA 2ND GENERATION CHANNEL

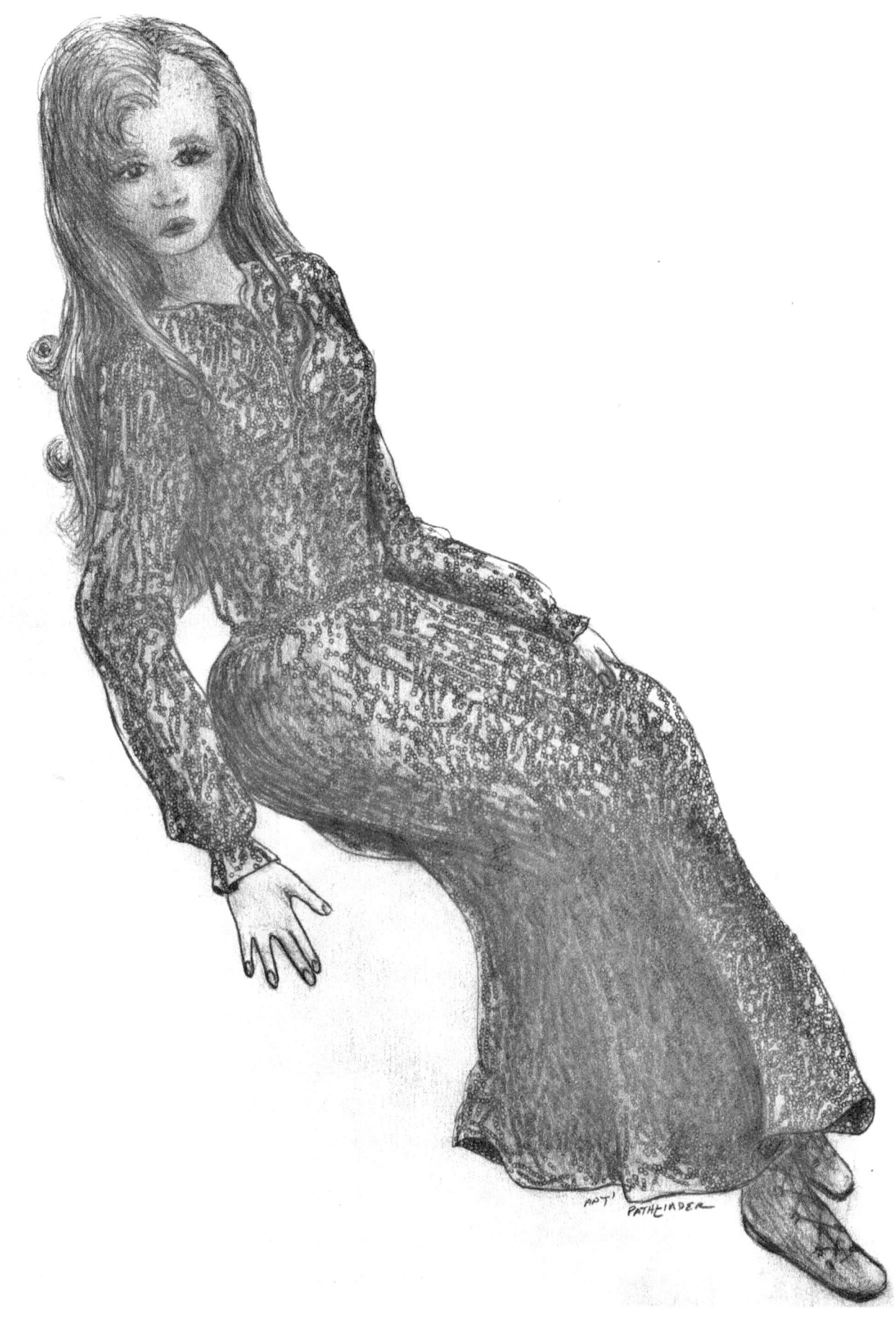

SPONGE DOLL

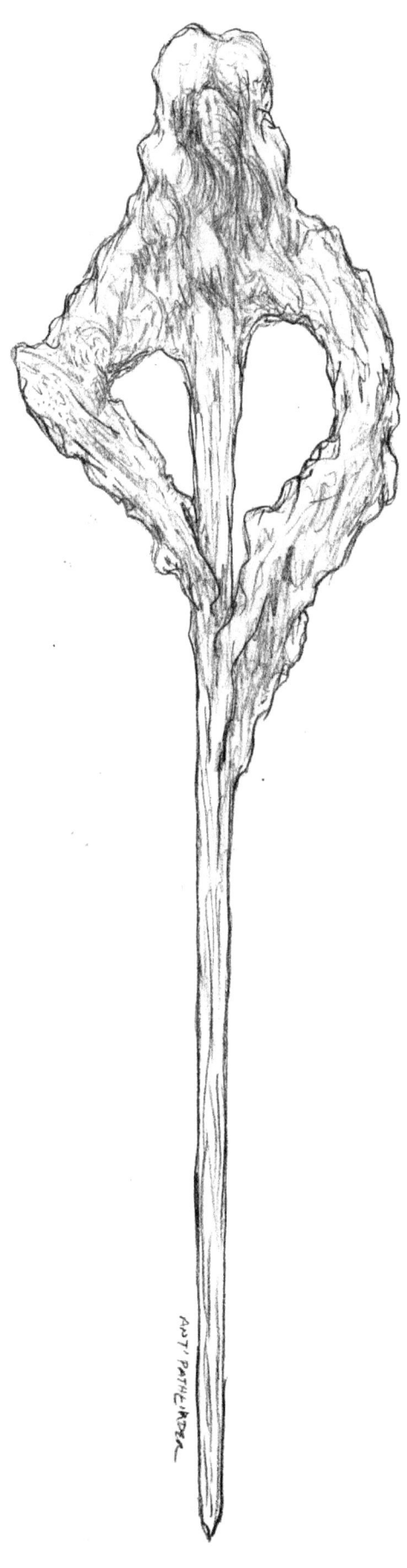

STAFF OF FORM

WILD CARDS FOR YOUR SOUL

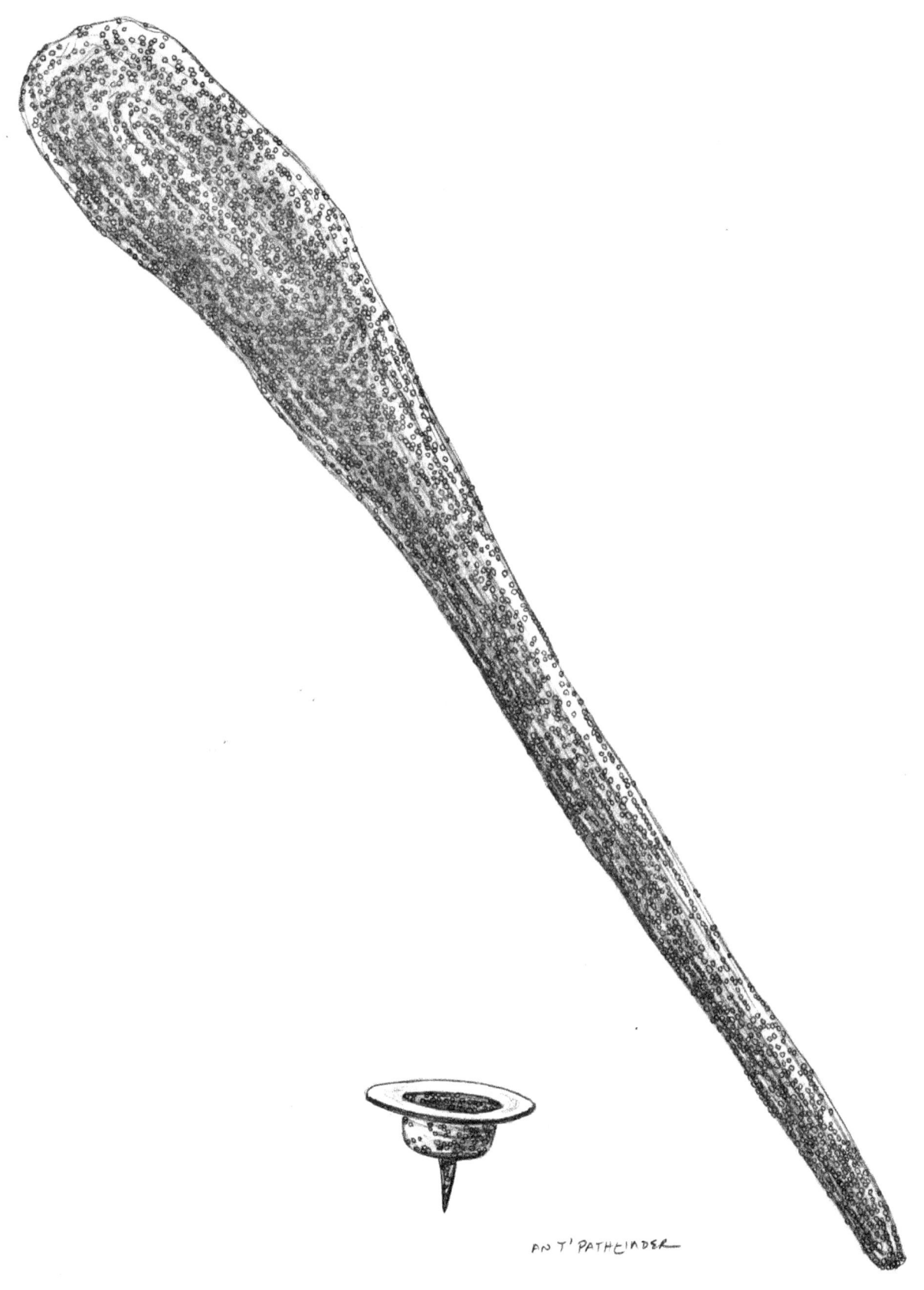

ANT' PATHFINDER

STAFF OF LAW & COMMAND CAP
FOUND WITH GUARDIAN PIPES

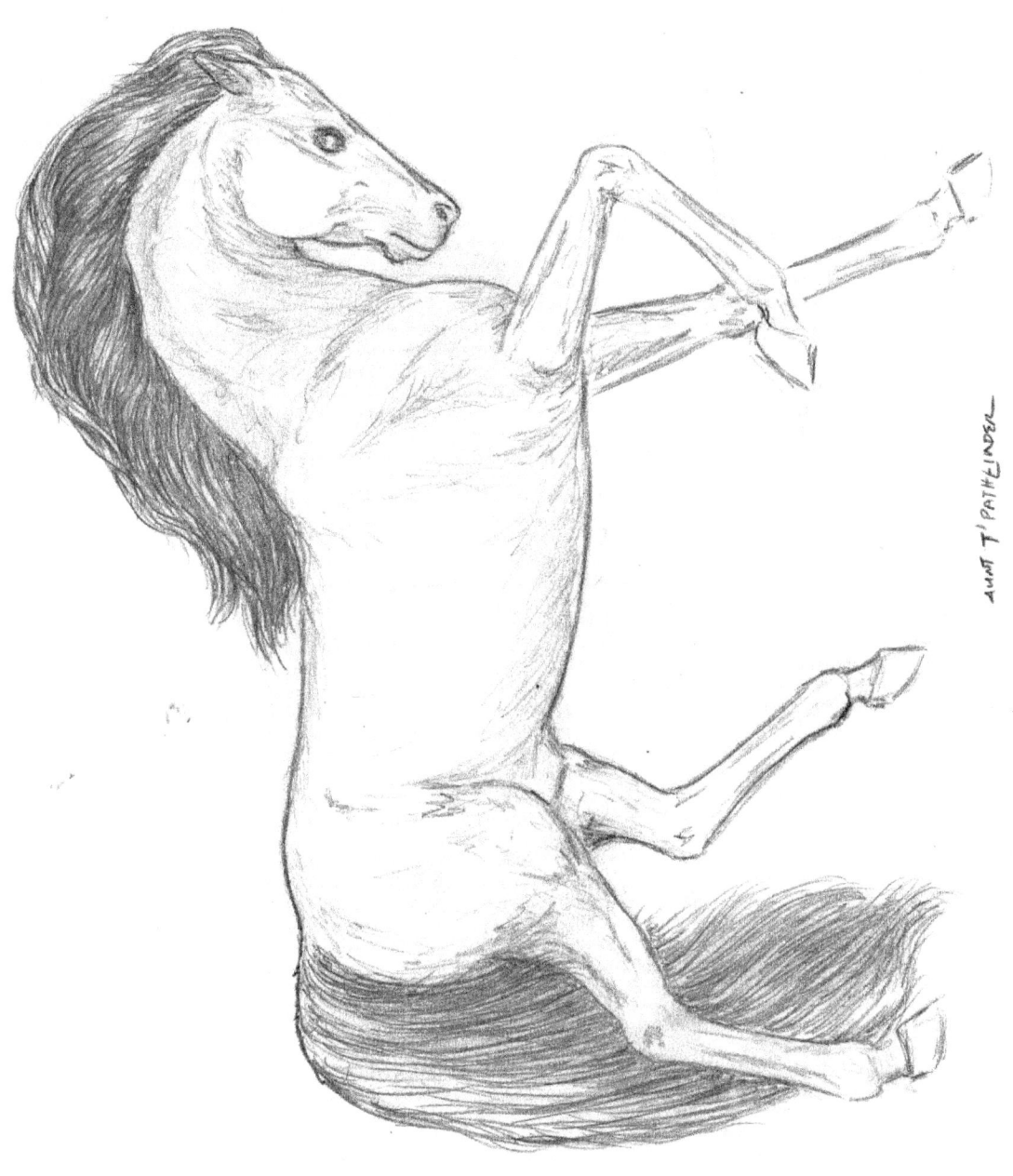

STALLION OF BALANCE
← BOTTOM

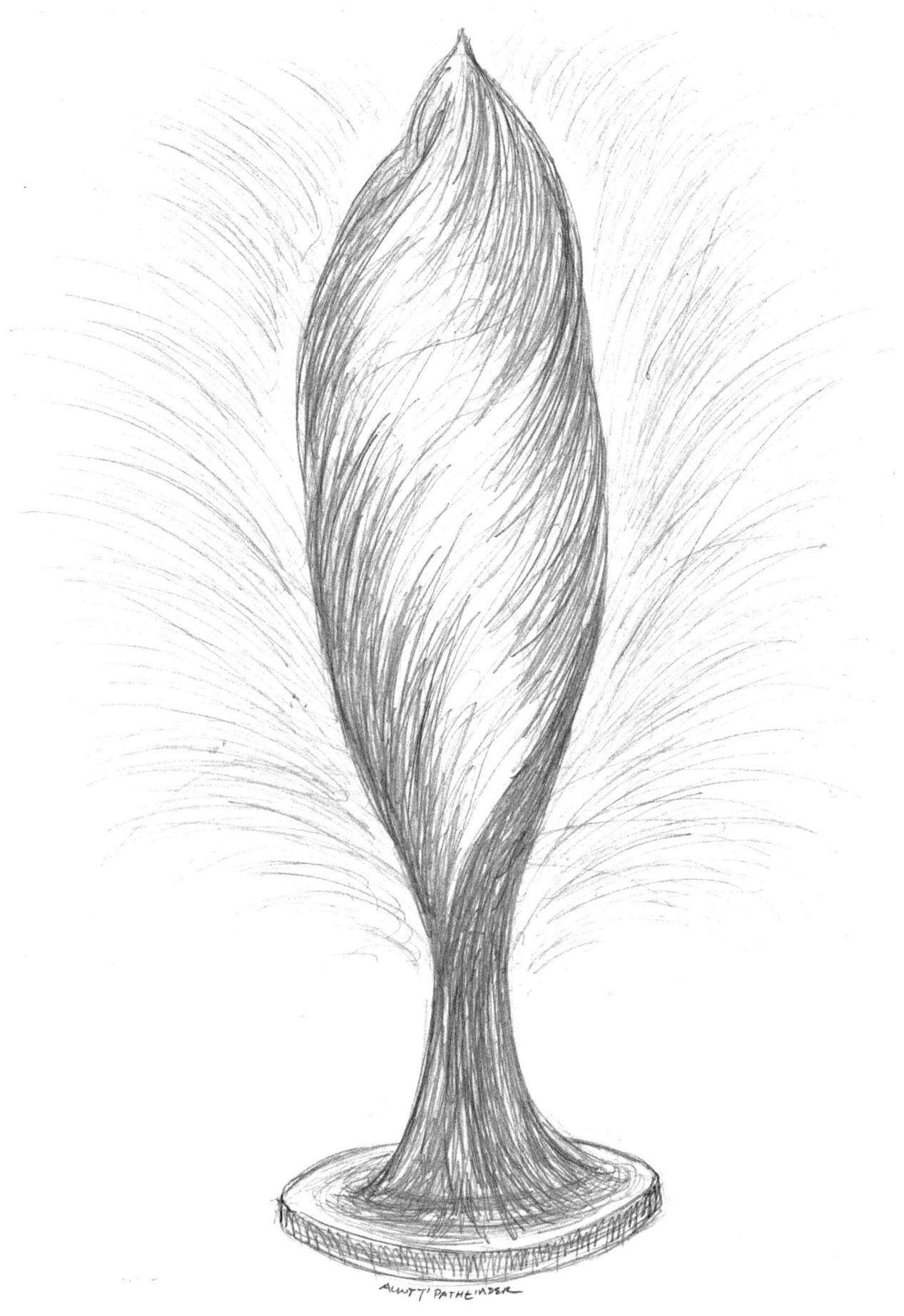

STARCH TREE

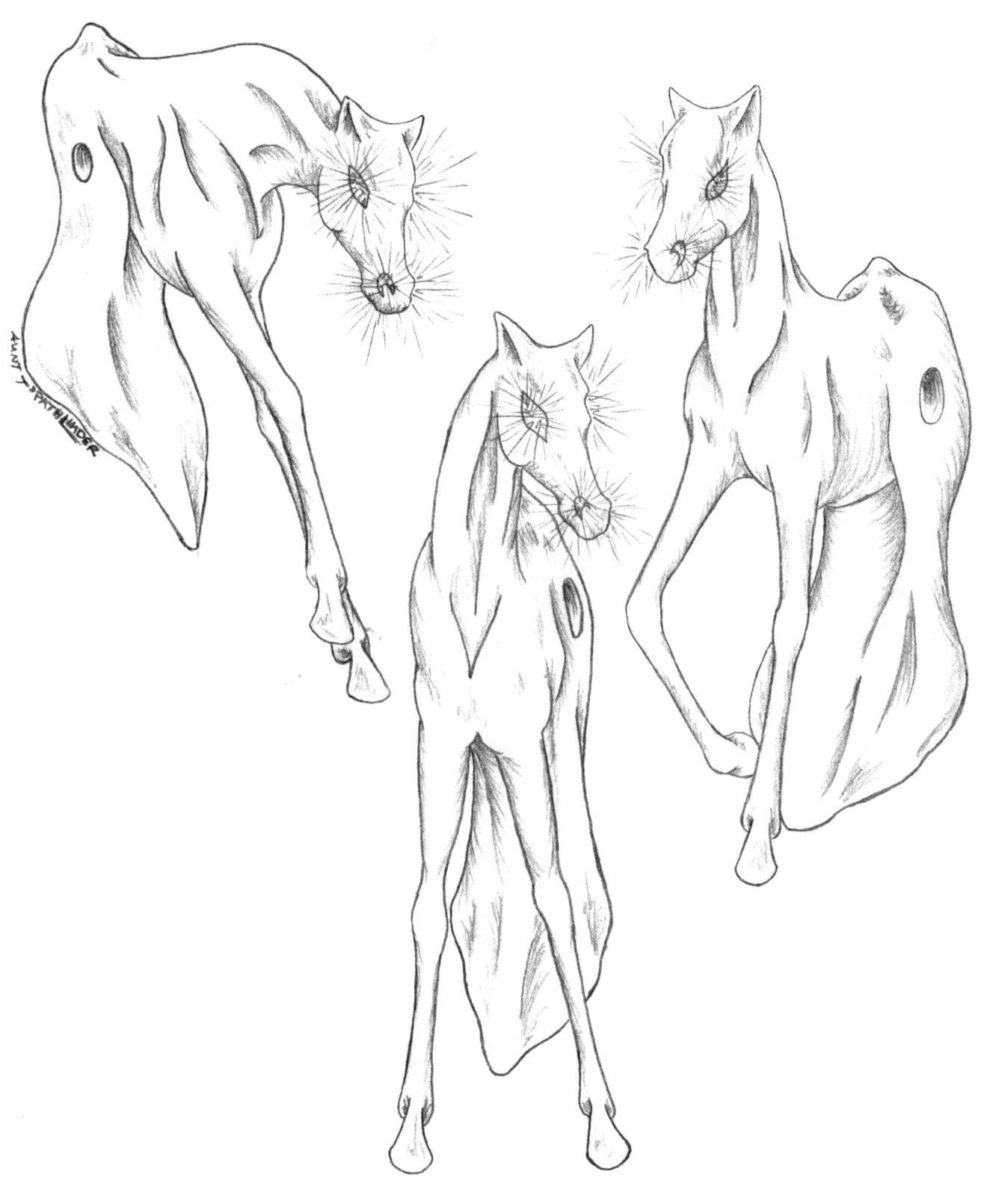

SUB-ATOMIC COMMAND LAMP

'COCCUS: WASTE PRODUCTS TRIGGER CANCER IN SOME CELL, WHICH THESE EAT.
QUARK BOUND/MAT'L BASE REALM (NOTE: EACH "CELL" SHOWING IS 2 LAYERS BELOW THE QUARK. THIS BUILDS A LARGER CELL, WHICH BUILDS A LARGER CELL, WHICH BUILDS THE QUARK CELL. THE 'COCCUS TRAVELS THEM ALL (WONDERFULLY)

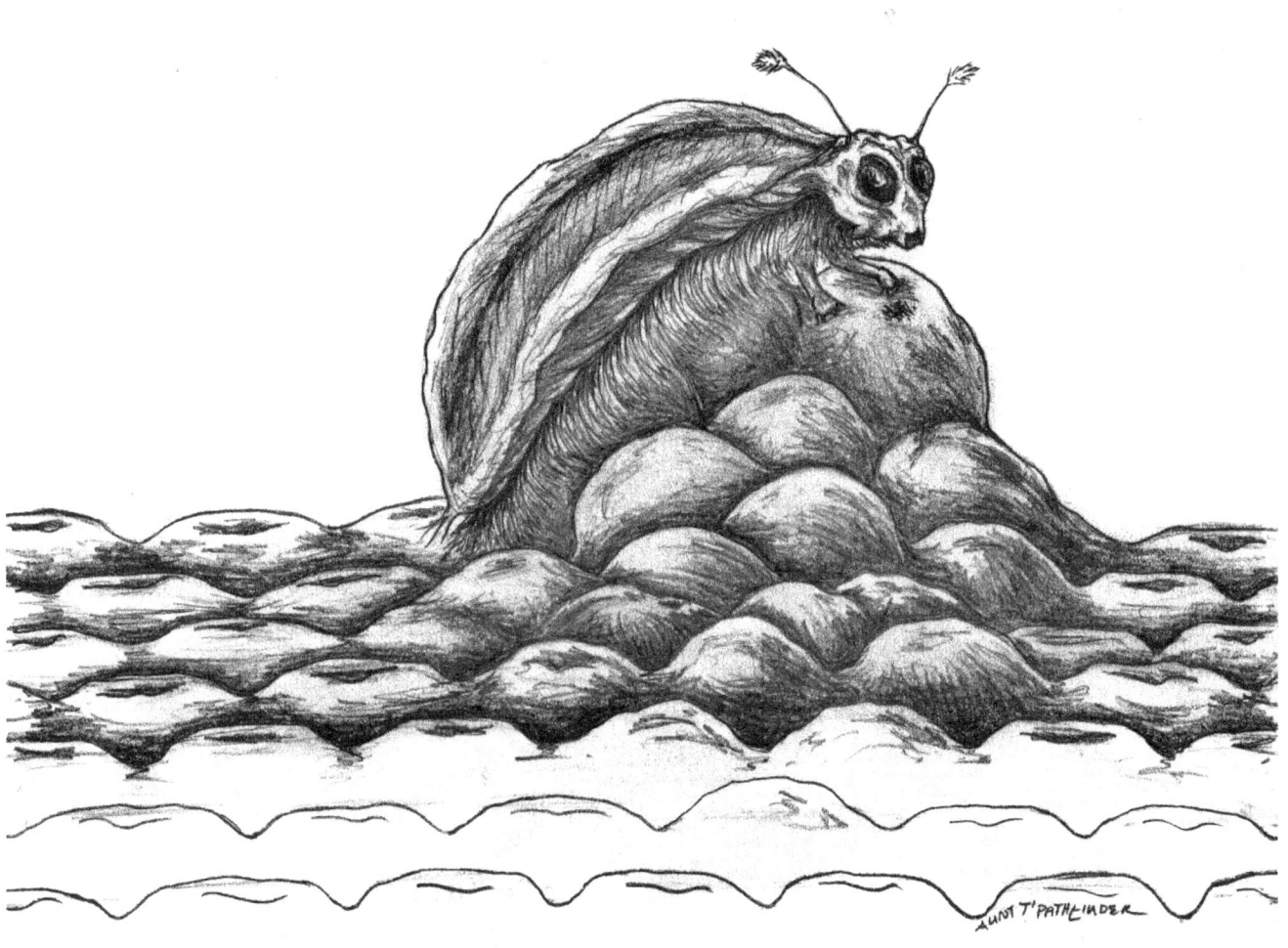

SUB-QUARK ECOSYSTEM & 'COCCUS GRAZER

WILD CARDS T

T: Terre's Fist; Thought Comb; Thought Command Flower & Planes Ring; Time Channel; Titles Center unlocked by Triple Key; Tomahawk of Honor; Traps Trap; Trash Compactor; Trash Sack; Trilogy Core; Trilogy Hook found on Wheel of Karma; Trilogy Sprouts; Trinity Conduit; Triple Plus Shields & Truth Stone; True Command Hook; True Destiny Book aka Birthing Forceps; True Destiny's Key; True Facet Flower; True Jobs List with Future Destiny Egg; Truth Pod; Truth-Bound Flute; Truth-Bound Tree & Shield Knot.

WILD CARDS FOR YOUR SOUL

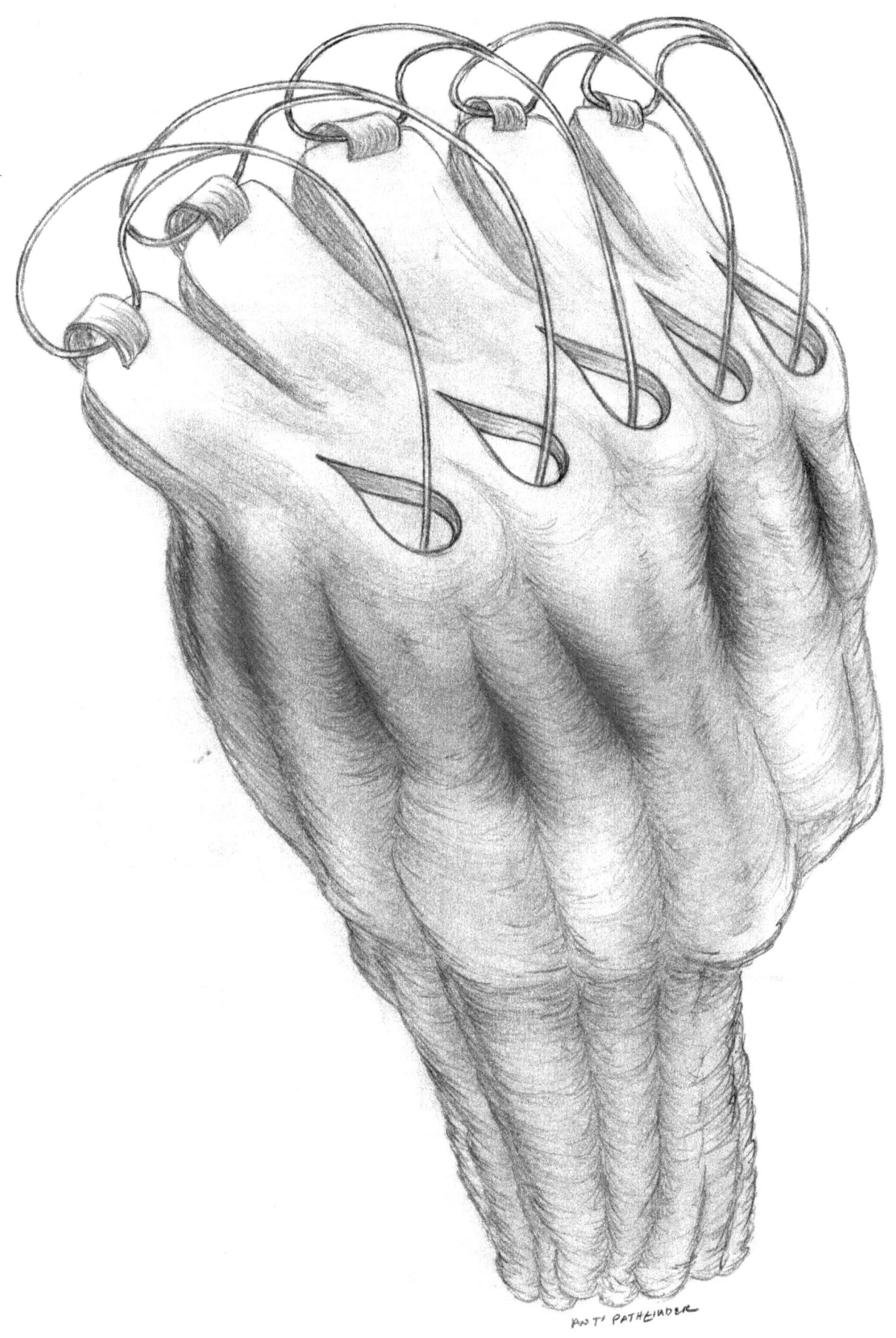

TERRE'S FIST

THOUGHT COMB

THOUGHT COMMAND FLOWER & PLANES RING

WILD CARDS FOR YOUR SOUL

TIME CHANNEL

TITLES CENTER
UNLOCKED BY TRIPLE KEY

WILD CARDS FOR YOUR SOUL

TOMAHAWK OF HONOR

TRAPS TRAP

TRASH COMPACTOR

TRASH SACK

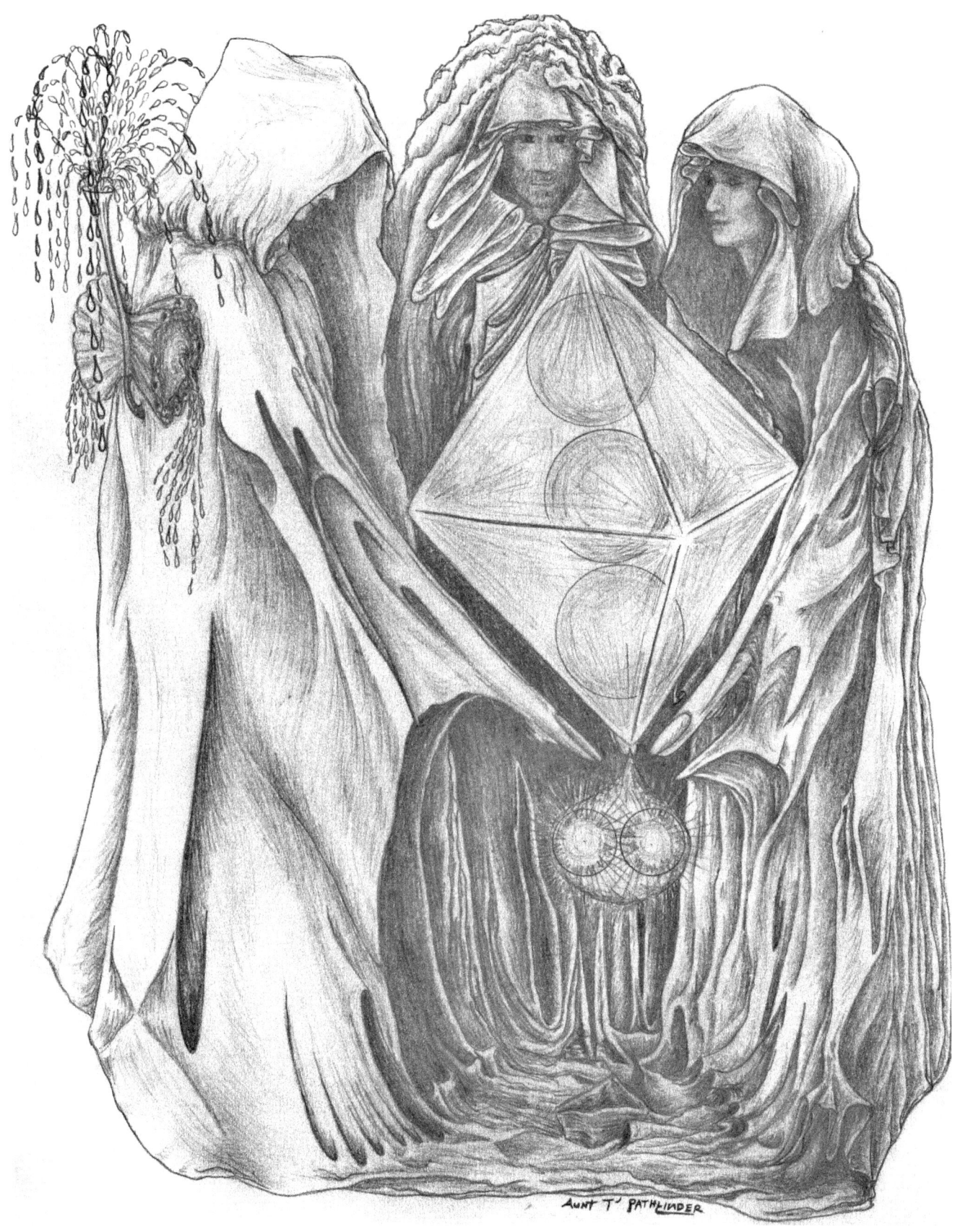

TRILOGY CORE

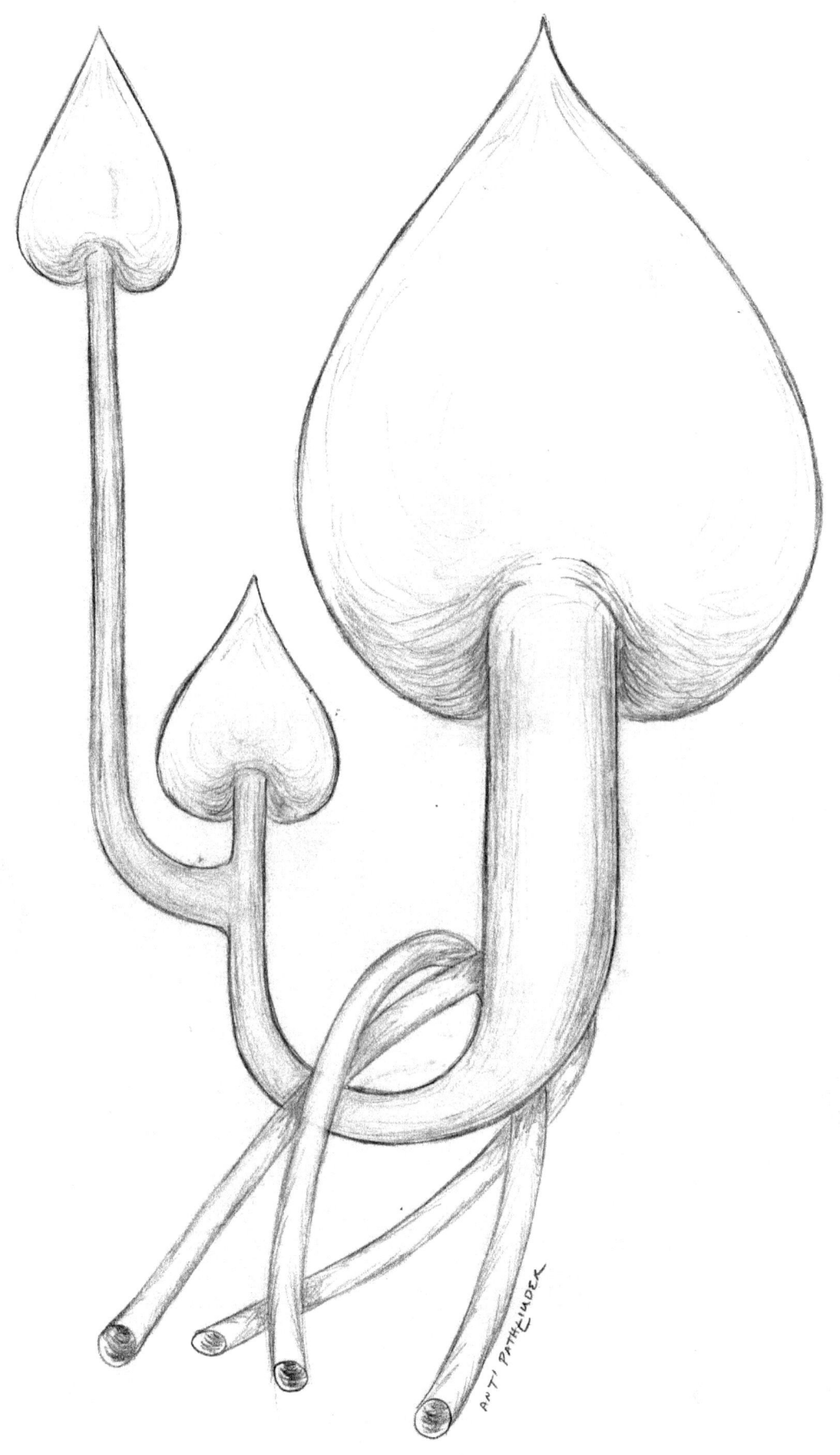

TRILOGY HOOK
FOUND ON WHEEL OF KARMA

WILD CARDS FOR YOUR SOUL

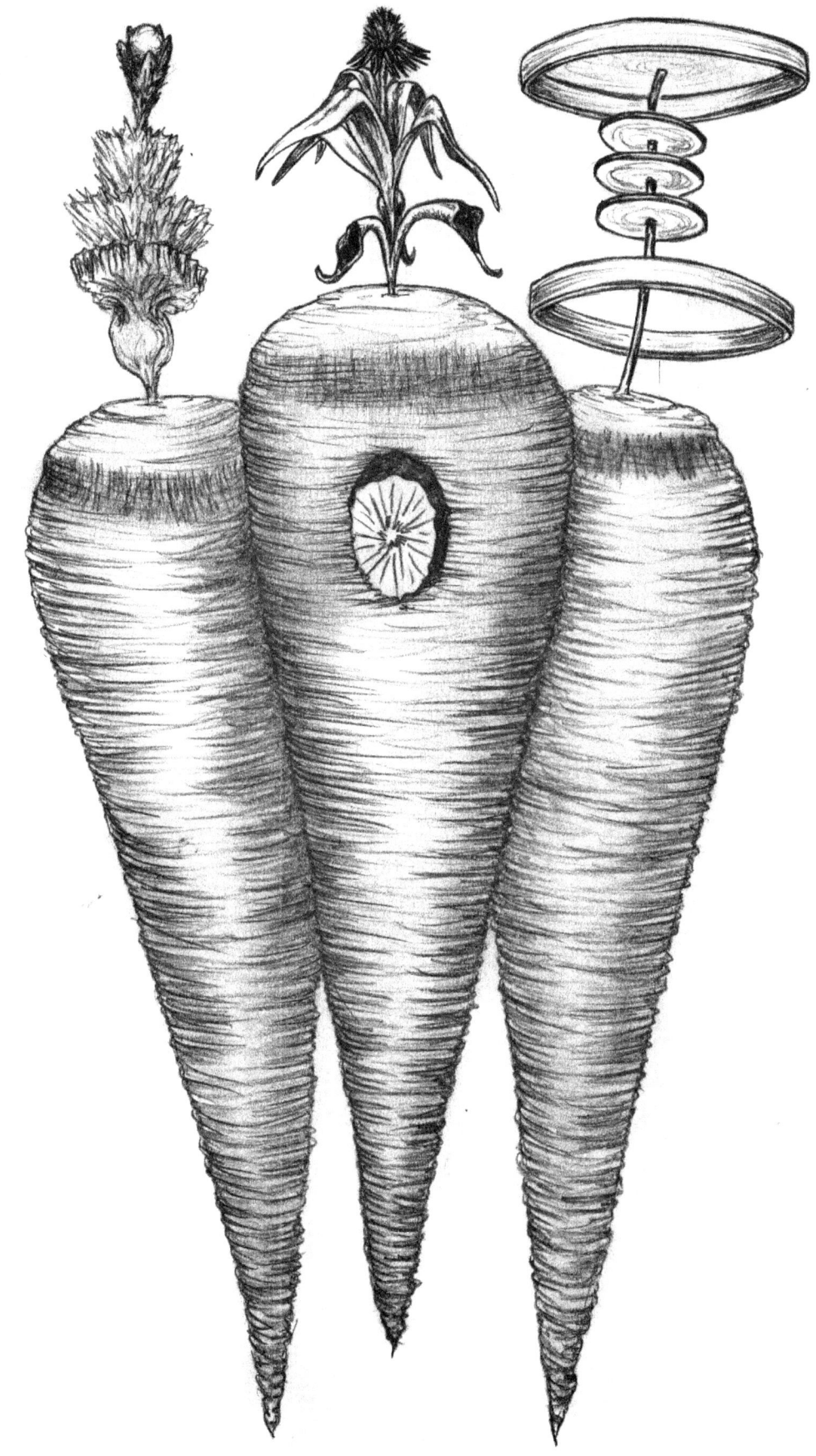

ANT' PATHFINDER

TRILOGY SPROUTS

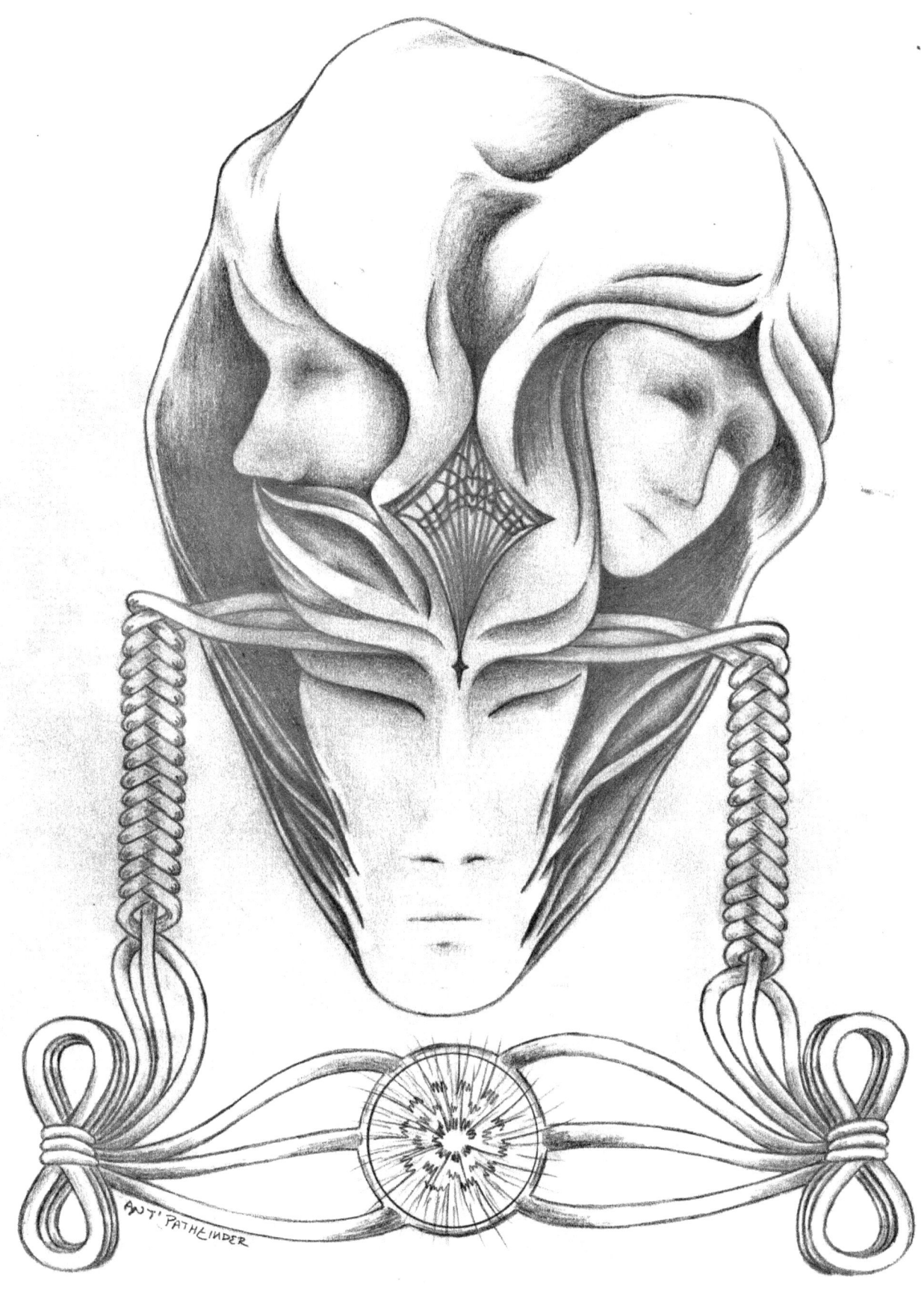

TRINITY CONDUIT

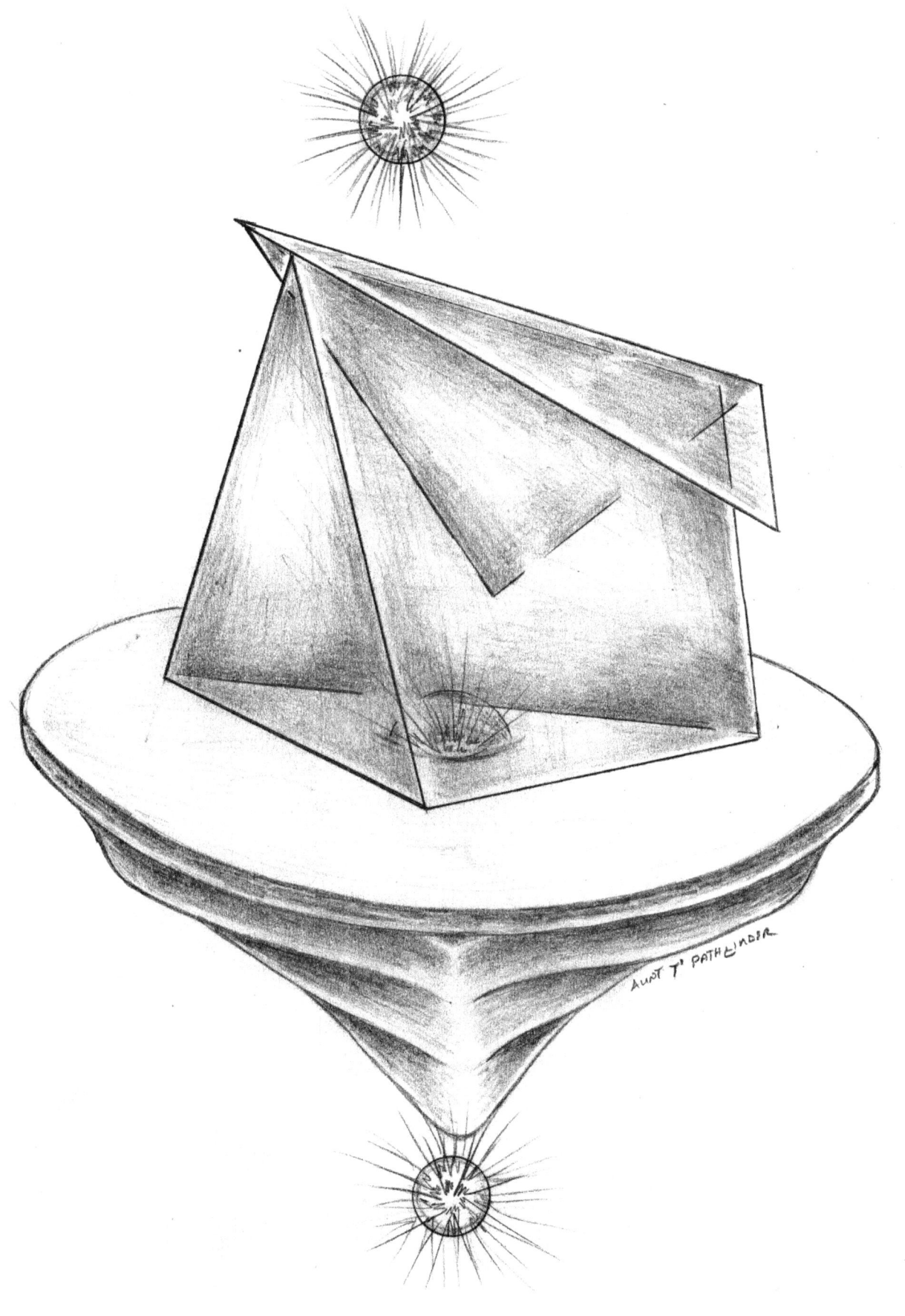

TRIPLE PLUS SHIELDS & TRUTH STONE

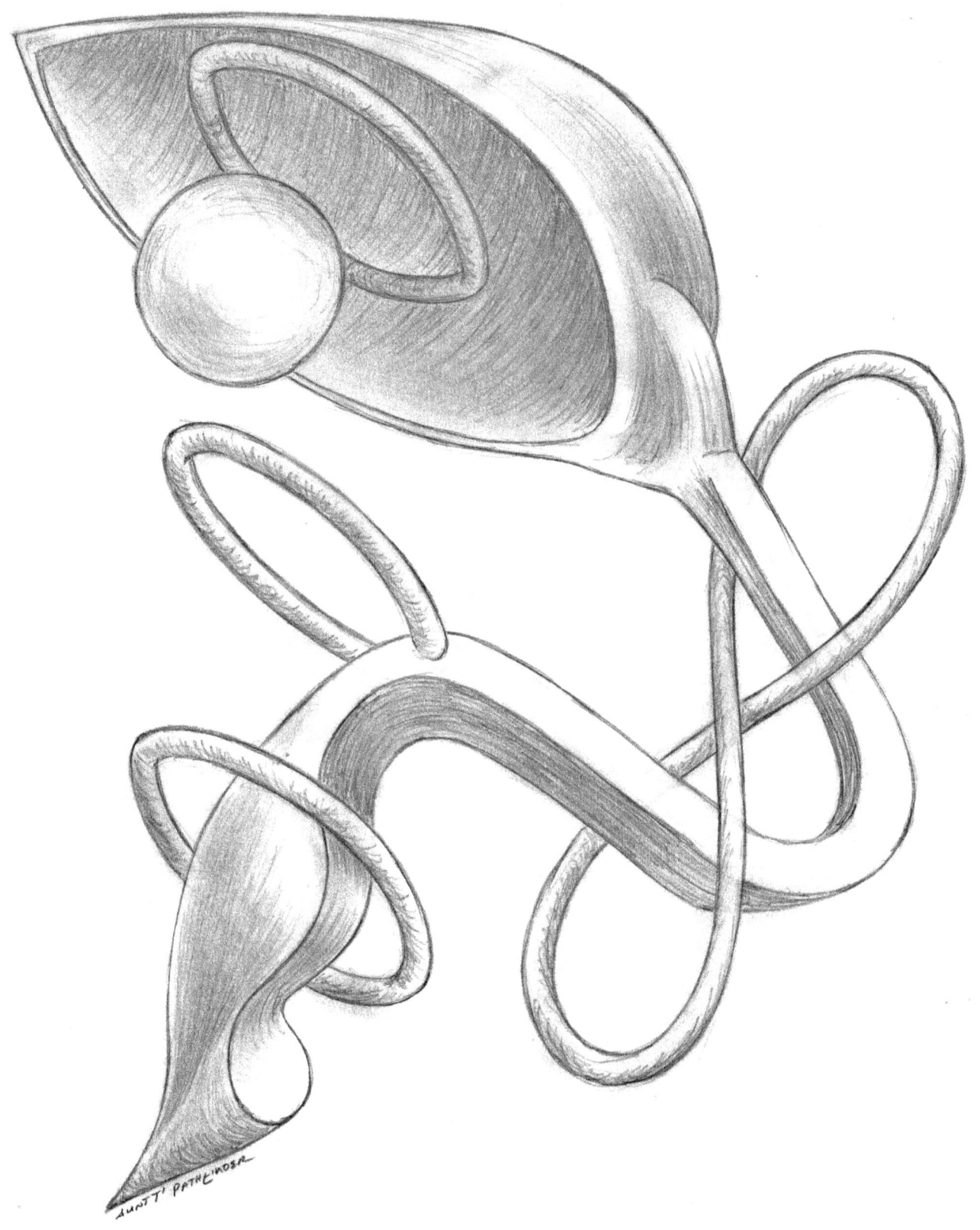

TRUE COMMAND HOOK

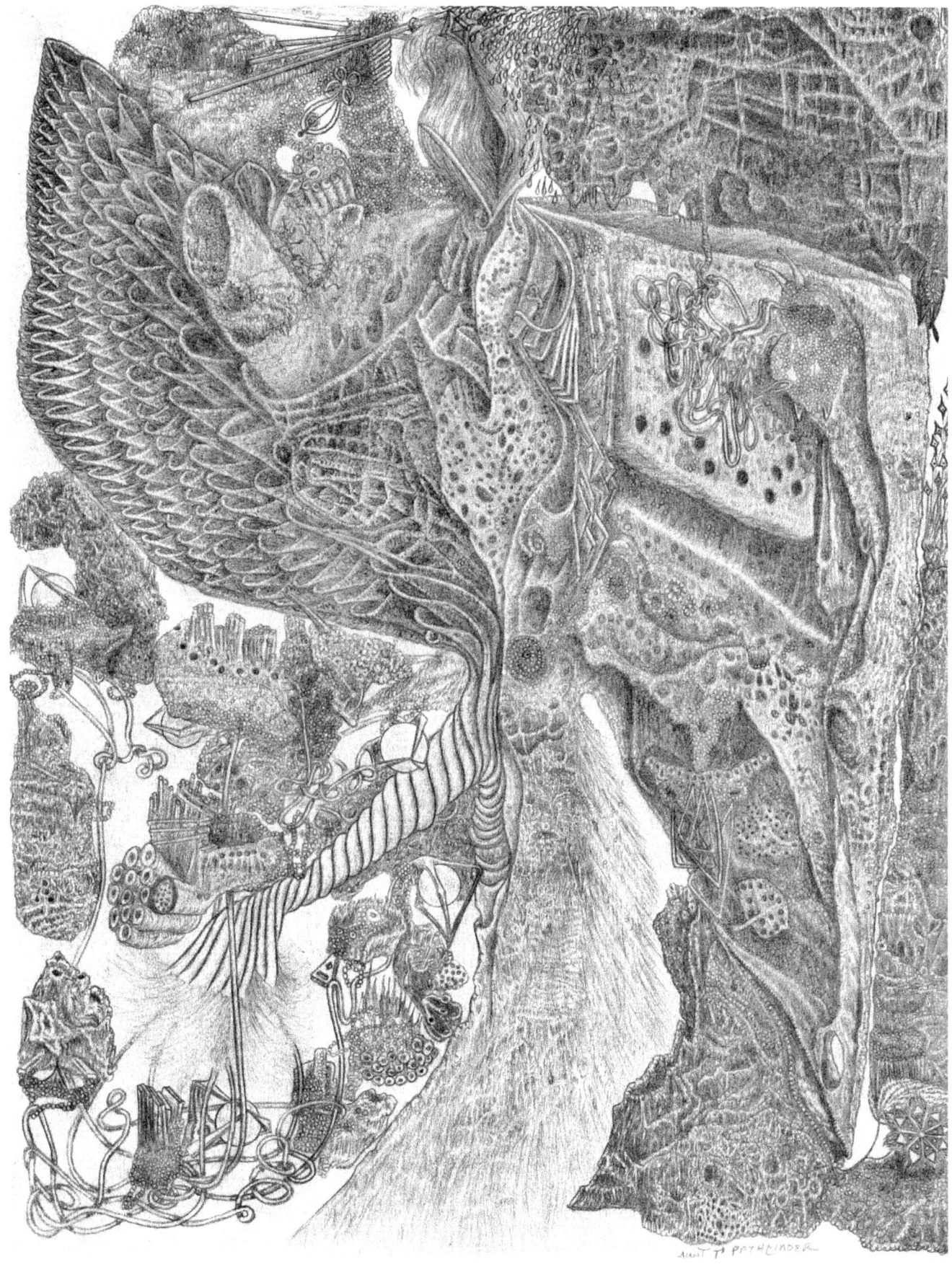

TRUE DESTINY BOOK AKA BIRTHING FORCEPS

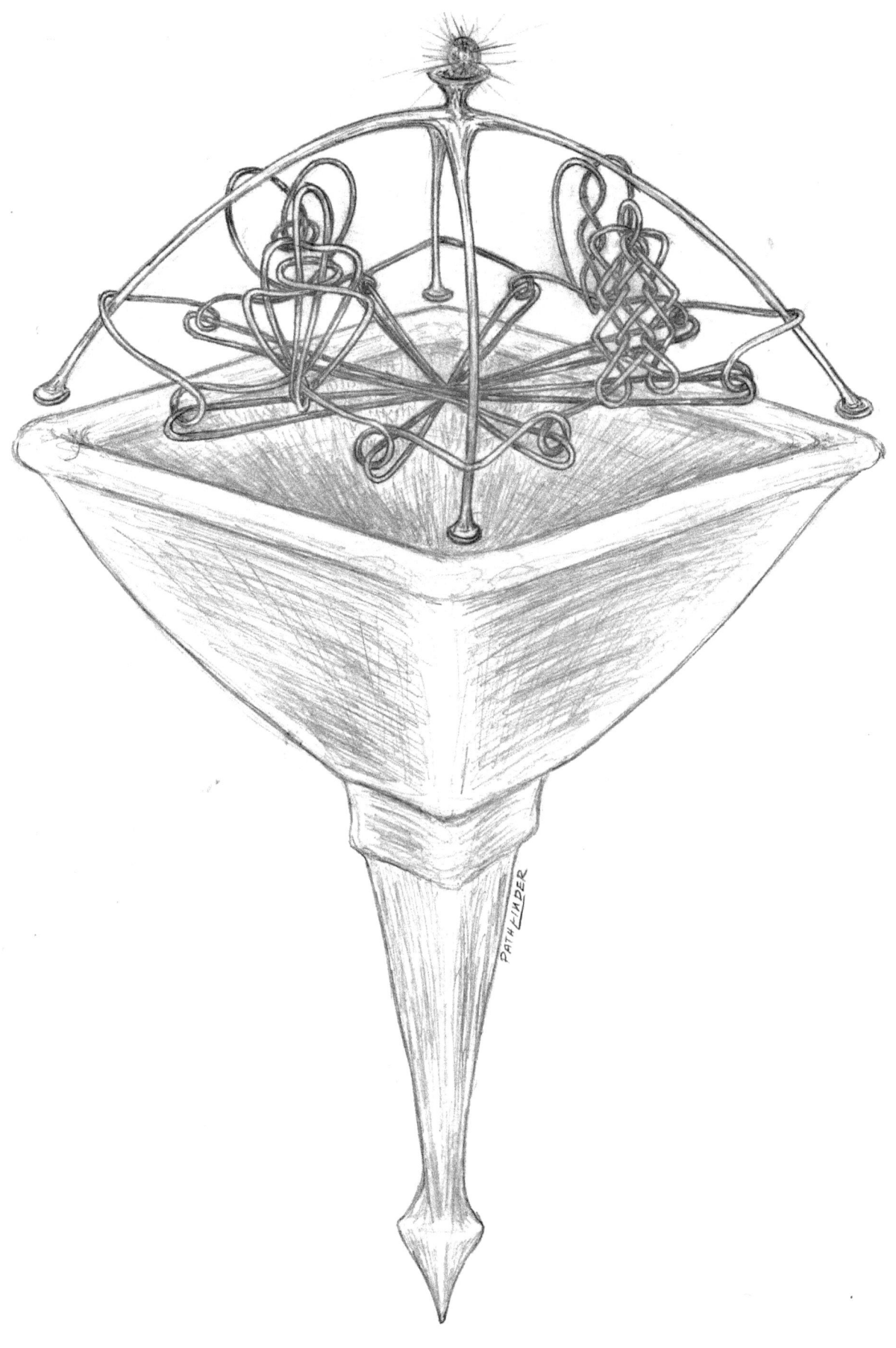

TRUE DESTINY'S KEY

WILD CARDS FOR YOUR SOUL

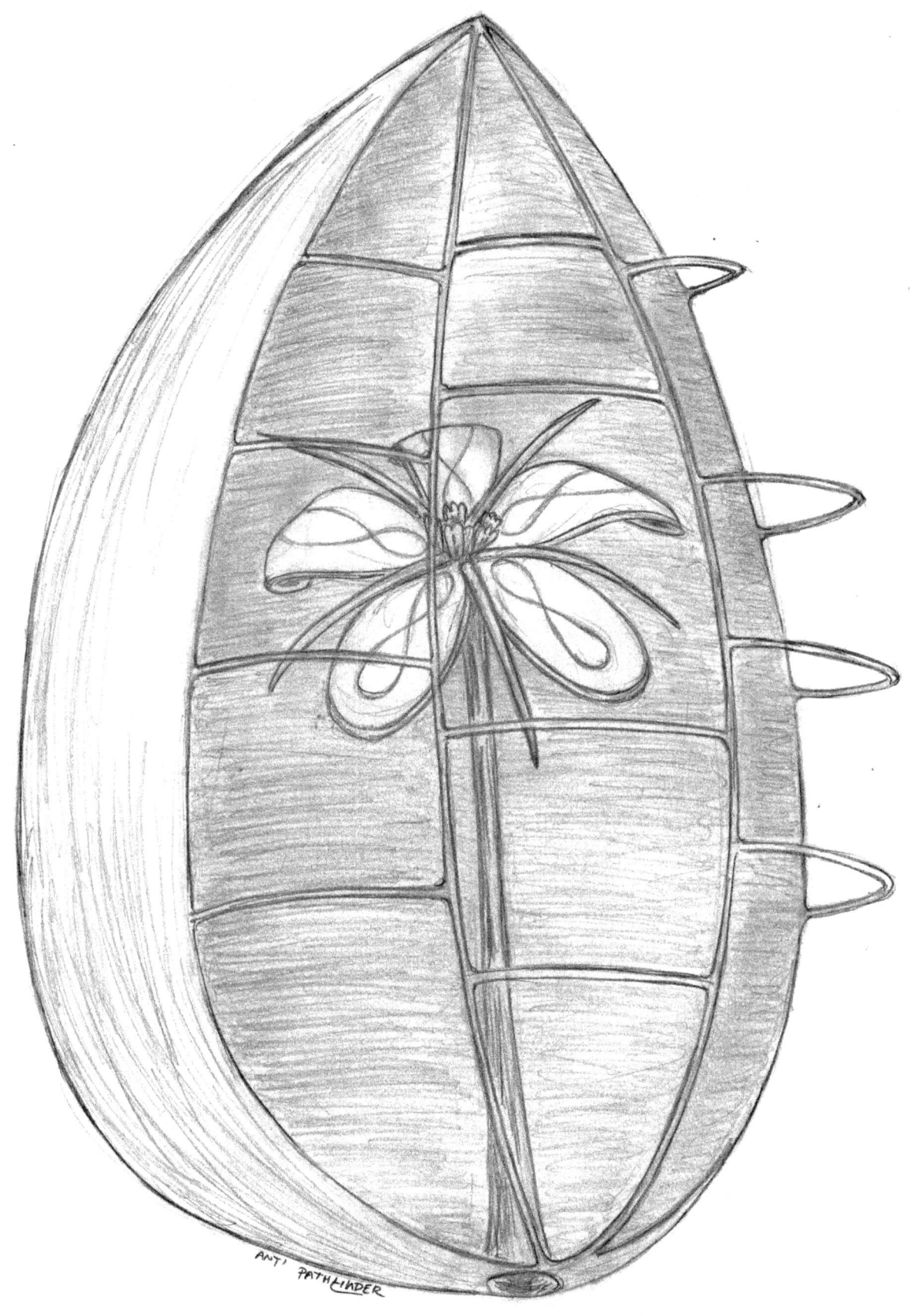

TRUE FACET FLOWER

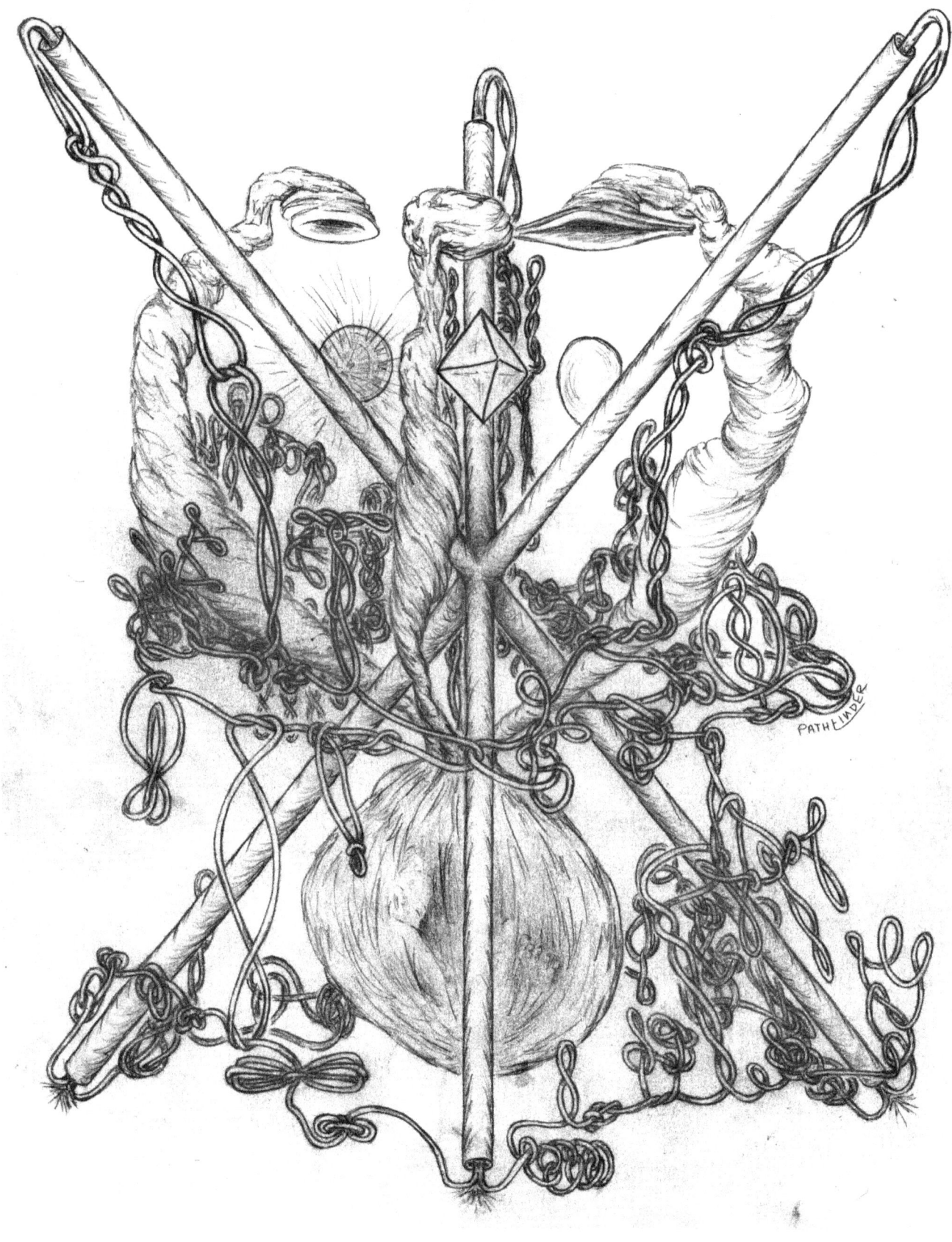

TRUE JOBS LIST WITH FUTURE DESTINY EGG

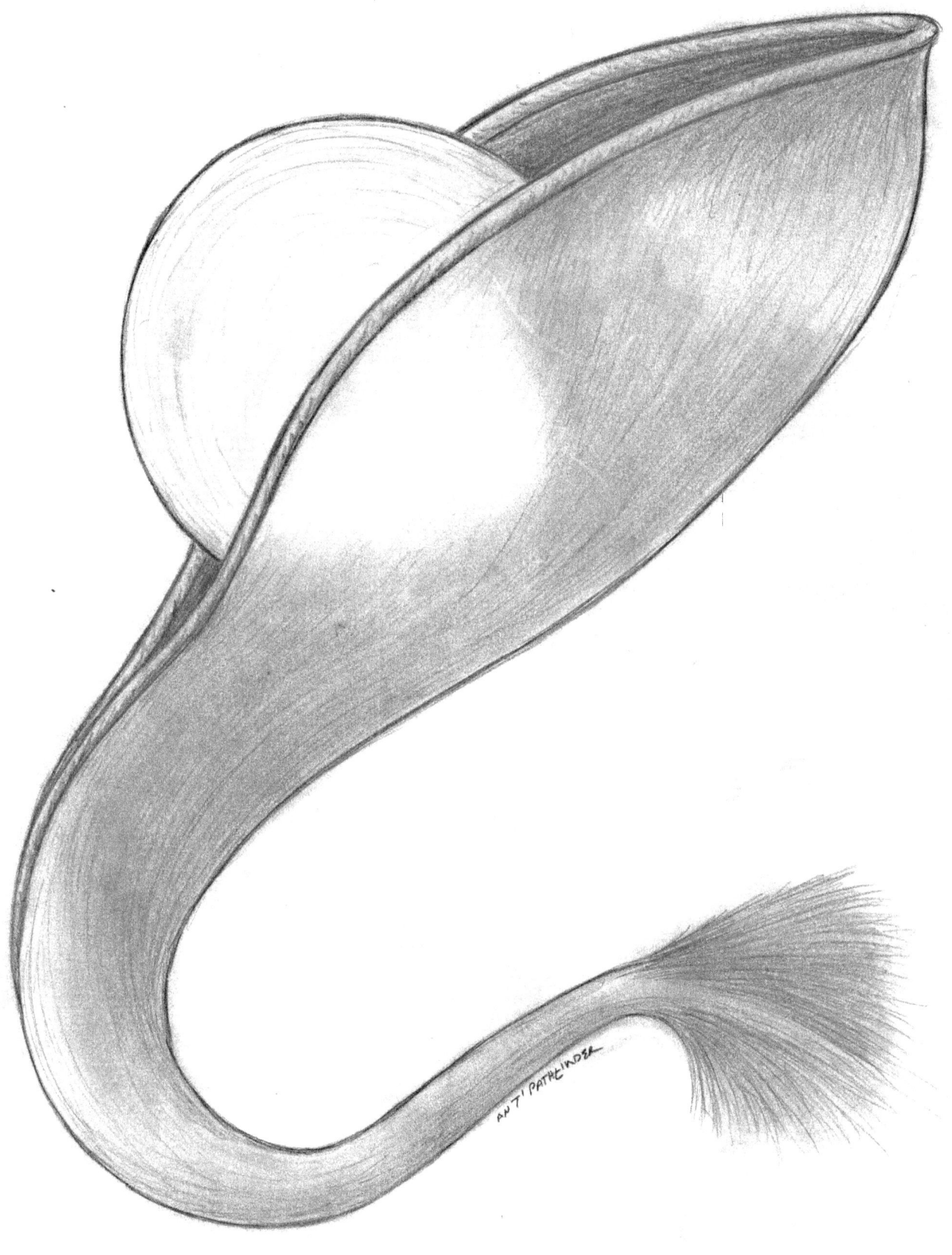

TRUTH POD

WILD CARDS FOR YOUR SOUL

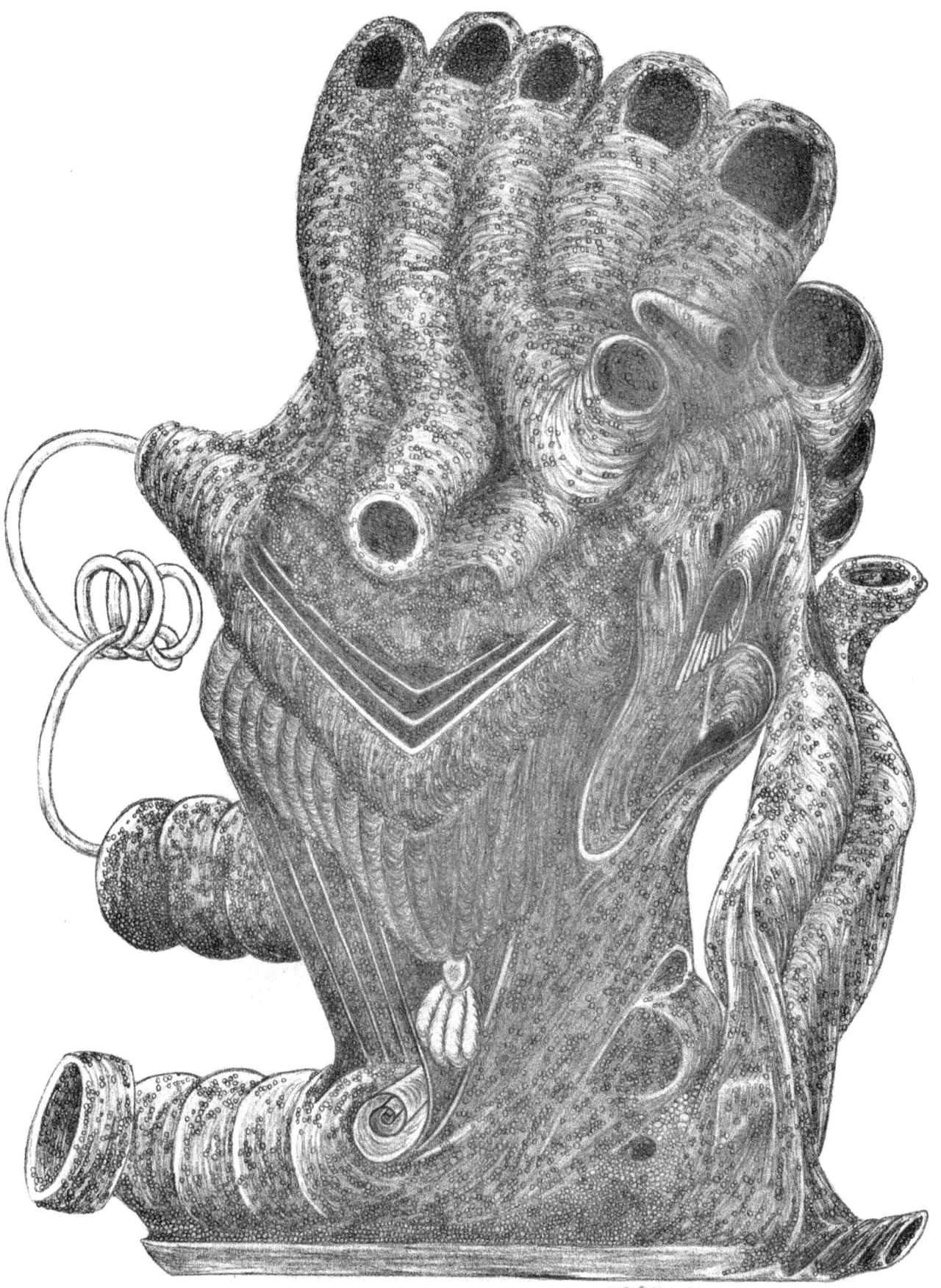

TRUTH-BOUND FLUTE

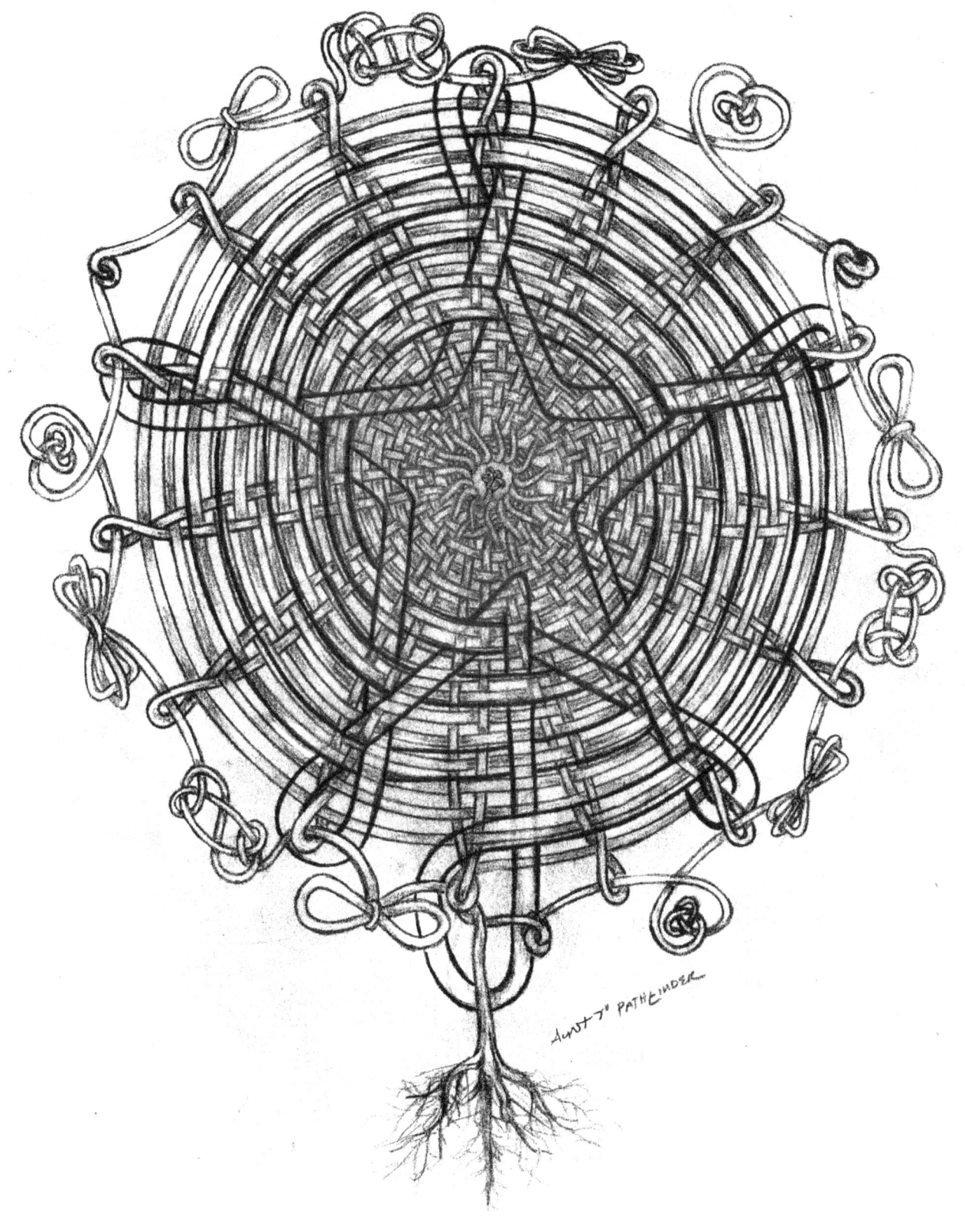

TRUTH-BOUND TREE & SHIELD KNOT

WILD CARDS U – V – W (NO X – Y – Z)

U: Unicorn of Pure Power; Unified Bowl; Upside Down Game of Life.

V: Vacuum Bone; Vacuum Chamber; Viral Vase found with Anti-Virus Shield & Base Guards.

W: Wall of Transformation with Life Threads Mask; Wheel of Karma; Wheel of Passion aka Independent Womb; Wind Hammer.

X: None.

Y: None.

Z: None.

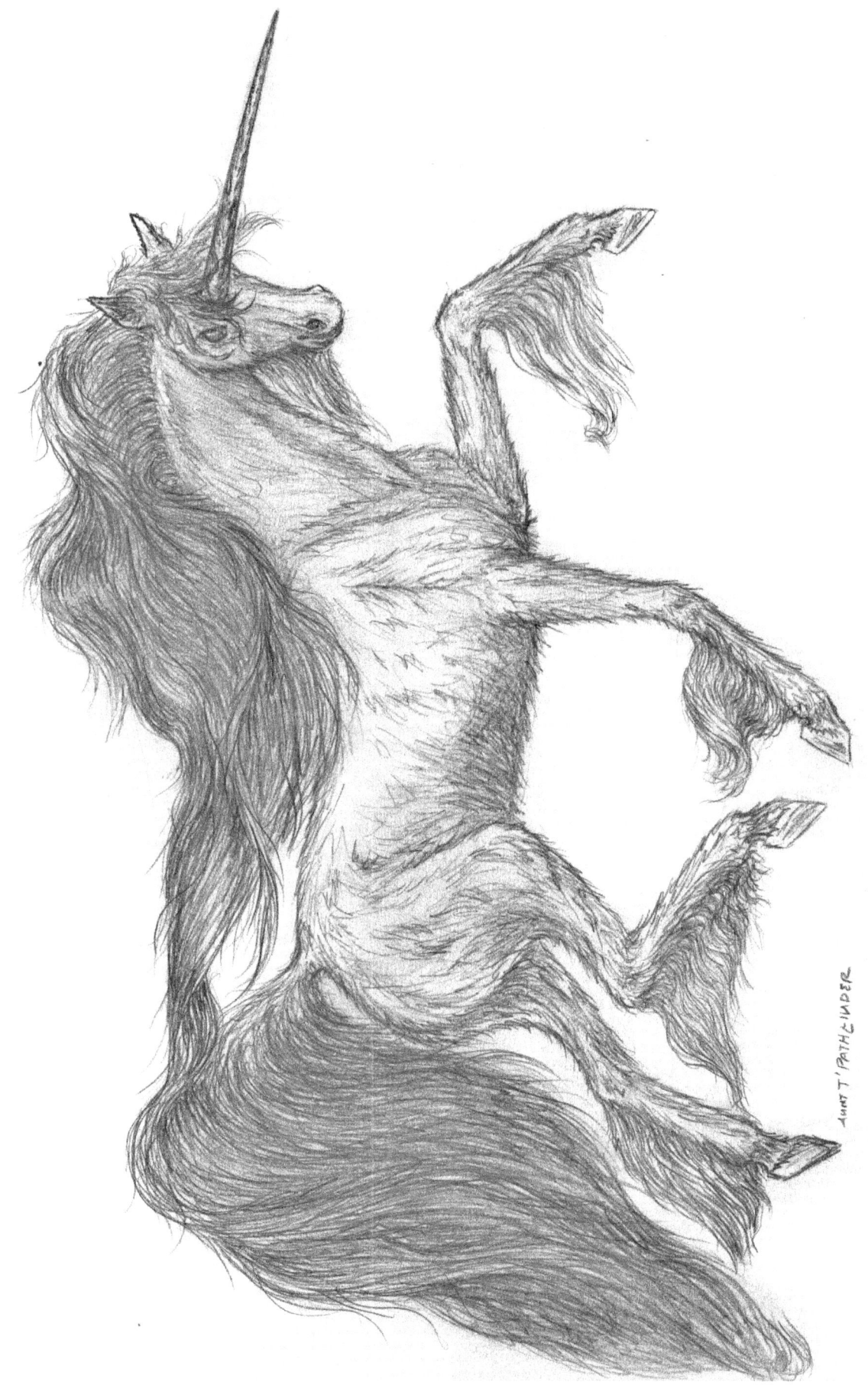

UNICORN OF PURE POWER

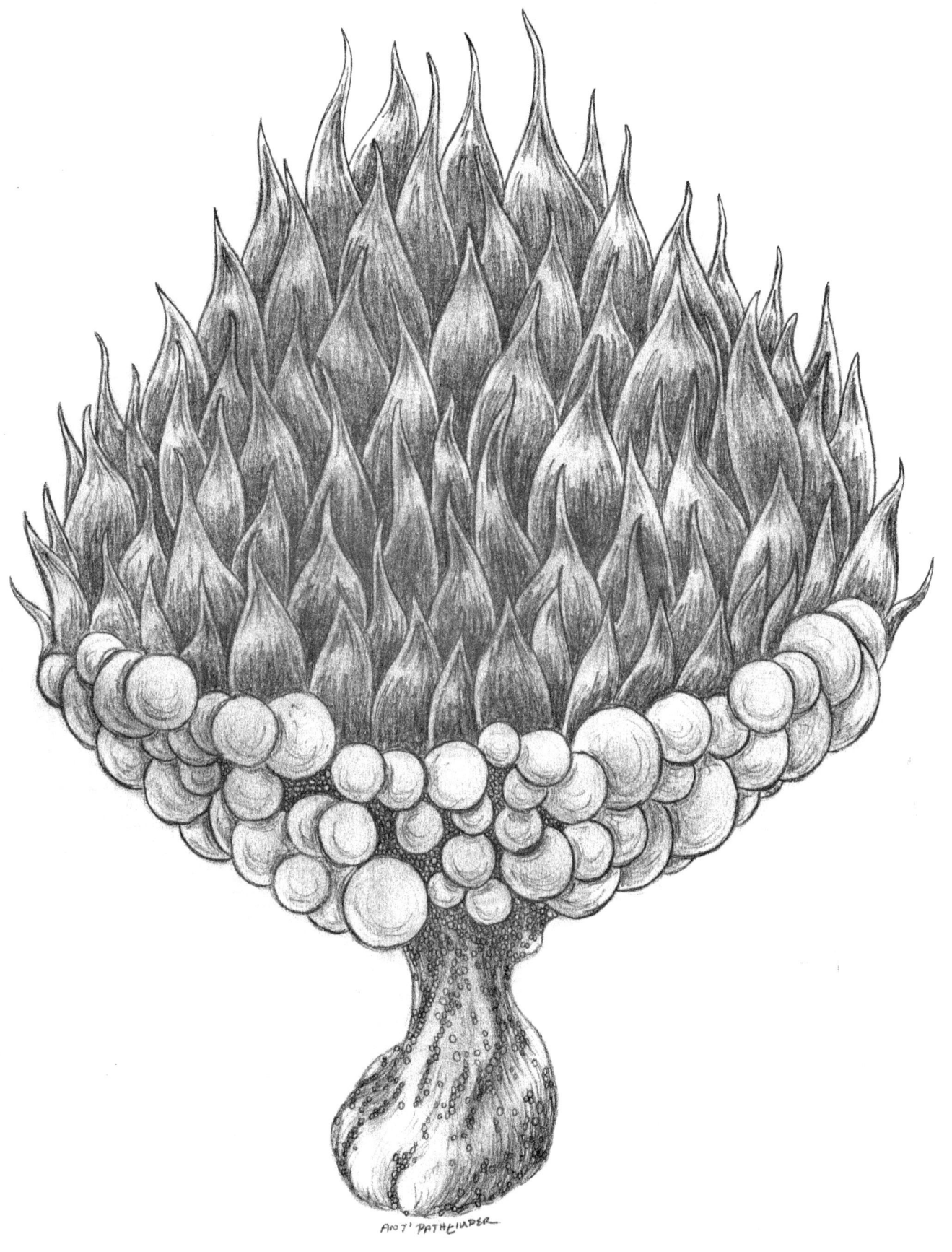

UNIFIED BOWL

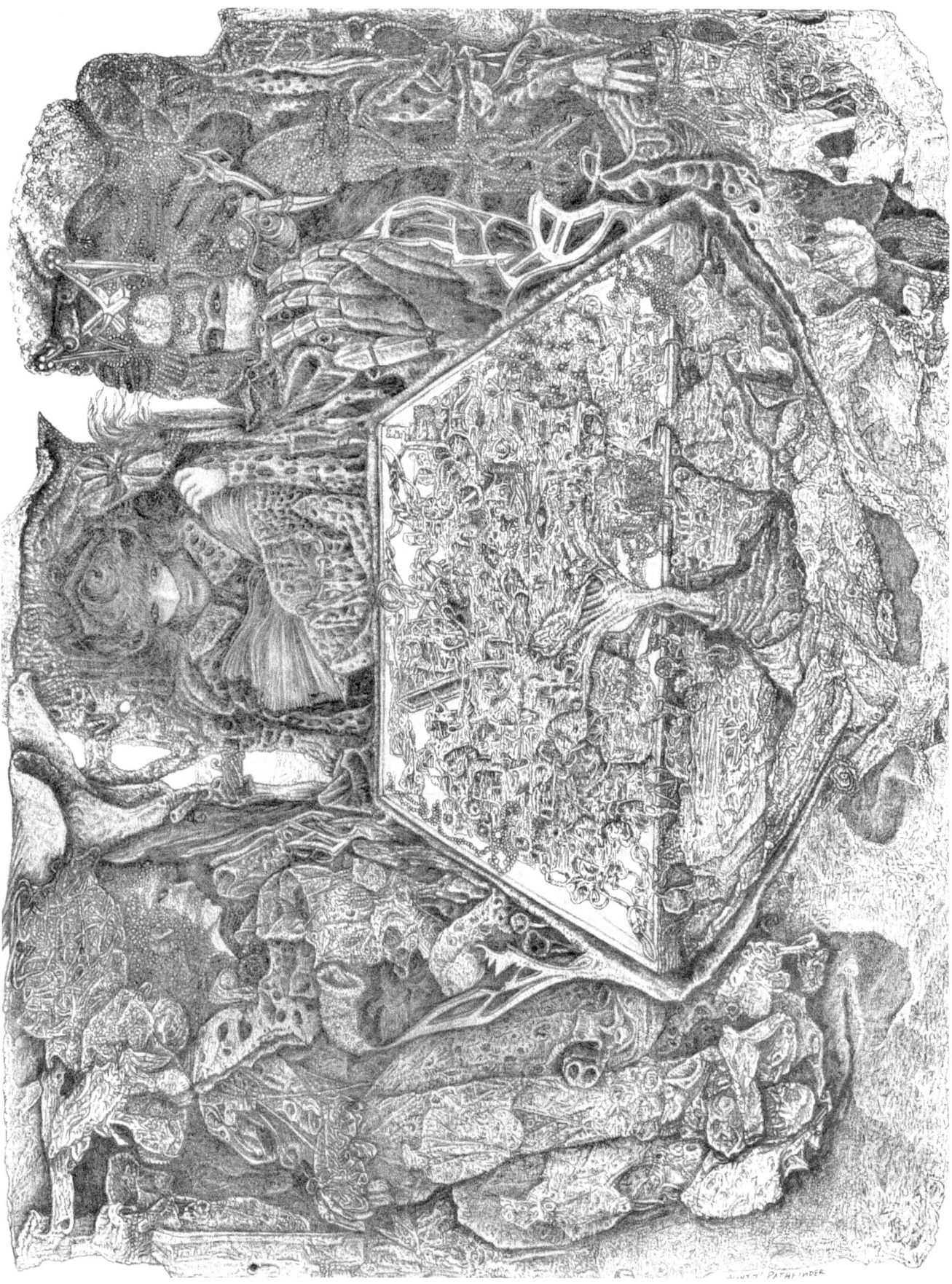

UPSIDE DOWN GAME OF LIFE

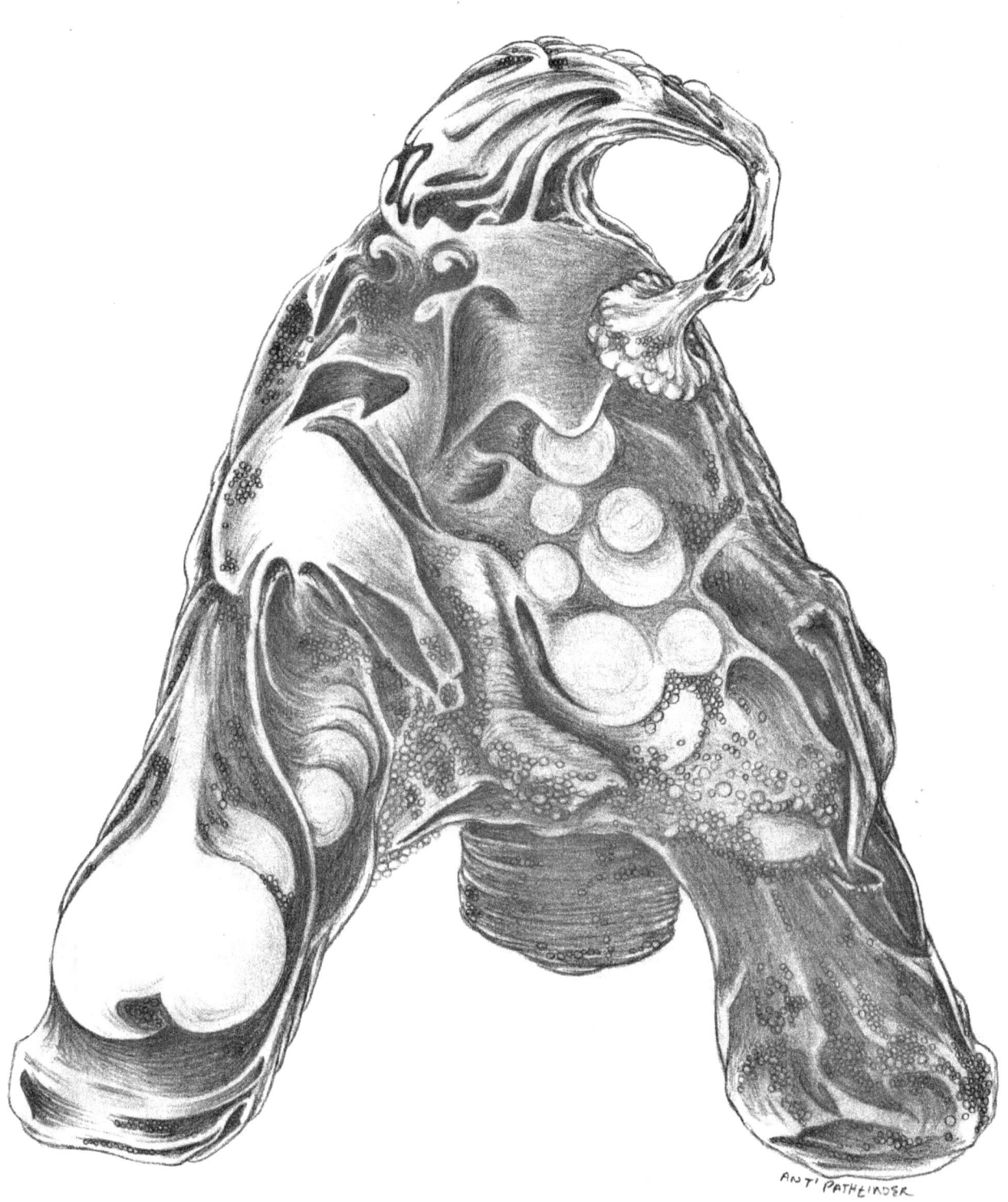

VACUUM BONE

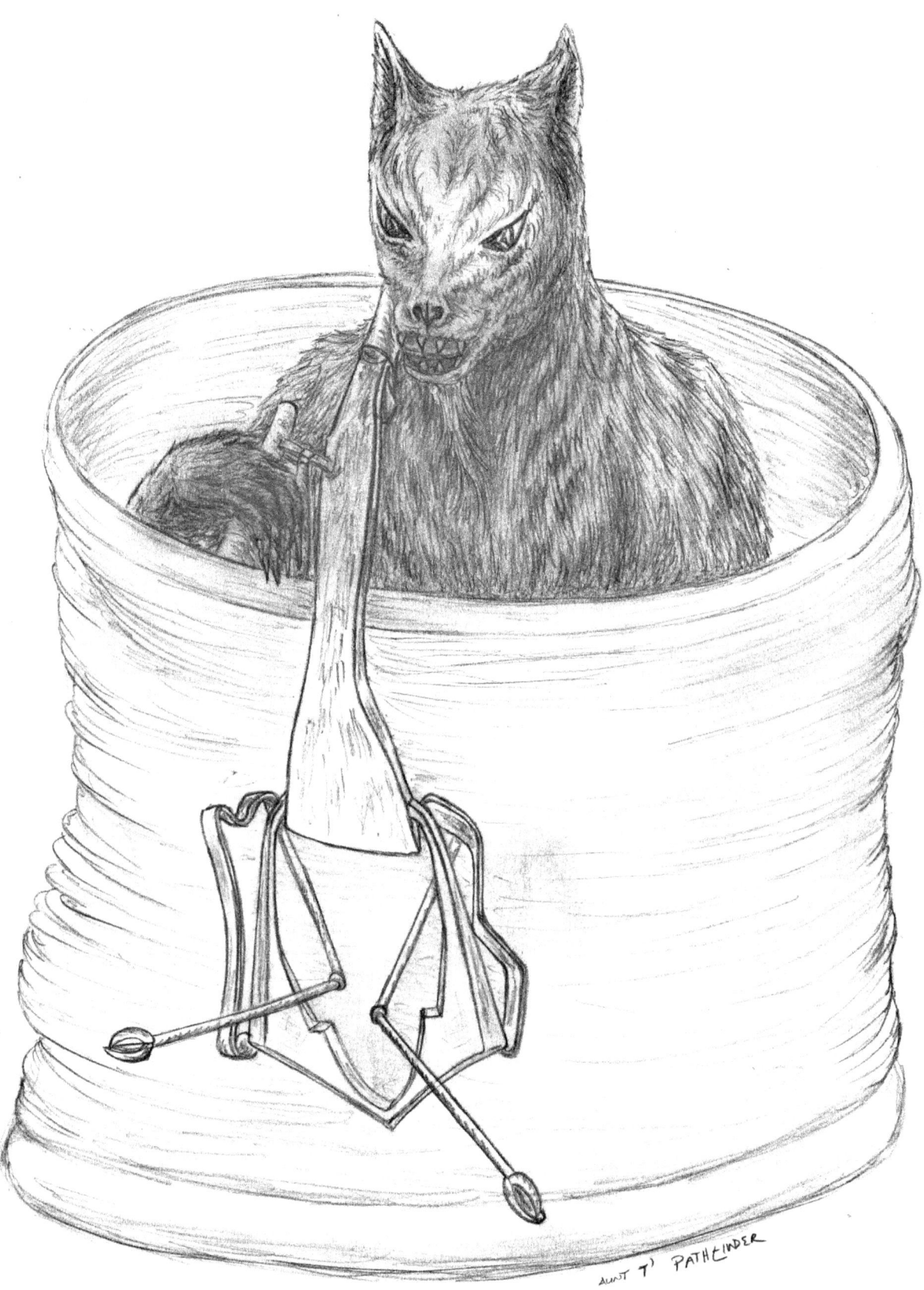

VACUUM CHAMBER

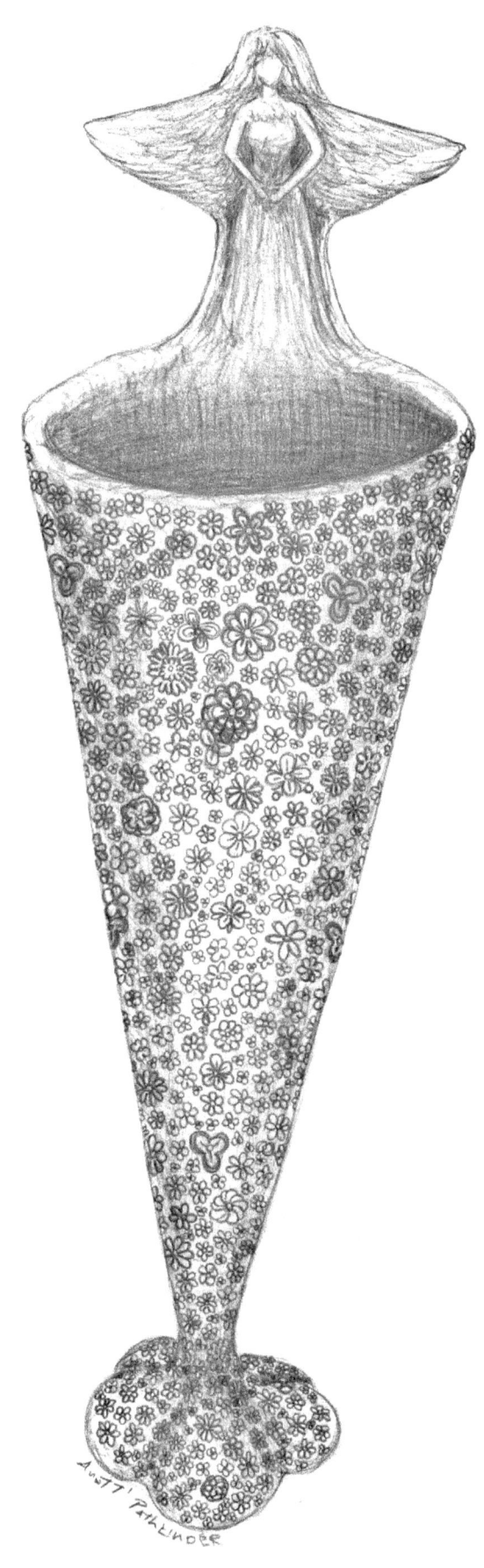

VIRAL VASE
FOUND WITH ANTI-VIRUS SHIELD & BASE GUARDS

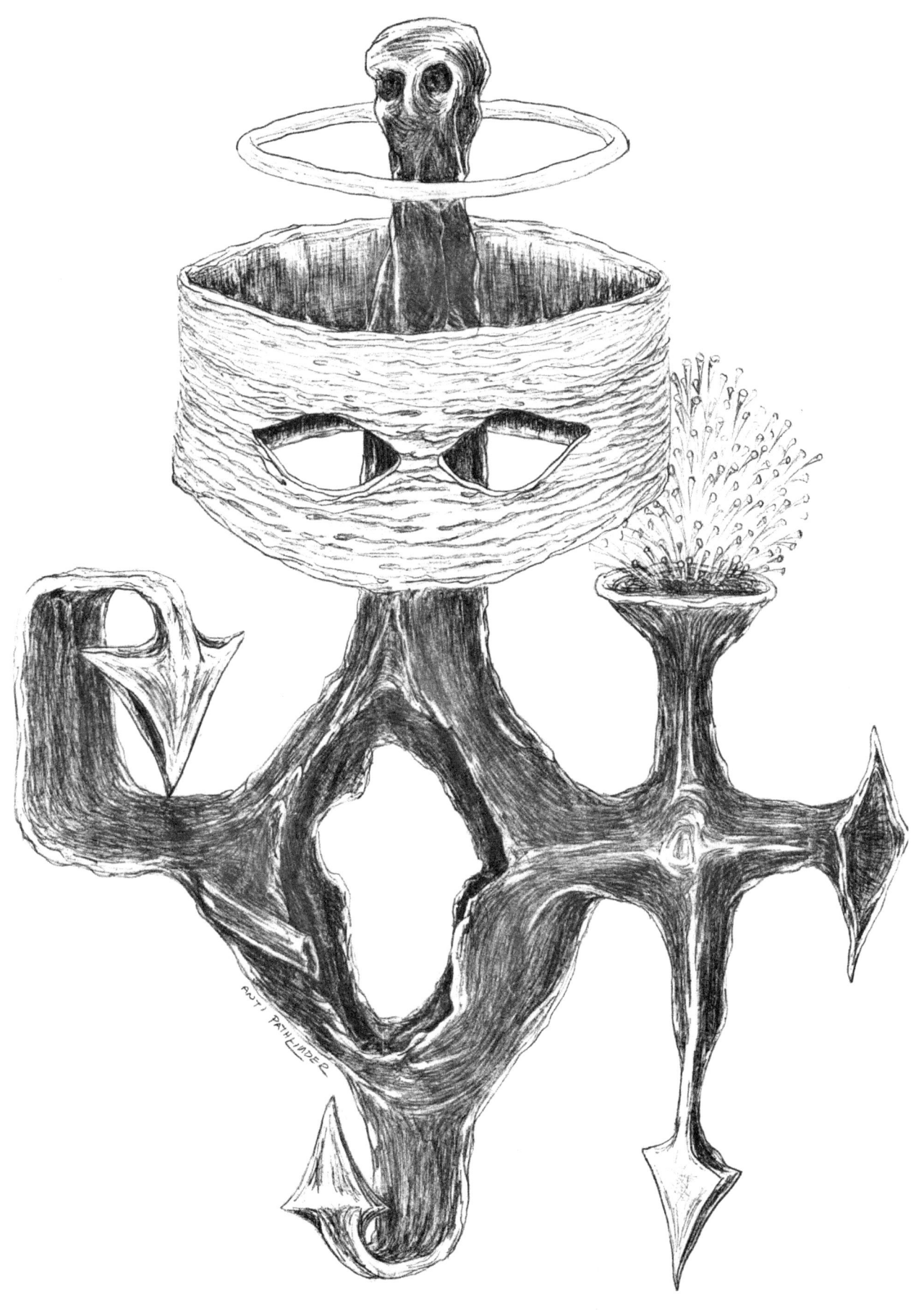

WALL OF TRANSFORMATION

WITH LIFE THREADS MASK

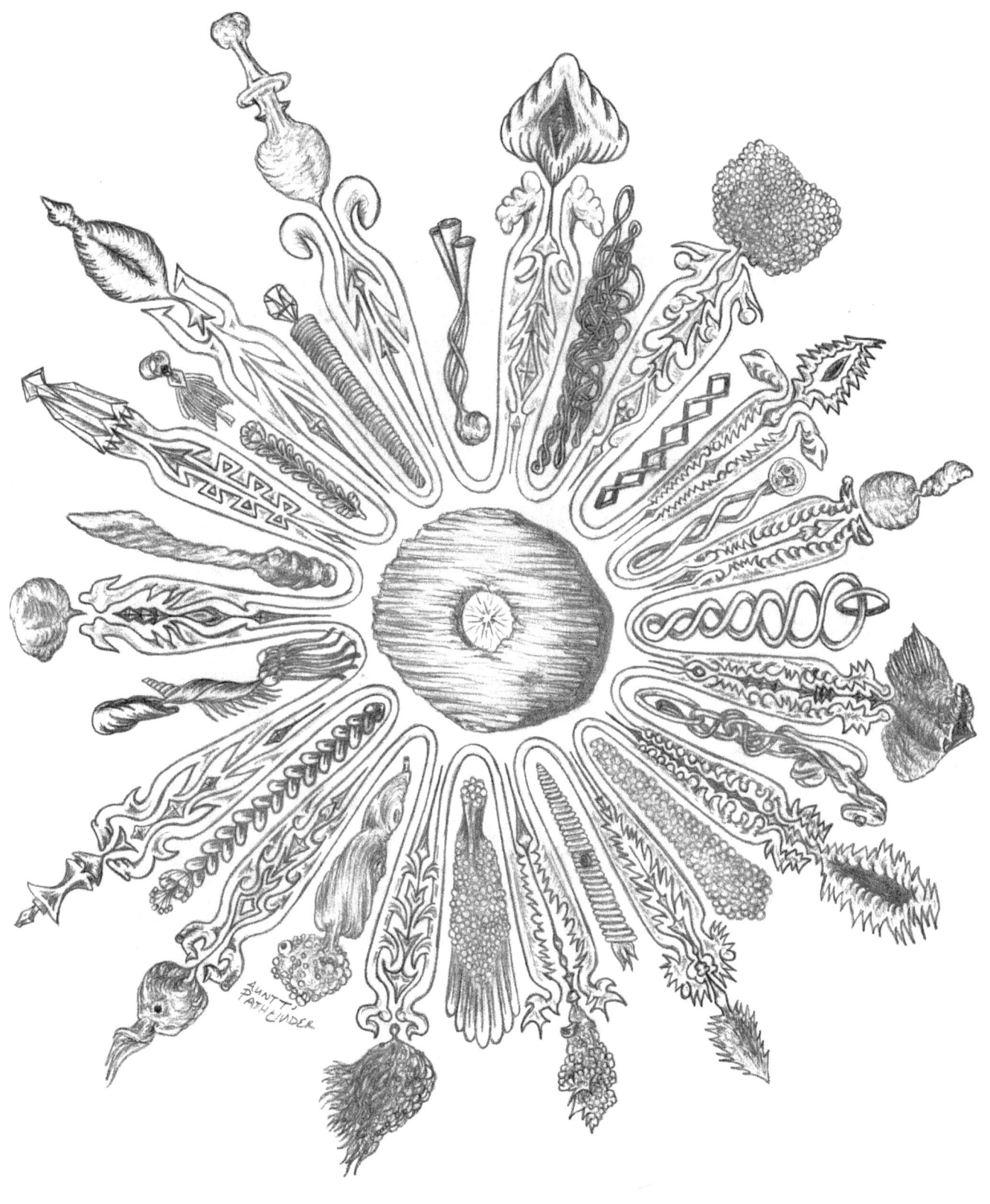

WHEEL OF KARMA

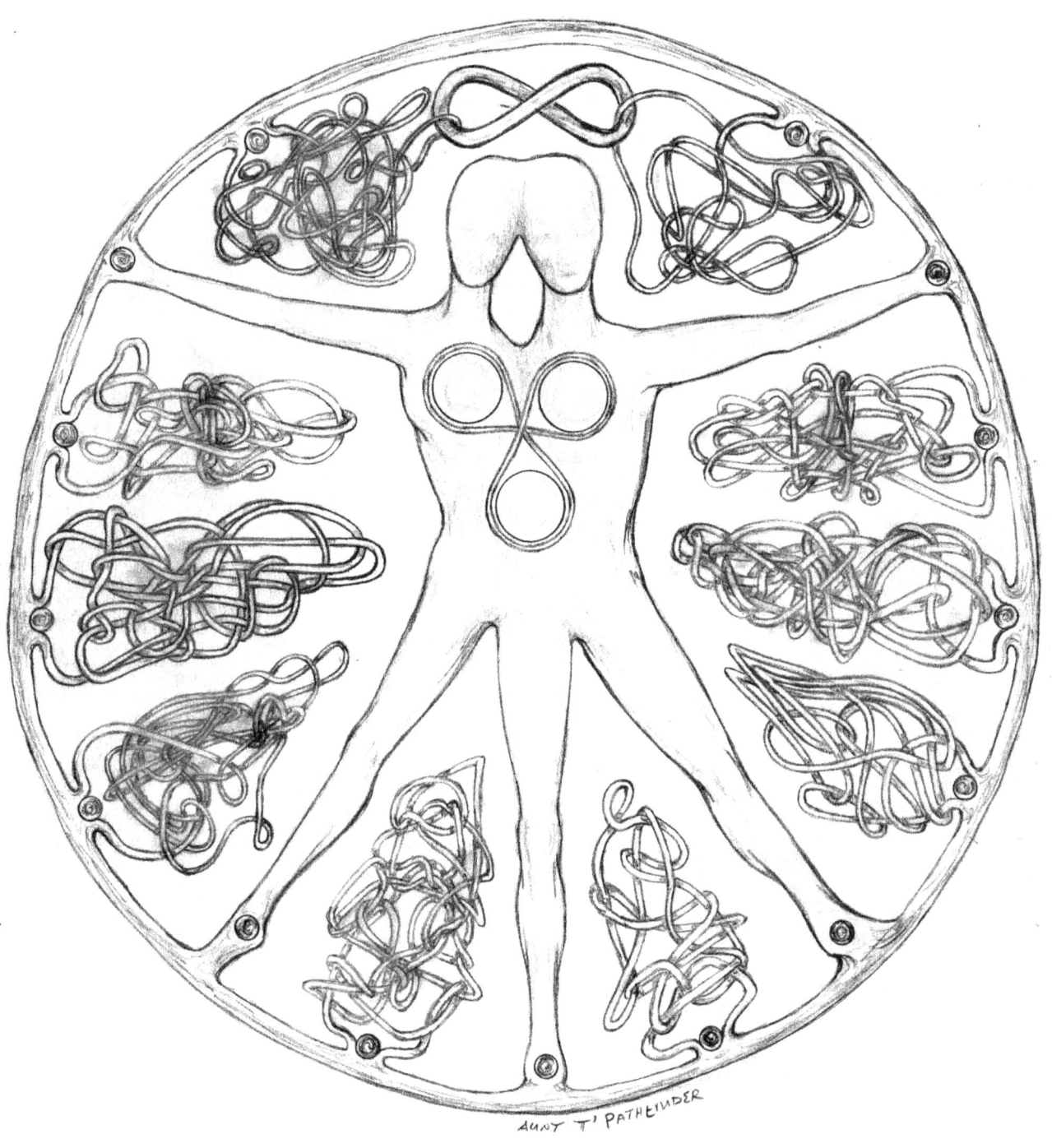

WHEEL OF PASSION AKA INDEPENDENT WOMB

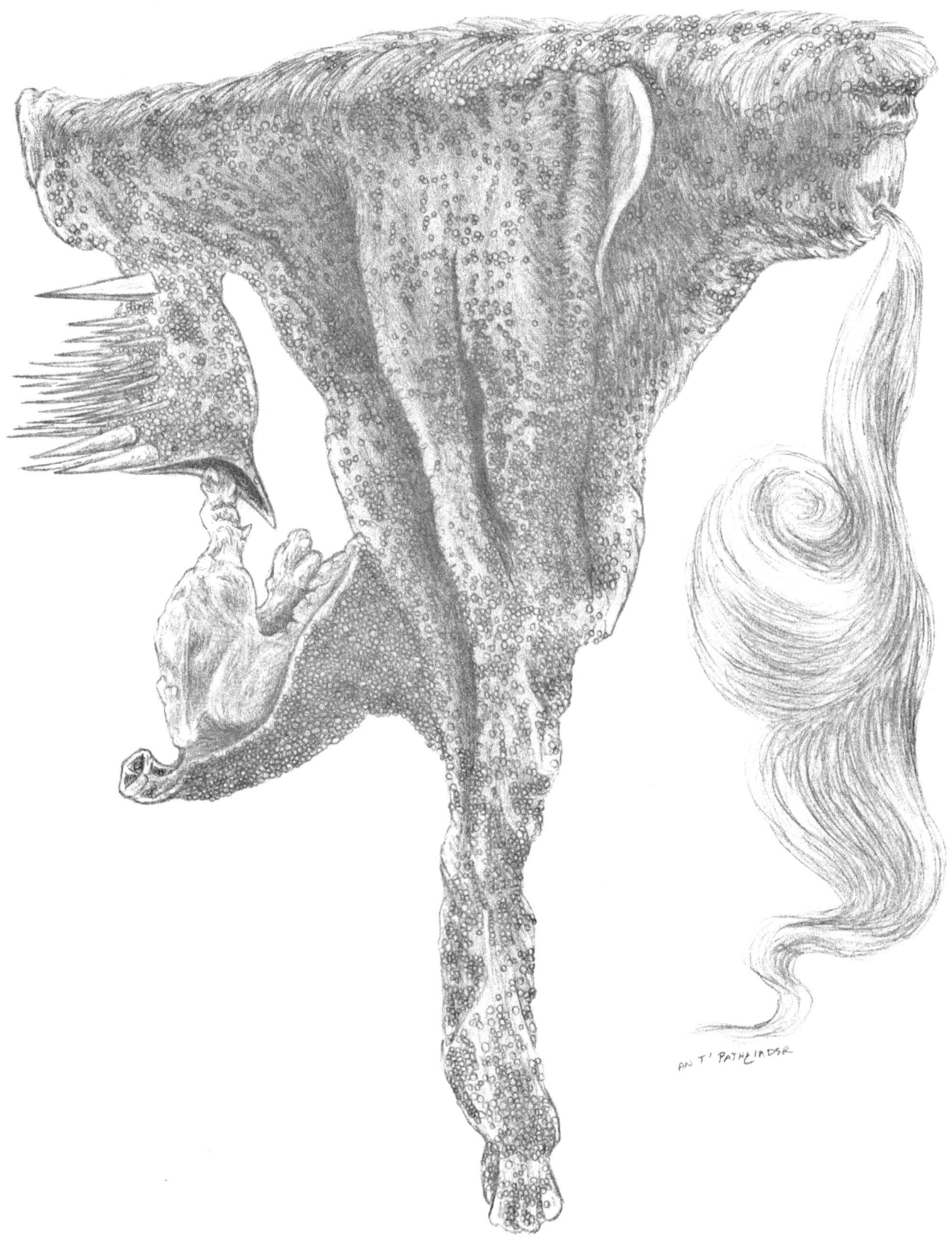

WIND HAMMER

ABOUT THE AUTHOR

Hi and hugs all around, I am the artist Aunt T Pathfinder:

I've already explained how the drawings evolved their depth and truths in my mind; and the techniques I used in creating them. I use the same basic technique (except for the Tree/paper connection) when I write my spiritually oriented syfy books (see Annie's Trail on Amazon). This helps channel my twitchy brain, which has a flaw. They have found it in the genes of others... you know the one... it can manifest as bipolar, schitzophrenia, OCD, depression, and other twists and turns. Whether what I see and believe is true or not, the stories are interesting and the drawings are... well, make up your own mind.

For those who remember my old websites, and the exlenations I had included for the Wild Cards (cleansing instructions), forget those explenations please. I am giving you only the names of each Wild Card and a scan of the drawing itself. If it was written on the paper in the process of the card's creation then it can stay; but I will give you only that. This is very deliberate, due to the realization I once confused many people and myself by trying to direct them in what they might see or feel, forgetting I was merely a pathfinder to the Gateways (Wild Cards). Through the process of Unconceived Drawings I found these gates and their names for those who look within and beyond themselves, but I cannot take you to the other side or do more than tell you the TRUTH is there nothing for you to fear... unless you allow yourself to fear what your own mind wishes for you to see and understand.

Color them if you want to, which is how I always wished the Wild Cards could be used (everyone picking their own colors) and so after twenty plus years of drawing them, I give you 193 spanning my evolution. I am open to people contacting me about mass production of the drawings (as cups, calendars, t-shirts, etc) for fair rates, so contact me through the information below.
Many hugs and much love, Aunt T Pathfinder

www.ingramcontent.com/pod-product-compliance
Lightning Source LLC
Chambersburg PA
CBHW082103220526
45472CB00009B/2027